T0213532

Advanced Design

John Reis

Advanced Design

Universal Principles for All Disciplines

 Springer

John Reis
Department of Engineering
East Carolina University
Greenville, NC, USA

ISBN 978-3-030-95784-1 ISBN 978-3-030-95782-7 (eBook)
https://doi.org/10.1007/978-3-030-95782-7

This Springer imprint is published by the registered company Springer Nature Switzerland AG
The registered company address is: Gewerbestrasse 11, 6330 Cham, Switzerland

Preface

I have always been a person of diverse interests. As a professional engineer, I have created things in support of my employer's needs. As a visual artist, I have created drawings and paintings that supported my interests. As a professor of engineering, I have developed curricula and research projects. As a university administrator, I have created new systems and processes. As a musician, I have composed songs, arranged tunes, and improvised with others. Although there are significant differences between all of these activities, there are also many similarities.

It is these similarities that really interested me. In particular, I wanted to know how my activities in one area could support my activities in other areas. Could I be a better engineer from my experience with music? Could I paint better art from my experience with creating new academic curricula? Could I write better engineering research proposals from my ability to paint abstract art? It turns out that the answer to these questions could be either emphatically yes or emphatically no. It was learning the difference that led to this book.

My journey began when I tried to improve how I taught design to engineering students by reading books on design in art. I quickly learned that books on art design are not useful for engineering students (and vice versa). To learn more, I began a more focused study of how design is woven through all of my interests. This study included a comprehensive literature review of literally thousands of peer-reviewed journal articles on related topics such as psychology, creativity, and decision-making. Through this process, I learned the difference between design and the implementation of design. There are hundreds of books on the implementation of design within narrow disciplines, but very few on universal design principles that cross all disciplines. It is these universal principles that interest me.

This book is the outcome of my study of design. It not only identifies the universal design activities that designers in all disciplines use, but it also provides a psychological and neurological basis for *how and why* those activities can lead to design success. Understanding these principles allows us to enhance and optimize our design effectiveness in whatever discipline we are in.

Yes, after completing this book, I am now a more effective teacher of engineering design. I am also a better engineer because of my activities in art and I am a better artist because of my activities in engineering. The key is to understand that design is not confined to the narrow boundaries of any given discipline. Design is universal. Let's now take a new look at the design.

Greenville, USA John Reis

Acknowledgements

First, I would like to thank my wife, Barbara, for her loving patience and support as we walked our convoluted life path. I would also like to thank East Carolina University for its support of my design studies, including its willingness to fund an engineering professor to take classes and workshops in art. In particular, I would like to thank Deans David White and Harry Ploehn and Department Chairs Hayden Griffin and Barbara Muller-Borer for their moral and financial support. I would also like to thank the many art professors at Pitt Community College and East Carolina University for their patience with me taking their classes. Additionally, I would like to acknowledge the dozens of professional artists who taught the many workshops I attended, shared their perspectives on design, and who critiqued my work. Image Credit: Cover photo and art, *Design, the Bridge Between Art and Engineering*, by John Reis.

Contents

1 The Universal Nature of Design 1
1.1 Introduction ... 1
1.2 I Know What Design is, I Think 1
1.3 Universal Design Activities 2
 1.3.1 Universal Design Activity: Clarify the Project 3
 1.3.2 Universal Design Activity: Generate Ideas 4
 1.3.3 Universal Design Activity: Select One Idea 4
1.4 Design is Structured, but Messy 4
1.5 Design and Problem Solving 6
1.6 Design and Creativity 7
1.7 Design Across the Disciplines 10
 1.7.1 STEM Disciplines 10
 1.7.2 Art and Engineering 11
1.8 Closing .. 13
1.9 Questions .. 15
References ... 16

2 How We Think and Learn Design 21
2.1 Introduction .. 21
2.2 How Do We Think? 21
 2.2.1 Intuitive and Analytical Thinking 22
 2.2.2 Which Thinking Mode Should We Use? 24
 2.2.3 Heuristic Thinking 25
 2.2.4 Feelings 26
2.3 How Do We Learn Design? 27
 2.3.1 Formal Design Education 28
 2.3.2 Informal Design Training 28
2.4 Closing .. 29
2.5 Questions .. 30
References ... 31

3 Universal Design Activity: Clarify the Project 45
 3.1 Introduction .. 45
 3.2 Steps to Clarifying the Project......................... 45
 3.2.1 Identify the Purpose 47
 3.2.2 Identify the Constraints....................... 47
 3.3 Why Clarify the Project 49
 3.4 How Do We Clarify the Project?........................ 50
 3.4.1 Ask Good Questions 51
 3.4.2 Review Other Designs 53
 3.4.3 Visualization 53
 3.4.4 Preliminary Design Iteration 53
 3.5 Closing ... 54
 3.6 Questions ... 54
 References .. 55

4 Universal Design Activity: Generate Ideas 61
 4.1 Introduction .. 61
 4.2 Getting Started with Idea Generation 61
 4.3 Intuition .. 62
 4.4 Seeding Ideas 64
 4.4.1 Seed Ideas from Clarifying the Project 64
 4.4.2 Seed Ideas From Heuristics (Rules of Thumb) 66
 4.4.3 Seed Ideas From Analogies...................... 68
 4.4.4 Seed Ideas From Randomness................... 69
 4.5 Design Fixation 70
 4.6 Effectiveness of Idea Generating Methods 71
 4.7 Closing ... 72
 4.8 Questions ... 73
 References .. 74

5 Universal Design Activity: Select One Idea 83
 5.1 Introduction .. 83
 5.2 Steps to Selecting One Idea........................... 83
 5.3 Defer Selection to Get More Information 84
 5.4 Elminate Ideas that Are not Useful 85
 5.5 Making the Final Selection 87
 5.5.1 Intuition...................................... 88
 5.5.2 Single Criterion Methods (Heuristics) 90
 5.5.3 Multiple Criteria Methods...................... 92
 5.6 Effectiveness of Selection Methods 93
 5.6.1 Intuition...................................... 94
 5.6.2 Single Criterion Methods (Heuristics) 95
 5.6.3 Multiple Criteria Methods...................... 95
 5.6.4 Combinations of Methods...................... 95

5.7 Closing . 96
5.8 Questions . 97
References . 98

6 **Improvisation** . 107
6.1 Introduction . 107
6.2 What is Improvisation? . 107
6.3 Types of Improvisation . 108
6.3.1 Artistic Improvisation . 109
6.3.2 Organizational Improvisation 109
6.4 Closing . 110
6.5 Questions . 111
References . 111

7 **What Makes a Good Designer?** . 115
7.1 Introduction . 115
7.2 Behaviors of Effective Designers . 115
7.3 Psychology of Effective Designers . 116
7.3.1 Flexibility in Thinking . 118
7.3.2 Control of Attention . 121
7.3.3 Secondary Characteristics 122
7.4 Impact of Cultural Background . 124
7.5 Closing . 125
7.6 Questions . 126
References . 127

8 **Enhancing Our Ability to Design** . 139
8.1 Introduction . 139
8.2 Cognitive Enhancement . 139
8.3 Incubation . 140
8.4 Sleep and Dreams . 140
8.4.1 Sleep . 140
8.4.2 Dreams . 141
8.4.3 Hypnagogia . 141
8.5 Focused Imagination . 142
8.6 Meditation . 142
8.7 Hypnosis . 143
8.8 Posture and Exercise . 143
8.9 Food and Drink . 143
8.10 Mind-Altering Substances . 144
8.10.1 Alcohol and Cannabis . 144
8.10.2 Prescription Drugs . 145
8.10.3 Hallucinatory Drugs . 145

	8.11	Technology	146
		8.11.1 Neurofeedback	146
		8.11.2 Transcranial Stimulation	147
		8.11.3 Brainwave Entrainment	148
	8.12	Closing	148
	8.13	Questions	149
	References		150

9 Biases in Design ... **165**
 9.1 Introduction ... 165
 9.2 Primary Source of Our Biases ... 165
 9.3 Biases from Heuristics ... 166
 9.3.1 Creative-Conservative Bias ... 167
 9.3.2 Familiarity Bias ... 168
 9.3.3 Confirmation Bias ... 169
 9.3.4 Simplicity Bias ... 169
 9.3.5 Balance Bias ... 170
 9.3.6 Color Perception Bias ... 172
 9.4 Biases from How We Think ... 173
 9.5 Biases from How We Feel ... 173
 9.6 Biases from Value Judgements ... 176
 9.7 Closing ... 178
 9.8 Questions ... 179
 References ... 180

10 Designing with Others ... **193**
 10.1 Introduction ... 193
 10.2 Individual Versus Team Design ... 193
 10.2.1 Clarifying the Project ... 194
 10.2.2 Generating Ideas ... 194
 10.2.3 Selecting One Idea ... 195
 10.2.4 Other Impacts ... 196
 10.3 Creating Effective Teams ... 196
 10.4 Supervising Design Teams ... 197
 10.5 Closing ... 200
 10.6 Questions ... 201
 References ... 202

11 Epilogue ... **211**

Index ... **213**

About the Author

Dr. John Reis has had a diverse career spanning both industry and academia. His formal academic education includes a B.S. degree from Oregon State University in nuclear engineering and an M.S. and Ph.D. from Stanford University in mechanical engineering. After completing his formal education, he worked in industry with Chevron Corporation designing improved methods to extract oil from oil fields. After spending some time continuing this research at the University of Texas at Austin, he shifted his primary focus to teaching at the Prescott, Arizona campus of Embry-Riddle Aeronautical University. This was followed by a period of university administration as a Department Head at Western Kentucky University and an Associate Dean at East Carolina University. He then returned to the ranks of faculty to focus on exploring the relationship between design in the arts and design in engineering. Over the course of his career, he has published about 50 papers, with half being in peer-reviewed journals, is co-inventor on two patents, and has published two books. His art interests include being an avid jazz keyboardist and abstract painter.

The Universal Nature of Design

<div style="text-align: right">**1**</div>

1.1 Introduction

What is design? Countless books have tried to answer this question. A superficial reading of those books suggest that design is very different for the many disciplines that use design. But is design really different in art than it is in engineering or is it actually the same? Is design universal? As a way to address this question, consider all of the books on design in art and remove everything that an engineer is not taught. What is left over? Then consider all of the books on design in engineering and remove everything that an artist is not taught. What is left over? Actually, what is left over is this book.

This chapter starts by identifying the universal activities of design that are common across all design disciplines, followed by a discussion of some of the key relationships between design and the related areas of problem solving and creativity. The chapter closes with discussing some of the key differences between design in art, science, math, and engineering.

1.2 I Know What Design is, I Think

Ask ten people what design is and you will get ten different responses. Nevertheless, many of the responses will be some variation of the following:

Design is an intentional change in something to achieve a purpose.

With this description, design has two requirements: an intentional change and a reason for making that change. Although this description works well for design in art, it falls short for engineering. The change is virtually always made in art design, i.e., a painting is completed, but the change is not necessarily made in engineering design. Instead, engineering design typically requires only that plans for the change be

J. Reis, *Advanced Design*, https://doi.org/10.1007/978-3-030-95782-7_1

completed. The change itself does not actually have to occur, i.e., the change does not have to be implemented. Noting this, a more accurate description of design might be.

Design is an intentional change in something (or completed plans for such a change) to achieve a purpose.

One important factor in this description of design is that it is not linked to any particular discipline; it treats all disciplines the same. In this context, design is considered to be universal (domain-general). Yet, is design in the fine arts really the same thing as design in engineering? Is design in art or engineering the same thing as design in the applied arts like architecture, technology, fashion design, landscape design, interior design, industrial design, new product design, etc.?

We can begin to answer this question by considering the difference between design and the *implementation* of design. Many descriptions of design are phrased in terms of the language of how design is implemented in any particular discipline. That language tends to be domain-specific. For example, the word "innovation" means different things in art and engineering. In art, innovation typically refers to the creation of a new style of art, not the completion of an individual work of art. In engineering, innovation typically refers to the implementation of a design plan. In engineering, innovation includes the management of how design is implementation. Innovation in art does not require separate project management activities.

Once we get past the language barrier between different design disciplines, we discover that all designers in all disciplines are really doing the same things. When we use a common language for design, we find that design is truly domain-general. Yes, as we will see, design in art is the same as design in engineering, it just implemented differently [1–5].

Using the observation that design is universal across all disciplines, another description of design can be developed:

Design is the set of activities that are common to all designers in all disciplines.

Although this seemingly circular description does not tell us what design is, it points us in a new direction for understanding design. We can compare design across many disciplines, eliminate the differences, and focus on what they have in common.

It is noted that the word 'design' is widely used to describe both a process (the word is used as a verb) and a product (the word is used as a noun). For the purposes of this book, however, the distinction between the design process and the design product is unimportant and will be ignored.

1.3 Universal Design Activities

So, what are those common elements of design that all designers use? Many activities have been used to describe design, such as composition, innovation, analysis, syntheses, testing, exploration, embodiment, gather more information,

creativity, reflection, empathy, modeling, decompose the problem, implement, development, evolve the problem and solution, test solutions, redesign, and others. Those words, however, are not universally used by all designers, nor do they have a universal meaning. A closer look at what designers actually do reveals that all design activities can fit within just three universal activities:

1. clarify an initially ambiguous project,
2. generate ideas, and
3. select one idea to implement.

Designers in all disciplines do these three things.

From this observation, a final description of design can be stated:

Design is clarifying an initially ill-defined project, generating a set of ideas that could be used to complete the project, and selecting one of those ideas to be implemented.

At first glance, this description of design does not appear to include the afore-mentioned intentional change or purpose required for design. As we will see, however, those concepts are integrated into the first of the universal design activities: clarify an initially ambiguous project.

One of the benefits of this description of design is that each of these universal activities requires different skills to complete and each uses different cognitive and neural processes. [6] By identifying which skills and processes are needed for each of these activities, we can focus on how to improve them. We can enhance our overall ability to design by focusing on enhancing our ability to complete each of these three universal activities.

These three universal design activities are briefly introduced here and will be discussed in greater detail in later chapters.

1.3.1 Universal Design Activity: Clarify the Project

The first of the universal design activities is to clarify an initially ambiguous project. Clarifying the project has two parts: determining the underlying purpose and identifying the constraints.

Purpose: Why are we doing this project? What is the underlying need, objective, or reason for doing the design project? What is the use of the project? What is the intended change? What is its aesthetic (emotional) or functional (physical) objective? Constraints: What are the constraints that will limit the project? What do we want the project to do? What do we want the project not to do? What factors will limit or guide the direction our project will go? How will we know if our project will be successful? How will we know when our project will be complete?

Determining the underlying purpose is needed because design projects, as initially perceived by us, are rarely what we really need or want. We typically see only

the symptoms or general nature of a situation, not the underlying purpose itself. Determining the purpose brings a focus to exactly what the design project is about.

Identifying the constraints is needed because all design projects exist in a context and that context provides constraints that limit which designs can successfully address the purpose. It is through satisfying the constraints that a design becomes useful. Constraints come in two primary varieties: hard and soft. Hard constraints are requirements that must be satisfied or the design will fail. Soft constraints are preferences that have flexibility in how they are addressed.

1.3.2 Universal Design Activity: Generate Ideas

The second of the universal design activities is to generate ideas (solution alternatives). This process is also known as ideation. How do we generate ideas? Where do ideas come from? How do we generate more ideas when we run out of ideas? Although it is very easy to generate ideas, we really don't know how we do it.

1.3.3 Universal Design Activity: Select One Idea

The third of the universal design activities is to select one of the generated ideas for implementation. Selecting one idea has three parts: defer the selection until a later time to get more information, eliminate those ideas that are not useful, and select the final idea from the useful ideas.

Defer: During most of the design processes, insufficient information is available to make a meaningful selection (decision). It is almost always necessary to defer making selections, at least for a while, to give us time to collect more information.
Eliminate: Not all of the ideas that we generate will be useful, nor should they. Ideas are considered to be useful if they address the purpose and satisfy the (hard) constraints. Useful ideas are those that are expected to lead to a successful design. Ideas that are not useful should be eliminated from further consideration.
Select: The final selection of which single idea is to be implemented is normally made by identifying which useful idea we prefer over the other useful ideas. Our preference is typically based on balancing soft constraints.

1.4 Design is Structured, but Messy

One of the common factors for all disciplines is that design has an underlying structure but is messy to complete.

We have already seen one underlying structure of design through the overall sequence of the three universal design activities. We tend to start a design project by clarifying the project, we then generate ideas related to the project, and finally, we select one of those ideas to implement.

We can identify a second underlying structure by recognizing that most design projects consist of higher-level and lower-level decisions that are organized into a hierarchy. We can decompose a complex, higher-level design project into set of smaller, easier, lower-level projects. We then treat each of the smaller projects as a separate design project, with each requiring the use of all three of the universal design activities. We do not need to complete the overall design project at one time [7–9].

One way of understanding this layered structure of design projects is through a simplistic three level model for design.

Level 1: Conceptual Design: This level involves the highest-level decisions of the design process in which the overall concepts for the design are worked out without focusing on the details. For artists, this is often the underpainting where the overall composition is determined. For engineers, this can be the selection of the overall technologies, approaches, or types of processes to be used.

Level 2: Preliminary Design: This is the intermediate level in the design hierarchy in which details are added to the overall concepts determined in the first level. For artists, this can be developing the body of the painting within the overall composition provided by the underpainting. For engineers, this can be where components and subcomponents are designed.

Level 3: Detailed Design: This level involves the lowest level decisions of the design process in which the final touches are added. For artists, this can be where the fine details such as highlights and accents are added. For engineers, this can be where the drawings and specifications are finalized.

In reality, however, designs do not have just three levels; design projects typically involve hundreds if not thousands of levels and sublevels [10, 11]. Every design project is really a combination of many smaller design projects.

Unfortunately, these structured approaches to design don't work very well. We can't just start at the beginning and work sequentially through the various activities in a set, predetermined sequence and expect to obtain a good design. We can't because we never have complete information for any design project, *ever*! We never have enough information to complete any task with certainty. If there is certainty, it is not design.

The best we can do with design is begin with one activity and do what we can with what we know. We then move on to another activity and do it using whatever information we have available. Every time we do something that is relevant (virtually anything!), we gain new information. We can then use that information as feedback and revisit our earlier activities and make improvements. That is the true nature of design.

This iterative process of bouncing back and forth among the many design tasks involves many cycles within cycles within cycles. We can iterate through the three universal design activities hundreds or even thousands of times over the course of a single design project. With each iteration, we get more information about the project, which significantly improves the quality of our designs compared to rigidly following fixed steps [12–16].

Design is structured because there is an overall pattern and direction to our activities, but it is also messy because there is no fixed sequence of activities that we can follow as we work through the project. We must rely on the information we gain as we work through the design process to guide our next step. We must iterate among the various design activities without having a clear path for doing so.

1.5 Design and Problem Solving

A process closely related to design is problem solving. Design involves a significant amount of problem solving, yet there are significant differences. Not all design is problem solving and not all problem solving is design.

Most of us become designers because of the pleasure we obtain by engaging in the design process. We just enjoy doing it. We design, not for the purpose of solving a problem, but for the sheer pleasure of creating something new. This creativity is part of who we are. Of course, we may also design for the sheer pleasure of solving the problems inherent in design. Either way, we design because it brings us personal joy that is independent of the problems we solve.

Another way to differentiate between design and problem solving is to note that not all problems are design problems.

- Problems can be either well-defined or ill-defined. Well defined problems are those in which the problem is understood and there is a clear and known pathway to a solution. Ill-defined problems are those in which the problem is ambiguous and there is no well-defined pathway to a solution. Design problems are ill-defined.
- Solutions to problems can be either closed-ended or open-ended. Closed ended problems are those that have a definitive solution that can be judged to be right or wrong. Open-ended problems have multiple useful solutions and those solutions cannot be judged as right or wrong. Design problems are open-ended.

Considering the two types of problems and the two types of solutions yields four overall types of problems: well-defined and closed-ended, well-defined and open-ended, ill-defined and closed-ended, and ill-defined and open-ended [17, 18]. These four different types of problems are not simple variations on an overall process of problem solving, however. They each require different skills and they each involve the activation of different neural regions of the brain. Although some people can be good at solving all of these types of problems, most people tend to be better at one type than another [19–30].

Of these four types of problems, only two will be discussed further: ill-defined, closed-ended problems, called insight problems, and ill-defined, open-ended problems, called design problems.

- Insight problems are those that are characterized by a single correct answer that we initially do not recognize. In a flash of insight, we suddenly recognize the solution. Insight problems are the primary type of problem solved in the disciplines of mathematics and science. They are also commonly found in clinical applications, such as medical practitioners or auto mechanics, where insight is used to diagnose or identify the source of a problem. Although insight problems are quite different from design problems, they can be relevant to design because insight and design problems share much of the same literature on creativity. The literature on creativity is introduced next.
- Design problems, unlike insight problems, are characterized by having multiple solutions that can all be expected to lead to a successful design and no clear way to judge or compare them. Design solutions are selected, not by determining whether they are right or wrong, but by balancing a complex set of ill-defined preferences (soft constraints). Because design problems are both ill-defined and have no clear solutions, they are sometimes referred to as "wicked" problems.

1.6 Design and Creativity

We now turn to the complex relationship between design and creativity. Before beginning, however, we need to have a better understanding of what creativity actually is. Over 60 different definitions and measures for creativity have been proposed in the literature [31, 32]. Unfortunately, the literature on creativity is highly fragmented and has no clear focus. The various definitions and measures of creativity are, at best, inconsistent and often are contradictory [33–37]. Nevertheless, we begin our understanding of how creativity relates to design by considering what the literature does agree upon.

One of the first detailed descriptions of creativity was proposed by Guilford [38]. He did not define creativity, but proposed eight different approaches to measuring it:

1. Fluency: the ability to generate a large number of ideas quickly,
2. Originality: the ability to generate novel and uncommon ideas,
3. Flexibility: the ability to think in different ways and break old habits of thinking (generate ideas in different categories),
4. Analysis: the ability to break down ideas into smaller parts (decomposition),
5. Synthesis: the ability to combine small ideas into larger ideas,
6. Reorganization and Redefinition: the ability to restructure ideas,
7. Complexity: the ability to consider many different ideas at the same time,
8. Evaluation: the ability to rank ideas by some relevant criteria.

All of these proposed measures of creativity fit within the three universal design activities introduced above.

A different approach to creativity is the widely-cited, two-factor model proposed by Stein [39]. In this model, a creative idea is an idea that is both original and useful. Because originality is related to idea generation and usefulness is related to idea evaluation (selection), this two-factor model also fits within the three universal design activities. This two-factor model was significantly expanded upon with the introduction of the Geneplore Model for Creativity [40]. Both originality and usefulness in design will be discussed in greater detail throughout this book.

Although these models for creativity are consistent with our description of design, there are two serious difficulties linking the body of work on creativity with design. First, creativity studies have largely ignored the role that context has on creativity. Creativity can vary significantly depending on the context in which it is being implemented, including which assessment instrument is used to measure it. Second, although most creativity studies generally acknowledge usefulness as being part of the definition of creativity, many of those studies then ignored usefulness and focused solely on originality [33, 41–46]. Design, on the other hand, does not ignore either context or usefulness. The context of design is defined through its purpose and constraints, while usefulness is determined through the way the purpose and constraints are addressed. Creativity studies generally lack both purpose and constraints. Creativity research needs better clarity to resolve its inconsistencies.

These difficulties with the creativity literature have essentially narrowed its value to only the universal design activity of idea generation, and in particular, the generation of original but not necessarily useful ideas. The creativity literature is of lesser value to all other aspects of design.

To better understand the limited relationship between creativity studies and design we will now briefly review three of the most widely used measures for creativity: the Remote Associates Test, the Alternative Uses Test, and the Torrance Tests of Creative Thinking.

Remote Associates Test (RAT): The Remote Associates Test involves being given three seemingly unrelated words and measuring the ability of people to find a fourth word that is commonly associated with them (e.g. cake, swiss, and cottage, with the common word being cheese). Because there is a single right answer to a RAT test, this creativity test involves insight problems and not design problems. Actually, because the RAT test is a well-defined problem, it does not even involve insight problems.

Alternative Uses Test (AUT): The Alternative Uses Test involves listing as many uses as possible for a common item (e.g., how many ways can a brick be used). The AUT involves a well-defined problem, as opposed to the ill-defined problems of design. This creativity test does not involve design problems.

Torrance Tests of Creative Thinking (TTCT): The Torrance Tests of Creative Thinking is a composite of over a dozen different measures for creativity. Some of its measures are verbal while others are visual. Scoring of the TTCT is based

primarily on the afore mentioned measures proposed by Guilford. Since the relationship between the individual Guilford measures of creativity and design are unclear, the relationship between the composite TTCT and design is also unclear.

We now see that the primary ways that have been used to measure creativity are not necessarily relevant to design.

The ambiguous relationship between creativity and design can be further seen by noting that many of the different measures of creativity activate different regions of the brain. The different measures of creativity actually measure very different things. There is not one type of creativity, there are multiple types that may or may not be related to each other. Our brains operate differently depending on the type of creative thinking in which we are engaged [47–50]. We will return to the neurology of creativity and its impact on design later.

Perhaps the most significant difficulty with relating the creativity literature with design is that many creativity researchers have not distinguished between creativity itself and the implementation of creativity for specific applications. This has resulted in an ongoing debate on whether creativity is domain-general or domain-specific, i.e., whether creativity is universal for all disciplines or is different for each discipline [51–57]. This lack of a differentiation on creativity being universal (domain-general) or discipline dependent (domain-specific) parallels the question of whether design is universal or discipline dependent. As we have already seen, this book takes the approach that design is universal and the implementation of design is discipline dependent. A similar approach for creativity may resolve some of the conflicts in its literature.

One model for creativity that recognizes the difference between domain-general and domain-specific creative skills is the Componential Model for Creativity. This model is a three-component model that separately focuses on universal skills (domain-general), disciplinary skills (domain-specific), and the motivation of people to do creative work [58, 59]. The impact of motivation on creativity (and hence, design) will be discussed in a later chapter.

We close our discussion on the relationship between creativity and design by discussing the nature of original ideas. All designs, whether in art, engineering, or any other discipline, require originality. Without at least some originality they are not designs; they are merely copies of something else. So how can originality be measured? What is an original idea?

Since most (if not all) ideas are really derived from other ideas, what makes an idea original? How much does an existing idea need to be modified before it is considered to be original? Perhaps the most widely used criterion for originality is whether an idea is obvious or not within the context of existing ideas (existing knowledge). If an idea is not considered to be an obvious variation or copy of an existing idea, it is considered to be original. Original ideas have the potential to be protected through intellectual property rights laws such as copyrights and patents.

One commonly used measure of originality in creativity studies is to have a group of people individually develop ideas on the same topic. The most original ideas are those that are identified by only one person and the least original ideas are those identified by many people. This is the most common approach to applying the Guilford creativity measure of fluency. This measure of originality, however, does not address whether an idea is new or it a trivial modification to an existing idea, nor does it necessarily address usefulness.

The most meaningful measure of originality in design is for people to use their experience to make a subjective judgment of originality. We do this all of the time, often without even thinking about it. To minimize our individual biases in making such judgements, the judgments of multiple individuals can be combined using the Consensual Assessment Technique [60]. The Consensual Assessment Technique is a formalized method for a group of evaluators to combine their judgements and determine their level of agreement.

We will explore how to generate original ideas (creativity) in greater detail in a later chapter.

1.7 Design Across the Disciplines

Now that we have a framework for understanding design, we can begin looking at how design is implemented within individual disciplines. We can move from design being a domain-general concept to the implementation of design being a domain-specific concept.

We will start this discussion by looking at the STEM disciplines (Science, Technology, Engineering, and Mathematics) and then consider some of the differences between the diverse design disciplines of art and engineering.

1.7.1 STEM Disciplines

Because of their ability to drive economic development and enhance quality of life, the STEM disciplines (Science, Technology, Engineering, and Mathematics) are receiving considerable social attention. Although these disciplines all use design, their different purposes require that design be implemented differently. Let's now look more deeply into those disciplines.

Math and Science are Disciplines of Discovery. Disciplines of Discovery have their primary purpose to discover unknown, but existing, facts (laws) about the current world and develop models that describe its probable past and predict its expected future behavior. Disciplines of Discovery focus on developing statements of truth. Traditional research, including that done in the disciplines of art and engineering, involves discovery. One of the most common implementations of design in the Disciplines of Discovery involves designing of research projects. Disciplines of Discovery are primarily involved with solving insight problems.

Engineering (and art!) is a Discipline of Creation. Disciplines of Creation have their primary purpose to create something new. They are focused on creating a different world from the one that currently exists. They are not focused on discovering truth. Those in the Disciplines of Creation use "truths" as constraints for their creations. Disciplines of Creation are primarily involved with solving design problems.

Technology is a Discipline of Management. Disciplines of Management have their primary purpose to operate and maintain systems designed by others. Maintaining (and improving) those systems, however, often requires design. The primary difference between design in technology and design in engineering is that engineers have more advanced tools to use (including more advanced mathematical tools) and can solve a broader range of design problems.

1.7.2 Art and Engineering

We now turn our attention to the specific design disciplines of art and engineering. Although both are Disciplines of Creation and both use design as a core function, the different needs of these disciplines require that design be implemented differently. [61] For simplicity, most of the examples for art in this book will focus on the visual arts, and in particular, on painting. It is not difficult to extend this content to other subdisciplines of art.

Some of the key differences between art and engineering that impact how design is implemented are discussed here.

1.7.2.1 Emotional or Physical Purpose

One of the most important differences between design in art and engineering lies in the underlying purpose of their respective designs. Art generally serves an emotional purpose that requires the use of aesthetic and psychological principles. Engineering generally serves a physical or functional purpose that requires the use of mathematical and scientific principles.

1.7.2.2 Intuitive or Analytical Thinking

Although design in all disciplines requires the use of both intuitive and analytical thinking (discussed in the next chapter), the different disciplines balance these two types of thinking in different ways. In particular, artists tend to use more intuitive thinking and engineers tend to use more analytical thinking. In fact, such differences in how intuitive and analytical thinking are balanced has been proposed as one possible scale to differentiate creativity among many different disciplines. [62–65] The roles of intuition and analysis in design will be discussed in great detail throughout this book.

1.7.2.3 Creativity

Creativity, as primarily measured by the ability to generate original ideas, is required for all designers. There is a significant difference, however, between how creativity is valued and emphasized between disciplines. Creativity (originality) is

highly valued in art but is less valued in engineering. Because of the greater risks associated with design failure in engineering, the usefulness dimension of creativity tends to be favored over the originality dimension.

Differences in the value of creativity are reflected in the type of education that students in the different disciplines receive. Art curricula tend to have many design (studio) courses in which creativity is emphasized (primarily originality). Engineering curricula tend to have only a few design/project courses in which creativity is even mentioned; creativity (originality) tends to not be strongly encouraged or rewarded in engineering curricula. Instead, engineering students are taught to focus on the usefulness of designs. [66, 67] Further, most engineering courses actually involve the Discipline of Discovery and not the Discipline of Creation, i.e., they involving solving insight problems and not design problems.

The different values placed on creativity are also reflected in the expectations of faculty hired to teach their respective programs. Art faculty are generally expected to engage in design through the practice of art. Engineering faculty, however, are generally not expected to engage in design through the practice of engineering. Instead, they are expected to engage in research. As we have seen, research is primarily an activity of Discovery that involves solving insight problems and not design problems. Other than designing research projects (and perhaps new curricula), few engineering faculty engage in design as part of their professional activities [68].

Differences in faculty experience with design can also be seen by the type of advanced education that faculty in the different disciplines receive. With very few exceptions, the advanced degree for artists (typically the MFA) is a degree of Creation while the advanced degrees for engineers (typically the MS and/or PhD) are degrees of Discovery. Advanced formal education for artists involves solving design problems, while advanced formal education for engineers involves solving insight problems. This difference in design experience is enhanced by the fact that many art faculty have worked professionally as artists, but many engineering faculty have never worked professionally as engineers. In spite of this, many engineering faculty have learned to be good designers.

Although engineers are involved with designing solutions to many of the difficult problems facing society, there is a wide-spread perception that they are limited by a lack of creativity. As a result, there is a push to add more creativity, i.e., originality, to the discussions of those problems. One approach is to add Art to the list of STEM disciplines to create the STEAM disciplines [69].

But are artists really more creative than engineers? Although the data are limited, domain-general creativity studies suggest that this is not necessarily the case. Those trained in art are not necessarily more creative than those trained in engineering [70–72]. The perception that artists are more creative than engineers may simply be a reflection of the way artists and engineers express their creativity, i.e., through how they balance originality and usefulness relative to the needs of their respective disciplines.

1.7.2.4 Social or Solitary

Another difference between design in art and engineering is the fact that the visual arts tend to be a solitary endeavor while engineering tends to be a social endeavor. It is noted that the performance arts of theater, music, and dance are also social in nature. Although visual artists do need to effectively communicate with others, such as patrons and galleries, such communication usually occurs only periodically. Engineers, on the other hand, normally operate in a team environment and must regularly communicate with others, both formally and informally [73, 74]. The primary reason that engineers work on teams is because engineering design projects tend to be significantly more complex than those in art. Many engineering projects are simply too large for one person to complete and multiple people are needed to share the tasks. Artists rarely work on projects that cannot be completed individually.

This difference in the social work environment places a different emphasis on the need for interpersonal communication skills, which drives some of the differences between art and engineering curricula. Art programs tend to not emphasize communication skills [75], while engineering programs do. In fact, demonstrating effective communication skills is required for engineering program accreditation.

Because artists tend to prefer a low level of social interaction and people with such a preference tend to select disciplines that do not require such interactions in their curricula, [76] many artists do not develop effective interpersonal communication skills. This can hinder the development of meaningful professional relationships and may be factor behind why only about 50% of the graduates of art programs work in the art field after graduation [77].

1.7.2.5 Implementation of Design

A final difference between design in art and engineering is one that we have already discussed; designs in art are implemented as part of the design process, but not so in engineering. Design in art is finished when the painting is complete. Design in engineering is finished when the plans are complete, not when the design is implemented. The actual implementation of the design in engineering is often conducted by others, if at all, because implementation normally requires skills and expertise different from those required for design [78].

1.8 Closing

The key conclusions from this chapter are.

1. Design involves making planned changes in something to achieve some purpose, physical (functional) or emotional (aesthetic).
2. Design is universal (domain-general) while the implementation of design is unique to each discipline (domain-specific).

3. There are three universal design activities that are common to all design projects, regardless of the discipline (domain-general). These universal design activities are

 a. Clarify the Project
 i. Identify the Purpose
 ii. Identify the Constraints
 b. Generate Ideas
 c. Select One Idea to Implement
 i. Defer the Selection to Get More Information
 ii. Eliminate Ideas That Are Not Useful
 iii. Select One of the Useful Ideas for Implementation.

4. Design has an underlying structure of tending to work sequentially through the universal design activities of clarifying the project, generating ideas, and selecting one idea to implement. Design also has an underlying structure of tending to make higher-level decisions before making lower-level decisions.
5. Design is messy because we cannot actually complete design activities sequentially as suggested by any underlying pattern. We never have complete information during design and must iterate back and forth among the various activities to gain more information. Design is iterative and has no specific, predetermined sequence of any steps.
6. Design problems are ill-defined and lack clarity about what is really needed or how to solve them. Design problems are also open-ended with multiple possible solutions that might be successfully implemented. Insight problems, in contrast with design problems, are also ill-defined but are closed-ended with a single, right answer that can be identified.
7. Creativity is widely recognized as having two aspects: originality and usefulness. In most cases, however, usefulness has been ignored and creativity has been primarily perceived as being only originality.
8. Art and engineering are Disciplines of Creation that primarily solve design problems. Math and sciences are Disciplines are Discovery that primarily solve insight problems. Design involves the creation of a new world while discovery involves identifying the nature of the existing world.
9. Although design is the same for art and engineering, there are some fundamental differences that require design to be implemented differently. These differences include:

 a. Art has an aesthetic (emotional) purpose and engineering has a functional (physical) purpose.
 b. Art tends to use more intuitive thinking and engineering tends to use more analytical thinking. All design disciplines, however, require both types of thinking.

c. Art places greater value on the originality dimension of creativity and engineering places greater value on usefulness dimension.
d. Art tends to be a solitary activity, while engineering tends to be a social activity.
e. Art design projects are implemented as part of the design process. Engineering projects are normally implemented separately for the design process and often by people other than the designers.

1.9 Questions

1. What is your personal definition for design? A widely used synonym for design in art is composition. How might that word fit design in other disciplines? What other words can be used to describe design? How might those words fit different disciplines?
2. What do you do when you design? How do your design processes fit or not fit within the three Universal Design Activities? Are your design activities common to other design disciplines? Are those activities design or the implementation of design? Do you see a difference between those types of activities?
3. Have you designed your current life path? What did you do? Was your path structured and planned or was it messy?
4. Pick any design you have completed. How many times did you engage in each of the three Universal Design Activities as you worked through your design project? Can you count them? Do you even recognize using them?
5. What is your preferred sequence of design activities? Do you use a structured or messy approach? What would happen if you approached design differently? How could you approach design differently?
6. Do you consider design and problem solving to be the same thing or do you consider them to be different?
7. How do insight problems relate to design problems? How might problem solving methods differ between the two?
8. The most widely used definition for creativity includes requirements for both originality and usefulness. Do you agree? What else might creativity involve?
9. How do you define creativity? Can you measure it? How do you define originality? Can you measure it? How do you define usefulness? Can you measure it? When might it matter?
10. How are the creative measures proposed by Guilford relevant to design? Can you place each of them in one of the three universal design activities?
11. Is creativity needed for clarifying a project? Is it needed for selecting an idea? How?
12. Do math and science involve design other than designing research projects? How?

13. What universal activities are common to people in the Disciplines of Discovery (mathematicians and scientists), regardless of their specific disciplines? Do such universal activities even exist across the Disciplines of Discovery?

14. What do mathematicians and scientists do differently from artists and engineers? What do they do that is the same?

15. Can you identify art designs that serve a physical function? Can you identify engineering designs that have an emotional (aesthetic) function? What design projects might involve both art and engineering? How do the applied arts (architecture, interior design, industrial design, graphic design, photography, etc.) use design? Is their function emotional, physical, or both? How do they use the three universal design activities?

16. Some of the differences between art and engineering include emotional versus physical purpose, relative amounts of intuitive versus analytical thinking, value of creativity (originality or usefulness), and social or solitary interpersonal needs. What other differences might there be? How does your design discipline fit within these distinctions?

17. Innovation is most commonly defined as a design that has been implemented. What is needed for a completed design to become an innovation? Is a completed painting an innovation? Is a painting implemented when the painter signs the painting and puts it away or when the painting is actually sold? Does innovation occur when an engineering design is completed? What is needed for a completed engineering design to become an innovation? What skills and activities are required to turn a design into an innovation? How might innovation depend upon the discipline?

References

1. Blackwell, A.F., Eckert, C.M., Bucciarelli, L.L., Earl, C.F.: Witnesses to design: a phenomenology of comparative design. Des. Issues **25**(1), 36–47 (2009). https://doi.org/10.1162/desi.2009.25.1.36

2. Burnett, B., Evans, D. Designing Your Life: How to Build a Well-Lived, Joyful Life. Knopf, New York (2016)

3. Eckert, C.M., Blackwell, A.B., Bucciarelli, L.L., Earl, C.F. Shared conversations across design. Des. Issues **26**(3), 27–39 (2010). https://doi.org/10.1162/DESI_a_00027

4. Mosely, G., Wright, N., Wrigley, C.: Facilitating design thinking: a comparison of design expertise. Think. Skills Creat. **27**, 177–189 (2018). https://doi.org/10.1016/j.tsc.2018.02.004a

5. Watson, A.D.: Design thinking for life. Art Educ. **68**(3), 12–18 (2015). https://doi.org/10.1080/00043125.2015.11519317

6. Liu, S., Erkkinen, M.G., Healey, M.L., Xu, Y., Swett, K.E., Chow, H.M., Braun, A.R.: Brain activity and connectivity during poetry composition: toward a multidimensional model of the creative process. Hum. Brain Mapp. **36**, 3351–3372 (2015). https://doi.org/10.1002/hbm.22849

7. Carroll, J.M., Thomas, J.C., Malhotra, A.: Clinical-experimental analysis of design problem solving. Des. Stud. **1**(2), 84–92 (1979). https://doi.org/10.1016/0142-694X(79)90004-8

8. Goel, V.: A comparison of design and nondesign problem spaces. Artif. Intell. Eng. **9**, 53–72 (1994). https://doi.org/10.1016/0954-1810(94)90006-X

9. Grantham, K., Kremer, G.E.O., Simpson, T.W., Ashour, O.: A study on situated cognition: product dissection's effect on redesign activities. Adv. Eng. Educ. **3**(4), 1–15 (2013). https://doi.org/10.1115/DETC2010-28334

10. Akin, O., Lin, C.: Design protocol data and novel design decisions. Des. Stud. **16**, 211–2236 (1995). https://doi.org/10.1016/0142-694X(94)00010-B

11. Harvey, S., Kou, C.-Y.: Collective engagement in creative tasks: the role of evaluation in the creative process in groups. Adm. Sci. Q. **58**(3), 346–386 (2013). https://doi.org/10.1177/0001839213498591

12. Berends, H., Reymen, I., Stultiens, R.G.L., Peutz, M.: External designers in product design processes of small manufacturing firms. Des. Stud. **32**, 86–108 (2011). https://doi.org/10.1016/j.destud.2010.06.001

13. Guindon, R.: Designing the design process: exploiting opportunistic thoughts. Hum. Comput. Interact. **5**, 305–344 (1990). https://doi.org/10.1207/s15327051hci0502&3_6

14. Kozbelt, A., Serafin, J.: Dynamic evaluation of high- and low-creativity drawings by artist and nonartist raters. Creat. Res. J. **21**(4), 349–360 (2009). https://doi.org/10.1080/10400410903297634

15. Serafin, J., Kozbelt, A., Seidel, A., Dolese, M.: Dynamic evaluation of high- and low-creativity drawings by artist and nonartist raters: replication and methodological extension. Psychol. Aesthet. Creat. Arts **5**(4), 350–359 (2011). https://doi.org/10.1037/a0023587

16. Toh, C.A., Miller, S.R.: How engineering teams select design concepts: a view through the lens of creativity. Des. Stud. **38**, 111–138 (2015). https://doi.org/10.1016/j.destud.2015.03.001

17. Jausovec, N., Bakracevic, K.: What can heart rate tell us about the creative process? Creat. Res. J. **8**(1), 11–24 (1995). https://doi.org/10.1207/s15326934crj0801_2

18. Wakefield, J.F.: Creativity and cognition some implications for arts education. Creat. Res. J. **2**(1–2), 51–63 (1989). https://doi.org/10.1080/10400418909534300

19. Arlin, P.K.: Cognitive development in adulthood: a fifth stage? Dev. Psychol. **11**(5), 602–606 (1975). https://doi.org/10.1037/0012-1649.11.5.602

20. Basadur, M., Runco, M.A., Vega, L.A. Understanding how creative thinking skills, attitudes, and behaviors work together: a causal process model. J. Creat. Behav. **34**(2), 77–100 (2000). https://doi.org/10.1002/j.2162-6057.2000.tb01203.x

21. Carson, D.K., Runco, M.A. Creative problem solving and problem finding in young adults: interconnections with stress, hassles, and coping abilities. J. Creat. Behav. **3**(3), 167–188 (1999). https://doi.org/10.1002/j.2162-6057.1999.tb01195.x

22. Chrysikou, E.G., Thompson-Schill, S.L.: Dissociable brain states linked to common and creative object use. Hum. Brain Mapp. **32**, 665–675 (2011). https://doi.org/10.1002/hbm.21056

23. Kaiser, S., Simon, J.J., Kalis, A., Schweizer, S., Tobler, P.N., Mojzisch, A. The cognitive and neural basis of option generation and subsequent choice. Cogn. Affect. Behav. Neurosci. **13**, 814–829 (2013. https://doi.org/10.3758/s13415-01300175-5

24. Lin, W.-L., Lien, Y.-W.: The different role of working memory in open-ended versus closed-ended creative problem solving: a dual-process theory account. Creat. Res. J. **25**(1), 85–96 (2013). https://doi.org/10.1080/10400419.2013.752249

25. Luo, J., Li, W., Qui, J., Wei, D., Liu, Y., Zhang, Q.: Neural basis of scientific innovation induced by heuristic prototype. PlosOne **8**(1), 1–7 (2013). https://doi.org/10.1371/journal.pone.0049231

26. Luo, J., Du, X., Tang, X., Zhang, E., Li, H., Zhang, Q.: The electrophysiological correlates of scientific innovation induced by heuristic information. Creat. Res. J. **25**(1), 15–20 (2013). https://doi.org/10.1080/10400419.2013.752179

27. Schraw, G., Dunkle, M.E., Bindixen, L.D.: Cognitive processes in well-defined and ill-defined problem solving. Appl. Cogn. Psychol. **9**, 523–538 (1995). https://doi.org/10.1002/acp.2350090605

28. Rosen, A., Reiner, M.: Right frontal gamma and beta band enhancement while solving a spatial puzzle with insight. Int. J. Psychophysiol. **122**, 50–55 (2017). https://doi.org/10.1016/j.ijpsycho.2016.09.008

29. Smilansky, J.: Problem solving and the quality of invention: an empirical investigation. J. Educ. Psychol. **76**(3), 377–386 (1984). https://doi.org/10.1037/0022-0663.76.3.377

30. Treffinger, D.J., Selby, E.C., Isaksen, S.G.: Understanding individual problem-solving style: a key to learning and applying creative problem solving. Learn. Individ. Differ. **18**, 390–401 (2008). https://doi.org/10.1016/j.lindif.2007.11.007

31. Furnham, A., Bachtair, B.: Personality and Intelligence as Predictors of Creativity. Personality Individ. Differ. **45**, 613–617 (2008). https://doi.org/10.1016/j.paid.2008.06.023

32. Taylor, C.W. Various approaches to and definitions of creativity. In: Sternberg, R.J. (ed.) The Nature of Creativity. Cambridge University Press, Cambridge (1988)

33. Batey, M., Furnham, A.: Creativity, intelligence, and personality: a critical review of the scattered literature. Generic Soc. Gen. Psychol. Monogr. **132**(4), 355–429 (2006). https://doi.org/10.3200/MONO.132.4.355-430

34. Cawelti, S., Rappaport, A., Wood, B. Modeling artistic creativity: an empirical study. J. Creat. Behav. **26**(2), 83–94 (1992). https://doi.org/10.1002/j.2162-6057.1992.tb01164.x

35. Davis, G.A., Belcher, T.L. How shall creativity be measured? torrance tests, RAT, alpha biographical, and IQ. J. Creat. Behav. **5**(3), 153–161 (1971)

36. Gray, C.M., Yilmaz, S., Daly, S., Seifert, C.M., Gonzalez, R. Creativity 'misrules': first year engineering students' production and perception of creativity in design ideas. In: Proceedings of the ASME 2015 International Design Engineering Technical Conferences and Computers and Information in Engineering Conferences, IDETC/CIE 2015, DETC2015-46492, Boston, MA, 2–5 Aug 2015. https://doi.org/10.1115/DETC2015-46492

37. Plucker, J.A., Beghetto, R.A., Dow, G.T. Why Isn't creativity more important to educational psychologists? potentials, pitfalls, and future directions in creativity research. Educ. Psychol. **39**(2), 83–96 (2004). https://doi.org/10.1207/s15326985ep3902_1

38. Guilford, J.P.: Creativity. Am. Psychol. **5**(9), 444–454 (1950)

39. Stein, M.I.: Creativity and culture. J. Psychol. **36**, 311–322 (1953)

40. Finke, R.A., Ward, T.B., Smith, S.M.: Creative Cognition, Theory, Research, and Applications. MIT Press, Cambridge, MA (1992)

41. Feldhusen, J.F., Goh, B.E.: Assessing and accessing creativity: an integrative review of theory, research, and development. Creat. Res. J. **8**(3), 231–247 (1995). https://doi.org/10.1207/s15326934crj0803_3

42. Hennessey, B.A., Amabile, T.M.: Creativity. Annu. Rev. Psychol. **61**, 569–598 (2010). https://doi.org/10.1146/annurev.psych.093008.100416

43. Lubart, T.I.: Models of the creative process: past, present and future. Creat. Res. J. **13**(3–4), 295–308 (2001). https://doi.org/10.1207/s1532634crj1334_07

44. Piffer, D.: Can creativity be measured? an attempt to clarify the notion of creativity and general directions for future research. Think. Skills Creat. **7**, 258–264 (2012). https://doi.org/10.1016/j.tsc.2012.04.009

45. Runco, M.A., Acar, S.: Divergent thinking as an indicator of creative potential. Creat. Res. J. **24**(1), 66–75 (2012). https://doi.org/10.1080/10400419.2012.652929

46. Runco, M.A., Sakamoto, S.O. Experimental studies of creativity. In: Sternberg, R.J. (ed.) Handbook of Creativity. Cambridge University Press, Cambridge (1999)

47. Dietrich, A.: The cognitive neuroscience of creativity. Psychon. Bull. Rev. **11**(6), 1011–1026 (2004). https://doi.org/10.3758/BF03196731

48. Li, Y.H., Tseng, C.Y., Tsai, A.C.H., Huang, A.C.W., Lin, W.L. Different brain wave patterns and cortical control abilities in relation to different creative potentials. Creat. Res. J. **28**(1), 89–98 (2016). https://doi.org/10.1080/10400419.2016.1125255

49. Shen, W., Yuan, Y., Liu, C., Zhang, X., Luo, J., Gong, Z. Is creative insight task-specific? a coordinate-based meta-analysis of neuroimaging studies on insightful problem solving. Int. J. Psychophysiol. **110**, 81–90 (2016). https://doi.org/10.1016/j.ijpsycho.2016.10.001

50. Sunavsky, A., Poppenk, J.: Neuroimaging predictors of creativity in healthy adults. Neuroimage (2019). https://doi.org/10.1016/j.neuroimage.2019.116292
51. Baer, J. (2010). Is creativity domain specific. In: Kaufman, J.C., Sternberg, R.J. (eds). The Cambridge Handbook of Creativity. Cambridge University Press, Cambridge (2010)
52. Baer, J., Kaufman, J.C.: Bridging the generality and specificity: the amusement park theoretical (APT) model of creativity. Roeper Rev. **27**(3), 158–163 (2005). https://doi.org/10.1080/02783190509554310
53. Feist, G. The evolved fluid specificity of human creative talent. In: Sternberg, R.J., Grigorenko, E. L., Singer, J.L. (eds.) Creativity from Potential to Realization. American Psychological Association, Washington, DC (2004)
54. Plucker, J.A. (2004). Generalization of creativity across domains: examination of the method effect hypothesis. J. Creat. Behav. **38**(1), 1–11 (First Quarter 2004). https://doi.org/10.1002/j.2162-6057.2004.tb01228.x
55. Plucker, J.A., Beghetto, R.A. Why creativity is domain general, Why is looks domain specific, and Why the distinction does not matter. In: Sternberg, R.J., Grogorenko, E.L., Singer, J.L. (eds.) Creativity: From Potential to Realization, pp. 153–167. American Psychological Association (2004)
56. Plucker, J., Zabelina, D.: Creativity and interdisciplinarity: one creativity or many creativities. Math. Educ. **41**, 5–11 (2009). https://doi.org/10.1007/s11858-008-0155-3
57. Reiter-Palmon, R., Illies, M.Y., Cross, L.K., Buboltz, C., Nimps, T.: Creativity and domain specificity: the effect of task type on multiple indexes of creative problem-solving. Psychol. Aesthet. Creat. Arts **3**(2), 73–80 (2009). https://doi.org/10.1037/a0013410
58. Amabile, T.M.: The social psychology of creativity: a component conceptualization. J. Pers. Soc. Psychol. **45**(2), 357–376 (1983). https://doi.org/10.1037/0022-3514.45.2.357
59. Amabile, T.M.: A model of creativity and innovation in organizations. Res. Organ. Behav. **10**, 123–167 (1988)
60. Amabile, T.M.: Social psychology of creativity: a consensual assessment technique. J. Pers. Soc. Psychol. **43**(5), 997–1013 (1982). https://doi.org/10.1037/0022-3514.43.5.997
61. Gridley, M.C.: Differences in thinking styles of artists and engineers. Career Develop. Q. **56**(2), 177–182 (2007). https://doi.org/10.1002/j.2161-0045.2007.tb00030.x
62. Furnham, A., Batey, M., Booth, T.W., Patel, V., Lozinskaya, D.: Individual difference predictors of creativity in art and science students. Think. Skills Creat. **6**, 114–121 (2011). https://doi.org/10.1016/j.tsc.2011.01.006
63. Hartley, J., Greggs, K.: Divergent thinking in arts and science students: contrary imaginations at keele revisited. Stud. High. Educ. **22**(1), 93–97 (1997). https://doi.org/10.1080/03075079712331381160
64. Simonton, D.K. Varieties of (scientific) creativity: a hierarchical model of domain-specific disposition, development, and achievement. Perspect. Psychol. Sci. **4**(5), 441–452 (2009). https://doi.org/10.1111/j.1745-6924.2009.01152.x
65. Webster, M.A., Walker, M.B.: Divergent thinking in arts and science students: the effect of item content. Br. J. Psychol. **72**(3), 331–338 (1981). https://doi.org/10.1111/j.2044-8295.1981.tb02192.x
66. Charyton, C., Snelbecker, G.E., Rahman, M.A., Elliott, J.O.: College students' creative attributes as a predictor of cognitive risk tolerance. Psychol. Aesthet. Creat. Arts **7**(4), 350–357 (2013). https://doi.org/10.1037/a0032706
67. Genco, N., Holtta-Otto, K., Seepersad, C.C.: An experimental investigation of the innovation capabilities of undergraduate engineering students. J. Eng. Educ. **101**(1), 60–81 (2012). https://doi.org/10.1002/j.2168-9830.2012.tb00041.x
68. Telenko, C., Sosa, R., Wood, K. L. Changing conversations and perceptions: the research and practice of design science. In: Chakrabarti, Lindemann (eds.) Impact of Design Research on Industrial Practice. Springer International Publishing, Switzerland (2016)

69. Bequette, J.W., Bequette, M.B.: A place for art and design education in the STEM conversation. Art Educ. **65**(2), 40–47 (2012). https://doi.org/10.1080/00043125.2012.11519167

70. Charyton, C., Jagacinski, R.J., Merrill, J.A. (2008). CEDA: a research instrument for creative engineering design assessment. Psychol. Aesthet. Creat. Arts **2**(3), 147–154 (2008). https://doi.org/10.1037/1931-3896.2.3.147

71. Charyton, C., Merrill, J.A.: Assessing general creativity and creative engineering design in first year engineering students. J. Eng. Educ. **98**(2), 145–156 (2009). https://doi.org/10.1002/j.2168-9830.2009.tb01013.x

72. Feist, G.J.: Synthetic and analytic thought: similarities and differences among art and science students. Creat. Res. J. **4**(2), 145–155 (1991). https://doi.org/10.1080/10400419109534382

73. Darling, A.L., Dannels, D.P.: Practicing engineers talk about the importance of talk: a report on the role of oral communication in the workplace. Commun. Educ. **52**(1), 1–16 (2003). https://doi.org/10.1080/03634520302457

74. Jonassen, D., Strobel, J., Lee, C.B.: Everyday problem solving in engineering: lessons for engineering educators. J. Eng. Educ. **95**(2), 139–151 (2006). https://doi.org/10.1002/j.2168-9830.2006.tb00885.x

75. Abuhamdeh, S., Csikszentmihalyi, H.: The artistic personality: a systems perspective. In: Sternberg, R.J., Grigorenko, E.L., Singer, J. L. (eds.) Creativity from Potential to Realization. American Psychological Association, Washington, DC (2004)

76. Casakin, H., Kreitler, S.: Motivation for creativity in architectural design and engineering design students: implications for design education. Int. J. Technol. Des. Educ. **20**, 477–493 (2010). https://doi.org/10.1007/s10798-009-9103-y

77. Getzels, J.W., Csikszentmihalyi, M.: The Creative Vision: A Longitudinal Study of Problem Finding in Art. John Wiley and Sons, New York (1976)

78. Birdi, K., Leach, D., Magadley, W.: The relationship of different capabilities and environmental support with different facets of designers' innovation behavior. J. Prod. Innov. Manag. **33**(1), 19–35 (2016). https://doi.org/10.1111/jpim.12250

How We Think and Learn Design

2

2.1 Introduction

The many different approaches to design arise because we all think differently about design. So, we begin our study of design by considering how we think. This chapter begins by introducing the primary ways that we think (intuitive and analytical thinking) and the role that each plays in design. The chapter then introduces both heuristic thought and feelings and their respective roles in our design processes. The chapter closes by reviewing the effectiveness of formal design education through academic classes and of informal design training taught through workshops and short courses.

2.2 How Do We Think?

How do we think? Do we think at all? How do we even know? Descartes claimed "I think, therefore I am." This statement implies that there is something called thinking but does not define what it is. It also implies that we have a recognition of beingness or existence yet does not define that either. Most importantly, Descartes's statement ignores that fact that there are multiple ways of thinking and that they each impact our ability to design in different ways.

We begin our study of how we can learn design by considering what thinking is and how it is different from feeling. For our purposes, thinking is the processing of information and feelings are experiences that may (or may not) be processed as information. Thinking is active. Thinking is something we do. Feeling is passive. Feeling is something we experience.

We will now look at some of the ways that we think and feel.

© The Author(s), under exclusive license to Springer Nature Switzerland AG 2022
J. Reis, *Advanced Design*, https://doi.org/10.1007/978-3-030-95782-7_2

2.2.1 Intuitive and Analytical Thinking

Thinking is simply the processing of information. Numerous studies have shown that there are two fundamentally different ways of processing information, i.e., there are two different modes of thinking. These different modes are often referred to as dual processing modes [1–15]. Although these two modes have been described in many different ways, for simplicity we will refer to them as the intuitive mode (intuition) and the analytical mode (analysis). These two thinking modes can be described as follows:

- intuitive thought (intuition) is thought that does not follow a conscious, sequential order or pattern. We cannot determine what our next thought will be based upon our prior thoughts. Our next thought comes into our awareness seemingly spontaneously and without any control.
- analytical thought (analysis) is thought that follows a conscious, sequential, algorithmic order or pattern. We can generally predict our next thought based on prior thoughts.

Some of the characteristics typically associated with these two modes of thought are provided in Table 2.1.

Within these descriptions, intuitive thought tends to encompass creative, irrational, and illogical thinking while analytical thought tends to encompass critical, rational, and logical thinking. Intuitive thought tends to be more effective for generating original ideas, while analytical thought tends to be more effective for evaluating (selecting) ideas. Intuition seems to be well suited for open-ended problems (design problems), while analysis seems to be well suited for

Table 2.1 Characteristics of the dual process thinking modes

Intuitive mode	Analytical mode
Creative thinking	Conservative thinking
Divergent thinking	Convergent/critical thinking
Expansive thinking	Constrained thinking
Open thinking	Closed thinking
Often unconscious	Mostly conscious
Relatively fast	Relatively slow
Processes holistically	Processes individual parts
Acquired through personal experience	Acquired through formal study
Weak correlation with intelligence	Strong correlation with intelligence
Mindless/Effortless	Deliberate/Effortful
Unfocused	Focused
Vulnerability	Strength
System 1	System 2

closed-ended problems (insight problems) [16, 17]. Both modes of thought are needed, however, for both design and insight problems.

Although there are two different modes of thinking, what they actually are remains unclear. In fact, many of the descriptions of these two modes are incompatible with each other [18–24]. One common factor among these descriptions, however, is that the two processing modes can be associated with distinct neural networks within the brain. The intuitive mode of thinking predominantly uses the Default Network and the analytical mode predominately uses the Executive Control Network. The Default Network is linked with creativity (originality) and the Executive Control Network is linked with judgment [25–41].

One of the reasons why there is a lack of clarity with the dual process models of thinking is that we don't know what either intuition or analysis really are. We simply don't know what thinking is or how it works. The best we can do is describe some of its characteristics.

Intuition tends to operate unconsciously and analytical thought tends to operate consciously (but not always) [42]. Because of this, we normally use our intuition without really being aware of what we are doing [24, 43, 44]. Yet, intuition is more than simple unconscious thought and more than simply not being aware [45–51]. In fact, there is actually a significant amount of neural activity during unconscious thought, which suggests that information is being processed (thinking is occurring) [52–57].

Both intuitive and analytical thought can involve pattern recognition. Pattern recognition is the ability to recognize the existence of patterns in seemingly unconnected pieces of information [22, 42]. Intuition tends to use unconscious pattern recognition and analysis tends to use conscious pattern recognition. Unconscious pattern recognition can involve a sense of coherence between items. This sense of coherence is a feeling that the items are related in some way, even if that relationship is not known [58–60]. We will return to pattern recognition when we introduce heuristic thinking.

Although intuition, by our definition, does not involve a sequential flow of thought, it is not random. Our intuition can be strongly influenced by the context in which we use it. In contrast, analysis is less influenced by the context in which we use it because it involves a predetermined sequence of thinking. As we will see, however our analysis can also be influenced by the context in which we use it. The influence of context on our thinking will be discussed in greater detail throughout this book.

A final comment on intuition is that there is not just one type of intuition, but multiple types. In fact, we may use a different type of intuition, each using a different neural network, for each of the three universal design activities. The types of intuition associated with the three universal design activities are:

Intuition of Understanding. This type of intuition is used when we clarify our design project. It involves how we integrate a wide range of divergent information into a comprehensive sense of understanding of the project. We don't understand how we integrate divergent information, but we still do it. We obtain a unified sense of wholeness without a clear reason for it.

Intuition of Idea Generation. This type of intuition is used when we generate ideas. We don't really know how we generate ideas, but we are quite good at it.

Intuition of Judgment. This type of intuition is used when we select one design idea to implement from a list of ideas. It involves passing judgment on ideas without having a clear idea of how we reached that judgment. We just have a sense of knowing (or feeling) which idea we should select without necessarily understanding why.

Unlike intuition, however, analysis appears to be a unitary process that involves comparing things and judging them as being similar or different. There does not appear to be different types of analysis for each the three universal design activities.

We now see that there are two fundamentally different types of thinking: intuition and analysis. Unfortunately, we don't know what either of them really are. Fortunately, we do not need to have a complete understanding of them. We just need to be able to recognize and use them. We can leave detailed explanations to those in Disciplines of Discovery. We have something much more important to do: Let's change the world by designing something!

2.2.2 Which Thinking Mode Should We Use?

We have two very different modes of thinking: intuition and analysis. Which do we use? Which should we use? We will jump ahead of ourselves here and simply state that effective designers use both intuition and analysis and switch between them many times over the course of a design project.

To effectively use both thinking modes, we must be able to recognize which mode we are currently using. The process of recognizing our current thinking mode is known as metacognition: thinking about how we are thinking. Successful designers have high levels of metacognition: they are able to identify which mode they are in and switch to the other mode as needed [61, 62].

As individuals, we tend to prefer using either an intuitive or an analytical thinking mode [3] and we are more comfortable when operating in our preferred mode [63]. This preference, however, can bias us against using the other thinking mode, which can harm our design effectiveness. Fortunately, we can switch between modes if we want to, i.e., if we have sufficient motivation [64]. In fact, switching to our non-preferred mode has been shown to lead to more effective idea generation [65]. The simplest way to switch our thinking mode is to do something that induces the other thinking mode. We will discuss some ways to do this in later chapters.

Our preferred thinking mode influences our career path. If our preference is toward intuition, we tend to initially choose a career in the arts, i.e., Disciplines of Creation. If our preference is toward analysis, we tend to choose a career in the sciences, i.e., Disciplines of Discovery [66, 67]. A preference toward analysis may also lead to choosing a career in engineering over art because of the larger amount of analysis used by engineers, even though engineering is a Discipline of Creation.

As we gain more education and experience, regardless of our discipline, we tend
recognize both modes within us and become more balanced how we use them [68].

In addition to our personal preferences for a thinking mode, the design envi-
ronment in which we work can also bias us toward one or the other thinking modes.

- We tend to use our intuition when we do not have sufficient time or information
 to make analytical decisions [69]. We also tend to use intuition when we are
 unsure what to do or when we are familiar with the topic of interest [70, 71]. We
 tend to use intuition more when we are working for ourselves (primarily artists)
 than when we are working for someone else (primarily engineers) [69].
- We tend to use analysis when we have information that is difficult to understand
 or is inconsistent with other information available to us [72]. We also tend to use
 analysis when the risks associated with a design are high or we might be per-
 sonally impacted by what we do.

A final comment about intuitive and analytical thought. There are no conditions
or situations where either one of them is completely right or completely wrong.
They both have strengths and they both have weaknesses. They are simply two
complementary modes of thinking. Intuition is more appropriate in some cases and
analysis is more appropriate in others: both are necessary for effective design [73,
74]. The appropriate use of intuition and analysis in design will be discussed in
greater detail in later chapters.

2.2.3 Heuristic Thinking

Although the balanced the use of both intuition and analysis is required for suc-
cessful design, such a balance is still insufficient. Thinking is processing of infor-
mation. We receive an overwhelming amount of information all of the time. We
simply do not have the cognitive capacity or ability to remember and process all of
the information available to us. Intuition and analysis, separately or together, are
incapable of making sense of all of the information available to us.

To simplify the information we receive, we look for patterns. Patterns are rep-
etitions within our experiences that allow us to make sense of things without taking
the time and effort to process all of the information available to us every time we
encounter something new. These patterns lead to heuristics. Heuristics are
rules-of-thumb that reflect those patterns. We process new information within the
context of our heuristics.

Because heuristics are based on pattern recognition, they only use some of the
information available to us. They do not use information that is outside of the
pattern; information that may still be relevant to us. As a result, heuristics are
limited and never provide complete information. Nevertheless, our lack of cognitive
capacity and ability to process all of the information available to us forces us to rely
on heuristics. We really have no choice. Although incomplete, the mental patterns

that form our heuristics are very real and are deeply rooted within our psychology to the level that they are imbedded in the neural networks of our brains [75–93].

For the purpose of design, heuristics can be divided into two types: externally-based heuristics and internally-based heuristics. Externally-based heuristics are those that use external information and internally-based heuristics are those that use internal information (typically feelings). We use both in the design process.

Externally-based heuristics are based on identifiable patterns that we observe external to us. Typically, these heuristics reflect that when we observe specific conditions, we can expect to experience specific outcomes. The so-called "laws of physics" are examples of externally-based heuristics. A key factor about externally-based heuristics is that they tend to not involve personal judgments; they are emotionally neutral.

Internally-based heuristics are based on the subjective value judgments of our feelings, preferences (including aesthetic preferences), or beliefs. These value judgments involve our memory and may be based on external patterns that have not risen to the level of our conscious awareness. We may not know why we feel a particular way about something, but our feelings are real. Internal heuristics may also include habits of behavior and judgment. Unlike externally-based heuristics, internally-based heuristics are not emotionally neutral.

A final comment about heuristics is that heuristic thinking is not really an independent mode of thinking. Heuristics are simply patterns based on past experience. Thinking is processing of information. Both intuitive and analytical thinking use the information in heuristics. Analytical thought tends to use externally-based heuristics and intuitive thought tends to use internally-based heuristics. Many examples of heuristics relevant to design will be provided in later chapters.

2.2.4 Feelings

Feelings are very important in design and can significantly impact our ability to design, even for engineers. One of the difficulties with understanding how feelings impact our ability to design arises because the word "feeling" means many different things to different people. For the purposes of design, however, we can group feelings into two broad types: feelings as information and feelings as experiences.

- Feelings as information is using our feelings to judge something external to us. If we feel good about something, we judge it positively and act accordingly. Conversely, if we feel bad about something, we judge it negatively. Feelings as information is a type of internally-based heuristic that involves our Intuition of Judgment, one of the three types of intuition used in design. We may not recognize why we feel the way that we do, but we do feel that way.
- Feelings as experiences involve our moods. They involve our current emotional state, i.e., how we feel, not how we feel *about* something. Psychologists often use the word 'affect' for feelings as experiences.

We use both feelings as information and feelings as experiences as we design and they both impact our ability to design. We use feelings as information as a direct input into our thinking processes. We use feelings as experiences as indirect inputs through how they control our mood, which then impacts our thinking processes. Although our feelings, like our modes of thinking, have been widely studied, we still do not really know what they are. Nevertheless, they are real and have an identifiable neurological basis [94–96]. The role of feelings on our ability to design will be discussed in more detail in later chapters.

2.3 How Do We Learn Design?

Now that we have a better understanding of how we use our thinking and feeling processes in design, the question arises about whether we can learn how to think and feel more effectively. Are intuition and analysis innate abilities, such as intelligence, that cannot necessarily be learned or improved, or are they something that can be learned and improved? Can we use heuristics beyond mere mechanical applications? It is easy to learn facts and figures through memorization and it is easy to learn scripted procedures. Neither of those, however, is design. The real question is can we learn how to improve our ability to design?

Learning is based on neuroplasticity. Even though many of our basic psychological and personality characteristics stabilize somewhere between the age of 21 and 30 [97–104] and these characteristics are largely controlled by our biological and genetic makeup [105–110], significant changes in our brain can and do occur as we learn. We literally alter the neural structure of our brains as we learn.

Both the gray matter of our brains (the bodies of the neurons that reside around the surface of the brain) and the white matter of our brains (the axons that pass through the depths of our brain to connect neurons) can be physically altered at any age through focused use [101, 111–137]. Because of this neural plasticity, we can overcome many of the limitations of our biological and genetic makeup through practice. Yes, we really can learn to design.

So, to alter our neural networks within our brains, i.e., to reprogram our brains for more effective design, we must practice the change we want to happen:

To learn design, we must practice design!

We get better at clarifying projects by practicing different ways to clarify projects; we get better at generating ideas by practicing different ways to generate ideas; we get better at selecting one idea from a list of ideas by practicing different ways to select ideas. It is really that easy! We just have to practice. Just thinking about it may not be enough. We have to actually reprogram our neural networks through use.

There are two primary ways for us to practice design outside of our normal design environment: formal design education as typically taught in academic institutions and informal design training as typically taught in workshops, short

courses, and seminars. Both ways of practicing design involve learning new ways to use both intuitive and analytical thought in a design environment. They also teach us relevant heuristics to guide our thinking. We will now look more deeply at both formal design education and information design training.

2.3.1 Formal Design Education

Design education involves formal academic learning taught within college classes. For fine artists, design education primarily occurs in studio courses and, for engineers, it primarily occurs in project/capstone courses. Regardless of whether design education occurs within individual courses [138–158] or is integrated across an entire curriculum [159–166], design education has been shown to be effective. We can learn design through formal academic curricula.

Formal education, however, does have limitations. Our ability to generate original ideas appears to peak during our third year in college. With each year of college, we generate more domain-specific skills that we can use to aid our idea generation. However, with each year of college we also develop more rigid thought patterns (heuristics), which inhibits our idea generation. The influence of these two opposing effects seems to cross in about the third year of college. Education extending beyond three years tends to result in reduced originality. In fact, earning a PhD results in the lowest overall creative achievement and the highest dogmatism of any education level [167]. Of course, the traditional PhD degree does not involve solving design problems; it involves solving insight problems. Because of this, the traditional PhD offers little to those wanting to learn design, unless the topic of the PhD is design.

Another limitation to design education is that it is not applied equally across all disciplines. People who study Disciplines of Discovery focus on learning how to solve insight problems, not design problems. As a result, people who study Disciplines of Discovery tend to be less creative (develop fewer skills for generating ideas) than people who study Disciplines of Creation [168, 169].

Without a specific focus on developing creativity, students often feel creativity is not valued in their classes. When students are not given sufficient time or opportunity to be creative, they do not feel safe taking creative risks [170, 171]. This is particularly true for engineering students who are taught to develop useful designs instead of original designs [172–177]. The difference in how creativity is valued can also be a significant factor when students select which discipline they wish to study [178]. Nevertheless, formal design education for all students, including engineering students, does result in the more effective designs [165, 172, 179].

2.3.2 Informal Design Training

Informal design training involves workshops, short courses, and seminars on a design-related topic. Such training programs tend to be relatively short-term (hours to days) instead of months to years for design education. Over 50 types of design

training programs have been reported [180]. Of course, reading this book can also be considered to be a type of design training.

Most design training programs can be grouped into one of two broad categories: training in original idea generation (creativity) and training in creative problem solving. Training in creativity tends to focus on developing our intuitive abilities for generating ideas, while training in creative problem solving tends to focus on developing both our intuitive and analytical abilities that can be applied in all three of the universal design activities.

The most common design training programs are those that focus on original idea generation. Overall, these training programs have been shown to be effective with no single program being superior to the others [24, 42, 152, 181–210]. Various training programs for creative problem solving are also available and they too have been shown to be effective [154, 211–218]. The most widely used training method for creative problem solving is "Creative Problem Solving" or CPS [219, 220]. CPS is a formalized method for creative problem solving that has evolved significantly over time. It has been shown to be effective in its many forms [198, 221–233]. A similar method for creative problem solving is Synectics [234]. It has also been shown to be effective [235].

Design training, even though it lasts for a relatively short period of time, can still result in a measurable alteration of neural activity that lasts beyond the training period, i.e., a short design training can rewire our brains through neural plasticity [188, 236–242].

2.4 Closing

The key conclusions from this chapter are.

1. We use two very different modes of thinking: intuition and analysis. Intuition is a mode of thinking in which our next thought cannot be predicted by our previous thoughts (non-sequential thinking). Analysis is mode of thinking in which our next thought can normally be predicted by our previous thoughts (sequential thinking). Both are necessary for effective design.
2. Intuitive thought tends to encompass creative, irrational, and illogical thinking that supports idea generation while analytical thought tends to encompass critical, rational, and logical thinking that supports idea selection.
3. There appears to be three different types of intuition that impact our design effectiveness. These types of intuition may use different neural networks.

 a. Intuition of Understanding, which is used as we clarify a project,
 b. Intuition of Idea Generation, which is used as we generate ideas, and
 c. Intuition of Judgment, which we use as we select our final idea for implementation.

4. Intuition tends to involve unconscious thought, while analysis tends to involve conscious thought. Intuition tends to use unconscious pattern recognition and analysis tends to use conscious pattern recognition.

5. Metacognition is the process of recognizing which thinking mode we are currently using. Effective designers use metacognition to help switch thinking modes many times over the course of a design project.

6. We tend to use an intuitive thinking mode when we do not have sufficient time or information to for analytical thinking, we are unsure of what to do, or we are familiar with the topic. We tend to use an analytical thinking mode when we have information that is difficult to understand, is inconsistent with other information, and when we want to minimize risks.

7. Heuristics are patterns of information that simplify the vast amount of information available to us. We use heuristics as shortcuts because we lack the cognitive capacity and ability to process that vast amount of information. Heuristics can be externally-based (using external information) or internally-based (using our subjective value judgments, such as feelings, preferences, and beliefs). Both intuitive and analytical thinking rely on heuristics.

8. Feelings are used in design in two ways. We can use our feelings as information when making design judgments (select the idea that feels right and reject ideas the feel wrong) or we can use our feelings as experiences. Our feelings as experiences involves our mood, which can influence our thinking.

9. Formal design education can be an effective way to learn design, both within individual courses and across an entire curriculum. Informal design training can also be an effective way to learn design. Many different methods for informal design training have been shown to be effective, with no single method being superior to the others.

2.5 Questions

1. What is intuition to you? How do you use your intuition? How do you use your intuition as you design?

2. What is analysis to you? How do you use your analysis? How do you use your analysis as you design?

3. Do you recognize when you should use intuition and when you should use analysis? What do you do best when you are in an intuitive mode of thought? What do you do best when you are in an analytical mode of thought? Is your level of metacognition sufficient for you to even recognize which thinking mode you are using?

4. We use intuition to make hundreds of decisions each day. Can you describe some? Are you even aware of them?

5. We use analysis to make hundreds of decisions each day. Can you describe some? Are you even aware of them?

6. Do you trust your intuition? Do you trust your analysis? When? When not? Have you ever thought about how you trust your thinking?
7. When you are in an analytical mode of thought but need to be in an intuitive mode, how do you make the switch? When you are in an intuitive mode of thought but need to be in an analytical mode, how do you make the switch?
8. We all use heuristics. Do you recognize some of your personal heuristics? What about your habits?
9. Do you use your feelings when you design? Do you recognize the difference between using feelings as information (how you feel *about* something) and feelings as experiences (how you feel, i.e., your mood)?
10. Consider the following statements:

 - I *feel* this is the right idea to choose,
 - I *think* this is the right idea to choose,
 - I *believe* that this is the right idea to choose.

 Do these statements mean the same thing? Do you have a preference for which word to use? Does your thinking mode (intuitive or analytical) bias which word you prefer? Do you prefer one of the words based on what your peers may think about which word to use?

11. Have you engaged in design learning, either through formal design education or informal design training? Did it help?
12. What steps can you take to enhance your design effectiveness?

References

1. Akinci, C., Sadler-Smith, E.: Assessing individual differences in experiential (Intuitive) and rational (Analytical) cognitive styles. Int. J. Sel. Assess. **21**(2), 211–221 (2013). https://doi.org/10.1111/ijsa.12030
2. Barr, N., Pennycook, G., Stolz, J.A., Fugelsang, J.A.: Reasoned connections: a dual-process perspective on creative thought. Think. Reason **21**(1), 61–75 (2015). https://doi.org/10.1080/13546783.2014.895915
3. Epstein, S., Pacini, R., Denes-Raj, V., Heier, H.: Individual differences in intuitive-experiential and analytical-rational thinking styles. J. Pers. Soc. Psychol. **71**(2), 390–405 (1996). https://doi.org/10.1037/0022-3514.71.2.390
4. Epstein, S., Lipson, A., Holstein, C., Huh, E.: Irrational reactions to negative outcomes: evidence for two conceptual systems. J. Pers. Soc. Psychol. **62**(2), 328–339 (1992). https://doi.org/10.1037//0022-3514.62.2.328
5. Evans, J. St. B. T.: Dual-processing accounts of reasoning, judgment, and social cognition. Ann. Rev. Psychol. **59**, 255–278 (2008). https://doi.org/10.1146/annurev.psych.59.103006.093629
6. Gerlach, K.D., Spreng, R.N., Gilmore, A.W., Schacter, D.L.: Solving future problems: default network and executive activity associated with goal-directed mental simulations. Neuroimage **55**, 1816–1824 (2011). https://doi.org/10.1016/j.neuroimage.2011.01.030

7. Hodgkinson, G.P., Sadler-Smith, E.: Complex or unitary? A critique and empirical re-assessment of the allinson-hayes cognitive style index. J. Occup. Organ. Psychol. **76**, 243–268 (2003). https://doi.org/10.1348/096317903765913722

8. Hodgkinson, G.P., Sadler-Smith, E., Sinclair, M., Ashkanasy, N.M.: More than meets the eye? Intuition and analysis revisited. Personality Individ. Differ. **47**, 342–346 (2009). https://doi.org/10.1016/j.paid.2009.03.025

9. Pacini, R., Epstein, S.: The relation of rational and experiential information processing style to personality, basic beliefs, and the ratio-bias phenomenon. J. Pers. Soc. Psychol. **76**(6), 972–987 (1999). https://doi.org/10.1037//0022-3514.76.6.972

10. Sadler-Smith, E.: The intuitive style: relationships with local/global and verbal/visual styles, gender, and superstitious reasoning. Learn. Individ. Differ. **21**, 263–270 (2011). https://doi.org/10.1016/j.lindif.2010.11.013

11. Sloman, S.A.: The empirical case for two systems of reasoning. Psychol. Bull. **119**(1), 3–22 (1996). https://doi.org/10.1037/0033-2909.119.1.3

12. Smith, E.R., DeCoster, J.: Dual-process models in social and cognitive psychology: conceptual integration and links to underlying memory systems. Pers. Soc. Psychol. Rev. **4**(2), 108–131 (2000). https://doi.org/10.1207/S15327957PSPR0402_01

13. Sowden, P.T., Pringle, A., Gabora, L.: The shifting sands of creative thinking: connections to dual-process theory. Think. Reason. **21**(1), 40–60 (2015). https://doi.org/10.1080/13546783.2014.885464

14. Stanovich, K.E., Toplak, M.E.: Defining features versus incidental correlates of type 1 and type 2 processing. Mind Soc. **11**(1), 3–13 (2012). https://doi.org/10.1007/s11299-011-0093-6

15. Wechsler, S.M., Saiz, C., Rivas, S.F., Vendramini, C.M.M., Almeida, L.S., Mundim, M.C., Franco, A.: Creative and critical thinking: independent or overlapping components. Think. Skills Creat. **27**, 114–122 (2018). https://doi.org/10.1016/j.tsc.2017.12.003

16. Armstrong, S., Priola, V.: Individual difference in cognitive style and their effects on task and social orientations of self-managed work teams. Small Group Res. **32**(3), 283–312 (2001). https://doi.org/10.1177/104649640103200302

17. McMackin, J., Slovic, P.: When does explicit justification impair decision making. Appl. Cogn. Psychol. **14**, 527–541 (2000). https://doi.org/10.1002/1099-0720(200011/12)14:63.0.CO;2-J

18. Behling, O., Eckel, N.L.: Making sense of intuition. Acad. Manag. **5**(1), 46–54 (1991). https://doi.org/10.5465/ame.1991.4274718

19. Evans, J. St. B.T., Stanovich, K.E.: Dual-process theories of higher cognition: advancing the debate. Perspec. Psychol. Sci. **8**(3), 223–241 (2013). doi:https://doi.org/10.1177/1745691612460685

20. Glockner, A., Witteman, C.: Beyond dual-process models: a categorization of processes underlying intuitive judgment and decision making. Think. Reason. **16**(1), 1–25 (2010). https://doi.org/10.1080/13546780903395748

21. Gore, J., Sadler-Smith, E.: Unpacking intuition: a process and outcome framework. Rev. Gen. Psychol. **15**(4), 304–316 (2011). https://doi.org/10.1037/a0025069

22. Hodgkinson, G.P., Langan-Fox, J., Sadler-Smith, E.: Intuition: a fundamental bridging construct in the behavioral sciences. Br. J. Psychol. **99**, 1–27 (2008). https://doi.org/10.1348/000712607X216666

23. Langan-Fox, J., Shirley, D.A.: The nature and measurement of intuition: cognitive and behavioral interests, personality, and experiences. Creat. Res. J. **15**(2&3), 207–222 (2003). https://doi.org/10.1207/S15326934CRJ152&3_11

24. Salas, E., Rosen, M.A., DiazGranados, D.: Expertise-based intuition and decision making in organizations. J. Manag. **36**(4), 941–973 (2010). https://doi.org/10.1177/0149206309350084

25. Andrews-Hanna, J.R., Reidler, J.S., Huang, C., Buckner, R.L.: Evidence for the default network's role in spontaneous cognition. J. Neurophysiol. **104**, 322–335 (2010). https://doi.org/10.1152/jn.00830.2009

26. Andrews-Hanna, J., Smallwood, J., Spreng, R.N.: The default network and self-generated thought: component processes, dynamic control, and clinical relevance. Ann. N. Y. Acad. Sci. **1316**, 29–52 (2014). https://doi.org/10.1111/nyas.12360

27. Beaty, R.E., Benedek, M., Kaufman, S.B., Silvia, P.J.: Default and executive network coupling supports creative idea production. Sci. Reports **5**(Report 10964), 1–14 (2015). Doi: https://doi.org/10.1038/srep10964

28. Beaty, R.E., Benedek, M., Silvia, P.J., Schacter, D.L.: Creative Cognition and brain network dynamics. Trends Cogn. Sci. **20**(2), 87–95 (2016). https://doi.org/10.1016/j.tics.2015.10.004

29. Beaty, R.E., Kaufman, S.B, Benedek, M., Jung, R.E., Kenett, Y.N., Jauk, E., Neubauer, A. C., Silvia, P.J.: Personality and complex brain networks: the role of openness to experience in default network efficiency. Human Brain Mapping **37**, 773–779 (2016). doi:https://doi.org/10.1002/hbm.23065

30. Bijlevelt, E., Custers, R., Van der Stigchel, Aarts, H., Pas, P., Vink, M.: Distinct neural responses to conscious versus unconscious monetary reward cues. Human Brain Mapping **35**, 5578–5586 (2014). doi:https://doi.org/10.1002/hbm.22571

31. Buckner, R.L., Andrews-Hanna, J.R., Schacter, D.L.: The brain's default network: anatomy, function, and relevance to disease. Ann. N. Y. Acad. Sci. **1124**, 1–38 (2008). https://doi.org/10.1196/annals.1440.011

32. De Neys, W., Goel, V.: Heuristics and Biases in the brain: dual neural pathways for decision making. In Vartanian, O., Mandel, D.R. (eds.), Neuroscience of decision making. Psychology Press, New York (2011). doi:https://doi.org/10.4324/9780203835920

33. Durning, S.J., Constanzo, M.E., Artino, A.R., Graner, J., van der Vleuten, C., Beckman, T. J., Wittich, C.M., Roy, M.J., Holmboe, E.S., Schuwirth, L.: Neural basis of nonanalytical reasoning expertise during clinical evaluation. Brain Behav., 1–10 (2015). doi:https://doi.org/10.1002/brb3.309

34. Glass, A., Riding, R.J.: EEG differences and cognitive style. Biol. Psychol. **51**, 23–41 (1999). https://doi.org/10.1016/s0301-0511(99)00014-9

35. Heilman, K.M.: Possible brain mechanisms of creativity. Arch. Clin. Neuropsychol. **31**, 285–296 (2016). https://doi.org/10.1093/arclin/acw009

36. Huang, F., Tang, S., Sun, P., Luo, J.: Neural correlates of novelty and appropriateness processing in externally induced constraint relaxation. Neuroimage **172**, 381–389 (2018). https://doi.org/10.1016/j.neuroimage.2018.01.070

37. Ilg, R., Vogeley, K., Goschke, T., Bolte, A., Shah, J.N., Poppel, E., Fink, G.R.: Neural processes underlying intuitive coherence judgments as revealed by fMRI on a semantic judgment task. Neuroimage **38**, 228–238 (2007). https://doi.org/10.1016/j.neuroimage.2007.07.014

38. Jung, R.E., Mead, B.S., Carrasco, J., Flores, R.A.: The structure of creative cognition in the human brain. Front. Human Neurosci. **7**(330), 1–13 (2013). doi:https://doi.org/10.3389/fnhum.2013.00330

39. Lieberman, M.D., Jarcho, J.M., Satpute, A.B.: Evidence-based and intuition-based self-knowledge: an fMRI study. J. Pers. Soc. Psychol. **87**(4), 421–435 (2004). https://doi.org/10.1037/0022-3514.87.4.421

40. Mayseless, N., Eran, A., Shamay-Tsoory, S.G.: Generating original ideas: the neural underpinning of originality. Neuroimage **116**, 232–239 (2015). https://doi.org/10.1016/j.neuroimage.2015.05.030

41. Parsons, L.M., Osherson, D.: New evidence for distinct right and left brain systems for deductive versus probabilistic reasoning. Cereb. Cortex **11**(10), 954–965 (2001). https://doi.org/10.1093/cercor/11.10.954

42. Eubanks, D.L., Murphy, S.T., Mumford, M.D.: Intuition as an influence on creative problem-solving: the effects of intuition, positive affect, and training. Creat. Res. J. **22**(2), 170–184 (2010). https://doi.org/10.1080/10400419.2010.481513

43. Bolte, A., Goschke, T.: On the speed of intuition: intuitive judgments of semantic coherence under different response deadlines. Mem. Cognit. **33**(7), 1248–1255 (2005). https://doi.org/10.3758/BF03193226

44. Bolte, A., Goschke, T.: Intuition in the context of object perception: intuitive gestalt judgements rests on the unconscious activation of semantic representations. Cognition **108**, 608–616 (2008). https://doi.org/10.1016/j.cognition.2008.05.001

45. Bargh, J.A., Gollwitzer, P.M., Lee-Chai, A., Barndollar, K., Trotschel, R.: The automated will: nonconscious activation and pursuit of behavioral goals. J. Pers. Soc. Psychol. **81**(6), 1014–1027 (2001). https://doi.org/10.1037/0022-3514.81.6.1014

46. Baumeister, R.F., Masicampo, E.J., Vohs, K.D.: Do conscious thoughts cause behavior? Annu. Rev. Psychol. **62**, 331–361 (2011). https://doi.org/10.1146/annurev.psych.093008.131126

47. Lewicki, P., Hill, T., Bizot, E.: Acquisition of procedural knowledge about a pattern of stimuli that cannot be articulated. Cogn. Psychol. **20**, 24–37 (1988). https://doi.org/10.1016/0010-0285(88)90023-0

48. Lewicki, P., Hill, T., Czyzewska, M.: Nonconscious acquisition of information. Am. Psychol. **47**(6), 796–801 (1992). https://doi.org/10.1037//0003-066x.47.6.796

49. McCormick, P.A.: Orienting attention without awareness. J. Exp. Psychol. Hum. Percept. Perform. **23**(1), 168–180 (1997). https://doi.org/10.1037//0096-1523.23.1.168

50. Niedenthal, P.M.: Implicit perception of affective information. J. Exp. Soc. Psychol. **26**, 505–527 (1990). https://doi.org/10.1016/0022-1031(90)90053-O

51. Winkielman, P., Berridge, K.C.: Unconscious emotion. Curr. Direct. Psychol. Sci. **13**(3), 120–123 (2004). doi:https://doi.org/10.1111/j.0963-7214.2004.00288.x

52. Bar, M., Tootell, R.B.H., Schacter, D.L., Greve, D.N., Gischi, B., Mendola, J.D., Rosen, B.R., Dale, A.M.: Cortical mechanisms specific to explicit visual object recognition. Neuron **29**, 529–535 (2001). https://doi.org/10.1016/s0896-6273(01)00224-0

53. Creswell, J.D., Bursley, J.K., Satpute, A.B.: Neural reactivation links unconscious thought to decision making performance. Soc. Cognit. Affect. Neurosci. **8**(8), 863–869 (2013). https://doi.org/10.1093/scan/nst004

54. Gao, Y., Zhang, H.: Unconscious processing modulates creative problem solving: evidence form and electrophysiological study. Conscious. Cogn. **26**, 64–73 (2014). https://doi.org/10.1016/j.concog.2014.03.001

55. Pessiglione, M., Petrovic, P., Daunizeau, J., Palminteri, S., Dolan, R.J., Frith, C.D.: Subliminal instrumental conditioning demonstrated in the human brain. Neuron **59**, 561–567 (2008). doi:https://doi.org/10.1016/j.neuron.2008.07.005

56. Van Gaal, de Lange, F.P., Cohen, M.X.: The role of consciousness in cognitive control and decision making. Front. Human Neurosci. **6**(121), 1–15 (2012). doi:https://doi.org/10.3389/fnhum.2012.00121

57. Voss, J.L., Paller, K.A.: An electrophysiological signature of unconscious recognition memory. Nat. Neurosci. **12**(3), 349–355 (2009). https://doi.org/10.1038/nn.2260

58. Bowers, K.S., Regehr, G., Balthazard, C., Parker, K.: Intuition in the context of discovery. Cogn. Psychol. **22**, 72–110 (1990). https://doi.org/10.1016/0010-0285(90)90004-N

59. Horr, N.K., Braun, C., Volz, K.G.: Feeling before knowing why: the role of the orbitofrontal cortex in intuitive judgments—an MEG study. Cogn. Affect. Behav. Neurosci. **14**, 1271–1285 (2014). https://doi.org/10.3758/s13415-014-0286-7

60. Volz, K.G., Von Cramon, D.Y.: What neuroscience can tell about intuitive processes in the context of perceptual discovery. J. Cogn. Neurosci. **18**(12), 2077–2087 (2006). https://doi.org/10.1162/jocn.2006.18.12.2077

61. Jausovec, N.: Metacognition in creative problem solving. In Runco (ed.), Problem Finding, Problem Solving, and Creativity, Ablex Publishing, Norwood, New Jersey (1994)

62. Kavousi, S., Miller, P.A., Alexander, P.A.: Modeling metacognition in design thinking and design making. Int. J. Technol. Des. Educ. **30**, 709–735 (2020). https://doi.org/10.1007/s10798-019-09521-9

63. Kickul, J., Gundry, L.K., Barbosa, S.D., Whitcanack, L.: Intuition versus analysis? Testing differential models of cognitive style on entrepreneurial self-efficacy and the new venture creation process. Entrep. Theory Pract. **33**(2), 439–453 (2009). https://doi.org/10.1111/j.1540-6520.2009.00298.x

64. Pringle, A., Sowden, P.T.: Unearthing the creative thinking process: fresh insights from a think-aloud study of garden design. Psychol. Aesthet. Creat. Arts **11**(3), 344–358 (2017). https://doi.org/10.1037/aca0000144

65. Dane, E., Baer, M., Pratt, M.G., Oldham, G.R.: Rational versus intuitive problem solving: how thinking "off the beaten path" can stimulate creativity. Psychol. Aesthet. Creat. Arts **5**(1), 3–12 (2011). https://doi.org/10.1037/a0017698

66. MacKay, C.K., Cameron, B.: Cognitive bias in scottish first-year science and arts undergraduates. Br. J. Educ. Psychol. **38**(3), 315–318 (1968). https://doi.org/10.1111/j.2044-8279.1968.tb02026.x

67. Smithers, A.G., Child, D.: Convergers and divergers? Different forms of neuroticism? Brit. J. Educat. Psychol. **44**, 304–306 (1974). doi:https://doi.org/10.1111/j.2044-8279.1974.tb00784.x

68. Field, T.W., Poole, M.E.: Intellectual style and achievement of arts and science undergraduates. Br. J. Educ. Psychol. **40**(3), 338–341 (1970). https://doi.org/10.1111/j.2044-8279.1970.tb02140.x

69. Sjoberg, L.: Intuitive Vs. analytical decision making: which is preferred? Scand. J. Manag. **19**, 17–29 (2003). https://doi.org/10.1016/S0956-5221(01)00041-0

70. Denes-Raj, V., Epstein, S.: Conflict between intuitive and rational processing: when people behave against their better judgment. J. Pers. Soc. Psychol. **66**(5), 819–829 (1994). https://doi.org/10.1037/0022-3514.66.5.819

71. Garcia-Marques, T., Mackie, D.M.: Familiarity impacts person perception. Eur. J. Soc. Psychol. **37**, 839–855 (2007). https://doi.org/10.1002/ejsp.387

72. Alter, A.L., Oppenheimer, D.M., Epley, N., Eyre, R.N.: Overcoming intuition: metacognitive difficulty activates analytic reasoning. J. Exp. Psychol. Gen. **136**(4), 569–576 (2007). https://doi.org/10.1037/0096-3445.136.4.569

73. Abrami, P.C., Bernard, R.M., Borokhovski, E., Waddington, D.I., Wade, C.A., Persson, T.: Strategies for teaching students to think critically: a meta-analysis. Rev. Educ. Res. **85**(2), 275–314 (2015). https://doi.org/10.3102/0034654314551063

74. Baker, M., Rudd, R.: Relationships between critical and creative thinking. J. Southern Agricult. Educ. Res. **51**(1), 173–188 (2001)

75. Cela-Conde, C.J., Marty, G., Maestu, F., Ortiz, T., Munar, E., Fernandez, A., Roca, M., Rossello, J., Quesney, F.: Activation of the prefrontal cortex in the human visual aesthetic perception. Proceedings of the National Academy of Science, vol. 101, no. 16, pp. 6321–6325 (2004). doi:https://doi.org/10.1073/pnas.0401427101

76. Cupchik, G.C., Vartanian, O., Crawley, A., Mikulis, D.J.: Viewing artworks: contributions of cognitive control and perceptual facilitation to aesthetic experience. Brain Cogn. **70**, 84–91 (2009). https://doi.org/10.1016/j.bandc.2009.01.003

77. De Martino, B., Kumaran, D., Seymour, B., Dolan, R.J., "Frames, biases, and rational decision-making in the human brain. Science **313**, 684–687 (2006). doi:https://doi.org/10.1126/science.1128356

78. Falk, E.B., Spunt, R.P., Lieberman, M.D.: Ascribing beliefs to ingroup and outgroup political candidates: neural correlates of perspective-taking, issue importance, and days until the election. Philos. Transac. Biolog. Sci. **367**(1589), 731–743 (2012). https://doi.org/10.1098/rstb.2011.0302

79. Goel, V., Dolan, R.J.: Explaining modulation of reasoning by belief. Cognition **87**, B11–B22 (2003). https://doi.org/10.1016/s0010-0277(02)00185-3

80. Greene, J.D., Sommerville, R.B., Nystrom, L.E., Darley, J.M., Cohen, J.D.: An fMRI investigation of emotional engagement in moral judgment. Science **293**, 2105–2108 (2001). doi:https://doi.org/10.1126/science.1062872

81. Harris, S., Sheth, S.A., Cohen, M.S.: Functional neuroimaging of belief, disbelief, and uncertainty. Ann. Neurol. **63**(2), 141–147 (2008). https://doi.org/10.1002/ana.21301

82. Ishai, A.: Art compositions elicit distributed activation in the human brain. In Shimamura, A. P., Palmer, S.E. (eds.), Aesthetic Science: Connecting Minds, Brains, and Experience. Oxford University Press, Oxford (2012). doi:https://doi.org/10.1093/acprof:oso/9780199732142.003.0074

83. Ishizu, T., Zeki, S.: The brain's specialized systems for aesthetic and perceptual judgment. Eur. J. Neurosci. **37**, 1413–1420 (2013). https://doi.org/10.1111/ejn.12135

84. Jacobsen, T., Schubotz, R.I., Hofel, L., Cramon, C.Y.V.: Brain correlates of aesthetic judgment of beauty. Neuroimage **29**, 276–285 (2006). https://doi.org/10.1016/j.neuroimage.2005.07.010

85. Kawabata, H., Zeki, S.: Neural correlates of beauty. J. Neurophysiol. **91**, 1699–1705 (2004). https://doi.org/10.1152/jn.00696.2003

86. Kirk, U., Skov, M., Christensen, M.S., Nygaard, N.: Brain correlates of aesthetic experience. Brain Cogn. **69**, 306–315 (2009). https://doi.org/10.1016/j.bandc.2008.08.004

87. Kirk, U., Skov, M., Hulme, O., Christensen, M.S., Zeki, S.: Modulation of aesthetic value by semantic context: an fMRI study. Neuroimage **44**, 1125–1132 (2009). https://doi.org/10.1016/j.neuroimage.2008.10.009

88. McClure, S.M., Li, J., Tomlin, D., Cypert, K.S., Montague, L.M., Montague, P.R.: Neural correlates of behavioral preference for culturally familiar drinks. Neuron **44**, 379–387 (2004). doi:https://doi.org/10.1016/j.neuron.2004.09.019

89. Vartanian, O., Skov, M.: Neural correlates of viewing paintings: evidence from a quantitative meta-analysis of functional magnetic resonance imaging data. Brian Cognit. **87**, 52–56 (2014). https://doi.org/10.1016/j.bandc.2014.03.004

90. Vartanian, O., Goel, V.: Neuroanatomical correlates of aesthetic preference for paintings. NeuroReport **15**(5), 893–897 (2004). https://doi.org/10.1097/00001756-200404090-00032

91. Vessel, E.A., Starr, G.G., Rubin, N.: Art reaches within: aesthetic experience, the self and the default mode network. Front. Neurosci. **7**(258), 1–9 (2013). doi:https://doi.org/10.3389/fnins.2013.00258

92. Yago, E., Ishai, A.: Recognition memory is modulated by visual similarity. Neuroimage **31**, 807–817 (2006). https://doi.org/10.1016/j.neuroimage.2005.12.014

93. Yonelinas, A.P., Otten, L.J., Shaw, K.N., Rugg, M.D.: Separating the brain regions involved in recollection and familiarity in recognition memory. J. Neurosci. **25**(11), 3002–3008 (2005). doi:https://doi.org/10.1523/JNEUROSCI.5295-04.2005

94. Ashby, F.G., Isen, A.M., Turken, U.: A neuropsychological theory of positive affect and its influence on cognition. Psychol. Rev. 106(3), 529–550 (1999). doi:https://doi.org/10.1037/0033-295x.106.3.529

95. Harle, K.M., Chang, L.J., van't Wout, M., Sanfey, A.G.: The neural mechanism of affect infusion in social economic decision-making: a mediating role of the anterior insula. NeuroImage **61**, 32–40 (2012). doi:https://doi.org/10.1016/j.neuroimage.2012.02.027

96. Subramaniam, K., Kounios, J., Parrish, T.B., Jung-Beeman, M.: A brain mechanism for facilitation of insight by positive affect. J. Cognit. Neurosci. **21**(3), 415–432 (2008). doi:https://doi.org/10.1162/jocn.2009.21057

97. Carroll, J.B.: Human cognitive abilities: a survey of factor-analytic studies. Cambridge University Press, New York (1993)

98. Costa, P.T., McCrae, R.R.: Set like plaster? Evidence for the stability of adult personality. In Heatherson, T., Weinberger, J., (eds.) Can Personality Change? American Psychological Association, Washington, DC (1994). doi:https://doi.org/10.1037/10143-002

99. Cramond, B., Matthews-Morgan, J., Bandalos, D., Zuo, L.: A report on the 40-year follow-up of the torrence tests of creative thinking: alive and well in the new millennium. Gifted Child Quart. **49**(4), 283–291, Fall (2005). doi:https://doi.org/10.1177/001698620504900402

100. Feist, G.J., Barron, F.X.: Predicting creativity from early to late adulthood: intellect, potential, and personality. J. Res. Pers. **37**, 62–88 (2003). https://doi.org/10.1016/S0092-6566(02)00536-6

101. Helson, R.: A Longitudinal Study of Creative Personality in Women. Creat. Res. J. **12**(2), 89–101 (1999). https://doi.org/10.1207/s15326934crj1202_2

102. Helson, R., Pals, J.L.: Creative potential, creative achievement, and personal growth. J. Pers. **68**, 1–27 (2000). https://doi.org/10.1111/1467-6494.00089

103. Helson, R., Roberts, B., Agronick, G.: Enduringness and change in creative personality and the prediction of occupational creativity. J. Pers. Soc. Psychol. **69**(6), 1173–1183 (1995). https://doi.org/10.1037//0022-3514.69.6.1173

104. Terracciano, A., Costa, P.T., McCrae, R.R.: Personality plasticity after age 30. Pers. Soc. Psychol. Bull. **32**(8), 999–1009 (2006). https://doi.org/10.1177/0146167206288599

105. Costa, P.T., Jr., Herbst, J.H., McCrae, R.R., Siegler, I.C.: Personality at midlife: stability intrinsic maturation, and response to life events. Assessment **7**(4), 365–378 (2000). https://doi.org/10.1177/107319110000700405

106. De Young, C.G., Hirsh, J.B., Shane, M.S., Papademetris, X., Rajeevan, N., Gray, J.R.: Testing predictions from personality neuroscience: brain structure and the big five. Psychol. Sci. **21**(6), 820–828 (2010). https://doi.org/10.1177/0956797610370159

107. Gurrera, R.J., Salisbury, D.F., O'Donnell, B.F., Nestor, P.G., McCarley, R.W.: Auditory P3 indexes personality traits and cognitive function in healthy men and women. Psychiatry Res. **133**, 215–228 (2005). https://doi.org/10.1016/j.psychres.2004.09.009

108. McCrae, R.R., Costa, P.T., Jr., Ostendorf, F., Angleitner, A., Hrebickova, M., Avia, M.D., Sanz, J., Sanchez-Bernardos, M.L., Kusdil, M.E., Woodfield, R., Saunders, P.R., Smith, P. B.: Nature over nurture: temperament, personality, and life span development. J. Pers. Soc. Psychol. **78**(1), 173 186 (2000). https://doi.org/10.1037//0022-3514.78.1.173

109. Runco, M.A., Noble, E.P., Reiter-Palmon, R., Acar, S., Ritchie, T., Yurkovich, J.M.: The genetic basis for creativity and ideational fluency. Creat. Res. J. **23**(4), 376–380 (2011). https://doi.org/10.1080/10400419.2011.621859

110. Strough, C., Donaldson, C., Scarlata, B., Ciorciari, J.: psychophysiological correlates of the NEO PI-R openness, agreeableness and conscientiousness: preliminary results. Int. J. Psychophysiol. **41**, 87–91 (2001). https://doi.org/10.1016/s0167-8760(00)00176-8

111. Abdul-Kareem, I.A., Stancak, A., Parkes, L.M., Sluming, V.: Increased gray matter volume of left pars opercularis in male orchestral musicians correlate positively with years of musical performance. J. Magn. Reson. Imag. **22**, 24–32 (2011). doi:https://doi.org/10.1002/jmri.22391

112. Aydin, K., Ucar, A., Oguz, K.K., Okur, O.O., Agayev, A., Unal, Z., Yilmax, S., Ozturk, C.: Increased gray matter density in the parietal cortex of mathematicians: a voxel-based morphometry study. Am. J. Neurorad. **28**, 1859–1864 (2007). doi:https://doi.org/10.3174/ajnr.A0696

113. Bengtsson, S.L., Nagy, Z., Skare, S., Forsman, L., Horssberg, H., Ullen, F.: Extensive piano practice has regionally specific effects on white matter development. Nat. Neurosci. **8**(9), 1148–1150 (2005). https://doi.org/10.1038/nn1516

114. Bhattacharya, J., Petsche, H.: Phase synchrony analysis of EEG during music perception reveals changes in functional connectivity due to musical expertice. Signal Process. **85**, 2161–2177 (2005). https://doi.org/10.1016/j.sigpro.2005.07.007

115. Bhattacharya, J., Petsche, H.: Drawing on mind's canvas: differences in cortical integration patterns between artists and non-artists. Hum. Brain Mapp. **26**, 1–14 (2005). https://doi.org/10.1002/hbm.20104

116. Chamberlain, R., McManus, I.C., Brunswick, N., Rankin, Q., Riley, H., Kanai, R.: Drawing on the right side of the brain: a voxel-based morphometry analysis of observational drawing. Neuroimage **96**, 167–173 (2014). https://doi.org/10.1016/j.neuroimage.2014.03.062

117. Cramer, S., Sur, M., Dobkin, B.H., O'Brien, C., Sanger, T.D., Trojanowski, J.Q., Rumsey, J. M., Hicks, R., Cameron, J., Chen, D., Chen, W.G., Cohen, L.G., deCharms, C., Duffy, C.J.,

Eden, G.F., Fetz, E.E., Filart, R., Freund, M., Grant, S.J., Haber, S., Kalivas, P.W., Kolb, B., Kramer, A.F., Lynch, M., Maybert, H.S., McQuiellen, P.S., Nitkin, R., Pascual-Leone, A., Reuter-Lorenz, P., Schiff, N., Sharma, A., Shemik, L., Stryker, M., Sullivan, E.V., Vinogradov, S.: Harnessing neuroplasticity for clinical applications. Brain **134**, 1591–1609 (2011). https://doi.org/10.1093/brain/awr039

118. Draganski, B., Gaser, C., Kempermann, G., Kuhn, H.G., Winkler, J., Buchel, C., May, A.: Temporal and spatial dynamics of brain structural changes during extensive learning. J. Neurosci. **26**(23), 6314–6317 (2006). doi:https://doi.org/10.1523/JNEUROSCI.4628-05. 2006

119. Eriksson, P.S., Perfilieva, E., Bjork-Eriksson, T., Alborn, A.-M., Nordborg, C., Peterson, D. A., Gage, F.H.: Neurogenesis in the adult human hippocampus. Nat. Med. **4**(11), 1313–1317 (1998). https://doi.org/doi:10.1038/3305

120. Bangert, M., Peschel, T., Schlaug, G., Rotte, M., Drescher, D., Hinrichs, H., Heinze, H.-J., Altenmuller, E.: Shared networks for auditory and motor processing in professional pianists: evidence from fMRI conjunction. NeuroImage (30), 917–926 (2006). doi:https://doi.org/10. 1016/j.neuroimage.2005.10.044

121. Harris, M.A., Brett, C.E., Johnson, W., Deary, I.J.: Personality stability from age 14 to age 77 years. Psychol. Aging **31**(8), 862–874 (2016). https://doi.org/10.1037/pag0000133

122. Johnson, J.K., Petsche, H., Richter, P., Von Stein, A., Filz, O.: The dependence of coherent estimates of spontaneous EEG on gender and music training. Music Perc. Interdisc. J. **13**(4), 563–581, Summer (1996). doi:https://doi.org/10.2307/40285702

123. Hoelzel, B., Carmody, J., Dusek, J., Hoge, E., Lazar, S., Morgan, L., Yerramsetti, S.: Meditation training leads to changes in regional gray matter concentration. Explore **5**(3), 165–166 (2009). https://doi.org/10.1016/j.explore.2009.03.058

124. Kang, D.-H., Jo, H.J., Jung, W.H., Kim, S.H., Jung, Y.-H., Choi, C.-H., Lee, U.S., An, S.C., Jang, J.H., Kwon, J.S.: The effect of meditation on brain structure: cortical thickness mapping and diffusion tensor imaging. Soc. Cognit. Affect. Neurosci. **8**, 27–33 (2013). https://doi.org/10.1093/scan/nss056

125. Lazar, S.W., Kerr, C.E., Wasserman, R.H., Gray, J.R., Greve, D.N., Treadway, M.T., McGarvey, M., Quinn, B.T., Dusek, J.A., Benson, H., Rauch, S.L., Moore, C.I., Fichl, B.: Meditation experience is associated with increased cortical thickness. NeuroReport **16**(18), 1893–1897 (2005). https://doi.org/10.1097/01.wnr.0000186598.66243.19

126. Leung, M.-K., Chan, C.C.H., Yin, J., Lee, C.-F., So, K.-F., Lee, T.M.C.: Increased gray matter volume in the right angular and posterior parahippocampal gyri in loving-kindness meditators. Soc. Cognit. Affect. Neurosci. **8**, 34–39 (2013). https://doi.org/10.1093/scan/nss076

127. Maguire, E.A., Gadian, D.G., Johnsrude, I.S., Good, C.D., Ashburner, J., Frackowiak, R.S. J., Frith, C.D.: Navigation-related structural change in the hippocampi of taxi drivers. Proceedings of the National Academy of Sciences, vol. 97, no. 8., pp. 4398–4403 (2000). doi:https://doi.org/10.1073/pnas.070039597

128. Neumann, N., Domin, M., Eerhard, K., Lotze, M.: Voxel-based morphometry in creative writers: grey matter increase in a prefronto-thalamic-cerebellar network. Eur. J. Neurosci. **48**, 1647–1653 (2018). https://doi.org/10.1111/ejn.13952

129. Neumann, N., Lotze, M., Eickhoff, S.B.: Cognitive expertise: an ELE meta-analysis. Hum. Brain Mapp. **37**, 262–272 (2016). https://doi.org/10.1002/hbm.23028

130. Pagnoni, G., Cekic, M.: Age effects on gray matter volume and attentional performance in Zen meditation. Neurobiol. Aging **28**, 1623–1627 (2007). https://doi.org/10.1016/j. neurobiolaging.2007.06.008

131. Pascual-Leone, A., Amedi, A., Fregni, F., Merabet, L.B.: The plastic human brain cortex. Annu. Rev. Neurosci. **28**, 377–401 (2005). https://doi.org/10.1146/annurev.neuro.27. 070203.144216

132. Schlegel, A., Alexander, P., Fogelson, S.V., Li, X., Lu, Z., Kohler, P.J., Riley, E., Tse, P.U., Meng, M.: The artist emerges: visual art learning alters neural structure and function. Neuroimage **105**, 440–451 (2015). https://doi.org/10.1016/j.neuroimage.2014.11.014

133. Schneider, P., Scherg, M., Dosch, H.G., Specht, H.J., Gutschalk, A., Rupp, A.: Morphology of Heschl's gyrus reflects enhanced activiation in the auditory cortex of musicians. Nat. Neurosci. **5**(7), 688–694 (2002). https://doi.org/10.1038/nn871

134. Spalding, K.L., Bergmann, O., Alkass, K., Bernard, S., Salehpour, M., Hutter, H.B., Bostrom, E., Westerlund, I., Vail, C., Buchholtz, B.A., Possnert, G., Mash, D.C., Druid, H., Frisen, J.: Dynamics of hippocampal neurogenesis in adult humans. Cell **153**, 1219–1227 (2013). doi:https://doi.org/10.1016/j.cell.2013.05.002

135. Terracciano, A., McCrae, R.R., Brant, L.J., Costa, P.T., Jr.: Hierarchical linear modeling analyses of the NEO-PI-R scales in the baltimore longitudinal study of aging. Psychol. Aging **20**(3), 493–506 (2005). https://doi.org/10.1037/0882-7974.20.3.493

136. Thompson, P., Cannon, T.D., Toga, A.W.: Mapping genetic influences on human brain structure. Ann. Med. **34**(7), 523–536 (2002). https://doi.org/10.1080/078538902321117733

137. Valkanova, V., Rodriquez, R.E., Ebmeier, K.P.: Mind over matter—what do we know about neuroplasticity in adults. Int. Psychogeriatr. **26**(6), 891–909 (2014). https://doi.org/10.1017/S1041610213002482

138. Bonnardel, N., Didier, J.: Enhancing creativity in an educational design context: an exploration of the effects of design project-oriented methods on students' evocation processes and creative output. J. Cognit. Educ. Psychol. **15**(1) (2016). doi:https://doi.org/10.1891/1945-8959.15.1.80

139. Bourgeois-Bourgrine, S., Buisine, S., Vandendriessche, C., Glaveanu, V., Lubart, T.: Engineering students' use of creativity and development tools in conceptual product design: what, when, and how? Think. Skills Creat. **24**, 104–117 (2017). https://doi.org/10.1016/j.tsc.2017.02.016

140. Clapham, M.M., Schuster, D.H.: Can engineering students be trained to think more creatively. J. Creat. Behav. **26**(1), 156–162, Third Quarter (1992). doi:https://doi.org/10.1002/j.2162-6057.1992.tb01171.x

141. Cropley, D.H., Cropley, A.J.: Fostering creativity in engineering undergraduates. High Abil. Stud. **11**(2), 207–219 (2000). https://doi.org/10.1080/13598130020001223

142. Daly, S.R., Mosyjowski, E.A., Seifert, C.M.: Teaching creative process across disciplines. J. Creat. Behav. **53**(1), 1–13 (2016). https://doi.org/10.1002/jocb.158

143. Daly, S.R., Christian, J.L., Yilmaz, S., Seifert, C.M., Gonzalez, R.: Assessing design heuristics for idea generation in an introductory engineering course. Int. J. Eng. Educ. **28**(2), 463–473 (2012)

144. Dineen, R., Niu, W.: The effectiveness of western creative teaching methods in China: an action research project. Psychol. Aesthet. Creat. Arts **2**(1), 42–52 (2008). https://doi.org/10.1037/1931-3896.2.1.42

145. Dumas, D., Schmidt, L.C., Alexander, P.A.: Predicting creative problem solving in engineering design. Think. Skills Creat. **21**, 50–66 (2016). https://doi.org/10.1016/j.tsc.2016.05.002

146. Gray, C.M., Yilmaz, S., Daly, S., Seifert, C.M., Gonzalez, R.: Creativity 'Misrules': first year engineering students' production and perception of creativity in design ideas. Proceedings of the ASME 2015 International Design Engineering Technical Conferences and Computers and Information in Engineering Conferences, IDETC/CIE 2015, DETC2015–46492, Boston, MA, Aug. 2–5, 2015. doi:https://doi.org/10.1115/DETC2015-46492

147. Greer, M., Levine, E.: Enhancing creative performance in college students. J. Creat. Behav. **25**(3):250–255, Third Quarter (1991). doi:https://doi.org/10.1002/j.2162-6057.1991.tb01377.x

148. Hester, K.S., Robledo, I.C., Barrett, J.D., Peterson, D.R., Hougen, D.P., Day, E.A., Mumford, M.D.: Causal analysis to enhance creative problem-solving: performance and effects on mental models. Creat. Res. J. **24**(2–3), 115–133 (2012). https://doi.org/10.1080/10400419.2012.677249

149. Hirst, G., Van Knippenberg, D., Chen, C.-H., Sacramento, C.A.: How does bureaucracy impact individual creativity" a cross-level investigation of team contextual influences on goal orientation-creativity relationships. Acad. Manag. J. **54**(3), 624–641 (2011). https://doi.org/10.5465/amj.2011.61968124
150. Karakelle, S.: Enhancing fluent and flexible thinking through the creative drama process. Think. Skills Creat. **4**, 124–129 (2009). https://doi.org/10.1016/j.tsc.2009.05.002
151. Karpova, E., Marcketti, S.B., Barker, J.: The efficacy of teaching creativity: assessment of student creative thinking before and after exercises. Cloth. Text. Res. J. **29**(1), 52–66 (2011). https://doi.org/10.1177/0887302X11400065
152. Kleinmintz, O.M., Goldstein, P., Mayseless, N., Abecasis, D., Shamay-Tsoory, S.G.: Expertise in musical improvisation and creativity: the mediation of idea evaluation. PLOSone **9**(7), e101568, 1–8 (2014). doi:https://doi.org/10.1371/journal.pone.0101568
153. Parnes, S.J.: Effects of extended effort in creative problem solving. J. Educ. Psychol. **52**(3), 117–122 (1961). https://doi.org/10.1037/h0044650
154. Peterson, D.R., Barrett, J.D., Hester, K.S., Robledo, I.C., Hougen, D.F., Day, E.A., Mumford, M.D.: Teaching people to manage constraints: effects on creative problem-solving. Creat. Res. J. **25**(3), 335–347 (2013). https://doi.org/10.1080/10400419.2013.813809
155. Sternberg, R.J., Ketron, J.L.: Selection of implementation of strategies in reasoning by analogy. J. Educ. Psychol. **74**(3), 399–413 (1982). https://doi.org/10.1037/0022-0663.74.3.399
156. Ulger, K.: The creative training in the visual arts education. Think. Skills Creat. **19**, 73–87 (2016). https://doi.org/10.1016/j.tsc.2015.10.007
157. Vande Zande, R., Warnock, L., Nokoomanesh, B., Van Dexter, K.: The design process in the art classroom: building problem-solving skills for life and careers. Art Educ. (2014). https://doi.org/10.1080/00043125.2014.11519294
158. Zwirn, S., Vande Zande, R.: Differences between art and design education—or differences in conceptions of creativity? J. Creat. Behav. **51**(3), 193–203 (2015). https://doi.org/10.1002/jocb.98
159. Chen, C.-K., Jiang, B.C., Hsu, K.-Y.: An empirical study of industrial engineering and management curriculum reform in fostering students' creativity. Eur. J. Eng. Educ. **30**(2), 191–202 (2005). https://doi.org/10.1080/03043790500087423
160. Cheung, C.-K., Roskams, T., Fisher, D.: Enhancement of creativity through a one-semester course in university. J. Creat. Behav. **40**(1), 1–25, First Quarter (2006). doi:https://doi.org/10.1002/j.2162-6057.2006.tb01264.x
161. Choi, H.H., Kim, M.J.: The effects of analogical and metaphorical reasoning on design thinking. Think. Skills Creat. **23**, 29–41 (2017). https://doi.org/10.1016/j.tsc.2016.11.004
162. Gilbert, F.W., Prenshaw, P.J., Ivy, T.T.: A preliminary assessment of the effectiveness of creativity training in marketing. J. Mark. Educ. **18**, 46–56 (1996). https://doi.org/10.1177/027347539601800306
163. Gunther, J., Ehrlenspeil, K.: Comparing designers from practice and designers with systematic design education. Des. Stud. **20**, 439–451 (1999). https://doi.org/10.1016/S0142-694X(99)00019-8
164. LaDuca, B., Ausdenmoore, A., Katz-Bounincontro, J., Hallinan, K.P., Marshall, K.L.: An arts-based instructional model for student creativity in engineering design. Int. J. Eng. Pedagogy **7**(1), 34–57 (2017). https://doi.org/10.3991/ijep.v7i1.6335
165. Venters, C., Reis, J., Griffin, H., Dixon, G.: A spiral curriculum in design and project management. Frontiers in Education, IEEE (2015). https://doi.org/10.1109/FIE.2015.7344210
166. Zhou, C.: Integrating creativity training into problem and project-based learning curriculum in engineering education. Eur. J. Eng. Educ. **37**(5), 488–499 (2012). https://doi.org/10.100/03043797.2012.714357
167. Simonton, D.K.: Formal education, eminence and dogmatism: the curvilinear relationship. J. Creat. Behav. **17**(3), 149–162, Third Quarter (1983). https://doi.org/10.1002/j.2162-6057.1983.tb00348.x

168. Cheung, C.-K., Rudowicz, E., Yue, X., Kwan, A.S.F.: Creativity of university students: what is the impact of field and year of study? J. Creat. Behav. **37**(1), 42–63, First Quarter (2003). doi:https://doi.org/10.1002/j.2162-6057.2003.tb00825.x

169. Genco, N., Holtta-Otto, K., Seepersad, C.C.: An experimental investigation of the innovation capabilities of undergraduate engineering students. J. Eng. Educ. **101**(1), 60–81 (2012). https://doi.org/10.1002/j.2168-9830.2012.tb00041.x

170. Alencar, E.M.L.S.: Obstacles to personal creativity among university students. Gift. Educ. Int. **15**, 133–140 (2001). https://doi.org/10.1177/026142940101500203

171. Baloche, L., Montgomery, D., Bull, K.S., Salyer, B.K.: Faculty perceptions of college creativity courses. J. Creat. Behav. **26**(4), 222–227, Fourth Quarter (1992). doi:https://doi.org/10.1002/j.2162-6057.1992.tb01180.x

172. Coleman, E., Shealy, T., Grohs, J., Godwin, A.: Design thinking among first-year and senior engineering students: a cross-sectional, national study measuring perceived ability. J. Eng. Educ. **109**, 72–87 (2020). https://doi.org/10.1002/jee.20298

173. Daly, S.R., Mosyjowski, E.A., Oprea, S.L., Huang-Saad, A., Seifert, C.M.: College students' views of creative process instruction across disciplines. Think. Skills Creat. **22**, 1–13 (2016). https://doi.org/10.1016/j.tsc.2016.07.002

174. Daly, S.R., Mosyjowski, E.A., Seifert, C.M.: Teaching creativity in engineering courses. J. Eng. Educ. **103**(3), 417–449 (2014). https://doi.org/10.1002/jee.20048

175. Kazerounian, K., Foley, S.: Barriers to creativity in engineering education: a study of instructors and students perceptions. J. Mech. Des. **129**, 761–768 (July 2007). https://doi.org/10.1115/1.2739569

176. Sola, E., Hoekstra, R., Fiore, S., McCauley, P.: An Investigation of the state of creativity and critical thinking in engineering undergraduates. Creat. Educ. **8**, 1495–1522 (2017). https://doi.org/10.4236/ce.2017.89105

177. Zappe, S.E., Reeves, P.M., Mena, I.B., Litzinger, T.A.: A cross-sectional study of engineering students' creative self-concepts: an exploration of creative self-efficacy, personal identity, and expectations. Proceedings of the 122 ASEE Annual Conference and Exhibition, Seattle, WA, June 14–17 (2015). doi:https://doi.org/10.18260/p.23373

178. Atwood, S.A., Pretz, J.E.: Creativity as a factor in persistence and academic achievement of engineering undergraduates. J. Eng. Educ. **105**(4), 540–559 (2016). https://doi.org/10.1002/jee.20130

179. Kim, J.-Y.: A longitudinal study of the relation between creative potential and academic achievement at an engineering university in Korea. J. Eng. Educ. **109**(4), 704–722 (2020). https://doi.org/10.1002/jee.20365

180. Geschka, H., Schaude, G.R., Schlicksupp, H.: Modern techniques for solving problems. Int. Stud. Manag. Organiz. 6(4), 45–63, Winter (1976–1977)

181. Amabile, T.M.: Creativity in context. Westview Press, Boulder, CO (1996)

182. Baer, J.: Creativity and divergent thinking: a task-specific approach. Lawrence Erlbaum Associates, New Jersey (1993)

183. Baruah, J., Paulus, P.B.: Effects of training on idea generation in groups. Small Group Res. **39**(5), 523–541 (2008). https://doi.org/10.1177/1046496408320049

184. Basadur, M., Graen, G.B., Scandura, T.A.: Training effects on attitudes toward divergent thinking among manufacturing engineers. J. Appl. Psychol. **71**(4), 612–617 (1986). https://doi.org/10.1037/0021-9010.71.4.612

185. Basadur, M., Pringle, P., Kirkland, D.: Crossing cultures: training effects on the divergent thinking attitudes of spanish-speaking south american managers. Creat. Res. J. **14**(3–4), 395–408 (2002). https://doi.org/10.1207/s15326934crj1434_10

186. Basadur, M., Runco, M.A., Vega, L.A.: Understanding how creative thinking skills, attitudes, and behaviors work together: a causal process model. J. Creat. Behav. **34**(2), 77–100, Second Quarter (2000). doi:https://doi.org/10.1002/j.2162-6057.2000.tb01203.x

187. Birdi, K.: A lighthouse in the desert? Evaluating the effects of creativity training on employee innovation. J. Creat. Beh. **41**(4), 249–270, Fourth Quarter (2007). doi:https://doi. org/10.1002/j.2162-6057.2007.tb01073.x

188. Byrge, C., Tang, C.: Embodied creativity training: effects on creative self-efficacy and creative production. Think. Skills Creat. **16**, 51–61 (2015). https://doi.org/10.1016/j.tsc. 2015.01.002

189. Clapham, M.M.: Ideational skills training: a key element in creativity training programs. Creat. Res. J. **10**(1), 33–44 (1997). https://doi.org/10.1207/s15326934crj1001_4

190. Feldhusen, J.F., Clinkenbeard, P.R.: Creativity instructional materials: a review of research. J. Creat. Behav. **20**(3), 153–182, Third Quarter (1986). doi:https://doi.org/10.1002/j.2162-6057.1986.tb00435.x

191. Fink, A., Graif, B., Neubauer, A.C.: brain correlates underlying creative thinking: EEG alpha activity in professional Vs. novice dancers. Neuroimage **46**, 854–862 (2009). https://doi.org/ 10.1016/j.neuroimage.2009.02.036

192. Gabora, L.: Revenge of the 'Neurds': characterizing creative thought in terms of the structure and dynamics of memory. Creat. Res. J. **22**(1), 1–13 (2010). doi:https://doi.org/10. 1080/10400410903579494

193. Harkins, J.D., Macrosson, W.D.K.: Creativity training: an assessment of a novel approach. J. Busin. Psychol. **5**(1), 143–148, Fall (1990). https://www.jstor.org/stable/25092270

194. Hogarth, R.: Intuition: a challenge for psychological research on decision making. Psychol. Inq. **21**, 338–353 (2010). https://doi.org/10.1080/1047840X.2010.520260

195. Hogarth, R.M.: Educating Intuition. University of Chicago Press, Chicago (2001)

196. Horstmann, N., Hausmann, D., Ryf, S.: Methods for inducing intuitive and deliberate processing modes. In Glockner, Witteman (eds.), *Foundations for Tracing Intuition*, Psychology Press, Hove and New York, (2010). DOI https://doi.org/10.4324/9780203861936

197. Howard, T.J., Culley, S., Dekoninck, E.A.: Reuse of ideas and concepts for creative stimuli in engineering design. J. Eng. Des. **22**(8), 5665–6581 (2011). https://doi.org/10.1080/09544821003598573

198. Huang, T.-Y.: Fostering creativity: a meta-analytic inquiry into the variability of effects. PhD Dissertation, Texas A&M University (2005)

199. Ku, Y.-L., Lo, C.-H.K., Wang, J.-J., Hsieh, J.L., Chen, K.-M.: The effectiveness of teaching strategies for creativity in a nursing concepts teaching protocol on the creative thinking of two-year RN-BSN students. J. Nurs. Res. **10**(2), 105–111 (2002). https://doi.org/10.1097/01. jnr.0000347589.98025.63

200. Ma, H.-H.: A synthetic analysis of the effectiveness of single components and packages in creativity training programs. Creat. Res. J. **18**(4), 435–446 (2006). https://doi.org/10.1207/s15326934crj1804_3

201. Mansfield, R.S., Busse, T.V., Krepelka, E.J.: The effectiveness of creativity training. Rev. Educ. Res. **48**(4), 517–536, Autumn (1978). doi:https://doi.org/10.2307/1170047

202. Markley, O.W.: Using depth intuition in creative problem solving and strategic innovation. J. Creat. Behav. **22**(2), 85–100, Second Quarter (1988). doi:https://doi.org/10.1002/j.2162-6057.1988.tb00670.x

203. Martindale, C.: Biological bases of creativity. In Handbook of Creativity, R.J. Sternberg (ed.), Cambridge University Press, Cambridge (1999)

204. Mosely, G., Wright, N., Wrigley, C.: Facilitating design thinking: a comparison of design expertise. Think. Skills Creat. **27**, 177–189 (2018). https://doi.org/10.1016/j.tsc.2018.02.004

205. Nickerson, R.S.: Enhancing creativity. In Sternberg (ed.), Handbook of creativity, pp. 392–430, Cambridge University Press (1999)

206. Rose, L.H., Lin, H.-T.: A meta-analysis of long-term creativity training programs. J. Creat. Behav. **18**(1), 11–22 (1984). doi:https://doi.org/10.1002/j.2162-6057.1984.tb00985.x

207. Sadler-Smith, E., Shefy, E.: Developing intuitive awareness in management education. Acad. Manag. Learn. Educ. **6**(2), 186–205 (2007). https://doi.org/10.5465/AMLE.2007.25223458

208. Scott, B., Leritz, L.E., Mumford, M.D.: The effectiveness of creativity training: a quantitative review. Creat. Res. J. **16**(4), 361–388 (2004). https://doi.org/10.1080/10400410409534549

209. Scott, B., Leritz, L.E., Mumford, M.D.: Types of creativity training: approaches and their effectiveness. J. Creat. Behav. **38**(3), 149–179, Third Quarter (2004). doi:https://doi.org/10.1002/j.2162-6057.2004.tb01238.x

210. Vera, D., Crossan, M.: Improvisation and innovation performance in teams. Organiz. Sci. **16**(3), 203–224 (2005). doi:https://doi.org/10.1287/orsc.1050.0126

211. Barrett, J.D., Peterson, C.R., Hester, K.S., Robledo, I.C., Day, E.A., Hougen, D.P., Mumford, M.D.: Thinking about applications: effects of mental models and creative problem-solving. Creat. Res. J. **25**(2), 199–212 (2013). https://doi.org/10.1080/10400419.2013.783758

212. Basadur, M., Wakabayashi, M., Graen, G.B.: Individual problem-solving styles and attitudes toward divergent thinking before and after training. Creat. Res. J. **3**(1), 22–32 (1990). https://doi.org/10.1080/10400419009534331

213. Basadur, M., Graen, G.B., Green, S.G.: Training in creative problem solving: effects on ideation and problem finding and solving in an industrial research organization. Organ. Behav. Hum. Perform. **30**, 41–70 (1982). https://doi.org/10.1016/0030-5073(82)90233-1

214. Ellspermann, S.J., Evans, G.W., Basadur, M.: The impact of training on the formulation of ill-structured problems. Omega **35**, 221–236 (2007). https://doi.org/10.1016/j.omega.2005.05.005

215. Nezu, A., D'Zurilla, T.J.: Effects of problem definition and formulation on the generation of alternatives in the social problem-solving process. Cogn. Ther. Res. **5**(3), 265–271 (1981). https://doi.org/10.1007/BF01193410

216. Osburn, H.K., Mumford, M.D.: Creativity and planning: training interventions to develop creative problem-solving skills. Creat. Res. J. **18**(2), 173–190 (2006). https://doi.org/10.1207/s15326934crj1802_4

217. Runco, M.A., Basadur, M.: Assessing ideational and evaluative skills and creative styles and attitudes. Creat. Innov. Manag. **2**(3), 166–173 (1993). https://doi.org/10.1111/j.1467-8691.1993.tb00088.x

218. Saggar, M., Quintin, E.-M., Bott, N.T., Keinitz, E., Chien, Y.-H., Hong, D.W.-C., Liu, N., Royalty, A., Hawthorne, G., Reiss, A.L.: Changes in brain activation associated with spontaneous improvisation and figural creativity after design-thinking-based training: a longitudinal fMI study. Cereb. Cortex **27**, 3542–3552 (2017). https://doi.org/10.1093/cercor/bhw171

219. Osborn, A.F.: Wake up your mind; 101 Ways to develop creativeness. Scribner, New York (1952)

220. Osborn, A.F.: Applied imagination. Charles Scribner's Sons, New York (1963)

221. Brophy, D.R.: Understanding, measuring, and enhancing individual creative problem-solving efforts. Creat. Res. J. **11**(2), 123–150 (1998). https://doi.org/10.1207/s15326934crj1102_4

222. Firestien, R.L.: Effects of creative problem solving training on communication behaviors in small groups. Small Group Res. **23**(4), 507–521 (1990). https://doi.org/10.1177/1046496490214005

223. Fontenot, N.A.: Effects of training in creativity and creative problem finding upon business people. J. Soc. Psychol. **113**(1), 11–22 (1993). https://doi.org/10.1080/00224545.1993.9712114

224. Isaksen, S.G., Dorval, K.B., Treffinger, D.J.: Creative approaches to problem solving. Sage Publications, Los Angeles (2011)

225. Ray, D.K., Romano, N.C., Jr.: Creative problem solving in GSS groups: do creative styles matter? Group Decis. Negot. **22**, 1129–1157 (2013). https://doi.org/10.1007/s10726-012-9309-3

226. Parnes, S.J.: CPSI—a program for balanced growth. J. Creat. Behav. **9**(1), 23–29 (1975). https://doi.org/10.1002/j.2162-6057.1975.tb00554.x

227. Isaksen, S.G., Treffinger, D.J.: Celebrating 50 years of reflective practice: versions of creative problem solving. J. Creat. Behav. **38**(2), 75–101, Second Quarter (2004). doi:https://doi.org/10.1002/j.2162-6057.2004.tb01234.x

228. Kabanoff, B., Bottger, P.: Effectiveness of creativity training and its relation to selected personality factors. J. Organ. Behav. **12**(3), 235–248 (1991). https://doi.org/10.1002/job.4030120306

229. Puccio, G.J., Wheeler, R.A., Cassandro, V.J.: Reactions to creative problem solving training: does cognitive style make a difference. J. Creat. Behav. **38**(3), 192–216, Third Quarter (2004). doi:https://doi.org/10.1002/j.2162-6057.2004.tb01240.x

230. Puccio, G.J., Firestien, R.L., Coyle, C., Masucci, C.: A review of the effectiveness of cps training: a focus on workplace issues. Creat. Innov. Manag. **15**(1), 19–33 (2006). https://doi.org/10.1111/j.1467-8691.2006.00366.x

231. Puccio, G.J., Murdock, M.C., Mance, M.: Current developments in creative problem solving for organizations: a focus on thinking skills and styles. Korean J. Think. Probl. Solv. **15**(2), 43–76 (2005)

232. Vernon, D., Hocking, I., Tyler, T.C.: An evidence-based review of creative problem solving tools: a practitioner's resource. Hum. Resour. Dev. Rev. **15**(2), 230–259 (2016)

233. Wang, C.-W., Horng, R.-Y.: The effects of creative problem solving training on creativity, cognition type, and R&D performance. R&D Manag. **32**, 35–45 (2002)

234. Gordon, W.J.J.: Synectics. Harper and Row, New York (1961)

235. Gendrop, S.C.: Effect of an intervention in synectics on the creative thinking of nurses. Creat. Res. J. **9**(1), 11–19. doi:https://doi.org/10.1207/s15326934crj0901_2

236. Fink, A., Benedek, M., Koschutnig, K., Pirker, E., Berger, E., Meister, S., Neubauer, A.C., Papousek, I., Weiss, E.M.: Training of verbal creativity modulates brain activity in regions associated with language- and memory-related demands. Hum. Brain Mapp. **36**, 4104–4115 (2015). https://doi.org/10.1002/hbm.22901

237. Fink, A., Grabner, R.H., Benedek, M., Neubauer, A.C.: Divergent thinking training is related to frontal electroencephalogram alpha synchronization. Eur. J. Neurosci. **23**, 2241–2246 (2006). https://doi.org/10.1111/j.1460-9568.2006.04751.x

238. Glover, J.A.: A creativity-training workshop short-term, long-term, and transfer effects. J. Genet. Psychol. **136**(1), 3–16 (1980). https://doi.org/10.1080/00221325.1980.10534091

239. Kowatari, Y., Lee, S.H., Yamamura, H., Nagamori, Y., Levy, P., Yamane, S., Yamamoto, M.: Neural networks involved in artistic creativity. Hum. Brain Mapp. **30**, 1678–1690 (2009). https://doi.org/10.1002/hbm.20633

240. O'Connor, P.J., Gardiner, E., Watson, C.: Learning to relax versus learning to ideate: relaxation-focused creativity training benefits introverts more than extroverts. Think. Skills Creat. **21**, 97–108 (2016). https://doi.org/10.1016/j.tsc.2016.05.008

241. Onarheim, B., Friis-Olavarius, M.: Applying the neuroscience of creativity to creativity training. Front Human Neurosci. **7k**(56), 1–10 (2013). doi:https://doi.org/10.3389/fnhum.2013.00656

242. Wei, D., Yang, J., Li, W., Wang, K., Zhang, Q., Qui, J.: Increased resting functional connectivity of the medial prefrontal cortex in creativity by means of cognitive stimulation. Cortex **51**, 92–102 (2014). https://doi.org/10.1016/j.cortex.2013.09.004

Universal Design Activity: Clarify the Project

<div style="text-align:right">**3**</div>

3.1 Introduction

One of the three universal design activities is to clarify the project. But that takes time and energy. Why not just jump in and get started? But get started doing what? Do we really know what we want our design to be when we have finished? If we are honest with ourselves, we will admit that we really don't know, at least not yet. Vague ideas are merely directions to go; they are not concrete, final designs. This chapter provides guidance on how to clarify any design project. In particular, it looks at the role of the project purpose and constraints (both hard and soft) and why we should take the time to clarify them. Finally, methods for effectively clarifying a project are presented.

3.2 Steps to Clarifying the Project

Sometimes in our hurry and anticipation to get on with our design project we do exactly that. We get on with it, but we do so without proper preparation. It is easy to forget that taking the time to understand what we are doing is part of getting on with it. Whenever we work on a design project, we need to ensure that what we are doing will lead to what we really want. We cannot do this without knowing what we want.

Clarifying our projects, or problem finding as it is sometimes known [1–3], provides a unifying, guiding light to help keep us on track as we move forward with the design process. As stated by Infeld and Einstein:

> The formulation of a problem is often more essential than its solution, which may be merely a matter of mathematical or experimental skill. To raise new questions, new possibilities, to regard old problems from a new angle, requires creative imagination and marks real advances in science [4].

J. Reis, *Advanced Design*, https://doi.org/10.1007/978-3-030-95782-7_3

As stated in A Course in Miracles, we complete our design projects in accordance with what we perceive them to be, not necessarily what they are:

> The value of deciding in advance what you want to happen is simply that you will perceive the situation as a means to make it happen [5].

There are two primary tasks that must be completed as part of clarifying the project:

1. Identify the underlying purpose of the project and
2. Identify the constraints that limit possible solution ideas.

The underlying purpose of a project sets its general direction. The constraints then refine that direction by identifying limits to what would be considered a successful design. The underlying purpose identifies why we are doing the design project, while the constraints narrow the scope of our solution ideas to those that are actually useful for the project.

Many artists make notes or draw thumbnail sketches to help clarify a new project while others do not. Successful artists, however, virtually always take some time to get mental clarity about what they want to do before they begin, even if that clarity has not risen to conscious awareness [6, 7]. This is true even for intuitive painters who rely on improvisation in their designs. Improvisation will be discussed in a later chapter.

Engineers, on the other hand, almost always need to develop formal, written documentation of their underlying purpose and constraints as part of their design process. Engineering design projects tend to be more complex, involve many people working on a team, and have greater risks and consequences of failure. Written documents are often needed to ensure success. Written documents help people communicate more effectively with each other and even serve as a type of design memory [8].

Clarifying a design project is not a one-time activity that occurs at the beginning of a project and then ends. Design is iterative. Successful designers constantly clarify, reclarify, and re-reclarify their projects as designs progress and evolve. It is quite common for a project to change its perceived direction multiple times as it evolves and we better understand what we actually want. Although we do gain clarity as we work through each design iteration, we never actually achieve complete certainty. Design is messy and remains somewhat ambiguous through the very end.

We will now look in more detail at the two parts to clarifying a project: identifying the purpose and the constraints.

3.2.1 Identify the Purpose

The first task in clarifying the project is to identify the purpose. The need for this has been clearly stated in <u>Alice in Wonderland</u>.

"Would you tell me, please, which way I ought to go from here?" asked Alice.

"That depends a good deal on where you want to get to," said the Cat.

"I don't much care where–" said Alice.

"Then it doesn't matter which way you go," said the Cat.

"–so long as I get SOMEWHERE," Alice added as an explanation.

"Oh, you're sure to do that," said the Cat, "if you only walk long enough" [9].

For designers in art, clarity of purpose is necessary for both representational and abstract (non-representational) artists [10–12]. The underlying purpose is normally determined by the artists themselves or by a patron for commissioned work. Identifying the purpose typically involves determining what we want to do with a particular work of art. Asking questions like "what do I want it to say (or not say) with the project before me?", "what excites me about this project?", or 'what emotion or aesthetic do I want to capture on this specific canvas?" helps clarify the purpose. Without a clear purpose or focus, a work of art can actually say nothing at all.

For designers in engineering, the project is normally given to the designer by a supervisor or client. Usually, the initial description does not address the real, underlying issues behind why the design is desired. An engineer is typically only told the symptoms that need to be addressed. Asking questions like "what do I really want the design to do?", "what will be different when the project is complete?", or "what need is not being addressed?" helps clarify the purpose. Without clarity of purpose, an engineer can successfully solve the wrong problem.

3.2.2 Identify the Constraints

The next task in clarifying the project is to identify its constraints. Constraints are limitations that reduce an infinite number of possible solutions to those that will provide a useful solution that satisfies the design purpose. In fact, it is the constraints that define the project by providing structure to its ill-defined nature. Without constraints, design cannot happen.

There are two primary types of constraints: hard and soft constraints.

- Hard constraints are those that must be satisfied for a design to be successful; they are requirements. Normally a design idea either satisfies a hard constraint or it does not. Design ideas that do not satisfy hard constraints result in failed designs, i.e., they are not useful.

- Soft constraints are our preferences for our design outcome. Unlike hard constraints, soft constraints are not judged as either being satisfied or not. They are just preferences. Normally there are multiple soft constraints and they are weighed and balanced against each other when we make design selections. Most soft constraints have some degree of flexibility, although some may be firmer than others.

An example of a hard constraint for artists may be the physical properties of the materials they use. An example of a soft constraint for artists may be how those materials are used to achieve a specific purpose. An example of a hard constraint for engineers may be the compatibility between a new design and existing systems. An example of a soft constraint for engineers may how that compatibility is achieved. Most constraints, ever for engineers, tend to be soft constraints that allow tradeoffs [13].

Some constraints that are common to virtually all designers are time, cost, compatibility, and the balance between originality and usefulness. These constraints may be hard or soft, depending on the specific needs of the project in question.

1. Time: There is virtually always a time constraint, except perhaps for those for whom design is a hobby. Professional designers, i.e., those whose income is generated primarily from design, can only spend a limited amount of time on one project before they must move on to the next one. Designers who work for others are almost always given deadlines for completing their design projects.
2. Cost: There is virtually always a cost constraint. Self-employed designers must balance the costs of materials, studio/office space, supplies, utilities, etc. with the income received from selling their designs. Designers who work for others are almost always given a budget within which they must work.
3. Compatibility: There is virtually always a compatibility constraint. Most designs must be compatible (or at least consistent) with prior designs. Artists need to paint pieces that can be recognized as belonging to a coherent body of work or they will not gain name recognition. Engineers normally design something that must fit within an existing system and infrastructure.
4. Originality or Usefulness: There is virtually always a need to balance originality and usefulness (the twin aspects of creativity). Original designs tend to bring higher rewards, but with higher risks of failure. Useful designs tend to bring lower rewards, but with a lower risk of failure. Extremely original designs, i.e., those that are radically different from any past or existing designs, tend to be rejected in both the art and engineering communities because they lack familiarity. Familiarity as a criterion for judgement will be discussed in a later chapter. On the other hand, designs that focus on usefulness without any originality also tend to be rejected in both communities because they offer no advancement beyond the status quo. The balance between originality and usefulness will be discussed in more detail throughout this book.

3.3 Why Clarify the Project

We have seen that clarifying a project has two major tasks: identifying the purpose and identifying the constraints. Although it takes time to complete these tasks, successful designers have learned through practical experience that there are significant benefits to taking the time to complete them. We will now look at some of those benefits.

Perhaps the most important benefit to identifying the purpose of a design project is to ensure that we create what we want to create or that we solve the right problem [14, 15]. Further, taking the time to clarify the underlying purpose can also result in more creative, original, and higher quality designs [1, 6, 16–33].

Identifying the constraints helps to ensure a successful design. Constraints operate with our design purpose to focus our design ideas to those that are useful. Yet constraints provide much more. Constraints paradoxically not only limit our design options, they also enhance our creativity [34, 35]. Because it is part of our basic nature to desire the freedom to express ourselves, we do not like to be limited. We want the flexibility to grow and thrive. When we are constrained, we use our creativity to seek ways to overcome those constraints. In fact, we can define ourselves as individuals by how we strive to overcome our personal constraints.

Instead of limiting our ability to generate original ideas, constraints can actually enhance that ability. Our creativity is maximized with a moderate number of constraints. Too many or too few constraints, however, particularly hard constraints, can limit our creativity [30, 31, 35–39]. The role of constraints on idea generation will be discussed in greater detail in the following chapter.

Because design projects in art tend to be under-constrained, it is common for artists to add their own (soft) constraints to their project to simulate more ideas. It is actually easier to generate ideas for a painting when there is a random mark on a canvas than if it is blank. An initial random mark on a canvas becomes a seed idea for the next brushstroke. Every time an artist makes a mark on a canvas, it becomes a constraint for the next one. A painting builds up, one stroke (one constraint) at a time [40, 41].

One the other hand, design projects in engineering often tend to be over-constrained. Engineers often need to find ways to stretch the limits of their (soft) constraints, particularly when they seem to be mutually incompatible. It is not unusual for there to be no possible design ideas that satisfy the preferences of all of the soft constraints. In this case, compromises must be made. Hard constraints, however, must always be satisfied [40, 42].

The nature of our constraints can impact how we think. For example,

- If our constraints are framed to maximize originality, then our resulting designs tend to be more original [43–55]. Similarly, if the constraints are framed to maximize usefulness, then our resulting designs tend to be more useful [50, 51, 53].

- If our constraints are framed to maximize the rewards, then our resulting designs tend to be more creative and more original, and if our constraints are framed to minimize risks, then our designs tend to be more conservative and less original [56–59].
- On the other hand, constraints that are framed to maximize originality appear to have a mixed impact on usefulness [50, 52] and those that are framed to maximize usefulness appear to have a mixed impact on originality [50, 60, 61].
- If our constraints are framed to value originality or maximizing rewards, we tend to use our intuitive thinking mode. Conversely, if the constraints are framed to value usefulness and minimizing risk, we tend to use our analytical thinking mode.

It is noted, however, that inconsistent definitions and measures of originality and usefulness used in these different studies bring uncertainty to these observations.

A final benefit to identifying our constraints is to recognize that these constraints can also be used as selection criteria for the universal design activity of selecting one idea to implement [62]. How we use constraints to make our selections will be discussed in a later chapter.

3.4 How Do We Clarify the Project?

Now that we have established that it is worth taking the time to clarify the project by identifying its purpose and constraints, what do we do? Unfortunately, there is no single path forward. There are no well-established or analytical methods for clarifying a project. Design is messy. It is not a logical process that follows a sequential order. All we can do is get started somewhere with anything and then proceed one step (iteration) at a time [27, 40, 63–68].

Because there is no clear, predictable path for clarifying a project, it requires the use of intuition. In this case we use the Intuition of Understanding, one of the types of intuition used in design. We gather what information we can, however we can, and intuitively assimilate it into a broader understanding of what the project is about.

Our understanding of a design project co-evolves as we work through it. Each step, no matter what it is, brings a deeper level of understanding of the project. The key is to just get started by doing something. Even doing something 'wrong' will provide information that we didn't have and bring more clarity. The concept of co-evolving the design purpose with completing the design itself is an integral part of the iterative nature of design. We normally have the best understanding of the purpose of the design project when we have finished it [65, 69–73].

Although there is no clear path for clarifying a project, experience has shown that successful designers take the time and effort to get additional information. Thus, a heuristic for clarifying a design project is "*get more information*". For artists, getting more information may involve more internal retrospection about

what we wish to convey with a particular project. For engineers, getting more information normally involves more external research, including talking with others. The value of getting more information and broadening our perspectives is reflected through changes in our neural networks that open new ways of thinking. Simply getting more information for one design results in neuroplastic changes in the brain that can enhance all future designs [74]. We learn design by practicing design.

There are a number of activities that designers can do to get more information about a design project. They include.

1. Ask Good Questions,
2. Review Other Designs,
3. Visualization,
4. Preliminary Design Iteration.

This list of activities, which is actually a set of heuristics, provides an analytical framework (a prescribed list of steps we can follow) for clarifying the project that we can use in combination with our Intuition of Understanding. Let's now look at each of these activities.

3.4.1 Ask Good Questions

One of the most useful ways to get more information about our design project is to ask good questions. Artists normally get more information by asking themselves questions and engineers normally get more information by asking other people questions [75]. The more questions we ask, particularly if we ask them of multiple external sources, the better our designs tend to be [21, 76, 77].

There are many questions that can be asked when seeking more information. A common list of questions that can be asked includes:

1. Who? Who wants it done? Who are the people involved, who are the stakeholders, who will do the work, who will be affected?
2. What? What must actually be done? What is the emotional (aesthetic) or physical (functional) purpose that is to be addressed? What artistic or engineering tools are available to address this project?
3. Why? Why is this design project to be done? What would happen if it were not done at all?
4. When? When must it be completed? Is there a timeline?
5. Where? Is there a particular location that the design must be completed or installed that has particular constraints?
6. How? How is this project to be conducted?

Another approach is to use the "six men" technique based an ancient parable from India about six blind men. In this story six blind men encounter an elephant.

One touches the truck and declares the elephant to be like a hose. The second touches the tusk and declares the elephant to be like a spear. The third touches an ear and declares that the elephant to be like a fan. The fourth touches a leg and declares the elephant to be like a tree trunk. The fifth touches the side and declares the elephant to be like a wall. The sixth touches the tail and declares the elephant to be like a rope [78]. When clarifying a design project, look at all of its aspects individually and then jointly. Any differences or conflicts point to more questions that can be asked.

Similarly, there are the questions suggested by the 'six hats" technique [79]. In this technique, we are asked to individually try on six different hats. Each hat has a distinct color and emphasizes a different style of thinking based on an aesthetic (emotional) value associated with that color. These hats are:

1. White. This color is often perceived as being neutral or objective. When wearing this hat, we focus on being concerned with objective facts and figures, without attempting any interpretations. With this hat, we consider questions like if something is true or false, or if something is a fact or just an opinion.
2. Red. This color is often perceived as expressing anger, rage and emotion. When wearing this hat, we focus on emotional content and disregard facts. With this hat we consider our hunches. We do not try to justify anything. We just consider our feelings about the matter.
3. Black. This color (or lack of color) is often perceived as expressing gloom and negativity. When wearing this hat, we focus on the negative aspects of why something cannot be done or the negative impact of its failure. With this hat we consider safety and fear, while engaging in critical judgment.
4. Yellow. This color is often perceived as expressing as being sunny and positive. When wearing this hat, we focus on the positive aspects of doing something and its benefits. With this hat, we consider optimism and hope, while engaging in constructive thinking.
5. Green. This color is often perceived as expressing fertility and growth. When wearing this hat, we focus on creativity and change. With this hat, we consider creativity, change, and new ideas.
6. Blue. This color is often perceived as expressing calmness and peace. When wearing this hat, we focus on control and organization of our thinking processes. With this hat we consider stability and balance in our thinking processes.

Other questions that can be asked include "what is stopping us from...?" and "what do we really want to do?" [80]. Many more possible questions for clarifying the purpose of a design project have been proposed in the literature [23, 81–83]. The key is to ask questions that get us thinking in new and different ways. An advantage of asking many questions is that some questions can induce an intuitive thinking mode and some can induce an analytical thinking mode. Asking different types questions can help us maintain a balance between our thinking modes.

3.4.2 Review Other Designs

Another valuable way to get more information about our design project is to review past and present design ideas that relate to the specific design project before us. We can look at those design ideas and identify what was successful and what was unsuccessful relative to our current design project. Knowing why an existing solution may or may not be useful helps us to clarify what we really want from our current design [84–86].

For artists, it could be reviewing their own previous work, a review of art history, or a review of contemporary work, either online or in art galleries or museums. For engineers, it could be a patent and literature search or a site visit to study a related design solution.

3.4.3 Visualization

A third way to get additional information is to create visual models and representations of the design project. Models may be two dimensional sketches and thumbnails, they may be three dimensional prototypes and maquettes, they may be virtual, or they may just be imaginative.

Making models helps us see the design project in a more realistic way, giving us more information about the relationships between the various parts of the design problem. Because models are, by intention, incomplete they provide us with a simplified version of the project. Having a simplified version of the project allows us identify connections and relationships between the different parts of the project more easily. Models allows us to focus on some parts of the design project while not being distracted by other parts. Seeing simplified relationships allows us to identify issues that we may not have otherwise identified. Models also serve as a type of memory, so we do not have to remember all of the details of a project. Finally, models, particularly sketches, can help with communicating our design ideas with others [87–100].

3.4.4 Preliminary Design Iteration

A final method for clarifying a project is to simply conduct a preliminary design cycle. We have already seen that design is iterative: the three universal design activities are repeated many times at different levels over the course of a design project. So just go through a complete design iteration. We can generate a set of ideas based on our current understanding of the project and evaluate them according to our current understanding of the constraints. This process will provide additional information about both the underlying purpose and the constraints. The goal of these preliminary iterations is *not* to identify a final design idea for the project. Instead, the goal is to use the information gained to clarify the project with the understanding that there will be additional rounds of idea generation and selection.

3.5 Closing

The key conclusions of this chapter are.

1. We need to know what the underlying purpose of the design project is so that we can ensure that we are addressing the right need.
2. We need to know the constraints that will be imposed on possible design ideas so that we can ensure that our design will be useful (successful). A useful design is one that addresses the purpose and satisfies the constraints.
3. There are two types of constraints: hard constraints (requirements) that cannot be violated and soft constraints (preferences) that are flexible.
4. Time, cost, compatibility with previous designs, and balancing originality with usefulness are constraints in virtually all design projects.
5. Having a moderate number of constraints can enhance our ability to generate creative ideas relative to no constraints or too many constraints.
6. Taking the time to clarify a project tends to result in better, more original, and more useful design ideas being generated.
7. When our constraints focus on originality, we tend to generate more original ideas. When our constraints focus on usefulness, we tend to generate more useful ideas.
8. Our understanding of the project, including its purpose and constraints, co-evolves as our design progresses. Our best understanding of a project occurs when we stop working on it.
9. We can clarify a project by seeking additional information

 a. through asking good questions,
 b. reviewing solutions to similar design problems,
 c. visualizing potential solutions to the project, and
 d. conducting preliminary design iterations.

3.6 Questions

1. Think about the various design projects that you have worked on. Did you write down or draw a purpose and/or constraints? If you did, did it help? If you didn't, do you think it might have?
2. As an example of clarifying a project, you have been asked to alter the appearance of a tall building. This is a vague and ambiguous project. To clarify the project, you can consider the following questions.

 a. Why is the appearance to be modified? What is the purpose of the modifications? Develop a list of as many reasons as possible why the appearance may need to be modified. Can you develop more than 25 reasons? Can you develop more than 100 reasons?

b. Develop a list of potential hard constraints that an artist might encounter when modifying the appearance. Do the same for an engineer.

c. Develop a list of potential soft constraints for an artist when modifying the appearance. Do the same for an engineer.

d. For your constraints, did you consider what material must be used? Did you consider how the modification is to actually be done? Did you consider how long the modifications are to last? Did you consider safety, environmental considerations, or legal factors? Cost? Time? Color? Texture? Compatibility, including aesthetic compatibility? What other factors might be relevant?

e. With the limited information provided (tall building, change appearance), the above questions are difficult to answer. What questions could you ask to get additional information? Can you develop more than fifty questions from the perspective of an artist? Can you develop more than fifty questions from the perspective of an engineer?

f. Quickly sketch several ideas for altering the appearance of the building from both an artistic and engineering perspective (is there a difference?). Can you use those sketches to generate more questions for clarifying the project (either purpose or constraints)? Repeat the process with 10 more sketches. If you are unable to generate at least 50 sketches, refer to the next chapter.

g. We improve our ability to clarify projects by practicing clarifying projects. How much effort did you actually put into the above exercises? Did you take this opportunity to practice clarifying a project? We learn design by practicing design.

3. Repeat this process for a different project(s).

References

1. Csikszentmihalyi, M., Getzels, J.M.: Concern for discovery: an attitudinal component of creative production. J. Pers. **38**(1), 91–105 (1970). https://doi.org/10.1111/j.1467-6494. 1970.tb00639.x

2. Getzels, J.W. Problem-finding and the inventiveness of solutions. J. Creat. Behav. **9**(1), 12–18 (1975). https://doi.org/10.1002/j.2162-6057.1975.tb00552.x

3. Jay, E.S., Perkins, D.N. Problem finding: the search for mechanism. In: Runco, M.A. (ed.) The Creativity Research Handbook, Vol 1. Hampton Press, Creskill, New Jersey (1997)

4. Einstein, A., Infeld, L. The Evolution of Physics (p. 95). Simon and Schuster, New York (1938)

5. Foundation for Inner Peace, Course in Miracles, 17.VI.4.1, Mill Valley, CA (2007)

6. Getzels, J.W.: Problem finding and the enhancement of creativity. NAASP Bull **69**, 55–61 (1985). https://doi.org/10.1177/019263658506948208

7. Getzels, J.W., Csikszentmihalyi, M.: The Creative Vision: A Longitudinal Study of Problem Finding in Art. John Wiley and Sons, New York (1976)

8. Dixon, G. Experiencing capstone design problem statements. In: Annual Conference and Exhibition, American Society for Engineering Education, AC2012-3039, San Antonio, TX (2012) https://peer.asce.org/21367

9. Carroll, L. Alice in Wonderland. Macmillan (1865)

10. Schmid, R.: Alla Prima II. Stove Prairie Press, Lancaster, PA (2013)

11. van Aalst, J. Kees, Realistic Abstracts. Search Press, Tunbridge Wells, Kent (2013)
12. van Vliet, R.: The Art of Abstract Painting. Search Press, Kent, Great Britain (2012)
13. Jonassen, D., Strobel, J., Lee, C.B.: Everyday problem solving in engineering: lessons for engineering educators. J. Eng. Educ. **95**(2), 139–151 (2006). https://doi.org/10.1002/j.2168-9830.2006.tb00885.x
14. Volkema, R.J. Problem formulation as a purposeful activity. Strateg. Manag. J. **7**(3), 267–279 (1986)
15. Volkema, R.J.: Problem formulation in planning and design. Manage. Sci. **29**(6), 639 (1983). https://doi.org/10.1287/mnsc.29.6.639
16. Adelman, L., Gualtieri, J., Stanford, S.: Examining the effect of causal focus on the option generation process: an experiment using protocol analysis. Organ. Behav. Hum. Decis. Process. **61**(1), 54–66 (1995)
17. Bonnardel, N., Didier, J. Enhancing creativity in an educational design context: an exploration of the effects of design project-oriented methods on students' evocation processes and creative output. J. Cogn. Educ. Psychol. **15**(1) (2016). https://doi.org/10.1891/1945-8959.15.1.80
18. Csikszentmihalyi, M., Getzels, J.M.: Discovery-oriented behavior and the originality of creative products: a study with artists. J. Pers. Soc. Psychol. **19**(1), 47–52 (1971). https://doi.org/10.1037/h0031106
19. Gettys, C.F., Pliske, R.M., Manning, C., Casey, J.T.: An evaluation of human act generation performance. Organ. Behav. Hum. Decis. Process. **39**, 23–51 (1987). https://doi.org/10.1016/0749-5978(87)90044-6
20. Illies, J.J., Reiter-Palmon, R.: The effects of type and level of personal involvement on information search and problem solving. J. Appl. Soc. Psychol. 34(8), 1709–1729 (2004). https://doi.org/10.1111/j.1559-1816.2004.tb02794.x
21. LaBanca, F. Impact of Problem Finding on the Quality of Authentic Open Inquiry Science Research Projects. Doctoral Dissertation, Western Connecticut State University (2008)
22. Ma, H.-H.: The effect size of variables associated with creativity: a meta-analysis. Creat. Res. J. **21**(1), 30–42 (2009). https://doi.org/10.1080/10400410802633400
23. Mumford, M.D., Baughman, W.A., Threlfall, K.V., Supinski, E.P., Constanza, D.P.: Process-based measures of creative problem solving skills: i. problem construction. Creat. Res. J. **9**(1), 63–76 (1996). https://doi.org/10.1207/s15326934crj0901_6
24. Peterson, D.R., Barrett, J.D., Hester, K.S., Robledo, I.C., Hougen, D.F., Day, E.A., Mumford, M.D.: Teaching people to manage constraints: effects on creative problem-solving. Creat. Res. J. **25**(3), 335–347 (2013). https://doi.org/10.1080/10400419.2013.813809
25. Redmond, M.R., Mumford, M.D., Teach, R.: Putting creativity to work: effects of leader behavior on subordinate creativity. Organ. Behav. Hum. Decis. Process. **55**, 120–151 (1993). https://doi.org/10.1006/obhd.1993.1027
26. Reiter-Palmon, R., Mumford, M.D., Threlfall, K.V.: Solving everyday problems creatively: the role of problem construction and personality type. Creat. Res. J. **11**(3), 187–197 (1998). https://doi.org/10.1207/s15326934crj1103_1
27. Reiter-Palmon, R., Mumford, M.D., Boes, J.O., Runco, M.A.: Problem construction and creativity: the role of ability, cue consistency, and active processing. Creat. Res. J. **10**(1), 9–23 (1997). https://doi.org/10.1207/s15326934crj1001_2
28. Rostan, S.M.: Problem finding, problem solving, and cognitive controls: an empirical investigation of critically acclaimed productivity. Creat. Res. J. **7**(2), 97–110 (1994). https://doi.org/10.1080/10400419409534517
29. Runco, M.A., Okuda, S.M.: Problem discovery, divergent thinking, and the creative process. J. Youth Adolesc. **17**(3), 211–220 (1988). https://doi.org/10.1007/BF01538162
30. Sagiv, L., Arieli, S., Goldenberg, J., Goldschmidt, A.: Structure And freedom in creativity: the interplay between externally imposed structure and personal cognitive style. J. Organ. Behav. **31**(8), 1086–1110 (2010). https://doi.org/10.1002/job.664

31. Stokes, P.D.: Using constraints to generate and sustain novelty. Psychol. Aesthet. Creat. Arts **1**(2), 107–113 (2007). https://doi.org/10.1037/1931-3896.1.2.107
32. Suwa, M.: Constructive perception: coordinating perception and conception toward acts of problem-finding in a creative experience. Jpn. Psychol. Res. **45**(4), 221–234 (2003). https://doi.org/10.1111/1468-5884.00227
33. Valkenburg, R., Dorst, K.: The reflective practice of design teams. Des. Stud. **19**, 249–271 (1998). https://doi.org/10.1016/S0142-694X(98)00011-8
34. Rassouli, A. The Book of Creativity (p. 113). Blue Angel Publishing, Victoria, Australia (2016)
35. Onarheim, B.: Creativity from constraints in engineering design: lessons learned at coloplast. J. Eng. Des. **23**(4), 323–336 (2012). https://doi.org/10.1080/09544828.2011.631904
36. Medeiros, K.E., Partlow, P.J., Mumford, M.D.: Not too much, not too little: the influence of constraints on creative problem solving. Psychol. Aesthet. Creat. Arts **8**(2), 198–210 (2014). https://doi.org/10.1037/a0036210
37. Stokes, P.D. Creativity from constraints: what can we learn from motherwell? from madrain? from klee? J. Creat. Behav. **42**(4), 223–236 (2008). https://doi.org/10.1002/j.2162-6057.2008.tb01297.x
38. Stokes, P.D.: Creativity From Constraints: The Psychology of Breakthrough. Springer Publishing Company, New York (2006)
39. Stokes, P.D., Harrison, H.M. Constraints have different concurrent effects and aftereffects on variability. J. Exp. Psychol. Gen. **131**(4), 552–566 (2002). https://doi.org/10.1037//0096-3445.131.4.552
40. Stacey, M., Eckert, C.: Reshaping the box: creative designing as constraint management. Int. J. Prod. Dev. **11**(3/4), 241–255 (2010). https://doi.org/10.1504/IJPD.2010.033960
41. Yokochi, S., Okada, T.: Creative cognition process of art making: a field study of a traditional chinese ink painter. Creat. Res. J. **17**(2–3), 241–255 (2005). https://doi.org/10.1080/10400419.2005.951482
42. Eckert, C.M., Stacey, M., Wyatt, D., Garthwaite, P.: Change as little as possible: creativity in design by modification. J. Eng. Des. **23**(4), 337–360 (2012). https://doi.org/10.1080/09544828.2011.639299
43. Chand, I., Runco, M.A.: Problem finding skills as components in the creative process. Pers. Individ. Differ. **14**(1), 155–162 (1993). https://doi.org/10.1016/0191-8869(93)90185-6
44. Chen, C., Kasof, J., Himsel, A., Dmitrieva, J., Dong, Q., Xue, G. Effects of explicit instruction to 'be creative' across domains and cultures. J. Creat. Behav. **39**(2), 89–110 (2005). https://doi.org/10.1002/j.2162-6057.2005.tb01252.x
45. Friedman, R.S.: Reinvestigating the effects of promised reward on creativity. Creat. Res. J. **2**(2–3), 258–264 (2009). https://doi.org/10.1080/10400410902861380
46. Gillebaart, M., Förster, J., Rotteveel, M., Jehle, A.C.M.: Unraveling effects of novelty on creativity. Creat. Res. J. **25**(3), 280–285 (2013). https://doi.org/10.1080/10400419.2013.813781
47. Green, A.E., Cohen, M.S., Raab, H.A., Yedibalian, C.G., Gray, J.R.: Frontopolar activity and connectivity support dynamic conscious augmentation of creative state. Hum. Brain Mapp. **36**, 923–934 (2015). https://doi.org/10.1002/hbm.22676
48. Green, A.E., Cohen, M.S., Kim, J.U., Gray, J.R.: An explicit cue improves creative analogical reasoning. Intelligence **40**, 598–603 (2012). https://doi.org/10.1016/j.intell.2012.08.005
49. Nusbaum, E.C., Silvia, P.J., Beaty, R.E.: Ready, set, create: what instructing people to 'be creative' reveals about the meaning and mechanisms of divergent thinking. Psychol. Aesthet. Creat. Arts **8**(4), 423–432 (2014). https://doi.org/10.1037/a0036549
50. Manske, M.E., Davis, G.A.: Effects of simple instructional biases upon performance in the unusual uses test. J. Gen. Psychol. **79**(1), 25–33 (1968). https://doi.org/10.1080/00221309.1968.9710449

51. O'Hara, L.A., Sternberg, R.J.: It doesn't hurt to ask: effects of instructions to be creative, practical, or analytical on essay-writing performance and their interaction with students' thinking styles. Creat. Res. J. **13**(2), 197–210 (2001). https://doi.org/10.1207/S15326934crj1302_7

52. Paulus, P.B., Kohn, N.W., Arditti, L.E. Effects of quantity and quality instructions on brainstorming. J. Creat. Behav. **45**(1), 38–46 (2011). https://doi.org/10.1002/j.2162-6057.2011.tb01083.x

53. Runco, M.A., Illies, J.J., Eisenman, R. Creativity, originality, and appropriateness: what do explicit instructions tell us about their relationships. J. Creat. Behav. **39**(2), 137–148 (2005). https://doi.org/10.1002/j.2162-6057.2005.tb01255.x

54. Runco, M.A., Okuda, S.M.: The instructional enhancement of the flexibility and originality scores of divergent thinking tests. Appl. Cogn. Psychol. **5**, 435–441 (1991). https://doi.org/10.1002/acp.2350050505

55. Weinberger, A.B., Iyer, H., Green, A.E. Conscious augmentation of creative state enhances 'real' creativity in open-ended analogical reasoning. PLOS One, e0150773, 1–13 (2016). https://doi.org/10.1371/journal.pone.0150773

56. Arts, J.W.C., Frambach, R.T., Bijmolt, T.H.A.: Generalizations on consumer innovation adoption: a meta-analysis on drivers of intention and behavoir. Int. J. Res. Mark. **28**, 134–144 (2011). https://doi.org/10.1016/j.ijresmar.2010.11.002

57. Ford, C.M., Gioia, D.A.: Factors influencing creativity in the domain of managerial decision making. J. Manag. **26**(4), 705–732 (2000). https://doi.org/10.1177/014920630002600406

58. Kareev, Y., Avrahami, J., Fiedler, K.: Strategic interactions, affective reactions, and fast adaptations. J. Exp. Psychol. Gen. **143**(3), 1112–1126 (2014). https://doi.org/10.1037/a0034641

59. Toh, C.A., Miller, S.R.: Creativity in design teams: the influence of personality traits and risk attitudes on creative concept selection. Res. Eng. Design **27**, 73–89 (2016). https://doi.org/10.1007/s00163-015-0207-y

60. Dennis, A.R., Minas, R.K., Bhagwatwar, A.P.: Sparking creativity: improving electronic brainstorming with individual cognitive priming. J. Manag. Inf. Syst. **29**(4), 195–216 (2013). https://doi.org/10.2753/MIS0742-1222290407

61. Mueller, J.S., Melwani, S., Goncalo, J.A.: The bias against creativity: Why people desire but reject creative ideas. Psychol. Sci. **23**(1), 13–17 (2012). https://doi.org/10.1177/0956797611421018

62. Bettman, J.R., Sujan, M.: Effects of Framing on evaluation of comparable and noncomparable alternatives by expert and novice consumers. J. Consum. Res. **14**(2), 141–154 (1987). https://doi.org/10.1086/209102

63. Adams, J.L.: Conceptual Blockbusting: A Guide to Better Ideas. Norton and Company, New York (1979)

64. Brown, T.: Change by Design: How Design Thinking Transforms Organizations and Inspires Innovation. HarperCollins, New York (2009)

65. Guindon, R.: Knowledge exploited by experts during software system design. Int. J. Man Mach. Stud. **33**, 279–304 (1990). https://doi.org/10.1016/S0020-7373(05)80120-8

66. Harfield, S.: On design 'problematization': theorizing differences in designed outcomes. Des. Stud. **28**(2), 159–173 (2007). https://doi.org/10.1016/j.destud.2006.11.005

67. Mumford, M.D., Reiter-Palmon, R., Redmond, M.R. Problem construction and cognition: applying problem representations in Ill-defined domains. In: Runco, M.A. (ed.) Problem Finding, Problem solving, and Creativity. Ablex Publishing Corporation, Norwood, New Jersey (1994)

68. Mumford, M.D., Mobley, M.I., Reiter-Palmon, R., Uhlman, C.E., Doares, L.M.: Process analytic models of creative capacities. Creat. Res. J. **4**(2), 91–122 (1991). https://doi.org/10.1080/104004190954380

69. Dorst, K., Cross, N.: Creativity in the design process: co-evolution of problem-solution. Des. Stud. **22**, 425–437 (2001). https://doi.org/10.1016/S0142-694X(01)00009-6

70. Maher, M.L., Tang, H.-H.: Co-evolution as a computational and cognitive model of design. Res. Eng. Des. **14**, 47–63 (2003). https://doi.org/10.1007/s00163-002-0016-y

71. Suwa, M., Gero, J., Purcell, T.: Unexpected discoveries and S-invention of design requirements: important vehicles for a design process. Des. Stud. **21**, 539–567 (2000). https://doi.org/10.1016/S0142-694X(99)00034-4

72. Visser, W.: More or less following a plan during design: opportunistic deviations in specifications. Int. J. Man Mach. Stud. **33**, 247–278 (1990). https://doi.org/10.1016/S0020-7373(05)80119-1

73. Wiltschnig, S., Christensen, B.T., Ball, L.J.: Collaborative problem-solution co-evolution in creative design. Des. Stud. **34**, 515–542 (2013). https://doi.org/10.1016/j.destud.2013.01.002

74. Dandan, T., Wenfu, L., Tianen, D., Nusbaum, H.C., Jiang, Q., Qinglin, Z.: Brain mechanisms of valuable scientific problem finding inspired by heuristic knowledge. Exp. Brain Res. **228**, 437–443 (2013). https://doi.org/10.1007/s00221-013-3575-4

75. Csikszentmihalyi, M.: Creativity: Flow and the Psychology of Discovery and Invention. HarperCollins Publishers, New York (1996)

76. Harvey, N., Fischer, I.: Taking advice: accepting help, improving judgment, and sharing responsibility. Organ. Behav. Hum. Decis. Process. **70**(2), 117–133 (1997). https://doi.org/10.1006/obhd.1997.2697

77. Mohedas, I., Daly, S., Sienko, K.H. Requirements development: approaches and behaviors of novice designers. J. Mech. Des. **137**, 071407-1–071407-10 (2015). https://doi.org/10.1115/1.4030058

78. Six Blind Men and the Elephant, ancient parable from Indian subcontinent

79. De Bono, E. Six Thinking Hats. Little, Brown, and Company, Boston (1985)

80. Ellspermann, S.J., Evans, G.W., Basadur, M.: The impact of training on the formulation of ill-structured problems. Omega **35**, 221–236 (2007). https://doi.org/10.1016/j.omega.2005.05.005

81. Dieter, G.E.: Engineering Design: A Material and Processing Approach. McGraw-Hill, New York (2000)

82. Pugh, S.: Total Design: Integrated Methods for Successful Product Engineering. Addison-Wesley, New York (1991)

83. Stokes, P.D., Fisher, D.: Selection, constraints, and creativity case studies: Max Beckmann and Philip Guston. Creat. Res. J. **17**(2–3), 283–291 (2005). https://doi.org/10.1207/s15326934crj1702&3_13

84. Benami, O., Jin, Y. Creative stimulation in conceptual design. In: Proceedings of the DETC'02 ASME 2002 Design Engineering Technical Conferences and Computer and Information in Engineering Conference, Montreal, Canada, Sept 29–Oct 2 2002. https://doi.org/10.1115/DETC2002/DTM-34023

85. Ellis, S., Davidi, I.: After-event reviews: drawing lessons from successful and failed experience. J. Appl. Psychol. **90**(5), 857–871 (2005). https://doi.org/10.1037/0021-9010.90.5.857

86. Ong, L.S., Leung, A.K.-Y.: Opening the creative mind of high need for cognitive closure individuals through activation of uncreative ideas. Creat. Res. J. **25**(3), 286–292 (2013). https://doi.org/10.1080/10400419.2013.813791

87. Eckert, C., Blackwell, A., Stacey, M., Earl, C., Church, L.: Sketching across design domains: roles and formalities. Artif. Intell. Eng. Des. Anal. Manuf. **26**(3), 245–266 (2012). https://doi.org/10.1017/S0890060412000133

88. Hoover, S.P., Rinderle, J.R., Finger, S.: Models and abstractions in design. Des. Stud. **12**(4), 237–245 (1991). https://doi.org/10.1016/0142-694X(91)90039-Y

89. Kokotovich, V., Purcell, T.: Mental synthesis and creativity in design: an experimental examination. Des. Stud. **21**, 437–449 (2000). https://doi.org/10.1016/S0142-694X(00)00017-X

90. Lemons, G., Carberry, A., Swan, C., Rogers, C., Jarvin, L.: The Benefits of model building in teaching engineering design. Des. Stud. **31**, 288–309 (2010). https://doi.org/10.1016/j.destud.2010.02.001
91. Lim, Y.K., Stolterman, E., Tenenberg, J. The anatomy of prototypes: prototypes as filters, prototypes as manifestations of design ideas. ACM Trans. Comput. Hum. Interacti. **15**(2), 1–27 (2008) (Article 7) https://doi.org/10.1145/1375761.1375762
92. Purcell, A.T., Gero, J.S.: Drawings and the design process. Des. Stud. **19**, 389–430 (1998). https://doi.org/10.1016/S0142-694X(98)00015-5
93. Ramduny-Ellis, D., Dix, A., Evans, M., Hare, J., Gill, S.: Physicality in design: an exploration. Des. J. **13**(1), 48–76 (2010). https://doi.org/10.2752/146069210X12580336766365
94. Römer, A., Weisshahn, G., Hacker, W., Pache, M., Lindemann, U.: Effort-saving product representations in design–results of a questionnaire survey. Des. Stud. **22**, 473–491 (2001). https://doi.org/10.1016/S0142-694X(01)00003-5
95. Simonton, D.K.: The creative process in picasso's *Guernica* sketches: monotonic improvements verses nonmonotonic variants. Creat. Res. J. **19**(4), 329–344 (2007). https://doi.org/10.1080/10400410701753291
96. Suwa, M., Purcell, T., Gero, J.: Macroscopic analysis of design processes based on a scheme for coding designers' cognitive actions. Des. Stud. **19**, 455–483 (1998). https://doi.org/10.1016/S0142-694X(98)00016-7
97. Suwa. M., Tversky, B. What architects see in their sketches: implications for design tools. In: Conference Companion on Human Factors in Computing Systems of CHI 96, Vancouver, BC (1996)
98. Tovey, M., Porter, S., Newman, R.: Sketching, concept development and automotive design. Des. Stud. **24**, 135–153 (2003). https://doi.org/10.1145/257089.257255
99. Van Der Lugt, R.: How sketching can affect the idea generation process in design group meetings. Des. Stud. **26**, 101–122 (2005). https://doi.org/10.1016/j.destud.2004.08.003
100. Yang, M.C.: A study of prototypes, design activity, and design outcome. Des. Stud. **26**, 649–669 (2005). https://doi.org/10.1016/j.destud.2005.04.005

Universal Design Activity: Generate Ideas

4

4.1 Introduction

Another one of the universal design activities is to generate ideas. Generating ideas is also known as ideation. So, how do we actually generate ideas? Where do ideas come from? How do we recognize when we have a new idea? Do we even have ideas? What are ideas? These are not trivial questions! There are many different opinions, perspectives, and beliefs regarding these questions. Some of them are even true. This chapter will review some of the ways we can generate ideas for design. It starts with the critical role of intuitive thought in idea generation and then discusses how to use seed ideas to expand our intuition. It closes by looking at design fixation and ways to overcome it.

4.2 Getting Started with Idea Generation

As designers, we are quite good at generating ideas. We normally generate many hundreds of ideas over the course of a design project, if not more. So, how do we actually do it? The literature is filled with suggestions for how we can generate ideas. One review of the literature identified 172 different methods [1].

One source of ideas is to make unexpected connections between existing ideas. We take two (or more) existing ideas and combine them in a new way. We can enhance our ability to make such connections by having more stuff stored in our memories that can be combined. Perhaps the simplest way to expanding our memories is to increase the depth, breadth, and diversity of our life experiences. Be curious. The more exposure we have had to a variety of experiences, the more things we have stored in our memories. The more things we have stored in our memories, the more potential connections we can make when are generating ideas [2–9]. Yet the question still remains: how do we actually generate ideas? How do we make those unexpected connections? What do we actually do?

© The Author(s), under exclusive license to Springer Nature Switzerland AG 2022
J. Reis, *Advanced Design*, https://doi.org/10.1007/978-3-030-95782-7_4

One way to start idea generation is to take advantage of the structured nature of design. We can decompose our design into a hierarchy of higher-level needs and lower-level needs. We can focus on ideas for the higher-level needs first and defer developing ideas for the lower-level needs until a later time. Similarly, we can decompose our design into individual parts and separately generate ideas for each part before combining the parts into a comprehensive whole. Of course, decomposition adds a compatibility constraint to that requires each individual idea to work with the others when combined.

An extreme form of decomposition is morphological analysis. Morphological analysis consists of decomposing a design problem into all of its relevant components or attributes (which are rarely, if ever, known), identifying all possible variations for each of those components or attributes (which are also rarely known), and then systematically considering all possible combinations of those individual variations to create the unified overall design. This method can generate hundreds, if not thousands, of design ideas. Unfortunately, the process of keeping track these ideas and then later evaluating them is extremely time consuming and difficult. As a result, complete morphological analysis has limited practical use in any discipline.

Although making new connections and decomposing a design project into smaller parts can help us with idea generation, the question still remains: how do we generate ideas? What do we actually do?

4.3 Intuition

Ultimately, all idea generation involves intuition. It is a natural human process. We just put our attention on generating ideas and they come. They even come without putting our attention on them. It is really that easy. The type of intuition used to generate ideas is the Intuition of Generating Ideas, one of the three types of intuition used in design. We don't really know how it works, but it works very well.

As we have already seen, intuition is very different from analytical thought. We can't predict our next thought or idea when we use intuition. Intuition does not operate under our mental control. In fact, intuition is more effective when we relax our mental control and just let it happen. Intuition involves a playful attitude of curiosity. Our intuition thrives in the silence of the heart instead of the noise of the mind. We nurture our intuition to generate ideas.

Most of us are familiar with our use of intuition to generate ideas through the process of brainstorming. Although brainstorming was first envisioned as a method for groups to generate ideas [10], the process has been widely extended to include individual idea generation. Brainstorming consists of letting ideas come into our awareness without judgment. We let our attention wander with only a gentle focus on the purpose of our design. This process automatically generates ideas that may (or may not) be relevant to our project. Our goal is to come up with as many ideas as we can without making any judgment about them. Quantity is preferred over

quality. Quality is just an ambiguous combination of originality and usefulness (as is creativity). Go for quantity at this stage of the design process!

Wild and crazy ideas are just as valuable as any other ideas during brainstorming and should actually be encouraged. Wild and crazy ideas may not, in themselves, be useful, but they may lead to better ideas during a later design cycle. One example of a wild and crazy idea leading to a good idea comes from solving a problem in the logging industry. In inaccessible areas, it is often not possible to build logging roads to extract cut logs. Heli-logging, the use of a helicopter to extract logs from inaccessible areas, was invented during a brainstorming session. One frustrated person reportedly suggested to have little green men from Mars come and remove the trees where roads could not be built. Although that may not have happened yet, the idea of Martians lifting logs for us did lead to the idea of using helicopters and blimps to lift the logs. Thus, heli-logging was born from a wild and crazy idea [11].

So how do we use our intuition to generate ideas? We cannot force ourselves to generate ideas, but we can induce an intuitive thinking mode that allows ideas to come to us. One of the simplest ways to induce intuition is to immerse ourselves in activities that do not require analytical thinking, particularly activities that we enjoy. Go have some fun! Pay attention to your mode of thinking as you engage in different types of activities (metacognition) and learn to recognize which activities induce an intuitive mode. Some additional things we might do include becoming unfocused, outrageous, or impulsive, look for beauty, seek ideas that are not rational or logical, or act in ways that appear stupid to break a mental mold [12]. A simple internet search will provide many additional methods for entering an intuitive thinking mode.

When using our intuition, the first ideas that come to mind tend to be those that we are most familiar with or are easiest to recall from memory. Those first ideas, however, tend to be less original than later ideas with which we have less familiarity or are more difficult to generate [13]. This means that we need to continue using our intuition to generate ideas after the initial, easy period of idea generation has passed. This normally results in the better ideas for our designs.

When we generate ideas, we should defer any judgement or evaluation of them until we later engage in the universal design activity of selecting one idea for implementation. Premature judgment of ideas is perhaps the most common reason for design failure [14–16]. Some common statements associated with premature judgments include "we've never done it before" or "we've tried that before", "it won't work" or "it'll mean more work for us", and "all right in theory but can you put it into practice?" [17] Statements such as these hinder idea generation by inducing an analytical mode of thinking. They can be important factors to consider, but not when we are generating ideas. Set such issues aside until a more appropriate time (idea selection). Go for quantity without judgment!

Sometimes we intuitively know that an idea will not work (is not useful) without making any judgments. We just know. This occurs when we use our Intuition of Judgment, one of the types of intuition used in design. Because this type of intuition does not necessarily involve entering into an analytical mode of thinking, it does not necessarily hinder idea generation. The key is for us to not act mentally on that

judgment, i.e., not shift into an analytical mode of thinking. We simply acknowledge that our intuition has judged the idea, set that judgment aside until a later time, keep that idea as a possibility, and continue generating ideas without prejudice. We address such ideas during the selection process.

4.4 Seeding Ideas

As powerful as our intuition is, we will eventually run out of ideas. Our intuition can only take us so far. We have already seen that our intuition is influenced by the context in which we use it. We can expand the range of our intuition (and resulting idea generation) by giving it a new context within which to work. We can seek inspiration for new ideas. We can do this by seeding our intuition with new ideas that are outside of our current area of thinking (called by some the design space). Seed ideas add a new context (new inspiration) for our intuition and open it to new directions.

Seed ideas paradoxically serve as constraints to our thinking while simultaneously expanding our thinking. They constrain our thinking by focusing our attention on the seed idea. They expand our thinking by providing new contexts for our intuition to operate.

Seed ideas are most effective for enhancing idea generation when we use many of them. Because each seed idea is a constraint that limits our thinking around it, each seed idea will allow us to generate only a limited number of new ideas. When we use multiple seed ideas, however, the combined result can be a significantly expanded list of ideas. The key to using multiple seed ideas is to consider them one at a time. Gently focus on one seed and let our intuition develop ideas without judgment. Then mentally put that seed aside and move on to the next seed. When we consider seed ideas separately, we are able to generate more ideas then when we consider them simultaneously [18–23].

There are many ways to create seed ideas to enhance idea generation. These methods often use analytical (systematic) processes. Some of the most commonly used ones are discussed in the following sections. Even morphological analysis, albeit in a simplified form, can be used to create seed ideas.

4.4.1 Seed Ideas from Clarifying the Project

One good source of seed ideas is to repeat the same processes that we used as we clarified the project, only do it with the focus of generating more ideas.

During the process of clarifying our project we obtained information to help us better understand our design project. We can use each piece of information as a seed idea. We can gently and intuitively consider new ideas in the context of that information. Some examples include:

- The same questions we asked to gather more information can be used as seed ideas. Both the six men and the six hats methods (introduced in Chap. 3) have been shown to be effective in enhancing idea generation [24].
- We can use other designs as seed ideas. We can identify why other designs may not be useful for our current project and generate ideas about how those designs can be modified to become useful. We can also identify why other designs may be useful and generate ideas about how we can better adapt them for our current project.
- The visualizations we created can also be used as seed ideas. These visualizations, such as sketches, thumbnails, prototypes, maquettes, etc., allow us to better see how elements of the design relate to each other. When we recognize those relationships, it enables us to generate even more ideas [25–39].
- Finally, the preliminary design iterations we conducted to clarify the project can also be used to generate more ideas. We can consider what we learned as we went through each design cycle and ask why those preliminary ideas may or may not be useful. By considering possible modifications to those preliminary ideas, we can generate even more ideas.

A related approach to identifying seed ideas involves using our project constraints. We can reflect on each constraint, one at a time, as a seed idea. For example, the four domain-general constraints introduced in the previous chapter can be used as seed ideas: time, cost, compatibility, and balancing originality and usefulness.

- If we have a constraint of time, we can consider ways to shorten the time to complete the design or ways to extend the design period.
- If we have a constraint of cost, we can consider cost cutting or resource adding measures.
- If we have a constraint of compatibility, we can consider which parts of the design must actually be compatible and which parts may not have to be.
- If we have a constraint balancing originality and usefulness, we can separately consider ways to separately enhance (or reduce) originality and/or usefulness.

Gently considering our constraints can provide new directions for our intuition to generate ideas.

Of course, the process of generating ideas by reflecting on what we learned from clarifying our project will also result in an enhanced clarity of the project. We can then use that enhanced clarity as a basis for a new round of idea generation. Design is iterative. Clarifying the project enhances idea generation. Idea generation enhances clarity of the project. Virtually everything we do moves our design forward. We iterate back and forth among the three universal design activities until we finish the project.

4.4.2 Seed Ideas From Heuristics (Rules of Thumb)

Another very useful source of seed ideas is to apply heuristics to identify possible modifications to existing ideas. Heuristics are rules of thumb (patterns) that have been developed through relevant experiences. We learn from experience what has been successful and what has not. Over time, these experiences get codified into heuristics that guide our thinking. Because heuristics are based on prior experience, many tend to be domain-specific; heuristics applicable for art design tend to not be applicable for engineering design and vice versa. Heuristics as a source of seed ideas tend to be externally-based, i.e., they are based on external observations. The heuristics themselves involve analytical thought to generate seed ideas because they reflect an identifiable pattern. Once a seed has been identified from a heuristic, however, we return to using our intuition to actually generate new ideas using that seed.

Let's now look at some commonly used heuristics (domain-specific) for artists and engineers.

4.4.2.1 Heuristics for Artists

Heuristics for artists are most commonly known as the rules of art. They are simply rules of thumb that have been developed to help distinguish between successful designs and unsuccessful designs. These rules appear in different forms and are provided in many art books.

Perhaps the simplest heuristic for artists to generate ideas is to consider the two primary errors in art: including something that should not be there and omitting something that should be there [40]. This heuristic is simply to look at a piece of art and identify what could be added and what could be deleted relative to its purpose.

Another commonly used heuristic for visual arts like painting is to modify the level of contrast that exists within it. This is important because we tend to focus our attention on areas of greatest contrast. Contrast is what makes a painting interesting. We maximize contrast among the elements of the painting that we want emphasized and we minimize contrast elsewhere. We determined which elements we want emphasized during the process of clarifying the project. Some common ways to alter the contrast within a painting can be summarized with the acronym: VVCLiST (Vocalist).

- Value: Value is a measure of how light or dark the various parts of a painting are.
- Variety: Variety is having the various elements of a painting look similar to or different from each other.
- Color: Color is the hue (as measured by its primary wavelength), saturation or purity (how much it is mixed with other colors), and value (how much black or white is mixed with the color).
- Line: Lines are the one-dimensional, quasi-linear features or interfaces between shapes (edges) that guide the eye around the painting.
- Shape: Shapes are areas that are visually different from adjacent areas.
- Texture: Texture is the subtle (or not subtle) variations within a shape.

We can use each of these elements for controlling contrast as seed ideas for generating new ideas. In fact, these elements could be used together in a simple form of morphological analysis for artists (although few artists would actually do it).

4.4.2.2 Heuristics for Engineers

Heuristics for engineers tend to be based on standardized methods to modify physical things.

One of the simplest set of heuristics for this is the SCAMPER method [41, 42]. SCAMPER is an acronym for:

- Substitute: Can something be replaced by something else?
- Combine: Can some things be combined with others?
- Adjust: can something be adjusted within the design?
- Modify/Magnify: Can the something be modified, such as through an increase in size?
- Purpose: Can the design be used for another purpose?
- Eliminate/Minify: Can something be eliminated or decreased in size?
- Reverse/Rearrange: Can the project be reversed or assembled in a different order or way?

To use SCAMPER, apply each of the above heuristics as a seed idea, one at a time, to the elements of an existing (and unsatisfactory) design.

A related, but much more extensive, set of heuristics to generate ideas is called Design Heuristics. The number of heuristics in this set varies up to 77, depending upon the version [43–51]. Examples of some of the Design Heuristics include.

1. Change where and how a product will be used.
2. Apply the design in a new way.
3. Create modular units.
4. Adjust functions to fit a different purpose.
5. Refocus on the core function of the product.

A more complex approach to generating ideas is the TRIZ method. TRIZ is a Russian language acronym for Theory of Solution of Inventive Problems [52, 53]. The heuristics of TRIZ were developed from studying thousands of patents to identify patterns within them. The TRIZ method involves four basic steps:

1. Identify the specific problem with an existing design and state it in terms of a contradiction or conflict between constraints.
2. Identify the corresponding generalized TRIZ principle associated with this contradiction.
3. Identify the generalized action associated with the generalized TRIZ principle,
4. Adapt the generalized solution to the specific problem.

About 40 generalized principles in which a conflict can occur have been identified. Four of these principles along with their associated generalized actions are provided here as examples:

1. Principle of Fragmentation (decompose the object into smaller parts)
2. Principle of Removal (remove a part that doesn't work in new design)
3. Principle of Asymmetry (change the symmetry of the object)
4. Principle of Joining (join parts together in a different way).

Although TRIZ has evolved over time, it is still very complex and tends to require training to be useful.

All of these heuristics can be used for seed ideas to simulate our intuition into generating more ideas.

4.4.3 Seed Ideas From Analogies

A third source of seed ideas is to use analogies. Analogies work by finding solutions to similar types of problems from other areas and adapting them to our current design project [54–58].

There are two basic types of analogies: near (strong) analogies that are based on obvious, surface, visual, or domain-specific features and distant (weak) analogies that are based on subtle, structural, functional, or domain-general features. Distant analogies are more abstracted than near analogies.

Examples of near and distant analogies for artists working on a painting of a favorite dog might be to look at images of wolves (near analogy) or to include elements in the painting that evoke the similar emotions, such as pictures of a favored grandparent (distant analogy). Examples of near and distant analogies for engineers working on the next generation interface for wearable electronic devices might be a way to adapt current types of non-wearable device interfaces, such as keyboard or neural feedback systems, (near analogy) or identifying ways in which other animals communicate with each other (distant analogy). Both near and distant analogies can play a role in generating ideas, but the use of distant analogies tends to generate more original but fewer ideas than the use of near analogies [56, 59–66].

One commonly-used source of analogies is to observe nature. We need only look at existing, natural solutions to find seed ideas for our design problem. Looking for biological analogies is called biomimicry [67–69]. For example, if an artist wishes to paint the emotion of freedom, that person can look at how nature expresses freedom, such as flying birds, leaping dear, or an open sky. If a structural engineer is tasked with designing a safer building in an area prone to earthquakes, that person can find analogous solutions by looking at how nature has solved the same problem for trees.

Using biologically inspired analogies is the basis of the heuristics of the SAPPhIRE method [70, 71]. SAPPhIRE is an acronym for.

- State, what are the physical components and interfaces between the current design and its environment?
- Action, how does the current design interact with the environment?
- Part, what parts of the current system interact with the environment?
- Phenomenon, what is the nature of that interaction?
- Input, what actually crosses the interface between the design and its environment?
- oRgan, what properties of the design and its environment are needed for that interaction?
- Effect, what actually occurs during the interaction?

Other heuristics based on analogies include WordTree, and Synectics. WordTree involves identifying word descriptors of the problem and then finding analogous words to those descriptors [72, 73]. Synectics involves considering different types of analogies: [74]

- Personal analogies in which we imagine that we are physically inside the problem,
- Direct analogies in which we compare parallel facts, function, or technology,
- Symbolic analogies in which we use objective and impersonal images to describe the problem, and
- Fantasy analogies in which we solve the problem by using our wildest imagination (logging with little green men).

A critical step in using analogies to generate ideas is to identify how concepts in other domains can be linked to our current design project [75–77]. Our ability to identify such concepts depends upon our level of experience both within our discipline and in the unrelated disciplines from which we may identify analogies [30, 78, 79]. Again, we return to the idea that broad life experiences enhance our ability to generate ideas.

All of these methods can be effective in seeding our intuition to generate more ideas.

4.4.4 Seed Ideas From Randomness

A final way to generate seed ideas is simply to consider any random word, activity, or object as our seed idea. It is not unusual for artists to make random marks on a canvas to which they can respond (generate ideas using their intuition). Engineers can also use randomness, but often use a more structured approach.

One widely used method for generating random seed ideas is metaphors [80, 81]. Metaphors are a connection between two unrelated ideas through a common abstract association. Some commonly used metaphors used by designers include "*form follows function*", coined by architect Louis Henry, and "*less is more*", coined by architect Ludwig Mies van der Rohe. Another metaphor appeared in the

movie Forrest Gump: "*life is a box of chocolates*." The abstract association between life and chocolates is that you never know what you are going to get.

One difficulty with using such metaphors to generate ideas, however, is that it may be difficult to see how they relate to our current design project. They may or may not be relevant. So, where do we get metaphors that are relevant to our specific design project?

Perhaps the best way to get relevant metaphors is to generate our own. One way to do this by considering how any random word might be abstractly linked to our design.

- A metaphor for an artist wanting to paint how light and shadow play across a field might be: 'the shadows are like a boxing ring', where boxing ring is simply a random idea. What ideas does a boxing ring generate? Dancing? Violence? Parallel lines? Square geometry? Considering how these ideas relate to painting shadows can help generate more ideas.
- A metaphor for an engineer wanting to build a new device might be: 'the new device is like a ruby', where the ruby is simply a random word. What ideas does a ruby generate? Color? Beauty? Cost? Piezo-electric properties? Considering how these ideas relate to the new device can help generate more ideas.

We do not even need to be consciously aware of how our random seed ideas relate to our design to generate ideas. We do not need to consciously recognize the metaphor. Just putting a new random word or idea into our attention provides a new context for our intuition to generate ideas [82–84]. Commercial software can also be used to provide random seeds based on either generic external information or domain-specific internal information [85–88].

The value of random seeds for aiding idea generation is supported by neurological studies of brain activation. Different regions are activated and deactivated when we are exposed to new ideas, even if we are not aware of it [89, 90].

4.5 Design Fixation

As we have seen, our intuition can be influenced by the context in which we use it. Although this can enhance our ability to generate ideas, it can also limit it. If we are stuck in a particular context and don't do anything to change that context, we tend to only generate ideas within that context. This process, called design fixation, limits our ability to generate original ideas outside of our current area of thinking. Design fixation can occur in all design disciplines and can even be observed in the neural behavior of our brains [91].

Design fixation tends to occur in the following conditions:

- We are exposed to ideas that do not broaden our thinking to new areas. Such non-broadening ideas include those that are highly relevant to our design project (such as examples of similar designs) or common ideas with which we already have familiarity [4, 92–99].
- Our design project is framed in a way that does not expand our thinking into new areas. Such limiting framing includes minimizing risk instead of maximizing reward, emphasizing craftsmanship or usefulness, considering constraints simultaneously instead of sequentially, and focusing on meeting the expectations of others (how others will judge or evaluate us) [100–106].
- We have expended considerable time, effort, and/or cost into an idea and want to minimize the loss of those sunken costs [107, 108].

Both experts and novices can experience design fixation. Experts tend to become fixated when they rely on past experience instead of deliberately generating new ideas [109–114]. Novices tend to become fixated because they lack a broad range of experience from which to draw new ideas [105, 112, 115, 116].

Fortunately, design fixation can be relatively easy to overcome, particularly if we are aware that we may be fixated. We simply change the context of our thinking. We deliberately explore new ideas. We can seek more information from others (such as through design briefings or art critiques), we can engage in more visualization, prototyping, and testing activities, we can reorganize our thoughts both visually and verbally, we can reframe our project through adding constraints to avoid specific problems from existing ideas, or we can expand our use of seed ideas [4, 96, 100, 116–123].

4.6 Effectiveness of Idea Generating Methods

Many different methods for enhancing our ability to generate ideas have been presented here. Studies have shown that all of these methods can work and that no single method is clearly superior to the others. All methods are effective in some circumstances and less effective in others. As long as our range of thinking is expanded, virtually anything we do tends to enhance idea generation [24, 50, 51, 124–137]. Not only do these methods work individually, they can be even more effective when multiple methods are used (sequentially) [51, 138]. It is noted that artists often spend only a few seconds or minutes to generate many of their ideas and rarely take the time to use multiple idea generation methods. Engineers, on the other hand, may spend days or longer to generate their ideas and can often take the time to use multiple methods.

Although the goal of the universal design activity of idea generation is to generate a lot of ideas, that is really not our ultimate goal as designers. We really do not want a lot of ideas that will eventually be discarded; what we want is one really good idea that we can use.

Fortunately, the methods described above are not only effective in generating a lot of ideas, they also tend to be effective in generating good ideas (along with a lot of bad ones). Although the relationship between quantity and quality of ideas is very complex, quantity does tend to result in quality. We will still need to screen the good ideas from bad ones during the universal design activity of selecting one idea, but quantity does help to ensure that we will have some good ones to consider [14, 16, 123, 132, 136, 137, 139–144].

Go for quantity! If you can't generate over one hundred ideas for a design project, try easier!

4.7 Closing

The key conclusions from this chapter are.

1. Complex projects can often be decomposed into smaller projects that can be more easily addressed. These smaller projects can then be combined into an overall design, as long as the smaller project designs are compatible with each other.
2. People with broader life experiences are better at generating ideas.
3. Idea generation is based primarily on intuition.
4. Idea generation is most effective when we defer making judgments about our ideas until a later time.
5. We can enhance our ability to generate ideas with seed ideas. Seed ideas can focus our attention (and intuition) in new directions.
6. Using seed ideas is most effective when we consider them individually and not simultaneously.
7. Sources of seed ideas include the methods we used to clarifying the project, heuristics, analogies, and even random ideas.
8. We can become fixated on one idea and not be able to think of anything else. This is called design fixation. Design fixation can be overcome by deliberately thinking outside of the scope of our fixation. We just provide a new context for our intuition.
9. All of the methods discussed for generating ideas have been shown to be effective, particularly when multiple methods are used. No single method has been shown to be clearly superior to the others.
10. Quantity in idea generation tends to result in quality of ideas. The more ideas we generate, the more likely we will generate some good ideas (along with a lot of bad ones).

4.8 Questions

1. What methods do you use to generate ideas?
2. When you generate ideas, do you stop when you think you have a good one or do you defer judgment and continue generating ideas?
3. How do you keep track of your ideas? Do you write them down, draw them, or just rely on memory? Do you forget your ideas?
4. How do you keep from prematurely judging ideas?
5. How do you enhance your intuition for idea generation?
6. For the design project of modifying the appearance of a tall building introduced in the previous chapter:

 a. How many ideas can you generate using your intuition?
 b. How many additional ideas can you generate by separately considering each of the activities you used to clarify the project in the previous chapter?
 c. What heuristics might you use to generate ideas? How many ideas can you generate with them?
 d. What analogies might you use to generate ideas? How many ideas can you generate with them?
 e. How many additional ideas can you generate using metaphors? Pick some random words and ask "Changing the appearance of this building is like (insert random word here). How many different random words does it take until you run out of ideas, time, or interest? Three? Ten? Five hundred?
 f. How many total ideas did you generate? People fluent in idea generation should have no problem generating many hundreds of ideas for virtually any design project. Most of them will not be useful, but that is not relevant during the universal design activity of idea generation. Go for quantity.
 g. How many ideas did you actually generate with this exercise? Did you take the time to practice any of these methods? We learn design by practicing design. To reprogram our neural networks, we must practice the change we want to happen.
 h. While working on this (or any) design project, did you experience design fixation? What did you do to overcome it?

7. Which idea generation methods do you find most useful? Why? Which methods do you find least useful? Why? Does the effectiveness of a particular idea generation method depend upon the type of design project? How?
8. How can you apply these methods for idea generation to a design project of your own choosing?

References

1. Smith, G.F.: Idea-generation techniques: a formulary of active ingredients. J. Creat. Behav. **32**(2), 107–133, Second Quarter (1998). doi:https://doi.org/10.1002/j.2162-6057.1998. tb00810.x
2. Clapham, M.M.: The effects of affect manipulation and information exposure on divergent thinking. Creat. Res. J. **13**(3–4), 335–350 (2001). https://doi.org/10.1207/ s15326934crj1334_11
3. Dugosh, K.L., Paulus, P.B.: Cognitive and social comparison process in brainstorming. J. Exp. Soc. Psychol. **41**, 313–320 (2005). https://doi.org/10.1016/j.jesp.2004.05.009
4. Dugosh, K.L., Paulus, P.B., Roland, E.J., Yang, H.-C.: Cognitive stimulation in brainstorming. J. Pers. Soc. Psychol. **79**(5), 722–735 (2000). https://doi.org/10.1037// 0022-3514.79.5.722
5. Goncalves, M., Cardoso, C., Badke-Schaub, P.: How far is too far? Using different levels in textual and visual stimuli. International Design Conference, Design 2012, Dubrovnik-Croatia, May 21–24, (2012)
6. Kassim, H., Nicholas, H., Ng, W.: Using a multimedia learning tool to improve creative performance. Think. Skills Creat. **13**, 9–19 (2014). https://doi.org/10.1016/j.tsc.2014.02.004
7. Lopez-Mesa, B., Mulet, E., Vidal, R., Thompson, G.: Effects of additional stimuli on idea-finding in design teams. J. Eng. Des. **22**(1), 34–54 (2011). https://doi.org/10.1080/ 09544820902911366
8. Malaga, R.A.: The effect of stimulus modes and associative distance in individual creativity support systems. Decis. Support Syst. **29**, 125–141 (2000). https://doi.org/10.1016/S0167-9236(00)00067-1
9. Nemeth, C.J., Kwan, J.L.: Minority influence, divergent thinking and detection of correct solutions. J. Appl. Soc. Psychol. **17**(9), 788–799 (1987). https://doi.org/10.1111/j.1559-1816.1987.tb00339.x
10. Osborn, A.F.: Applied imagination. Charles Scribner's Sons, New York (1953)
11. Holtzapple, M.T., Reece, W.D.: Concepts in engineering. McGraw Hill, New York (2005)
12. Finke, R.A., Bettle, J.: Chaotic cognition: principles and applications. Lawrence Erlbaum Associates, Mahwah, New Jersey (1996)
13. Ward, T.B., Patterson, M.J., Sifonis, C.M., Dodds, R.A., Saunders, K.N.: The role of graded category structure in imaginative thought. Mem. Cognit. **30**(2), 199–216 (2002). https://doi. org/10.3758/BF03195281
14. Basadur, M., Runco, M.A., Vega, L.A.: Understanding how creative thinking skills, attitudes, and behaviors work together: a causal process model. J. Creat. Behav. **34**(2), 77–100, Second Quarter (2000). doi:https://doi.org/10.1002/j.2162-6057.2000.tb01203.x
15. Basadur, M., Ellspermann, S.J., Evans, G.W.: A new methodology for formulating Ill-structured problems. OMEGA Int. J. Manag. Sci. **22**(6), 627–645 (1994). https://doi.org/ 10.1016/0305-0483(94)90053-1
16. Kudrowitz, B.M., Wallace, D.: Assessing the quality of ideas from prolific, early-stage product ideation. J. Eng. Des. **24**(2), 120–139 (2013). https://doi.org/10.1080/09544828. 2012.676633
17. Davis, G.A.: Creativity is forever. Kendall/Hunt Publishing Company, Dubuque (1986)
18. Butler, A.B., Scherer, L.L.: The effects of elicitation aids, knowledge, and problem content on option quantity and quality. Organ. Behav. Hum. Decis. Process. **72**(2), 184–202 (1997). https://doi.org/10.1006/obhd.1997.2737
19. Butler, A.B., Scherer, L.L., Reiter-Palmon, R.: Effects of solution elicitation aids and need for cognition on the generation of solutions to Ill-structured problems. Creat. Res. J. **15**(2 & 3), 235–244 (2003). https://doi.org/10.1080/10400419.2003.9651415
20. Coskun, J., Paulus, P.B., Brown, B., Sherwood, J.J.: Cognitive stimulation and problem presentation in idea-generating groups. Group Dyn. Theory Res. Pract. **4**(4), 307–329 (2000). https://doi.org/10.1037/1089-2699.4.4.307

21. Dennis, A.R., Valacich, J.S., Connolly, T., Wynne, B.E.: Process structuring in electronic brainstorming. Inf. Syst. Res. **7**(2), 268–277 (1996). https://doi.org/10.1287/isre.7.2.268
22. Horr, N.K., Braun, C., Zander, T., Volz, K.G.: Timing matters! The neural signature of intuitive judgments differs according to the way information is presented. Consci. Cognit. **38**, 71–87, 201. doi:https://doi.org/10.1016/j.concog.2015.10.0085
23. Yagolkovskiy, S.R., Kharkhurin, A.V.: The roles of rarity and organization of stimulus material in divergent thinking. Think. Skills Creat. **22**, 14–21 (2016). https://doi.org/10.1016/j.tsc.2016.08.001
24. Vernon, D., Hocking, I.: Thinking hats and good men: structured techniques in a problem construction task. Think. Skills Creat **14**, 41–46 (2014). https://doi.org/10.1016/j.tsc.2014.07.001
25. Anderson, R.E., Helstrup, T.: Visual discovery in mind and on paper. Mem. Cognit. **21**(3), 283–293 (1993). https://doi.org/10.3758/BF03208261
26. Anderson, R.E., Helstrup, T.: Multiple perspectives on discovery and creativity in mind and on paper. In Roskos-Ewoldson, B., Intons-Peterson, M.J., Anderson, R.E. (Eds.), Imagery, creativity, and discovery: a cognitive perspective, Elsevier (1993)
27. Athavankar, U.A.: Mental imagery as a design tool. Cybern. Syst. **28**, 25–41 (1997). https://doi.org/10.1080/019697297126236
28. Bilda, Z., Gero, J.S.: The impact of working memory limitations on the design process during conceptualization. Des. Stud. **28**, 343–367 (2007). https://doi.org/10.1016/j.destud.2007.02.005
29. Bilda, Z., Gero, J.S., Purcell, T.: To sketch or not to sketch? That is the question. Des. Stud. **27**, 587–613 (2006). https://doi.org/10.1016/j.destud.2006.02.002
30. Casakin, H., Goldschmidt, G.: Expertise and the use of visual analogy: implications for design education. Des. Stud. **20**, 153–175 (1999). https://doi.org/10.1016/S0142-694X(98)00032-5
31. Finke, R.A., Ward, T.B., Smith, S.M.: Creative cognition, theory, research, and applications. MIT Press, Cambridge, MA (1992)
32. Goldschmidt, G.: Serial sketching: visual problem solving in designing. Cybernet. Syst. Int. J. **23**, 191–219 (1992). https://doi.org/10.1080/01969729208927457
33. Lemons, G., Carberry, A., Swan, C., Rogers, C., Jarvin, L.: The benefits of model building in teaching engineering design. Des. Stud. **31**, 288–309 (2010). https://doi.org/10.1016/j.destud.2010.02.001
34. Mumford, M.D., Hester, K.S., Robledo, I.C., Peterson, D.R, Day, E.A., Hougen, D.F., Barrett, J.D.: Mental models and creative problem-solving: the relationship of objective and subjective model attributes. Creat. Res. J. **24**(4), 311–330, (2012). doi:https://doi.org/10.1080/10400419.2012.730008
35. Palmiero, M., Nori, R., Piccardi, L.: Visualizer cognitive style enhances visual creativity. Neurosci. Lett. **615**, 98–101 (2016). https://doi.org/10.1016/j.neulet.2016.01.032
36. Schutze, M., Sachse, P., Romer, A.: Support value of sketching in the design process. Res. Eng. Design **14**, 89–97 (2003). https://doi.org/10.1007/s00163-002-0028-7
37. Song, S., Agogino, A.M.: Insights on designers' sketching activities in new product design teams. Proceedings of the DETC'04 ASME 2004 Design Engineering Technical Conferences and Computers and Information in Engineering Conference, Salt Lake City, Utah, DETC2004–57474, Sept. 28-Oct. 2 (2004). doi:https://doi.org/10.1115/DETC2004-57474
38. Verstijnen, I.M., Hennessey, J.M., van Leeuwen, C., Hamel, R., Goldschmidt, G.: Sketching and creative discovery. Des. Stud. **19**, 519–546 (1998)
39. Yang, M.C.: Concept generation and sketching: correlations with design outcomes. In Proceedings of DETC 2003 2003 Design Engineering Technical Conferences, DETC2003/DTM-48677, Chicago, Il, Sept. 206 (2003). doi:https://doi.org/10.1016/S0142-694X(98)00017-9
40. Schmid, R.: Alla prima II. Stove Prairie Press, Lancaster, PA (2013)

41. Eberle, R.F.: Developing imagination through scamper. J. Creat. Behav. **6**(3), Third Quarter (1972). doi:https://doi.org/10.1002/j.2162-6057.1972.tb00929.x

42. Eberle, B.: Scamper. Prufrock Press, Waco, TX (2008)

43. Daly, S.R., Yilmaz, S., Christian, J.L., Seifert, C.M., Gonzalez, R.: Design heuristics in engineering concept generation. J. Eng. Educ. **101**(4), 601–629 (2012). https://doi.org/10.1002/j.2168-9830.2012.tb01121.x

44. Daly, S., Yilmaz, S., Seifert, C., Gonzalez, R.: Cognitive heuristic use in engineering ideation. In Proceedings of the AC210–1032 Annual Conference of the American Society for Engineering Education, Louisville, Ky, (2010). doi:https://doi.org/10.18260/1-2–16280

45. Murphy, L., Daly, S.R., Yilmaz, S., Seifert, C.M.: Supporting novice engineers in idea generation using design heuristics. Am. Soc. Eng. Educ. Paper 19008, (2017). doi:https://doi.org/10.18260/1-2–28887

46. Yilmaz, S., Seifert, C., Daly, S.R., Gonzalez, R.: Design heuristics in innovative products. J. Mechan. Des. **138**, 071102–1 to 071102–12 (2016). doi:https://doi.org/10.1115/1.4032219

47. Yilmaz, S., Daly, S.R., Seifert, C.M., Gonzalez, R.: Evidence-based design heuristics for idea generation. Des. Stud. **46**, 95–124 (2016). https://doi.org/10.1016/j.destud.2016.05.001

48. Yilmaz, S., Daly, S.R., Christian, J.L., Seifert, C.M., Gonzalez, R.: Can experienced designers learn from new tools? A case study of idea generation in a professional engineering team. Int. J. Des. Creat. Innov. **2**(2), 82–96 (2014). https://doi.org/10.1080/21650349.2013.832016

49. Yilmaz, S., Christian, J.L., Daly, S.R., Seifert, C.M., Gonzalez, R.: Idea generation in collaborative settings. In Proceedings of the International Conference on Engineering and Product Design Education, City University, London, UK, Sept. 8–9 (2011)

50. Yilmaz, S., Daly, S.R., Seifert, C.M., Gonzalez, R.: How do designers generate new ideas? Design heuristics across two disciplines. Des. Sci. **1**(E4), 1–19 (2015). https://doi.org/10.1017/dsj.2015.4

51. Yilmaz, S., Seifert, C.N.: Creativity through design heuristics: a case study of expert product design. Des. Stud. **32**(4) (2011). doi:https://doi.org/10.1016/j.destud.2011.01.003

52. Altshuller, G.: And suddenly the inventor appeared: TRIZ the theory of inventive problem solving. Technical Innovation Center, Inc., Worcester, MA (2004)

53. Altschuller, G.: Creativity as an exact science: the theory of the solution of inventive problems. Gordon and Breach Science Publishers, New York (1984)

54. Clement, J.: Observed methods for generating analogies in scientific problem solving. Cognit. Sci. **12**, 563–586 (1988). doi:https://doi.org/10.1016/0364-0213(88)90013-4

55. Dreistadt, R.: The use of analogies and incubation in obtaining insights in creative problem solving. J. Psychol. **71**(2), 159–175 (1969). https://doi.org/10.1080/00223980.1969.10543082

56. Linsey, J.S., Laux, J., Clauss, E.F., Wood, K.L., Markman, A.B.: Effects of analogous product representation on design-by-analogy. International Conference on Engineering Design, ICED'07, August 28–31 (2007)

57. Novick, L.R.: Representational transfer in problem solving. Psychol. Sci. **1**(2), 128–132 (1990). https://doi.org/10.1111/j.1467-9280.1990.tb00081.x

58. Tseng, I., Moss, J., Cagan, J., Kotovsky, K.: The role of timing and analogical similarity in the stimulation of idea generation in design. Des. Stud. **29**, 203–221 (2008). https://doi.org/10.1016/j.destud.2008.01.003

59. Christensen, B.T., Schunn, C.D.: The relationship of analogical distance to analogical function and preinventive structure: the case of engineering design. Memory Cogn. **35**(1), 29–38 (2007). doi:https://doi.org/10.3758/BF03195939

60. Clement, C.A., Mawby, R., Giles, D.E.: The effects of manifest relational similarity on analog retrieval. J. Mem. Lang. **33**, 396–420 (1994). https://doi.org/10.1006/jmla.1994.1019

61. Dahl, D.W., Moreau, P.: The influence and value of analogical thinking during new product ideation. J. Mark. Res. **39**(1), 47–60 (2002). https://doi.org/10.1509/jmkr.39.1.47.18930

62. Gassmann, O., Zeschky, M.: Opening up the solution spade: the role of analogical thinking for breakthrough product innovation. Creat. Innov. Manag. **17**(2), 97–106 (2008). https://doi.org/10.1111/j.1467-8691.2008.00475.x

63. Hender, J.M., Dean, D.L., Rodgers, T.L., Nunamaker, J.F., Jr.: An examination of the impact of stimuli type and GSS structure on creativity: brainstorming versus non-brainstorming techniques in a GSS environment. J. Manag. Inform. Syst. **18**(4), 59–85, Spring (2002). doi:https://doi.org/10.1080/07421222.2002.11045705

64. Holyoak, K.J., Koh, K.: Surface and structural similarity in analogical transfer. Memory Cogn. **15**(4), 3332–3340 (1987). doi:https://doi.org/10.3758/BF03197035

65. Keane, M.: On retrieving analogues when solving problems. Quart. J. Experim. Psychol. Sect. A **39**(1), 29–41. doi:https://doi.org/10.1080/02724988743000015

66. Linsey, J.S., Wood, K.L., Markman, A.B.: Modality and representation in analogy. Artif. Intell. Eng. Des. Anal. Manuf. **22**, 85–100 (2008). https://doi.org/10.1017/S0890060408000061

67. Helms, M., Vattan, S.S., Goel, A.K.: Biologically inspired design: process and products. Des. Stud. **30**, 606–622 (2009). https://doi.org/10.1016/j.destud.2009.04.003

68. Vattam, S.S., Helms, M.E., Goel, A.K.: A content account of creative analogies in biologically inspired design. Artif. Intell. Eng. Des. Anal. Manuf. **24**, 467–481 (2010). https://doi.org/10.1017/S089006041000034X

69. Wilson, J.O., Rosen, D., Nelson, B.A., Yen, J.: The effects of biological examples in idea generation. Des. Stud. **31**, 169–186 (2010). https://doi.org/10.1016/j.destud.2009.10.003

70. Sartori, J., Pal, U., Chakrabarti, A.: A methodology for supporting 'transfer' in biomimetic design. Artif. Intell. Eng. Des. Anal. Manuf. **24**, 483–505 (2010). https://doi.org/10.1017/S0890060410000351

71. Chakrabarti, A., Sarkar, P., Leelavathamma, B., Nataraju, B.S.: A Functional representation for aiding biomimetic and artificial inspiration of new ideas. Artif. Intell. Eng. Des. Anal. Manuf. **19**, 113–132 (2005). https://doi.org/10.1017/S0890060405050109

72. Linsey, J.S., Markman, A.B., Wood, K.L.: Design by analogy: a study of the wordtree method for problem re-representation. J. Mechan. Des. **134**, 041009–1 to 041009–12 (2012). doi:https://doi.org/10.1115/1.4006145

73. Linsey, J.S., Wood, K.L., Markman, A.B.: Increasing innovation: presentation and evaluation of the wordtree design-by-analogy method. In Proceedings of the ASME-2008 International Design Engineering Technical Conference and Computers and Information in Engineering Conference, IDETC/CIE 2008, Brooklyn, New York, Aug. 3–6 (2008)

74. Gordon, W.J.J.: Synectics. Harper and Row Publishers, New York, The Development of Creative Capacity (1961)

75. Anolli, L., Antonietti, A., Crisafulli, L., Cantoia, M.: Accessing source information I analogical problem-solving. Quart. J. Exper. Psychol. Sect. A **54**(1), 237–261 (2001). https://doi.org/10.1080/02724980042000093

76. Gick, M.L., Holyoak, K.J.: Schema induction and analogical transfer. Cogn. Psychol. **15**, 1–38 (1983). https://doi.org/10.1016/0010-0285(83)90002-6

77. Gick, M.L., Holyoak, K.J.: Analogical problem solving. Cogn. Psychol. **12**, 306–355 (1980). https://doi.org/10.1016/0010-0285(80)90013-4

78. Ahmed, S., Christensen, B.T.: An In-Situ study of analogical reasoning in novice and experienced design engineers. J. Mechan. Des. **131**, 111004–1 to 111004–9 (2009). doi:https://doi.org/10.1115/1.3184693

79. Novick, L.R.: Analogical transfer, problem similarity, and expertise. J. Exp. Psychol. Learn. Mem. Cogn. **14**(3), 510–520 (1988). https://doi.org/10.1037//0278-7393.14.3.510

80. Casakin, H.P.: Assessing the use of metaphors in the design process. Environ. Plann. B. Plann. Des. **33**, 253–268 (2006). https://doi.org/10.1068/b3196

81. Hey, J., Linsey, J., Agogino, A.M., Wood, K.L.: Analogies and metaphors in creative design. Int. J. Eng. Educ. **24**(2), 283–294 (2008)

82. Goldschmidt, G., Sever, A.L.: Inspiring design ideas with texts. Des. Stud. **32**, 139–155 (2011). https://doi.org/10.1016/j.destud.2010.09.006
83. Goldschmidt, G., Smolkov, M.: Variances in the impact of visual stimuli on design problem solving performance. Des. Stud. **27**, 549–569 (2006). https://doi.org/10.1016/j.destud.2006.01.002
84. Howard-Jones, P.A., Murray, S.: Ideational productivity, focus of attention, and context. Creat. Res. J. **15**(2–3), 153–166 (2003). https://doi.org/10.1080/10400419.2003.9651409
85. Benedek, M., Fink, A., Neubauer, A.C.: Enhancement of ideational fluency by means of computer-based training. Creat. Res. J. **18**(6), 317–328 (2006). https://doi.org/10.1207/s15326934crj1803_7
86. Howard, T.J., Culley, S., Dekoninck, E.A.: Reuse of ideas and concepts for creative stimuli in engineering design. J. Eng. Des. **22**(8), 5665–6581 (2011). https://doi.org/10.1080/09544821003598573
87. MacCrimmon, K.R., Wagner, C.: Stimulating ideas through creativity software. Manage. Sci. **40**(11), 1514–1532 (1994). https://doi.org/10.1287/mnsc.40.11.1514
88. Massetti, B.: An empirical examination of the value of creativity support systems on idea generation. MIS Q. **20**(1), 83–97 (1996). https://doi.org/10.2307/249543
89. Fink, A., Koschutnig, K., Benedek, M., Reishofer, G., Ischebeck, A., Weiss, E.M., Ebner, F.: Stimulating creativity via the exposure to other people's ideas. Hum. Brain Mapp. **33**, 2603–2610 (2012). https://doi.org/10.1002/hbm.21387
90. Fink, A., Grabner, R.H., Gebaur, D., Reishofer, G., Koschutnig, K., Ebner, F.: Enhancing creativity by means of cognitive stimulation: evidence from an fMRI study. Neuroimage **52**, 1687–1695 (2010). https://doi.org/10.1016/j.neuroimage.2010.05.072
91. Fu, K., Sylcott, B., Das, K.: Using fMRI to deepen our understanding of design fixation. Des. Sci. **5**(e22), 1–31 (2019). doi:https://doi.org/10.1017/dsj.2019.21
92. Agogue, M., Kazakci, A., Hatchuel, A., Masson, P.L., Weil, B., Poirel, N., Cassotti, M.: The impact of type of examples on originality: explaining fixatino and stimulation effects. J. Creat. Behav. **48**(1), 1–12 (2013). https://doi.org/10.1002/jocb.37
93. Bonnardel, N., Marmeche, E.: Evocation processes by novice and expert designers: towards stimulating analogical thinking. Creat. Innov. Manag. **13**(3), 176–186 (2004). https://doi.org/10.1111/j.0963-1690.2004.00307.x
94. Marsh, R.L., Bink, M.L., Hicks, J.L.: Conceptual priming in a generative problem-solving task. Mem. Cognit. **27**(2), 355–363 (1999). https://doi.org/10.3758/bf03211419
95. Nijstad, B.A., Stroebe, W., Lodewijkx, H.F.M.: Cognitive stimulation and interference in groups: exposure effects in and idea generation task. J. Exp. Soc. Psychol. **38**, 535–544 (2002). https://doi.org/10.1016/S0022-1031(02)00500-0
96. Perttula, M., Sipila, P.: The idea exposure paradigm in design idea generation. J. Eng. Des. **18**(1), 93–102 (2007). https://doi.org/10.1080/09544820600679679
97. Rook, L., van Knippenberg, D.: Creativity and imitation: effects of regulatory focus and creative exemplar quality. Creat. Res. J. **23**(4), 346–356 (2011). https://doi.org/10.1080/10400419.2011.621844
98. Sherman, S.J., Mackie, D.M., Driscoll, D.M.: Priming and the differential use of dimensions in evaluation. Pers. Soc. Psychol. Bull. **16**(3), 405–418 (1990). https://doi.org/10.1177/0146167290163001
99. Sio, U.N., Kotovsky, K., Cagan. J.: Fixation or inspiration? A meta-analytic review of the role of examples on design processes. Des. Stud. **39**, 70–99 (2015). doi:https://doi.org/10.1016/j.destud.2015.04.004
100. Crilly, N.: Fixation and creativity in concept development: the attitudes and practices of expert designers. Des. Stud. **38**, 54–91 (2015). https://doi.org/10.1016/j.destud.2015.01.002
101. Csikszentmihalyi, M., Getzels, J.M.: Discovery-oriented behavior and the originality of creative products: a study with artists. J. Pers. Soc. Psychol. **19**(1), 47–52 (1971). https://doi.org/10.1037/h0031106

102. Csikszentmihalyi, M., Getzels, J.M.: Concern for discovery: an attitudinal component of creative production. J. Pers. **38**(1), 91–105 (1970). https://doi.org/10.1111/j.1467-6494.1970.tb00639.x

103. Getzels, J.W.: Problem finding and the enhancement of creativity. NAASP Bull. **69**, 55–61 (1985). https://doi.org/10.1177/019263658506948208

104. Getzels, J.W., Csikszentmihalyi, M.: The creative vision: a longitudinal study of problem finding in art. John Wiley and Sons, New York (1976)

105. Smith, S.M., Ward, T.B., Schumacher, J.S.: Constraining effects of examples in a creative generation task. Mem. Cognit. **21**(6), 837–845 (1993). https://doi.org/10.3758/BF03202751

106. Ward, T.B., Patterson, M.J., Sifonis, C.M.: The role of specificity and abstraction in creative idea generation. Creat. Res. J. **16**(1), 109 (2004). https://doi.org/10.1207/s15326934crj1601_1

107. Arkes, H.R., Blumer, C.: The psychology of sunk cost. Organ. Behav. Hum. Decis. Process. **35**, 124–140 (1985). https://doi.org/10.1016/0749-5978(85)90049-4

108. Viswanathan, V.K., Linsey, J.S.: Role of sunk cost in engineering idea generation: an experimental investigation. J. Mechan. Des. **135**, 121002–1 through 121002–12 (2013). doi: https://doi.org/10.1115/1.4025290

109. Besnard, D., Bastien-Toniazzo, M.: Expert error in trouble-shooting: an exploratory study in electronics. Int. J. Hum Comput Stud. **50**, 391–405 (1999). https://doi.org/10.1006/ijhc.1999.0251

110. Choudhry, N.K., Fletcher, R.H., Soumerai, S.B.: Systematic review: the relationship between clinical experience and quality of health care. Ann. Int. Med. **142**(4), 260–273 (2005). doi:https://doi.org/10.7326/0003-4819-142-4-200502150-00008

111. Cross, N.: Expertise in design: an overview. Des. Stud. **25**, 427–441 (2004). https://doi.org/10.1016/j.destud.2004.06.002

112. Jansson, D.G., Smith, S.M.: Design fixation. Des. Stud. **12**(1), 3–11 (1991). https://doi.org/10.1016/0142-694X(91)90003-F

113. Kim, J., Ryu, H.: A design thinking rationality framework: framing and solving design problems in early concept generation. Human-Comp. Inter. **29**, 516–553 (2014). https://doi.org/10.1080/07370024.2014.896706

114. Marchant, G., Robinson, J., Anderson, U., Schadewald, M.: Analogical transfer and expertise in legal reasoning. Organ. Behav. Hum. Decis. Process. **48**, 272–290 (1991). https://doi.org/10.1016/0749-5978(91)90015-L

115. Purcell, A.T., Gero, J.S.: Design and other types of fixation. Des. Stud. **17**, 363–383 (1996). https://doi.org/10.1016/S0142-694X(96)00023-3

116. Viswanathan, V., Atilola, O., Esposito, N., Linsey, J.: A study on the role of physical models in the mitigation of design fixation. J. Eng. Des. **25**(1–3), 25–43 (2014). https://doi.org/10.1080/09544828.2014.885934

117. Chrysikou, E.G., Weisberg, R.W.: Following the wrong footsteps: fixation effects of pictorial examples in a design problem-solving task. J. Exp. Psychol. Learn. Mem. Cogn. **31**(5), 1134–1148 (2005). https://doi.org/10.1037/0278-7393.31.5.1134

118. Howard, T.J., Maier, A.M., Onarheim, B., Friis-Olivarius, M.: Overcoming design fixation through education and creativity methods. In Proceedings of the International Conference on Engineering Design, ICED13, Seoul South Korea (2013)

119. Linsey, J.S., Tseng, I., Fu, K., Cagan, J., Wood, K.L., Schunn, C.: A study of design fixation, its mitigation and perception in engineering design faculty. J. Mech. Des. **132**, 041003–1 through 041003–12. (2010)

120. Storm, B.C., Patel, T.N.: Forgetting as a consequence and enabler of creative thinking. J. Exp. Psychol. Learn. Mem. Cogn. **40**(6), 1594–1609 (2014). https://doi.org/10.1037/xlm0000006

121. Ward, T.B., Sifonis, C.M.: Task demands and generative thinking: what changes and what remains the same? J. Creat. Behav. **31**(4), 245–259, Fourth Quarter (1997). doi:https://doi.org/10.1002/j.2162-6057.1997.tb00797.x

122. Youmans, R.J.: The effects of physical prototyping and group work on the reduction of design fixation. Des. Stud. **32**, 115–138 (2011). https://doi.org/10.1016/j.destud.2010.08.001

123. Zahner, D., Nickerson, J.V., Tversky, B., Corter, J.E., Ma, J.: A fix for fixation? Rerepresenting and abstracting as creative processes in the design of information systems. Artif. Intell. Eng. Des. Analy. Manufact. **24**, 231–244 (2010). doi:https://doi.org/10.1017/S0890060410000077

124. Birdi, K., Leach, D., Magadley, W.: Evaluating the impact of TRIZ creativity training: an organizational field study. R&D Manag. **42**(4), 315–326 (2012). https://doi.org/10.1111/j.1467-9310.2012.00686.x

125. Chang, Y.-S., Chien, Y.-H., Yu, K.-C., Chu, Y.-H., Chen, M.Y.-C.: Effect of TRIZ on the creativity of engineering students. Think. Skills Creat. **19**, 112–133 (2016). https://doi.org/10.1016/j.tsc.2015.10.003

126. Chulvi, V., Gonzalez-Cruz, M.C., Mulet, E., Aguilar-Zambrano, J.: Influence of the type of idea-generation method on the creativity of solutions. Res. Eng. Design **24**, 33–41 (2013). https://doi.org/10.1007/s00163-012-0134-0

127. Chulvi, V., Mulet, E., Chakrabarti, A., Lopez-Mesa, B., Gonzalez-Cruz, C.: Comparison of the degree of creativity in the design outcomes using different design methods. J. Eng. Des. **23**(4), 241–269 (2012). https://doi.org/10.1080/09544828.2011.624501

128. Daly, S.R., Seifert, C.M., Yilmaz, S., Gonzalez, R.: Comparing ideation techniques for beginning designers. J. Mech. Des. **138**, 101108–1 to 101108–12 (2016). doi:https://doi.org/10.1115/1.4034087

129. Dumas, D., Schmidt, L.C., Alexander, P.A.: Predicting creative problem solving in engineering design. Think. Skills Creat. **21**, 50–66 (2016). https://doi.org/10.1016/j.tsc.2016.05.002

130. Nakagawa, T.: Education and training of creative problem solving thinking with TRIZ/USIT. Proc. Eng. **9**, 582–595 (2011). https://doi.org/10.1016/j.proeng.2011.03.144

131. Sangelkar, S., de Vries, C. Ashour, O., Lasher, W.C.: Teaching idea generation to undergraduate students within the time constraints of a capstone course. 122 Annual Conference and Exposition of American Society for Engineering Education, Paper #13352, Seattle, WA, June 14–17 (2015)

132. Scott, G.M., Lonergan, D.C., Mumford, M.D.: Conceptual combination: alternative knowledge structures, alternative heuristics. Creat. Res. J. **17**(1), 79–98 (2005). https://doi.org/10.1207/s15326934crj1701_7

133. Tan, C.-K., Aris, B., Harun, J., Lee, K.-W.: Enhancing and assessing student teachers' creativity using brainstorming activities and ICT-based morphological analysis method. Acad. Res. Intern. **2**(1), 241–250 (2012)

134. Vargas-Hernandez, N., Schmidt, L.C., Okudan, G.E.: Systematic ideation effectiveness study of TRIZ. J. Mech. Des. **135**, 1–10 (2013). https://doi.org/10.1115/1.4024976

135. Veisz, D., Namouz, E.Z., Joshi, S., Summers, J.D.: Computer-aided design versus sketching: an exploratory case study. Artif. Intell. Eng. Des. Anal. Manuf. **26**, 317–335 (2012). https://doi.org/10.1017/S0890060412000170

136. Warren, T.F., Davis, G.A.: Techniques for creative thinking: an empirical comparison of three methods. Psychol. Rep. **25**, 207–214 (1969). https://doi.org/10.2466/pr0.1969.25.1.207

137. Yang, M.C.: Observations on concept generation and sketching in engineering design. Res. Eng. Design **20**, 1–11 (2009). https://doi.org/10.1007/s00163-008-0055-0

138. Yilmaz, S., Daly, S.R., Seifert, C.M., Gonzalez, R.: How do designers generate new ideas? Design heuristics across two disciplines. Des. Sci. **1**(E4), 1-19 (2015). doi:https://doi.org/10.1017/dsj.2015.4

139. Yilmaz, S., Seifert, C.N.: Creativity through design heuristics: a case study of expert product design. Des. Stud. **32**(4) (2011). https://doi.org/10.1016/j.destud.2011.01.003

140. White, C., Wood, K., Jensen, D.: From brainstorming to C-sketch to principles of historical innovators: ideation techniques to enhance student creativity. J. STEM Educ. **13**(5), 12–25 (2012)

141. Del Missier, F., Visentini, M., Mantyla, T.: Option generation in decision making: ideation beyond memory retrieval. Front. Psychol. **5**(1584), 1–16 (2015). doi:https://doi.org/10.3389/fpsyg.2014.01584

142. Kudrowitz, B., Dippo, C.: Getting to the novel ideas: exploring the alternative uses test of divergent thinking. In: Proceedings of the 4 ASME 2013 International Design Engineering Technical Conferences and Computers and Information in Engineering Conference, IDETC/CIE 2013, DETC2013–13262, Portland, OR, Aug. 4–7 (2013). doi:https://doi.org/10.1115/DETC2013-13262

143. Yang, M.C.: Observations on concept generation and sketching in engineering design. Res. Eng. Des. **20**, 1-11 (2009). doi:https://doi.org/10.1007/s00163-008-0055-0

144. Vargas-Hernandez, N., Shah, J.J., Smith, S.M.: Understanding design ideation mechanisms through multilevel aligned empirical studies. Des. Stud. **31**, 382–410 (2010). https://doi.org/10.1016/j.destud.2010.04.001

Universal Design Activity: Select One Idea

<div style="text-align:right">**5**</div>

5.1 Introduction

The third universal design activity is how to select one idea to implement from perhaps hundreds, if not thousands, of ideas. How do we judge and compare ideas? How do we actually pick "the one"? This is not a trivial matter, particularly when design has no right or wrong answers; it only has complex preferences. So how do we actually sort through them and choose just one? The chapter starts with determining if it is time to make the selection or if we should defer a selection until we get more information. Next, the chapter reviews how to determine which ideas are useful for the design project, i.e., which ideas will work, and which ideas should be discarded. Useful ideas are those that satisfy the purpose and constraints. The chapter closes by reviewing specific methods for selecting just one idea from the list of useful ideas.

5.2 Steps to Selecting One Idea

The universal design activity of selecting one idea is perhaps the most complex of the three universal design activities. What we do when we select one idea is to compare and judge all of the ideas in some way. To do this, however, we need to know enough about the ideas to be able to judge them. We also need some standards by which we can judge them. So, what do we do?

Overall, there are three primary steps that must be completed as part of the universal design activity of selecting one final idea to implement from our list of ideas:

1. Defer the selection to get more information. During most of the design process we lack sufficient information to make an informed selection. We will almost always need to defer making a selection, at least for a while, so we can get more information.

2. Eliminate ideas that are not useful, i.e., they do not satisfy the purpose and (hard) constraints. Most of the ideas we generate will not be useful (nor should they) because we generated them without judgment. We need to remove those ideas from consideration before going through the process of making our final selection.
3. Make the final selection from among the useful ideas. The final selection is done by balancing the preferences of our soft constraints.

Each of these tasks will be discussed in greater detail below.

5.3 Defer Selection to Get More Information

One of the steps in making a final selection is to determine if it is time to make that selection or if the selection should be deferred until a later time. In nearly all cases (but not quite all), it is best to defer the final selection and continue with other design activities. The primary reason to defer a selection is to get more information. As we have seen, prematurely making a selection is one of the most common reasons, if not the most common reason, for design failure [1–3].

Some of the questions we can ask to determine if we are ready to make a selection include:

1. Do we have sufficient clarity of the project needs, including its purpose and constraints, against which to compare and judge our ideas?
2. Do we think we have at least some ideas in our list of ideas that we expect will result in a successful design? Do we need to generate more ideas before making the final selection?
3. Do we have enough information about our ideas to be able to compare and judge them?
4. Do we know how we will make our final selection? Do we know which process or processes we will use to compare and judge our ideas?

Answering these questions typically involves intuitive thought.

If we need additional information, one of the best ways to get it is to test our current ideas. We can visualize them through two-dimensional drawings and sketches of what a partial or complete solution may look like. We can also create three-dimensional models such as prototypes or maquettes. If we are numerically oriented, we can create mathematical or computer models.

This is the time to apply the design adage: "fail fast, fail often". Try something, learn something, try something else, learn something else. Whatever we do, do it quickly and cheaply. Don't necessarily try to get it right the first time. Failure in the earlier stages of design using models can give us a lot of valuable information at a

time when failure is not as costly as in later stages of design. Such testing allows us to clarify our design strategies, identify and eliminate extraneous information, and get information about the key design attributes of interest. Testing normally results in more effective designs [4–9]. Of course, testing our ideas advances all three of the universal design activities. Design is truly iterative.

Deferring our final selection can result in more original ideas. If we generate our initial ideas within just a few seconds to minutes, as is common for artists, our first ideas tend to be more obvious and less original. If we spend more time before making our selection, we have an opportunity to enter new areas of thought and generate more original ideas [10–13]. Artists can often improve their designs simply by deliberately pausing and reflecting between brushstrokes (most good artists do this).

Ultimately, the question will arise about when to stop deferring our selection and actually make that final selection. How do we know when we must actually choose? Unfortunately, there are no easy answers to this question. Artists can rework a painting endlessly without adding value and can even destroy a painting by over-working it. Engineers can study and tinker endlessly without adding value to their project. Except for cases in which we have someone else telling us when we must stop, there are rarely any guidelines to help us [2]. In most cases, knowing when to stop is a matter of experience. We must learn through the pain of both taking too much time and not taking enough.

5.4 Elminate Ideas that Are not Useful

Another step in making the final selection is reduce the number of ideas we need to consider in the final selection process by eliminating those ideas that are not useful, i.e., they do not satisfy the purpose and (hard) constraints of the design project. During idea generation, we did not judge our ideas, we just generated them. Now is the time to consider which ones are any good, i.e., which ones will work.

Artists typically do this unconsciously (intuitively), while engineers often use a more formal assessment of usefulness. In either case, we decide which ideas are useful, i.e., which ideas are expected to lead to a successful design, and which ones are not. It is noted that the language of engineering often uses the word 'feasible' instead of 'useful' at this stage of design.

When we determine usefulness, we evaluate each idea according to the under-lying purpose and the constraints, particularly the hard constraints. Ideas that are compatible with the purpose and constraints are considered to be useful, while those that are incompatible are considered to be not useful. If an idea is determined to be useful, i.e., it is expected to lead to a successful design, it is carried forward to the final selection process. If it is determined to be not useful, it is either modified into a useful idea or eliminated from further consideration.

Determining usefulness (feasibility) is often a very fast and simple process and can be nothing more than a quick intuitive judgment on an idea (if we have enough information about that idea). Determining usefulness allows us to rapidly identify and eliminate ideas that do not deserve the greater time and attention often required in the final selection process of balancing preferences [14, 15].

Unfortunately, it is not always possible to make a clear distinction about whether an idea is useful or not. No matter how much effort we put into clarifying the project, our understanding of it is never complete. How hard, really, is a hard constraint? How soft, really, is a soft constraint? What constraints have we missed or tacitly assumed? How broad is our purpose? There is always ambiguity in these questions. Design selection is a moving and fuzzy target.

If the usefulness of an idea is unclear, we may need additional information about that idea before determining if it will work. We can ask the following questions to help determine if it worthwhile to take the time to get that additional information:

- What are the risks of simply eliminating the unclear idea and what are the risks of delaying making a selection until more information has been obtained?
- How likely is it that an unclear idea will be determined to be useful if more information were available?
- How likely is it that the unclear idea will result in a better (more preferred) solution than ideas than have already been determined to be useful?

Of course, the answers to these questions is normally determined through intuitive thought.

A final comment on determining usefulness is that some people refer to some ideas as being more useful (more feasible) than others. That language is not used here. In this book, determining usefulness (feasibility) is a yes/no decision regarding whether an idea is to be included in the final selection process of balancing preferences. Usefulness does not involve preferences. Ideas are not more useful than others, they are simply useful (they are expected to lead to a successful design) or they are not useful (they are not expected to lead to a successful design). We often can (and should) eliminate most of our ideas by determining usefulness. This significantly simplifies the final selection itself, which is based on preferences.

Instead of using the language of one idea being more useful than another, the language of one idea being more preferred is used. Determining usefulness and preference balancing (making the final selection) are two different processes based on two different sets of criteria. Determining usefulness is based on considering an idea relative to the purpose of the project and its hard constraints, while making the final selection is based on balancing the soft constraints of our preferences. The final selection determines which idea we prefer from among a list of ideas that should all work.

One final benefit of taking the time to determine usefulness is that it generates more information about the project and the ideas that were generated. We can use this new information as the basis for a new design iteration. We may evaluate usefulness (feasibility) many times during a design project before actually making the final selection.

5.5 Making the Final Selection

Ok, it is time. No more delays. Pick one! Our final step is to pick one idea from a list of ideas that we have already determined to be useful. So, how do we actually do it? How do we actually pick just one idea and discard the rest? What criteria or methods do we use? These questions lead to an even deeper question: how do we actually make decisions? We don't have good answers to these questions either.

Decision-making is a very complex process. There is an entire discipline of study about it and many different decision-making processes have been proposed. These various types of decision-making processes are so fundamentally different from each other that they can induce different physiological and neural activities in the brain [16–21].

A careful examination of the various decision-making processes, however, reveals that most are really not suitable for design problems. They are focused on solving closed-ended, insight problems. It is relatively easy to assess the validity of a decision-making process when you can determine if the process yields the correct answer. In design problems, however, there are no correct answers, so such an assessment is simply not possible. Making the final selection in design isn't about finding the right answer, it is about balancing ambiguous preferences to identify a preferred solution. Since preferences themselves are subjective, balancing those preferences is also subjective. A best method for making design selections simply does not exist, just like a best idea does not exist. All we have are preferences.

Conventional decision theory claims that decisions should be made using rational (analytical) thought [22, 23]. As we have already seen, analytical thought is thought that follows a prescribed pathway. Rational thought, however, is only possible when such a prescribed pathway exists. This requires complete information, sufficient time to process that information, and an understanding of the methods by which the information is to be processed. Those conditions do not exist in design projects, *ever*! Rational decision-making, by itself, is simply not possible in design. There are no prescribed pathways to follow when making a selection. At best, rational (analytical) thought is simply one of the tools available to designers. It is an important tool but, in itself, is insufficient. As we will see, the most valuable use of rational (analytical) thinking is not to make the final selection, but to help separate more preferred ideas from less preferred ideas.

So, how can we make good design selections? How can we effectively balance our preferences? In spite of the complexity of design and the lack of a clear pathway for making such selections, we make successful design selections all the time. So how do we do it? There are three primary methods in which we make design selections:

1. Intuition: a gut feeling on which idea is the preferred one without necessarily knowing why (Intuition of Judgment),
2. Single Criterion Methods (heuristics): identify the single, most-important selection criterion (preference) and pick the idea that ranks the highest for that criterion while ignoring all other information, and
3. Multiple Criteria Methods: weigh and balance each of the design ideas against a list of selection criteria (preferences).

Using intuition to make our final selection uses, well, intuitive thought. Using either single and multiple criteria methods involves a combination of both intuitive and analytical thought.

- Single criterion methods (heuristics) use analytical thinking because they have a prescribed path of action: identify the most important selection criterion, score all of the ideas according to that criterion, and then select the idea that has the highest score. Single criterion methods also use intuitive thought because there is not always a prescribed path for identifying which heuristic to be used or how to score each idea according to that heuristic.
- Multiple criteria methods use analytical thinking because they also have a prescribed path of action: identify all of the relevant selection criteria, score each idea according to each of those criteria, weight each of those criteria according to a prescribed method, and make a selection based on the results of that weighing. Multiple criterion methods also use intuition because there are no prescribed pathways for determining any of that information.

We will now explore these selection processes in more detail.

5.5.1 Intuition

Intuition is used in making virtually all design selections in all disciplines. Using our intuition to make the final selection can be just an extension of using our intuition to eliminate ideas that are not useful. This often the only selection method used by artists.

Intuition is needed to determine which information is relevant and which is not, how random elements may impact the process, and how different and competing factors must be compared and weighted against each other. Further, intuition can integrate our personal preferences, beliefs, and experiences, the professional standards of our respective design disciplines, and the preferences and desires of the clients or patrons. There are no analytical methods that can balance such a wide

range of information; they simply do not exist! Even the numerical information required as input by many analytical selection processes must be obtained at least partially from intuition [24–27]. Of course, most professionals don't say they use their intuition. Instead, they say they use their professional judgment based on prior experience. Same thing!

The type of intuition primarily used during idea selection is the Intuition of Judgement. Our Intuition of Judgment involves using our feelings as information (introduced in Chap. 2) in which we use how we feel about something as an internally-based heuristic to make our design selections. When we use our Intuition of Judgment, we have a feeling or sense of knowing that one idea is superior to the others and should be selected. Conversely, we may have a feeling that a particular idea is not appropriate and should not be selected. We may or may not know how or why we feel that way nor can we necessarily explain or justify it to others. Nevertheless, we know how we feel about our ideas. We simply make an unconscious judgment of the ideas and pick the one that feels the best [28–33]. Although we can't explain how we make this judgement, such judgment is correlated with identifiable neural processes within our brains [34–39]. It is noted that our Intuition of Judgement may be based on externally-based heuristics that haven't risen to our level of awareness [40–42].

One way to enhance our Intuition of Judgment when making design selections is to engage in mindfulness. Mindfulness is a mental state in which we are gently aware of our surroundings. For design selections using intuition, we gently consider each of our design ideas. We look at their strengths and weakness without judgment. We effortlessly allow ourselves to become aware of the attributes and characteristics of the different ideas relative to our preferences. We compare ideas without judgment simply by becoming aware of how they compare. Through this mindfulness state, our intuition can unconsciously bring into our awareness a preference for one or more ideas over the others. This Intuition of Judgment is not an active, analytical judgment. It occurs naturally and without effort. We can't explain how it works, but we can identify our resulting preferences.

Although we may not understand how our intuition works when making selections, we can identify when we are more likely to use it.

- We tend to use our intuition to make our selection when we have insufficient information or time to analyze all of our ideas and when we have strong feelings about the selection but do not have a personal stake in the outcome of the selection [28, 29, 33, 43–51].
- We are less likely to use intuition when we have a personal stake in the outcome, including when we expect that our selection will be evaluated or criticized by others [52].
- We tend to use our intuition more often as we gain experience with it or have more confidence in it [53–55].
- Intuition is widely used when making institutional decisions, particularly by business executives [43, 44, 48, 56–58].

5.5.2 Single Criterion Methods (Heuristics)

Heuristics (externally-based) are the most widely used selection method that involves at least some analytical thought. We identify a single, objective criterion upon which we will make the decision, score all of the useful ideas according to that criterion, and then select the idea with the highest score. All other information, including all of the other soft constraints and preferences, is ignored. This use of single criterion methods does not balance multiple preferences.

A variation on this method that allows some preference balancing is to independently use multiple heuristics for selection. Ideas that score high on multiple heuristics may be more preferred than ideas that score high on only a few. Of course, balancing the results from any conflicting outcomes from using multiple heuristics is done using intuition.

Perhaps the most valuable aspect of using heuristics is that they are simple decision-making processes. They are easy to understand, can be used very quickly, and require minimal information or resources. In fact, the more complex the decision and the greater the pressure to make a selection, the more likely that we will use the single criterion method of heuristics instead of the more complex, time-consuming, multi-criteria methods [41, 59–65].

Although we can use heuristics to identify a preferred idea, we should still use our intuition (professional judgment) to see if we agree with the results of our heuristic analyses. We must remain aware that we may not have used the most appropriate heuristic or may not have used the most appropriate scoring for each idea. Our intuition is often the best way (perhaps the only way) to address those concerns.

We will now review some common domain-general heuristics for making a design selection.

5.5.2.1 Take the Best

Ultimately, all selection heuristics are variations of this one overarching heuristic: *Take the Best*. The *Take the Best* heuristic selects the best idea based on what we have considered to be the most important selection criterion. If multiple design ideas perform the same way relative to that criterion, the second most important selection criterion is then used to make a selection from those top ideas. This process is repeated with less important criteria until only one idea remains. This heuristic is also known as outranking. When a design idea is outranked by another idea, that idea is eliminated [66]. This heuristic can be very effective when our chosen selection criterion is more important than the others. It is less effective, however, when multiple criteria have similar importance and each identifies a different preferred idea.

5.5.2.2 Take the First

This heuristic is simply to take the first idea that is identified as being useful, i.e., the first idea that has been found to address the underlying purpose and meet the hard constraints. As soon as the first useful idea is identified, it is selected, and the

selection process is stopped. All remaining ideas are eliminated without being considered. Artists often use this heuristic.

This heuristic and its many variations are known as satisficing, a word that combines satisfying and sufficing. It is based on the concept of bounded rationality, which occurs when we lack the ability or resources to make a rational (analytical) selection. We just select the first idea that satisfies our selection criteria [67].

A significant disadvantage to the *Take the First* heuristic is that it, like all heuristics, ignores all of the other selection criteria. This heuristic does not balance our preferences. Design ideas that might be more preferred will not even be considered. This problem can be compounded if the *Take the First* heuristic is applied early in the design process before a sufficient number of design iterations have been completed. This heuristic can prematurely freeze our understanding of the purpose and constraints of the problem before we really know what we want to achieve and can stop idea generation before we have gotten past the more obvious, but less original, initial ideas. The better and more refined ideas that often come after many design iterations may never come into awareness. Thus, the *Take the First* heuristic tends to select the most obvious and least creative idea [68].

Perhaps the most common users of the *Take the First* heuristic are those that engage in design through some type of physical activity, such as those who play sports or engage in improvisation during the performing arts. Such people are frequently required to make very quick selections without the time to consider other ideas [69–71]. Improvisation will be discussed in the following chapter.

5.5.2.3 Take the Simplest

For many design projects, the simplest designs often tend to be the most successful designs. They tend to be less expensive and are easier to use. This heuristic is perhaps better known for its acronym: KISS (*Keep It Simple, Stupid*). This heuristic is also expressed through the previously mentioned metaphor "*less is more*".

There are many measures of simplicity, each of which could be considered a separate heuristic. For artists, simplicity could be a limited palette (only use a few tube colors and mix everything else), while for engineers, simplicity could be a part count (select the idea that requires the fewest number of components). Simplicity can also be related to domain-general constraints, such as cost and time to completion. Other domain-general measures of simplicity may include the related concepts of understandability, coherency, representativeness, and compatibility:

- Understandability. Select the idea that is easiest to understand, recall from memory, or that seems to make the most sense [60, 72–79].
- Coherency. Select the idea in which all of the parts seem coherent, i.e., they seem to fit together or work together. There is a sense of unity in the design [80, 81].
- Representativeness. Select the idea that seems to best represent what we believe a successful solution should look like. This is often linked to our perception of how well it addresses the underlying purpose [82–84].

- Compatibility. Select the idea that seems most compatible with the overall context of the design. Compatibility for artists can involve developing a signature style that is compatible with their other works, i.e., patrons would recognize it as a work of that artist. Although originality tends to be favored in art schools by professors who are paid for their teaching and not necessarily for their ability to make a living as an artist, professional artists who make their living selling art must produce works that are compatible with their patron's expectations. Compatibility for engineers generally requires that the new design effectively interfaces with existing systems.

Of course, evaluating these measures of simplicity involves an intuitive judgment.

5.5.2.4 Risk Versus Reward

This heuristic is based on how risk and reward are balanced. Is the objective to maximize the potential rewards from the design or is it to minimize the potential risks? Artists may prefer to maximize the potential rewards and engineers may prefer to minimize the potential risks. This heuristic is based on selecting the idea whose risks versus rewards best matches that of the needs of the design (and the designer).

5.5.3 Multiple Criteria Methods

Multiple criteria methods are the only methods that allows us to use analytical thought to simultaneously consider many of the preferences of the soft constraints (other than comparing the results of using multiple heuristics). Multiple criteria methods are the most complex of the decision-making methods and are the most time consuming and costly to implement. Artists virtually never use these methods and most engineers tend to use only the simplest ones. Advanced multiple criteria methods tend to be primarily of academic interest because they can be impractical to implement in real design situations.

There are many different multiple criteria methods for decision-making, such as optimization methods, Pugh matrices, utility theory, fuzzy logic, Quality Function Deployment, Analytical Hierarchy Process, and others. There have been hundreds, if not thousands, of papers published describing and comparing these methods [85–90].

Although there are many variations of these methods, they typically involve four basic activities:

1. Identify the attributes/criteria by which the ideas will be evaluated. These attributes are often based on the soft constraints.
2. Identify the relative importance (weighting) of each of those attributes.
3. For each idea, assign a score or rating for each of those attributes, and
4. Aggregate the resulting ratings for each idea into some type of ranking.

The idea with the highest aggregate ranking is typically considered to be the preferred idea. If the scores of all attributes other than the most important one are set to zero, this method reverts to the *Take the Best* heuristic.

A significant difficulty with multiple criteria methods is that when they are compared to each other for the same situation, they often yield different and conflicting results; they do not agree with each other. Such comparison studies have shown that there is no single multiple-criteria decision method that is clearly superior to any of the others [91–95]. Because of the uncertainties with the outcomes of the multiple criteria methods, their primary value is not in making the final selection, but simply in identifying more preferred ideas from less preferred ideas [96].

So, what do we do? We use whatever multiple criterion methods we like to identify more preferred from less preferred ideas. Then we go with what feels right, i.e., we still use our intuition (professional judgment) to make the final selection from among the more preferred ideas. If our intuition is silent about the outcome of a multiple criteria method (as it often is), we might as well select the idea with the highest multiple criteria ranking. If our intuition does not agree with the outcome, however, we should ask ourselves why.

5.6 Effectiveness of Selection Methods

We have seen that there are three primary ways to select which idea to implement: intuition (which involves professional judgment), single criterion decision methods (heuristics), and multiple criteria decision methods. So, the question is which method is best? Which one should we use? They all have strengths and they all have weaknesses.

Before we can determine which selection method we should use, however, we need to turn to the question of how we even know if a design is successful. How do we measure design success? Even though the literature is filled with studies on the effectiveness of various decision-making methods, most of those studies focus on insight problems with their single, identifiable right answers. There are very few studies of the success of decision-making methods on design problems which balance the preferences of multiple useful ideas.

So how do we measure design success? There are three common methods for doing this: usefulness, heuristics, and human judgment.

1. Usefulness. All of the design ideas that have been determined to be useful can be said to satisfactorily address the underlying purpose and satisfy the hard constraints. As a result, all useful ideas should yield a successful design. We may have preferences regarding the different design ideas as expressed through soft constraints, but the different ways that those preferences are balanced are not necessarily a measure of success [97].

2. Heuristics. We can also measure the success of a design through simple rules of thumb (heuristics). These heuristics may or may not be the same ones used to generate ideas or to make our final selection. For example, two commonly used heuristics for determining the success of an art design is whether or not it sells and helps the artist make their living or whether it achieves external recognition and acclaim (which will lead to selling more works and help them make their living). Similarly, two commonly used heuristics for determining the success of an engineering design is whether the project was completed on time and under budget. None of these measures of success relate to the design process itself.

3. Human Judgment. Ultimately, our human judgment is the primary way in which design success is measured. Such judgment is based, of course, on our intuition (Intuition of Judgement). In some cases, we just feel that a design was successful without being able to explain why [98, 99].

So how effective are these three selection methods? Although many, if not most, of the studies conducted on decision-making are not directly relevant to design, they suggest the following:

1. All of the decision-making methods can be successful in some cases.
2. None of the decision-making methods will be successful in all cases.
3. Successful designers tend to use multiple decision-making methods over the course of their projects.

We now turn out attention to the effectiveness of each of these three selection methods.

5.6.1 Intuition

Studies have revealed mixed results for the effectiveness of intuition relative to other decision-making methods. One reason for the mixed results is from inconsistent definitions and measures of intuition. There are multiple types of intuition reported in the literature and their corresponding measures can yield different results when applied to the same situation [100, 101].

In some cases, intuition has been shown to be equal to or superior to analysis, [29, 31, 32, 50, 100, 102–111] but in other cases, analysis has been shown to be superior to intuition [112–117]. People tend to trust their intuitive judgments over analytical thought when decisions are complex and when there is a lot of information to be processed about each idea.

Although not necessarily a design selection, one situation in which intuition appears to be particularly effective is in judging the personal characteristics of others. Through the process of "thin-slice" behavior, which occurs by observing someone for 30 seconds or less, our intuition can provide an accurate characterization of their personality that does not change with longer observation times. Following thin-slice observations, however, we are normally unable to identify the

reasons why we characterize a person that way [118–121]. Similarly, taking a long time to observe the performance of a system for which a new design is desired may not necessarily result in an improved design relative to a shorter observation time. Of course, our ability to judge through "thin-slice" behavior is strongly dependent upon having sufficient prior experience and whether we are able to observe the critical information.

5.6.2 Single Criterion Methods (Heuristics)

Studies have revealed mixed results for the effectiveness of heuristics relative to other decision-making methods. In some types of problems, heuristics can perform equal to or better than both intuition and multiple criteria methods, even if sufficient time, information, and computational ability are available to use multiple criteria methods [59, 63, 66, 122–124]. No single heuristic can perform well for all tasks, however.

Heuristics tend to be more effective when the single criterion upon which the selection is based is very important relative to the other criteria and less effective when multiple criteria have a similar importance. Heuristics are particularly good for screening bad ideas from good ones [124]. Heuristics tend to be more effective in environments in which the heuristic was originally developed (domain-specific) and less effective in new environments (domain-general [125].

5.6.3 Multiple Criteria Methods

Studies have revealed mixed results for the effectiveness of multiple criteria methods relative to other decision-making methods. Multiple criteria methods can be superior to intuition or heuristics for some types of problems, [45, 91–93, 113–115] but can be less effective in others, particularly for complex, dynamic, heterogeneous situations when the relationships between the selection criteria are unclear (like design!) [63, 66, 91, 106, 123, 126].

For insight problems involving clinical judgement, such as a doctor or mechanic making a diagnosis, multiple criteria methods based on statistical data are almost always superior to intuition [127–134]. Design problems, however, are virtually never repeated enough times to obtain meaningful statistical data (or to develop relevant heuristics), so this observation is not necessarily relevant for design problems.

5.6.4 Combinations of Methods

Although there is no single selection method that is clearly superior to the others for design selection, the evidence suggests that the use of multiple methods is superior to the use of just a single method [43–45, 47, 48, 50, 135–139]. In particular, the

use of methods that involve balancing both intuition and analysis appear to yield the most successful results.

In summary, the recommended method to make the final selection of the one idea to implement is to

1. use our intuition to separate useful ideas from not useful ideas (analysis is often required to obtain sufficient information to make this intuitive judgment),
2. use multiple single criterion and/or multiple criteria methods (involving both intuitive and analytical thought) to identify the more preferred ideas from the less preferred ideas, and
3. use our intuition to make the final selection from the more preferred ideas.

5.7 Closing

The key conclusions from this chapter are

1. We should defer making the final selection of our design idea until we have sufficient information to make a good selection. The information we need includes

 a. ensuring a satisfactory understanding of the purpose and constraints,
 b. a sufficient number of ideas to ensure that we will have at least one good idea,
 c. an understanding of how the final selection will be made, and
 d. sufficient information about each of the ideas for them to be meaningfully evaluated.

2. An important way to obtain more information is to test our ideas, either through two-dimensional sketches, three-dimensional physical models, or mathematical models. Testing such models to failure can often be valuable.
3. Because the idea generation process tends to be most effective if we do not also judge our ideas at the same time, most of the ideas we generate will probably not be useful, i.e., they will not address the purpose or satisfy the (hard) constraints. If these ideas cannot be modified to become useful, they should be eliminated from consideration in the final selection process.
4. The final selection process involves selecting a one idea from the remaining list of useful ideas by balancing our preferences.
5. There are three primary ways of making a final design selection: intuition, single criterion methods, and multiple criteria methods.

a. Intuition is the most widely used selection method for all designers. We select the idea that we feel is right, without necessarily knowing why. Our intuition is able to successfully integrate a broader range of information than any other selection method.
b. Single criterion methods (externally-based heuristics) are based on identifying the single-most important selection criterion, scoring (ranking) all useful design ideas according to that criterion, and selecting the idea that has the highest resulting score. All other information about our ideas is ignored. As a variation of this method, we can use multiple heuristics and compare their results, using intuition to resolve conflicts.
c. Multiple criteria methods balance a number of selection criteria, typically based on our soft preferences. They are the most complex decision-making method and take the most time to implement. Because of their complexity and time required to learn and apply them, their practical use is limited to only the simpler methods.

6. All decision-making methods will work for some cases and none will work effectively for all cases. Effective designers tend to use multiple methods that balance both intuition and analysis over the course of a design project.
7. The recommended method for making the final selection is to

a. use our intuition to identify the useful ideas (after using analysis to get information),
b. use a combination of single-criteria and multiple-criterion methods to identify the more preferred ideas from among the useful ideas, and
c. use intuition to make the final selection from the more preferred ideas.

5.8 Questions

1. How do you know when to stop working on design project and select your final idea to implement?
2. How do you determine if you:

a. have a satisfactory understanding of the purpose and constraints of your project,
b. have a sufficient number of ideas to ensure at least one good one,
c. have a good understanding of how the final selection will be made,
d. have sufficient information about each of the ideas for them to be meaningfully evaluated?

3. Are there conditions when you might defer a selection even if you have all of the information you think you need to select your preferred idea?

4. Have you ever conducted a feasibility (usefulness) assessment by thinking about whether or not an idea would lead to a successful design? What were the results? Did it help? Why or why not?
5. How often do you have a feeling or sense of knowing something about a design idea without knowing why? How often have you found that feeling right? How often have you found that feeling was wrong? What was your relevant prior experience?
6. What heuristics do you commonly use in your design selections? If you do not use heuristics, how might it help for you to use them. Which ones may be the most effective for you?
7. Can you identify additional heuristics for making the final selection that might be relevant to your area of interest?
8. Do you use rational analysis in your selection processes? When? When not? What information does it provide? What are the primary reasons that rational analysis tends to be either effective or ineffective during your design process?
9. Have you ever conducted a multiple criteria decision analysis? How did you feel about the results? Was it worth your time?
10. Which selection method do you use the most: intuition, heuristics, or multiple criteria methods? Which method do you trust use the most? Do you use multiple methods? Do you switch selection methods for different circumstances? What are those circumstances?
11. In what ways can artists and engineers use similar selection processes? Why might they use different selection processes?

References

1. Basadur, M., Runco, M.A., Vega, L.A.: Understanding how creative thinking skills, attitudes, and behaviors work together: a causal process model. J. Creative Behav. 34(2), 77–100 (2000). https://doi.org/10.1002/j.2162-6057.2000.tb01203.x
2. Guindon, R.: Knowledge exploited by experts during software system design. Int. J. Man Mach. Stud. 33, 279–304 (1990). https://doi.org/10.1016/S0020-7373(05)80120-8
3. Heller, D., Levin, I.P., Goransson, M.: Selection of strategies for narrowing choice options: antecedents and consequences. Organ. Behav. Human Decis. Process. 89, 1194–1213 (2002). https://doi.org/10.1016/S0749-5978(02)00028-6
4. Babineaux, R., Krumboltz, J.: Fail Fast, Fail Often: How Losing Can Help You Win. Penguin Group, New York (2013)
5. Dow, S.P., Heddleston, K., Klemmer, S.R.: The efficacy of prototyping under time constraints. In: Proceedings of the 7th ACM Conference on Creativity and Cognition, pp. 165–174. Berkeley, CA (2009). https://doi.org/10.1007/978-3-642-13757-0_7
6. Hoover, S.P., Rinderle, J.R., Finger, S.: Models and abstractions in design. Des. Stud. 12(4), 237–245 (1991). https://doi.org/10.1016/0142-694X(91)90039-Y
7. Lemons, G., Carberry, A., Swan, C., Rogers, C., Jarvin, L.: The benefits of model building in teaching engineering design. Des. Stud. 31, 288–309 (2010). https://doi.org/10.1016/j.destud.2010.02.001
8. Lim, Y.-K., Stolterman, E., Tenenberg, J.: The anatomy of prototypes: prototypes as filters, prototypes as manifestations of design ideas. ACM Trans. Comput.-Human Interact. 15(2), Article 7, 1–27 (2008). https://doi.org/10.1145/1375761.1375762

9. Lin, P.-Y., Hong, H.-Y., Chai, C.S.: Fostering college students' design thinking in a knowledge-building environment. Educ. Technol. Res. Dev. **68**, 949–974 (2020).https://doi.org/10.1007/s11423-019-09712-0

10. Beaty, R.E., Silvia, P.J.: Why do ideas get more creative across time? An executive interpretation of the serial order effect in divergent thinking tasks. Psychol. Aesthetics, Creativity, Arts **6**(4), 309–319 (2012). https://doi.org/10.1037/a0029171

11. Christensen, P.R., Guilford, J.P., Wilson, R.C.: Relations of creative responses to working time and instructions. J. Exp. Psychol. **53**(2), 82–88 (1957). https://doi.org/10.1037/h0045461

12. Morse, D.T., Morse, L.W., Johns, G.A.: Do time press, stimulus, and creative prompt influence the divergent production of undergraduate students? Yes, yes, and no, not very much. J. Creative Behav. **35**(2), 102–114 (2001). https://doi.org/10.1002/j.2162-6057.2001.tb01224.x

13. Parnes, S.J.: Effects of extended effort in creative problem solving. J. Educ. Psychol. **52**(3), 117–122 (1961). https://doi.org/10.1037/h0044650

14. Beach, L.R.: Broadening the definition of decision making: the role of prechoice screening of options. Psychol. Sci. **4**(4), 215–220 (1993). https://doi.org/10.1111/j.1467-9280.1993.tb00264.x

15. Venters, C., Reis, J. Griffin, H., Dixon, G.: A spiral curriculum in design and project management. In: Proceedings of the 2015 IEEE Frontiers in Education Conference (FIE), El Paso, TX (2015). https://doi.org/10.1109/FIE.2015.7344210

16. Greene, J.D., Sommerville, R.B., Nystrom, L.E., Darley, J.M., Cohen, J.D.: An fMRI investigation of emotional engagement in moral judgment. Science **293**, 2105–2108 (2001). https://doi.org/10.1126/science.1062872

17. Guillaume, S., Jollant, F., Jaussent, I., Lawrence, N., Malafosse, A., Courtet, P.: Somatic markers and explicit knowledge are both involved in decision-making. Neuropsychologia **47**, 2120–2124 (2009). https://doi.org/10.1016/j.neuropsychologia.2009.04.003

18. Krain, A.L., Wilson, A.M., Arbuckle, R., Castellanos, F.X., Milham, M.P.: Distinct neural mechanisms of risk and ambiguity: a meta-analysis of decision making. NeuroImage **32**, 477–484 (2006). https://doi.org/10.1016/j.neuroimage.2006.02.047

19. Paulus, M.P.: Neurobiology of decision-making: quo vadis? Cogn. Brain Res. **23**, 2–10 (2005). https://doi.org/10.1016/j.cogbrainres.2005.01.001

20. Volz, K.G., Schubotz, R.I., von Cramon, D.Y.: Variants of uncertainty in decision-making and their neural correlates. Brain Res. Bull. **67**, 403–412 (2005). https://doi.org/10.1016/j.brainresbull.2005.06.011

21. Zysset, S., Wendt, C.S., Volz, K.G., Neumann, J., Huber, O., von Cramon, C.Y.: The neural implementation of multi-attribute decision making: a parametric fMRI study with human subjects. NeuroImage **31**, 1380–1388 (2006). https://doi.org/10.1016/j.neuroimage.2006.01.017

22. Baron, J.: Rationality and Intelligence. Cambridge University Press, Cambridge (1985)

23. Hastie, R., Dawes, R.M.: Rational Choice in an Uncertain World. Sage Publications, Thousand Oaks (2001)

24. Dijksterhuis, A., Nordgren, L.F.: A theory of unconscious thought. Perspect. Psychol. Sci. **1**(2), 95–109 (2006). https://doi.org/10.1111/j.1745-6916.2006.00007.x

25. Inbar, Y., Cone, J., Gilovich, T.: People's intuitions about intuitive insight and intuitive choices. J. Pers. Soc. Psychol. **99**(2), 232–247 (2010). https://doi.org/10.1037/a0020215

26. Stanovich, K.E., West, R.F.: Individual differences in rational thought. J. Exp. Psychol. Gen. **127**(2), 161–188 (1998). https://doi.org/10.1037/0096-3445.127.2.161

27. Stauffer, L.A., Ullman, D.G.: A comparison of the results of empirical studies into the mechanical design process. Des. Stud. **9**(2), 107–114 (1988). https://doi.org/10.1016/0142-694X(88)90036-1

28. Clore, G.L., Schwarz, N., Conway, M.: Affective causes and consequences of social information processing. In: Wayer, R.S., Srull, T.K. (eds.) Handbook of Social Cognition. Lawrence Erlbaum Associates, Hillsdale, New Jersey (1994)
29. Greifeneder, R., Bless, H., Pham, M.T.: When do people rely on affective and cognitive feelings in judgment? A review. Pers. Soc. Psychol. Rev. **15**(2), 107–141 (2011). https://doi.org/10.1177/1088868310367640
30. Loewenstein, G.F., Weber, E.U., Hsee, C.K., Welch, N.: Risk as feelings. Psychol. Bull. **127** (2), 276–286 (2001). https://doi.org/10.1037/0033-2909.127.2.267
31. Pham, M.T., Cohen, J.B., Pracejus, J.W., Hughes, G.D.: Affect monitoring and the primacy of feelings in judgments. J. Consum. Res. **28**(2), 167–188 (2001). https://doi.org/10.1086/322896
32. Pham, M.T., Lee, L., Stephen, A.T.: Feeling the future: the emotional oracle effect. J. Consum. Res. **39**, 461–477 (2012). https://doi.org/10.1086/663823
33. Schwarz, N., Clore, G.: How do I feel about it? Information functions of affective states. In: Fiedler, K., Forgas, J. (eds.) Affect, Cognition and Social Behavior. Hogrefe, Toronto, Canada (1988)
34. Bartra, O., McGuire, J.T., Kable, J.W.: The valuation system: a coordinate-based meta-analysis of BOLD fMRI experiments examining neural correlates of subjective value. NeuroImage **76**, 412–427 (2013). https://doi.org/10.1016/j.neuroimage.2013.02.063
35. Kable, J.W., Glimcher, P.W.: The neural correlates of subjective value during 35 choice. Nat. Neurosci. **10**(12), 1625–1633 (2007). https://doi.org/10.1038/nn2007
36. Kikyo, H., Ohki, K., Miyashita, Y.: Neural correlates for feeling-of-knowing: an fMRI parametric analysis. Neuron **36**, 177–186 (2002). https://doi.org/10.1016/S0896-6273(02)00939-X
37. Koriat, A., Levy-Sadot, R.: The combined contributions to the cue-familiarity and accessibility heuristics to feelings of knowing. J. Exp. Psychol. **27**(1), 34–53 (2001). https://doi.org/10.1037//0278-7393.27.1.34
38. Levy, I., Lazzaro, S.C., Rutledge, R.B., Glimcher, P.W.: Choice from no-choice: 38 consumer preferences from blood oxygenation level-dependent signals obtained during passive viewing. J. Neurosci. **31**(1), 118–125 (2011). https://doi.org/10.1523/JNEUROSCI.3214-10.2011
39. Maril, A., Simons, J.S., Mitchell, J.P., Schwartz, B.L., Schacter, D.L.: Feeling-of-knowing in episodic memory: an event-related fMRI study. NeuroImage **18**, 827–836 (2003). https://doi.org/10.1016/s1053-8119(03)00014-4
40. Daly, S., Yilmaz, S., Seifert, C., Gonzalez, R.: Cognitive heuristic use in engineering ideation. In: Proceedings of the AC210–1032 Annual Conference of the American Society for Engineering Education. Louisville, Ky (2010). https://doi.org/10.18260/1-2–16280
41. Gigerenzer, G., Gaissmaier, W.: Heuristic decision making. Annu. Rev. Psychol. **62**, 451–482 (2011). https://doi.org/10.1146/annurev-psych-120709-145346
42. Yilmaz, S., Seifert, C.N.: Creativity through design heuristics: a case study of expert product design. Des. Stud. **32**(4) (2011). https://doi.org/10.1016/j.destud.2011.01.003
43. Agor, W.H.: The logic of intuition: how top executives make important decisions. Organ. Dyn. **14**(3), 5–18 (1986). https://doi.org/10.1016/0090-2616(86)90028-8
44. Blattberg, R.C., Hoch, S.J.: Database models and managerial intuition: 50% model + 50% manager. Manage. Sci. **36**(8), 887–899 (1990). https://doi.org/10.1287/mnsc.36.8.887
45. Elbanna, S., Child, J., Dayan, M.: A model of antecedents and consequences of intuition in strategic decision making: evidence From Egypt. Long Range Plan. **46**, 149–176 (2013). https://doi.org/10.1016/j.lrp.2012.09.007
46. Gasper, K., Clore, G.L.: Do you have to pay attention to your feelings to be influenced by them? Pers. Soc. Psychol. Bull. **26**(6), 698–711 (2000). https://doi.org/10.1177/0146167200268005

47. Guinipero, L. Dawley, D., Anthony, W.P.: The impact of tacit knowledge on purchasing decisions. J. Supply Chain Manage. **35**(1), 42–49 (1999). https://doi.org/10.1111/j.1745-493X.1999.tb00055.x

48. Hensman, A., Sadler-Smith, E.: Intuitive decision making in banking and finance. Eur. Manage. J. **29**, 51–66 (2011). https://doi.org/10.1016/j.emj.2010.08.006

49. Janiszewski, C.: Preconscious processing effects: the independence of attitude formation and conscious thought. J. Consum. Res. **15**(2), 199–209 (1988). https://doi.org/10.1086/209157

50. Khatri, N., Ng, H.A.: The role of intuition in strategic decision making. Human Relat. **53**(1), 57–86 (2000). https://doi.org/10.1177/0018726700531004

51. White, K., McFarland, C.: When are moods most likely to influence consumers' product preferences? The role of mood focus and perceived relevance of moods. J. Consum. Psychol. **19**, 526–536 (2009). https://doi.org/10.1016/j.jcps.2009.05.004

52. Kramer, T., Maimaran, M., Simonson, I.: Asymmetric option effects on ease of choice criticism and defense. Organ. Behav. Human Decis. Process. **117**, 179–191 (2012). https://doi.org/10.1016/j.obhdp.2011.10.005

53. Avnet, T., Pham, M.T., Stephen, A.T.: Consumers' trust in feelings as information. J. Consum. Res. **39**, 720–735 (2012). https://doi.org/10.1086/664978

54. Koriat, A.: When confidence in a choice is independent of which choice is made. Psychon. Bull. Rev. **15**(5), 997–1001 (2008).https://doi.org/10.3758/PBR.15.5.997

55. Simmons, J.P., Nelson, L.D.: Intuitive confidence: choosing between intuitive and nonintuitive alternatives. J. Experiential Psychol.: Gen. **135**(3), 409–428 (2006). https://doi.org/10.1037/0096-3445.135.3.409

56. Agor, W.H.: How intuition can be used to enhance creativity in organizations. J. Creative Behav. **25**(1), 11–19 (1991). https://doi.org/10.1002/j.2162-6057.1991.tb01348.x

57. Burke, L.A., Miller, M.K.: Taking the mystery out of intuitive decision making. The Acad. Manage. Executive **13**(4), 91–99 (1999). https://doi.org/10.5465/ame.1999.2570557

58. Clarke, I., Mackaness, W.: Management 'Intuition': an interpretative account of structure and content of decision schemas using cognitive maps. J. Manage. Stud. **38**(2), 147–172 (2001). https://doi.org/10.1111/1467-6486.00232

59. Bingham, C.B., Eisenhardt, K.M.: Rational heuristics: the 'simple rules' that strategists learn from process experience. Strateg. Manag. J. **32**, 1437–1464 (2011). https://doi.org/10.1002/smj.965

60. Blair, C.S., Mumford, M.D.: Errors in idea evaluation: preference for the unoriginal? J. Creative Behav. **41**(3), 197–222 (2007). https://doi.org/10.1002/j.2162-6057.2007.tb01288.x

61. Grether, D.M.: Testing Bayes rule and the representativeness heuristic: some experimental evidence. J. Econ. Behav. Organ. **17**, 31–57 (1992). https://doi.org/10.1016/0167-2681(92)90078-P

62. Krabuanrat, K., Phelps, R.: Heuristics and rationality in strategic decision making: an exploratory study. J. Bus. Res. **41**, 83–93 (1998). https://doi.org/10.1016/S0148-2963(97)00014-3

63. Payne, J.W., Bettman, J.R., Johnson, E.J.: Adaptive strategy selection in decision making. J. Exp. Psychol. Learn. Mem. Cogn. **14**(3), 534–552 (1988). https://doi.org/10.1037/0278-7393.14.3.534

64. Siemer, M., Reisenzein, R.: Effects of mood and evaluative judgements: influence of reduced processing capacity and mood salience. Cogn. Emot. **12**(6), 783–805 (1998). https://doi.org/10.1080/026999398379439

65. Zanakis, S.H., Evans, J.R., Vazacopoulos, A.A.: Heuristic methods and applications: a categorized survey. Eur. J. Oper. Res. **43**, 88–110 (1989). https://doi.org/10.1016/0377-2217(89)90412-8

66. Gigerenzer, G., Goldstein, D.G.: Reasoning the fast and frugal way: models of bounded rationality. Psychol. Rev. **103**(4), 650–669 (1996). https://doi.org/10.1093/acprof:oso/9780199744282.003.0002

67. Simon, A.B.: A Study of Decision-Making Processes in Administrative Organizations, 4th edn. The Free Press, New York (1997)
68. Basadur, M., Thompson, R.: Usefulness of ideation principle of extended effort in real world professional and managerial creative problem solving. J. Creative Behav. **20**(1), 23–34 (1986). https://doi.org/10.1002/j.2162-6057.1986.tb00414.x
69. Hepler, T.J., Feltz, D.L.: Take the first heuristic, self-efficacy, and decision-making in sport. J. Exp. Psychol.: Appl. **18**(2), 154–161 (2012). https://doi.org/10.1037/a0027807
70. Johnson, J.G., Raab, M.: Take the first: option-generation and resulting choices. Organ. Behav. Hum. Decis. Process. **91**, 215–229 (2003). https://doi.org/10.1016/S0749-5978(03)00027-X
71. Raab, S., Laborde, S.: When to blink and when to think: preference for intuitive decisions results in faster and better tactical choices. Res. Q. Exerc. Sport **82**(1), 89–98 (2011). https://doi.org/10.1080/02701367.2011.10599725
72. Alter, A.L., Oppenheimer, D.M.: Uniting the tribes of fluency to form a metacognitive nation. Pers. Soc. Psychol. Rev. **13**(3), 219–235 (2009). https://doi.org/10.1177/1088868309341564
73. Greifeneder, R., Bless, H.: Relying on accessible content versus accessibility experiences: the case of processing capacity. Soc. Cogn. **25**(6), 853–881 (2007). https://doi.org/10.1521/soco.2007.25.6.853
74. Menon, G., Raghubir, P.: Ease-of retrieval as an automatic input in judgments: a mere-accessibility framework. J. Consum. Res. **30**(2), 230–243 (2003). https://doi.org/10.1086/376804
75. Novemsky, N., Dhar, R., Schwarz, N., Simonson, I.: Preference fluency in choice. J. Mark. Res. **44**(3), 347–356 (2007). https://doi.org/10.1509/jmkr.44.3.347
76. Onarheim, B., Christensen, B.T.: Distributed idea screening in stage-gate development process. J. Eng. Des. **23**, 660–673 (2012). https://doi.org/10.1080/09544828.2011.649426
77. Schwarz, N.: Accessible content and accessibility experiences: the interplay of declarative and experiential information in judgment. Pers. Soc. Psychol. Rev. **2**(2), 87–99 (1998). https://doi.org/10.1207/s15327957pspr0202_2
78. Schwarz, N.: Metacognitive experience in consumer judgment and decision making. J. Consum. Psychol. **14**(4), 332–348 (2004). https://doi.org/10.1207/s15327663jcp1404_2
79. Tversky, A., Kahneman, D.: Availability: a heuristic for judging frequency and probability. Cogn. Psychol. **5**, 207–232 (1973). https://doi.org/10.1016/0010-0285(73)90033-9
80. Rawson, K.A., Dunlosky, J.: Are performance predictions for text based on ease of processing? J. Exp. Psychol. **28**(1), 69–80 (2002). https://doi.org/10.1037//0278-7393.28.1.69
81. Topolinski, S.: A process model of intuition. Eur. Rev. Soc. Psychol. **22**(1), 274–315 (2011). https://doi.org/10.1080/10463283.2011.640078
82. Kahneman, D., Tversky, A.: Subjective probability: a judgment of representativeness. Cogn. Psychol. **3**, 430–454 (1972). https://doi.org/10.1016/0010-0285(72)90016-3
83. Kahneman, D., Tversky, A.: On the psychology of prediction. Psychol. Rev. **80**(4), 237–251 (1973). https://doi.org/10.1037/h0034747
84. Klein, G., Calderwood, R., Clinton-Cirocco, A.: Rapid decision making on the fire ground: the original study plus a postscript. J. Cogn. Eng. Decis. Making **4**(3), 186–209 (2010). https://doi.org/10.1518/155534310x128448000801203
85. Antucheviciene, J., Kala, Z., Marzouk, M., Vaidogas, E.R.: Solving civil engineering problems by means of fuzzy and stochastic MCDM methods: current state and future research. Math. Probl. Eng. **2015**, Article ID 362579, 1–16 (2015). https://doi.org/10.1155/2015/362579
86. Bragge, K., Korhonen, P., Wallenius, H., Wallenius, J.: Scholarly communities of research in multiple criteria decision making: a bibliometric research profiling study. Int. J. Inf. Technol. Decis. Making **11**(2), 401–426 (2012). https://doi.org/10.1142/S0219622012400081

87. Mardani, A., Josoh, A., Nor, KMD., Khalifah, Z., Zakwan, N., Valipour, A.: Multiple criteria decision-making techniques and their applications—a review of the literature from 2000 to 2014. Econ. Res. **28**(1), 516–571 (2015). https://doi.org/10.1080/1331677x.2015.1075139

88. Okudan, G.E., Tauhid, S.: Concept selection methods—a literature review from 1980 to 2008. Int. J. Des. Eng. **1**(3), 243–277 (2008). https://doi.org/10.1504/IJDE.2008.023764

89. Zavadskas, E.K., Turskis, Z., Kildiene, S.: State of the art surveys of overviews on MCDM/MADM methods. Technol. Econ. Dev. Econ. **20**(1), 165–179 (2014). https://doi.org/10.3846/20294913.2014.892037

90. Zavadskas, E.K., Turskis, Z.: Multiple criteria decision making (MCMD) methods in economics: an overview. Technol. Econ. Dev. Econ. **17**(2), 397–427 (2011). https://doi.org/10.3846/20294913.2011.593291

91. Akhavi, G., Hayes, C.C.: Decision making in engineering design tasks: do designers benefit from representations of uncertainty. In: Proceedings of the Human Factors and Ergonomics Society 51st Annual Meeting, Baltimore, MD (2007). https://doi.org/10.1177/154193120705100447

92. Frey, D.D., Herder, P.M., Wijnia, Y., Subrahmanian, E., Katsikopoulos, K.I., Clausing, D.P.: The pugh controlled convergence method: model-based evaluation and implications for design theory. Res. Eng. Des. **20**, 41–58 (2009).https://doi.org/10.1007/s00163-008-0056-z

93. Frey, D.D., Herder, P.M., Wijnia, Y., Subrahmanian, E., Katsikopoulos, K.I., Clausing, D.P.: An evaluation of the pugh controlled convergence method. In: Proceedings of the ASME DETC: Design Engineering Technical Conference, pp. 1–11. Las Vegas, Nevada (2007). https://doi.org/10.1115/DETC2007-34758

94. Hazelrigg, G.A.: Validation of engineering design alternative selection methods. Eng. Optim. **32**(2), 103–120 (2003). https://doi.org/10.1080/0305215031000097059

95. Hitt, M.A., Tyler, B.B.: Strategic decision models: integrating different perspectives. Strateg. Manag. J. **12**, 327–351 (1991). https://doi.org/10.1002/smj.4250120502

96. Pugh, S.: Total Design: Integrated Methods for Successful Product Engineering. Addison-Wesley, New York (1991)

97. Girod, M., Elliott, A.C., Burns, N.D., Wright, I.C.: Decision making in conceptual engineering design: an empirical investigation. In: Proceedings of the Institution of Mechanical Engineers, vol. 217, no. 9, pp. 1215–1228. https://doi.org/10.1243/095440503322420142

98. Toh, C.A., Miller, S.R.: How engineering teams select design concepts: a view through the lens of creativity. Des. Stud. **38**, 111–138 (2015). https://doi.org/10.1016/j.destud.2015.03.001

99. Dannels, D.P., Martin, K.N.: Critiquing critiques: a genre analysis of feedback across novice to expert design studios. J. Bus. Tech. Commun. **22**(2), 135–159 (2008). https://doi.org/10.1177/1050651907311923

100. Goldschmidt, G., Hochman, H., Dafni, I.: The design studio 'Crit': teacher-student communication. Artif. Intell. Eng. Des. Anal. Manuf. **24**, 285–302 (2010). https://doi.org/10.1017/S089006041000020X

101. Hammond, K.R., Hamm, R.M., Grassia, J., Pearson, T.: Direct comparison of the efficacy of intuitive and analytical cognition in expert judgment. IEEE Trans. Syst., Man, Cybern. **SMC-17**(5), 753–770 (1987). https://doi.org/10.1109/TSMC.1987.6499282

102. Hogarth, R.: Intuition: a challenge for psychological research on decision making. Psychol. Inq. **21**, 338–353 (2010). https://doi.org/10.1080/1047840X.2010.520260

103. Dayan, M., Elbanna, S.: Antecedents of team intuition and its impact on the success of new product development projects. J. Prod. Innov. Manage. **28**(1), 159–174 (2011). https://doi.org/10.1111/j.1540-5885.2011.00868.x

104. Dijksterhuis, A., Bos, M.W., Nordgren, L.F., van Baaren, R.B.: On making the right choice: the deliberation-without-attention effect. Science **311**(5763), 1005–1007 (2006). https://doi.org/10.1126/science.1121629

105. Guss, C.D., Evans, J., Murray, D., Schaub, H.: Conscious versus unconscious processing in dynamic decision making tasks. In: Proceedings of the Human Factors and Ergonomics Society, 53rd Annual Meeting, pp. 227–231 (2009). https://doi.org/10.1518/107118109X12524441080182

106. Ham, J., van den Bos, K., Van Doorn, E.A.: Lady justice thinks unconsciously: unconscious thought can lead to more accurate justice judgments. Soc. Cogn. **27**(4), 509–521 (2009). https://doi.org/10.1521/soco.2009.27.4.509

107. Harteis, C., Gruber, H.: Intuition and professional competence: intuitive versus rational forecasting of the stock market. Vocations Learn. **1**, 71–85 (2008). https://doi.org/10.1007/s12186-007-9000-z

108. Hicks, J.A., Cicero, D.C., Trent, J., Burton, C.M., King, L.A.: Positive affect, intuition, and feelings of meaning. J. Pers. Soc. Psychol. **98**(6), 967–979 (2010). https://doi.org/10.1037/a0019377

109. Lawrence, M., Goodwin, P., O'Connor, M., Onkal, D.: Judgmental forecasting: a review of progress over the last 25 years. Int. J. Forecast. **22**, 493–518 (2006). https://doi.org/10.1016/j.ijforecast.2006.03.007

110. Ritchie, W.J., Kolodinsky, R.W., Eastwood, K.: Does executive intuition matter? An empirical analysis of its relationship with nonprofit organization financial performance. Nonprofit Voluntary Sector Q. **36**(1), 140–155 (2007). https://doi.org/10.1177/0899764006293338

111. Sadler-Smith, E.: Cognitive style and the management of small and medium-sized enterprises. Organ. Stud. **25**(2), 155–181 (2004). https://doi.org/10.1177/0170840604036914

112. Strick, M., Dijksterhuis, A., Bos, M., Sjoerdsma, A., van Baaren, R.B., Nordgren, L.F.: A meta-analysis on unconscious thought effects. Soc. Cogn. **29**(6), 738–762 (2011). https://doi.org/10.1521/soco.2011.29.6.738

113. Acker, F.: New findings on unconscious versus conscious thought in decision making: additional empirical data and meta-analysis. Judgment Decis. Making **3**(4), 292–303 (2008)

114. Dean, J.W., Jr., Sharfman, M.P.: Does decision process matter? A study of strategic decision-making effectiveness. Acad. Manag. J. **39**(2), 368–396 (1996). https://doi.org/10.2307/256784

115. Elbanna, S., Naguib, R.: How much does performance matter in strategic decision making. Int. J. Prod. Perform. Manage. **58**(5), 437–459 (2009). https://doi.org/10.1108/17410400910965715

116. Elbanna, S., Child, J.: Influences on strategic decision effectiveness: development and test of an integrative model. Strateg. Manag. J. **28**, 431–453 (2007). https://doi.org/10.1002/smj.597

117. Huizenga, H.M., Wetzels, R., van Ravenzwaaij, D., Wagenmakers, E.-J.: Four empirical tests of unconscious thought theory. Organ. Behav. Hum. Decis. Process. **117**, 332–340 (2012). https://doi.org/10.1016/j.obhdp.2011.11.010

118. Kahneman, D., Klein, G.: Conditions for intuitive expertise. Am. Psychol. **64**(6), 515–526 (2009). https://doi.org/10.1037/a0016755

119. Albrechtsen, J.S., Meissner, C.A., Susa, K.J.: Can intuition improve deception detection performance? J. Exp. Soc. Psychol. **45**, 1052–1055 (2009). https://doi.org/10.1016/j.jesp.2009.05.017

120. Ambady, N., Rosenthal, R.: Thin slices of expressive behavior as predictors of interpersonal consequences: a meta-analysis. Psychol. Bull. **111**(2), 256–274 (1992). https://doi.org/10.1037/0033-2909.111.2.256

121. Ambady, N.: The perils of pondering: intuition and thin slice judgments. Psychol. Inq. **21**, 271–278 (2010). https://doi.org/10.1080/1047840X.2010.524882

122. Ambady, N., Rosenthal, R.: Half a minute: predicting teacher evaluations from thin slices of nonverbal behavior and physical attractiveness. J. Pers. Soc. Psychol. **62**(3), 431–441 (1993). https://doi.org/10.1037/0022-3514.64.3.431

123. Bennis, W.M., Pachur, T.: Fast and frugal heuristics is sports. Psychol. Sport Exerc. **7**, 611–629 (2006). https://doi.org/10.1016/j.psychsport.2006.06.002

124. Hogarth, R.M., Karelaia, N.: Heuristic and linear models of judgment: matching rules and environments. Psychol. Rev. **114**(3), 733–758 (2007). https://doi.org/10.1037/0033-295X.114.3.733

125. Thorngate, W.: Efficient decision heuristics. Behav. Sci. **25**, 219–225 (1980). https://doi.org/10.1002/bs.3830250306

126. Bingham, C.B., Eisenhardt, K.M., Furr, N.R.: What makes a process a capability? Heuristics, strategy, and effective capture of opportunities. Strateg. Entrepreneurship J. **1**, 27–47 (2007). https://doi.org/10.1002/sej.1

127. Fredrickson, J.W., Mitchell, T.R.: Strategic decision process: comprehensiveness and performance in an industry with an unstable environment. Acad. Manag. J. **27**(2), 399–423 (1984). https://doi.org/10.5465/255932

128. Danziger, S., Levav, J., Avnaim-Pesso, L.: Extraneous factors in judicial decisions. In: Proceedings of the National Academy of Science, vol. 108, no. 17, pp. 6889–6892 (2011). https://doi.org/10.1073/pnas.1018033108

129. Dawes, R.M., Faust, D., Meehl, P.E.: Clinical versus actuarial judgment. Science **243**(4899), 1668–1674 (1989). https://doi.org/10.1126/science.2648573

130. De Dombal, F.T., Leaper, D.J., Horrocks, J.C., Staniland, J.R., McCann, A.P.: Human and computer-aided diagnosis of abdominal pain: further report with emphasis on performance of clinicians. Br. Med. J. **1**, 376–380 (1974). https://doi.org/10.1136/bmj.1.5904.376

131. Dhami, M.K.: Psychological models of professional decision making. Psychol. Sci. **14**(2), 175–180 (2003). https://doi.org/10.1111/1467-9280.01438

132. Einhorn, H.J.: Expert measurement and mechanical combination. Organ. Behav. Human Perform. **7**, 86–106 (1972). https://doi.org/10.1016/0030-5073(72)90009-8

133. Grove, W.M., Zald, D.H., Lebow, B.S., Snitz, B.E., Nelson, C.: \Clinical versus mechanical prediction: a meta analysis. Psychol. Assess. **12**(1), 19–30 (2000). https://doi.org/10.1037//1040-3590.12.1.19

134. Grove, W.M., Meehl, P.E.: Comparative efficiency of informal (subjective, impressionistic) and formal (mechanical, algorithmic) prediction procedures: the clinical-statistical controversy. Psychol., Public Policy, Law **2**(2), 293–323 (1996). https://doi.org/10.1037/1076-8971.2.2.293

135. Sawyer, J.: Measurement and prediction, clinical and statistical. Psychol. Bull. **66**(3), 178–200 (1966). https://doi.org/10.1037/h0023624

136. Cooper, R., Edgett, S., Kleinschmidt, E.: Portfolio management for new product development: results of an industry practices study. R&D Manage. **31**(4), 361380 (2001). https://doi.org/10.1111/1467-9310.00225

137. Kleinmuntz, B.: Why we still use our heads instead of formulas: toward an integrative approach. Psychol. Bull. **107**(3), 296–310 (1990). https://doi.org/10.1037/0033-2909.107.3.296

138. Moritz, B., Siemsen, E., Kremer, M.: Judgmental forecasting: cognitive reflection and decision speed. Prod. Oper. Manage. **23**(7), 1146–1160 (2014). https://doi.org/10.1111/poms.12105

139. Nordgren, L.F., Bos, M.W., Dijksterhuis, A.: The best of both worlds: integrating conscious and unconscious thought best solves complex decisions. J. Exp. Soc. Psychol. **47**, 509–511 (2011). https://doi.org/10.1016/j.jesp.2010.12.007

Improvisation

<div style="text-align: right">**6**</div>

6.1 Introduction

Sometimes we don't have time to go through all of the steps and iterations of design. Sometimes we just have to get it done right now! Sometimes we just have to improvise. Improvisation is a special type of design in which all three of the universal design activities (clarify a project, generate ideas, select one idea for implementation) are completed virtually simultaneously instead of iteratively. During improvisation, there is little, if any, time for planning. This chapter reviews improvisation and the ways that artists and engineers tend to improvise (artistic and organizational improvisation, respectively), as well as identifies ways to improve our ability to improvise.

6.2 What is Improvisation?

In its most fundamental form, improvisation involves quickly responding to the conditions we are experiencing in ways that cannot be predicted or anticipated. Because we can't predict our response, improvisation relies heavily on intuition. We don't think too much about what we do, we just do [1–8]. We don't take the time to think, plan or analyze while improvising. In fact, planning can make improvisation less successful [9].

Improvisation, however, is not random. It has the significant constraint of being compatible with the current state of affairs, i.e., it must address the purpose of the design project. A musical improvisation must be consistent with the overall framework of the tune and what has just been performed. The brushstrokes of an intuitive painter must fit the mood and style of the rest of the painting. An engineering improvisation must still address the needs of the current project.

© The Author(s), under exclusive license to Springer Nature Switzerland AG 2022
J. Reis, *Advanced Design*, https://doi.org/10.1007/978-3-030-95782-7_6

Improvisation appears to be one of the very few activities that simultaneously engage both the neural systems of the Default Network used primarily by intuition and the Executive Control Network used primarily by analysis [10–21]. As a result, improvisation may simultaneously involve some elements of both analytical and intuitive thought.

Successful improvisation depends on relevant prior experience, both within our respective design disciplines (domain-specific experience) and/or with improvisation itself (domain-general experience).

1. Domain-Specific Experience: The more experiences we have within our specific discipline, the more relevant information we have stored in our memories that we can use as seed ideas. To be useful during improvisation, this information must be integrated and internalized to a point where we can use it unconsciously. This internalization process can take years to evolve and may involve hundreds of relevant experiences [22–25].
2. Domain-General Experience. The more domain-general experience we have with improvisation itself, the more effectively we can do it. Improvisation trains us to simultaneously use both our Default and Executive Control Networks and to simultaneously engage in all three of the universal design activities. We can enhance our ability to improvise in our professional discipline by practicing improvisation in an unrelated area [7, 21, 24, 26–31].

Although mastery of improvisation at a professional level typically requires years of relevant experience, we can learn to improvise at any level of experience. We find simple ways to practice improvisation in any area using whatever skills we have. We learn improvisation by practicing improvisation. We learn design by practicing design.

A key difference between traditional design and improvisation is that traditional design involves iterating among the three universal design activities over a period of time while improvisation involves simultaneously doing all three activities without iteration. Improvisation is based on the *Take the First* heuristic without any conscious screening to see if an idea is useful. Unconscious screening for usefulness, however, does occur and improves with practice.

6.3 Types of Improvisation

There are two primary types of improvisation: artistic and organizational improvisation. Artistic improvisation is most commonly used by visual artists (such as painters doing intuitive painting) and performing artists (such as musicians, actors, and dancers). Organizational improvisation is most commonly used by engineers and organizational executives.

Although there are some common elements between these types of improvisation, such as making quick decisions without planning while staying within the context of an overall purpose, there are some significant differences. [32] Two of these differences are

- Artistic improvisation tends to involve a gentle sense of timelessness while organizational improvisation tends to involve an intense sense of time pressure,
- Artistic improvisation tends to rely more on domain-specific experience while organizational improvisation tends to rely more on domain-general experience.

We will now take a closer look at these two types of improvisation.

6.3.1 Artistic Improvisation

The sense of timelessness encountered during artistic improvisation tends to induce the Intuition of Idea Generation. This timelessness is often experienced as a flow state, or being "in the zone". Flow is a very enjoyable state of awareness in which our actions merge with our awareness. In this state, we become totally absorbed in what we are doing. Although we are very aware of our actions and we remain in control of them, our actions occur effortlessly and without conscious thought [33–37].

Artistic improvisation tends to occur spontaneously within a very short time scale, a few seconds or less. Musicians perform their next note as they improvise without any noticeable time delay from their previous note. Although they may have a sense of possibilities for that next note as they are playing the previous one, they may not consciously know what that next note will be until they play it. Intuitive painters often make their next brushstroke without conscious thought.

Artists gain significant domain-specific experience for improvisation through hundreds to thousands of hours of practice within the narrow context of their discipline. Jazz musicians often memorize and rehearse hundreds of "licks" (short musical phrases) to build their personal improvisational repertoire. Effective intuitive painters tend to have the prior experience of dozens if not hundreds of completed paintings within their style of painting. Because of this extensive domain-specific experience, artists tend to get limited additional benefit from engaging in improvisation outside of their discipline.

6.3.2 Organizational Improvisation

Unlike artistic improvisation, organizational improvisation generally occurs during a state of intense time pressure. As a result, a flow state rarely occurs unless the improvisor truly enjoys working under such pressure. The time pressures typically associated with organizational improvisation tend to inhibit our idea generation and limits our ability to evaluate any ideas available to us [7, 32, 38, 39].

Organizational improvisation tends to occur over a longer time scale than artistic improvisation, although still too short for meaningful planning. Engineers and business executives may have a period of hours or days before they must make a selection. Although this period of time is sufficient for some conscious, analytical thought and even the completion of some very quick design cycles, it is normally insufficient to gather much additional information or to make detailed plans for how to implement the next steps.

Organizational improvisation tends to occur in fast-paced, unstable environments that perhaps have never existed before and will likely never exist again. Because of this lack of repetition, engineers and managers tend to not get much experience with repetitive, domain-specific experiences. This limits their ability to practice improvisation while on the job. They can, however, enhance their ability to improvise through seeking experiences with improvisation outside of their discipline. Many successful engineering designers have hobbies that utilize artistic improvisation. We learn improvisation by practicing improvisation. We practice the changes that we want.

6.4 Closing

The key conclusions from this chapter are

1. Improvisation occurs when we rapidly respond to external conditions without taking the time to think, plan, or analyze.
2. Improvisation is not random. It requires actions that are compatible with the current state of affairs and what just happened.
3. Improvisation simultaneously engages the Default Network in the brain, which is correlated with intuitive thought, and the Executive Control Network, which is correlated with analytical thought.
4. Our ability to improvise can be enhanced by practicing improvisation through either relevant domain-specific improvisational activities (improvisation within our discipline) or domain-general improvisational activities (improvisation outside of our discipline).
5. Unlike traditional design, improvisation does not involve iteration. All three of the universal design activities are engaged virtually simultaneously. The first idea is immediately implemented through the *Take the First* heuristic.
6. There are two primary types of improvisation: artistic and organizational.

 a. Artists tend to engage in artistic improvisation and engineers tend to engage in organizational improvisation.
 b. Artistic improvisation involves a sense of timelessness, while organizational improvisation involves a sense of intense time pressure.

c. Artistic improvisation occurs over a very short time period, perhaps as long as a few seconds, while organizational improvisation occurs over a longer time period, perhaps days.
d. Artistic improvisation tends to rely on domain-specific experiences, while organizational improvisation tends to rely more on domain-general experiences.

6.5 Questions

1. What do you do when you need to get something done in a very short period of time and don't have a clue what to do?
2. Have you ever experienced flow? What can you do to induce it?
3. Have your ever engaged in artistic improvisation? Can you describe what you did? How did it feel? How is it different from other activities?
4. Have your ever engaged in organizational improvisation? Can you describe what you did? How did it feel? How is it different from other activities?
5. Although improvisation at a professional level tends to require years of relevant experience, improvisation can be done with any level of experience. Artists can improvise with a color palette that does not require any knowledge of how to mix colors. Engineers can improvise with prototypes. We can even practice improvisation by banging a stick on the ground and experimenting with different rhythms, particularly when we do it with others. We learn improvisation by practicing improvisation. What are some ways that you can begin improvising in areas in which you have minimal experience?

References

1. Akgun, A.E., Byrne, J.C., Lynn, G.S., Keskin, H.: New product development in turbulent environments: impact of improvisation and unlearning on new product performance. J. Eng. Tech. Manag. **24**, 203–230 (2007). https://doi.org/10.1016/j.jengtecman.2007.05.008
2. Biasutti, M., Frezza, L.: Dimensions of music improvisation. Creat. Res. J. **21**(2–3), 232–242 (2009). https://doi.org/10.1080/10400410902861240
3. Biasutti, M.: Teaching improvisation through process. Applications in music education and implications for general education. Front. Psychol. **8**, Article 911, 1–8 (2017). https://doi.org/10.3389/fpsyg.2017.00911
4. Lemons, G.: When the horse drinks: enhancing everyday creativity using elements of improvisation. Creat. Res. J. **17**(1), 25–36 (2005). https://doi.org/10.1207/s15326934crj1701_3
5. Leybourne, S., Sadler-Smith, E.: The role of intuition and improvisation in project management. Int. J. Project Manag. **24**, 483–492 (2006). https://doi.org/10.1016/j.ijproman.2006.03.007
6. Mendonca, D., Wallace, W.A.: Cognition in Jazz improvisation: an exploratory study. In: Proceedings of the Annual Meeting of the Cognitive Science Society, UC Merced, Jan. 2004
7. Miner, A.S., Bassoff, P., Moorman, C.: Organizational improvisation and learning: a field study. Adm. Sci. Q. **46**(2), 304–337 (2001). https://doi.org/10.2307/2667089

8. Sawyer, K.: Improvisational creativity: an analysis of jazz performance. Creat. Res. J. **5**(3), 253–263 (1992). https://doi.org/10.1080/10400419209534439
9. Kozbelt, A.: Hierarchical linear modeling of creative artists' problem solving behavior. J. Creat. Behav. **42**(3), 181–200 (2008). https://doi.org/10.1002/j.2162-6057.2008.tb01294.x
10. Bengtsson, S.L., Csikszentmihalyi, M., Ullen, F.: Cortical regions involved in the generation of musical structures during improvisation of pianists. J. Cogn. Neurosci. **19**(5), 830–842 (2007). https://doi.org/10.1162/jocn.2007.19.5.830
11. Berkowitz, A.L., Ansari, D.: Expertise-related deactivation of the right temporoparietal junction during musical improvisation. Neuroimage **49**, 712–719 (2010). https://doi.org/10.1016/j.neuroimage.2009.08.042
12. Berkowitz, A.L., Ansari, D.: Generation of novel motor sequences: the neural correlates of musical improvisation. Neuroimage **41**, 535–543 (2008). https://doi.org/10.1016/j.neuroimage.2008.02.028
13. Brown, S., Martinez, M.J., Parsons, L.M.: Music and language side by side in the brain: a PET study of the generation of melodies and sentences. Eur. J. Neurosci. **23**, 2791–2803 (2006). https://doi.org/10.1111/j.1460-9568.2006.04785.x
14. Dikiy, I.S., Dikaya, L.A., Skirtach, I.A.: Interhemispheric functional organization of brain cortex in musicians during improvisation. Int. J. Psychophysiol. **94**, 127 (2014). https://doi.org/10.1016/j.ijpsycho.2014.08.606
15. Fink, A., Graif, B., Neubauer, A.C.: Brain correlates underlying creative thinking: EEG alpha activity in professional vs. novice dancers. Neuroimage **46**, 854–862 (2009)
16. Limb, C.J., Braun, A.R.: Neural substrates of spontaneous music performance: an fMRI study of jazz improvisation. PLoS ONE **3**(2), e1670, 195 (2008). https://doi.org/10.1371/journal.pone.0001679
17. Liu, S., Chow, H.M., Xu, Y., Erkkinen, M.G., Swett, K.E., Eagle, M.W., Rizik-Baer, D.A., Braun, A.R.: neural correlates of lyrical improvisation: an fMRI study of freestyle rap. Sci. Rep. **2**, Article 834 (2012). https://doi.org/10.1038/srep00834
18. McPherson, M.J., Barrett, F.S., Lopez-Gonzalez, M., Jiradejvong, P., Limb, C.J.: Emotional intent modulates the neural substrates of creativity: an fMRI study of emotionally targeted improvisation in jazz musicians. Sci. Rep. **6**, Article 18460, 1–14 (2016). https://doi.org/10.1038/srep18460
19. Pinho, A.L., de Manzano, O., Fransson, P., Eriksson, H., Ullen, F.: Connecting to create: expertise in musical improvisation is associated with increased functional connectivity between premotor and prefrontal areas. J. Neurosci. **34**(18), 6156–6163 (2014). https://doi.org/10.1523/JNEUROSCI.4769-13.2014
20. Pinho, A.L., Ullen, F., Castelo-Branco, M., Fransson, P., de Manzano, O.: Addressing a paradox: dual strategies for creative performance in introspective and extrospective networks. Cereb. Cortex **26**, 3052–3063 (2016). https://doi.org/10.1093/cercor/bhv130
21. Przysinda, E., Zeng, T., Maves, K., Arkin, C., Loui, P.: Jazz musicians reveal role of expectancy in human creativity. Brain Cogn. **119**, 45–53 (2017). https://doi.org/10.1016/j.bandc.2017.09.008
22. Madura, P.D.: Relationships among vocal jazz improvisation achievement, jazz theory knowledge, imitative ability, musical experience, creativity, and gender. J. Res. Music Educ. **44**(3), 252–267 (1996). https://doi.org/10.2307/3345598
23. Ohly, S., Sonnentag, S., Pluntke, F.: Routinization, work characteristics and their relationships with creative and proactive behaviors. J. Organ. Behav. **27**, 257–279 (2006). https://doi.org/10.1002/job.376
24. Palmer, C.M.: Instrumental jazz improvisation development: characteristics of novice, intermediate, and advanced improvisors. J. Res. Music Educ. **64**(3), 360–378 (2016). https://doi.org/10.1177/0022429416664897
25. Savrami, K.: A duet between science and art: neural correlates of dance improvisation. Res. Dance Educ. **18**(3), 273–290 (2017). https://doi.org/10.1080/14647893.2017.1369509

26. Beaty, R.E., Smeckens, B.A., Silvia, P.J., Hodges, D.A., Kane, M.J.: A first look at the role of domain-general cognitive and creative abilities in jazz improvisation. Psychomusicol. Music Mind Brain 23(4), 262–268 (2013). https://doi.org/10.1037/a0034968

27. Benedek, M., Borovnjak, B., Neubauer, A.C., Kruse-Weber, S.: Creativity and personality in classical, jazz, and folk musicians. Personality Individ. Differ. 63, 117–121 (2014). https://doi.org/10.1016/j.paid.2014.01.064

28. Fink, A., Woschnjak, S.: Creativity and personality in professional dancers. Personal. Individ. Differ. 51, 754–758 (2011). https://doi.org/10.1016/j.paid.2011.06.024

29. Gerber, E.: Improvisation principles and techniques for design. In: Proceedings of the CHI 2007 Conference on Human Factors in Computing Systems, San Jose, CA, April 28–May 3 (2007). https://doi.org/10.1145/1240624.1240786

30. Lewis, C., Lovatt, P.J.: Breaking away from set patterns of thinking: improvisation and divergent thinking. Think. Skills Creativ. 9, 46–58 (2013). https://doi.org/10.1016/j.tsc.2013.03.001

31. Vera, D., Crossan, M.: Improvisation and innovation performance in teams. Org. Sci. 16(3), 203–224 (2005). https://doi.org/10.1287/orsc.1050.0126

32. Barrett, F.J.: Coda-creativity and improvisation in jazz and organizations: implications for organizational Learning. Organ. Sci. 9(5), 605–622 (1998). https://doi.org/10.1287/orsc.9.5.605

33. Byrne, C., MacDonald, R., Carlton, L.: Assessing creativity in musical compositions: flow as an assessment tool. Br. J. Music Educ. 20, 277–290 (2003). https://doi.org/10.1017/s0265051703005448

34. Csikszentmihalyi: Flow: The Psychology of Optimal Experience. Harper and Row, New York (1990)

35. Csikszentmihalyi, M.: Play and intrinsic rewards. J. Humanis. Psychol. 15(3), 41–63 (1975). https://doi.org/10.1177/002216787501500306

36. Gruzelier, J., Inoue, A., Smart, R., Steed, A., Steffert, T.: Acting performance and flow state enhanced with sensory-motor rhythm neurofeedback comparing ecologically valid VR and training screen scenarios. Neurosci. Lett. 480, 112–116 (2010). https://doi.org/10.1016/j.neulet.2010.06.019

37. Jackson, S.A.: factors influencing the occurrence of flow state in elite athletes. J. Appl. Sports Psychol. 7, 138–166 (1995). https://doi.org/10.1080/10413209508406962

38. Barrett, F.J.: Managing and improvising: lessons from jazz. Career Dev. Int. 3(7), 283–286 (1998). https://doi.org/10.1108/13620439810240719

39. Chelariu, C., Johnston, W.J., Young, L.: Learning to improvise, improvising to learn. a process of responding to complex environments. J. Bus. Res. 55, 141–147 (2002). https://doi.org/10.1016/S0148-2963(00)00149-1

What Makes a Good Designer?

<div align="right">

7

</div>

7.1 Introduction

Although we have already seen that we can learn and enhance our designs, let's face it; some of us are just better designers than others. Some of us can just get it done. So, what makes a good designer? This chapter starts by reviewing the behaviors of expert designers relative to novice designers. The chapter then turns to the psychological profile of effective designers, including the role of flexibility in thinking and the control of our attention. It then closes with a review of how our cultural background can play a role in our design effectiveness.

7.2 Behaviors of Effective Designers

Effective or expert designers approach design differently than novice designers. Expert designers use a more structured, formalized, and systematic approach to design while novices use a more random, trial and error approach based on guesswork. Experts tend to have a plan for how to approach design, such that outlined in this book, while novices do not [1–12].

Experts spend more time than novices clarifying their project before advancing to other design activities. They do more background research and gather more task-relevant information early in the design process [4, 13–17]. Because of this, experts take a broader approach to a design project and are less likely to be biased by how a design project is framed, i.e., a project being framed as original/useful or creative/conservative [18]. Biases will be discussed in greater detail in a later chapter.

Experts are more effective than novices in generating ideas. Experts spend more time generating ideas and generate more ideas than do novices [1, 7, 19–23]. The ideas generated by effective designers tend to be associated with deeper, more

J. Reis, *Advanced Design*, https://doi.org/10.1007/978-3-030-95782-7_7

subtle, structural issues of the design project, while those of novices tend to focus on functional or superficial aspects [20, 24–27].

Experts are also more effective in making their final selection than are novices. Experts use a broader range of information in making their final selection and rely less on single criteria methods (heuristics). Experts are also more effective in using their intuition in making their selections than are novices [28].

These differences in the behaviors of expert and novice designers are reflected in different neural processes within their respective brains. Expert designers truly do think differently than novice designers [29–32]. It is noted, however, that the difference between experts and novices may be greater for insight problems than it is for design problems [33–39].

7.3 Psychology of Effective Designers

There are many jokes about stereotypical artists and many jokes about stereotypical engineers. Some may even be true. Very few successful artists or engineers, however, truly fit within those stereotypes. Virtually all successful designers in any discipline are focused, hard workers who are dedicated to their design activities and approach them with professionalism [40–43]. Perhaps those stereotypes have been created by people in Disciplines of Discovery who do not really understand that people in the Disciplines of Creation truly think differently. Solving design problems requires a different approach than solving insight problems.

So, what are the psychological characteristics of a successful designer? Psychologists have devised many tests to identify characteristics and traits that differentiate people from each other. Three of the tests that are relevant to design are:

- the Five-Factor Model of Personality (Big 5),
- the Myers Briggs Type Indicator (MBTI), and
- the Kirton Adaption-Innovation Inventory.

Perhaps the most widely used psychological test for creativity has been the Five-Factor Model of Personality (Big 5) [44, 45]. The BIG 5 describes human personality traits over five dimensions:

- Openness to Experience: This is a measure of how open or closed minded we are to being exposed to new ideas or experiences.
- Extroversion: This is a measure of how we engage with others, including how assertive we are in social situations.
- Neuroticism: This is a measure of our tendency toward emotional distress, including anxiety, frustration, fear, anger, guilt, worry, depressed mood, and loneliness.

- Agreeableness: This is a measure of how we approach our interpersonal behaviors, including warmth, friendliness, sympathy, and tact toward others.
- Conscientiousness: This is a measure of the diligence or care with which we approach our activities.

As we will see, only openness to experience is directly linked with the universal design activity of generating ideas, although some studies have shown a weak connection for Extraversion. Conscientiousness is the only trait that seems to be linked with the two universal design activities of clarifying the project and selecting one idea. Openness to Experience seems to be more closely linked with intuition and conscientiousness seems to be more closely linked with analysis.

The Myers Briggs Type Indicator (MBTI) is perhaps the most widely used psychology test used to study engineers [46]. The MBTI describes human personality traits over four dimensions:

- Extroversion Introversion: This is a measure of how we exchange personal energy with others. Extroverts tend to gain energy when interacting with others, while introverts tend to lose energy when interacting with others. This definition of extroversion is different (perhaps) from that of the Big 5. The Big 5 model tends to measure extroversion by how engaging we are in a social situation, while the MBTI tends to measure extroversion by how a social environment personally energizes us.
- Intuitive-Sensing: This is a measure of how a person likes to receive information. Intuitive people tend to prefer to develop their ideas internally, while sensing people tend to prefer to develop their ideas from information they obtain externally. This definition of intuition is different (perhaps) from the non-sequential thinking definition used in this book.
- Thinking-Feeling: This is a measure of how people like to make decisions. Thinking oriented people tend to use analytical or logical processes to make decisions, while feeling people tend to use their feelings to make decisions. This trait appears to be related to a person's preference for analytical or intuitive thinking or perhaps to a preference for externally- or internally-based heuristics.
- Judging-Perceiving: This is a measure of how we approach the external world. Judgers like a concrete world and perceivers prefer a more abstract world. This trait appears to be related to our tolerance for ambiguity, which is discussed below.

Of these traits, only the intuitive side of the Intuitive-Sensing dimension has been shown to be directly linked with the universal design activity of generating ideas, [47, 48] while the sensing, thinking and judging sides of the other three dimensions appear to be linked with the two universal design activities of clarifying the project and selecting one idea [49].

The final psychological test discussed here is the Kirton Adaption-Innovation Inventory. This test identifies designers who are more likely to adapt existing ideas (adapters) from those who are more likely to create new ideas (innovators).

Adaptors are people who do things better, while innovators are those who do things differently [50].

Adaptors appear to be more effective with the universal design activities of clarifying the project and selecting one idea while innovators appear to be more effective with the universal design activity of generating ideas. Since effective designers must successfully engage in all three of these activities, this psychology test may provide a way to identify how individual designers may specialize within the universal design activities [51–54].

One key point that has come from psychological studies related to design is that we can be effective designers no matter how we score on any of the tests. We may have activities that we are more comfortable with, such as a preference for intuitive versus analytical thinking or a preference for idea selection versus idea generation, but such preferences do not prevent us from being successful designers [42, 55–62]. One reason for this is that the three universal design activities are not completely independent of each other. If we are good at generating original ideas, we also tend to be good at identifying and selecting ideas [63–67]. Perhaps this is true because all three of the universal design activities require us to balance intuitive and analytical thinking. If we can maintain such a balance, we can successfully complete any of the universal design activities.

Deeper thought reveals there are common characteristics of effective designers that are not directly measured by these psychology tests. Some of the most important characteristics are flexibility in thinking and the ability to control our focus of attention. Some secondary characteristics that have a lesser impact include emotional stability, social orientation, intelligence, and gender. We will now look at those characteristics.

7.3.1 Flexibility in Thinking

Perhaps the most important characteristic of successful designers is flexibility in thinking, i.e., the ability to switch back and forth between the mental processing modes of intuition and analysis. It is not unusual for successful designers to switch thinking modes many times over the course of a project. In fact, it is not unusual for some designers to switch modes every few minutes [68, 69].

In addition to having the flexibility to switch thinking modes, successful designers must have the ability to use all parts of their brain through the design process. Although creativity and intuition are traditionally associated with the right hemisphere of the brain and logic and analysis are traditionally associated with the left hemisphere, neurological studies show a far more complex picture [70–90]. Perhaps a more accurate way to describe the difference between the hemispheres is that the right hemisphere is better at seeing the big picture (the forest) while the left hemisphere is better at seeing finer details (the trees) [91–93]. Effective designers must use both hemispheres of their brains, i.e., they must be able to see both the forest as a whole and the details of the individual trees; [94] they must be able to use both their intuition and analysis.

Neurological studies have shown that the openness to experience dimension of the Big 5, which is linked with creativity and idea generation, is not limited to the right hemisphere. In fact, it is correlated with neural networks across the entire brain. The remaining four traits of the Big 5, which have not been as strongly correlated with design effectiveness (if at all), have been linked with specific regions of the brain [95]. These observations provide neurological evidence that design success does not reside in one part or even one hemisphere of the brain: it requires the use of all of our brain.

So how can we, as designers, use all parts of our brains, or more importantly, improve our flexibility in thinking? Perhaps the most effective way is to practice switching between our intuitive and analytical modes of thought. Through experiencing what it feels like to need to switch and then to actually making the switch, we can get better at it. We must practice metacognition. To learn design, we must practice design.

One way to switch is to engage in activities that induce the desired mode of thinking. For example, we can ask "why" questions (why do things work?) which tend to induce an open, intuitive mode of thought. Conversely, we could ask "how" questions (how do things work?) which tend to induce a closed, analytical mode of thought.

To induce intuition, we can also engage in activities that involve unfocused or unconscious thought. This could be from something as simple as being distracted from what we are doing in a way that does not require focused thought, [96–100] or by doing something enjoyable [101]. Artists commonly do a series of warmup activities, i.e., a series of quick paintings or studies without any pressure for quality, before they engage in their primary work of the day.

To induce analysis we can engage in activities that involve almost any kind of focused thought, and in particular, activities that involve judgment.

Although there are currently no widely used tests to directly measure our flexibility in thinking, there are three well known traits that reflect such flexibility: Openness to Experience, Curiosity, and Tolerance for Ambiguity. These traits are discussed here.

7.3.1.1 Openness to Experience

Perhaps the most widely studied trait related to flexibility in thinking is the openness to experience trait of the Big 5. Of all of the psychological tests, this trait is the one most commonly linked to creativity (idea generation) [41, 102–110]. This trait is also linked to the Default Network of the brain, which further connects this trait to idea generation [111].

Openness to experience has been positively correlated with success for artists, scientists, [116–118] and engineers [43]. It has also been linked to academic grades in project classes, i.e., those that tend to involve design, but not with overall academic grades. Overall academic grades tend to be based on analytical thinking and memory [112–115].

7.3.1.2 Curiosity

A second trait linked with flexibility in thinking is curiosity. Curiosity is a desire to seek more information or a better understanding about some topic. Curiosity has been positively correlated with both idea generation and evaluation of ideas [119–121]. Curious people tend to ask more questions than less curious people and tend to seek more associations, relationships, and connections between different concepts [122–124]. Curious people also tend to have high self-efficacy (belief in their ability to succeed) and high self-esteem (they feel good about themselves). High self-efficacy and high self-esteem have both been correlated with creativity [125, 126].

One measure of curiosity is our interest in things outside of our primary discipline. Designers tend to be more successful when they have outside hobbies and interests [127, 128] and are less successful when they stay focused within their narrow discipline [124, 129]. However, merely looking outside of our discipline without making an effort to integrate what we might learn does not necessarily enhance our professional success [130].

Although curiosity has been linked to openness to experience [120, 131–133], which further connects it with creativity, curiosity has at least one significant difference from openness to experience; curiosity tends to drive activity and searches for new knowledge while openness to experience can be a willingness to accept new experiences without actually seeking them out. Curiosity tends to be active, while openness to experience can be passive.

Several different types of curiosity have been proposed, each impacting design in a different way: diversive and specific curiosities [131]. Diversive curiosity reflects a drive to explore unfamiliar and new topics while specific curiosity reflects a drive for a deeper understanding of a familiar topic. Diversive curiosity leads to a broad understanding of many different topics, which suggests right brain neural activity, while specific curiosity leads to mastery in narrower topics, which suggests left brain activity. Both types of curiosity have been positively linked to creativity [134, 135].

7.3.1.3 Tolerance of Ambiguity

A third trait linked with flexibility in thinking is our tolerance of ambiguity. Since design is inherently ill-defined, effective designers must be able to work within ambiguous situations without prematurely trying to resolve that ambiguity. We have already seen that premature selection of ideas is a leading cause of design failure. Deferral of resolution of ambiguity is an important component of creativity because it supports continued openness to new ideas during the design process [136, 137]. Our tolerance for ambiguity is correlated to our design effectiveness. If we have a high tolerance for ambiguity, we tend to be better at idea generation. Conversely, if we have a low tolerance for ambiguity, we tend to be better at idea evaluation (selection) [57, 138, 139]. As we have seen, our tolerance for ambiguity may be related to the Judging-Perceiving dimension of the Myers-Briggs Type Indicator.

A closely related trait is the need for cognitive closure. The need for cognitive closure involves a desire to attain closure (resolution of ambiguity) as soon as possible and an inclination to maintain closure for as long as possible. The need for cognitive closure includes an acute need for certainty, which is driven by a need to maintain high confidence in our own course of action or our solutions to problems. People with a high need for cognitive closure (low tolerance for ambiguity) are less able to generate ideas than those with a lower need for closure [140, 141]. People with a high need for closure tend to be more interested in science than design. Science, because it is a Discipline of Discovery, is focused on finding closure to insight problems [116]. Design, because it is within the Discipline of Creation, does not necessarily seek closure; it seeks to create something new. Design requires deferral of cognitive closure.

Our tolerance for ambiguity is reflected in our aesthetic preference for art. People with a low tolerance for ambiguity (high need for closure) tend to prefer representational art over nonrepresentational (abstract) art. To enjoy abstract art often requires an ability to suspend the need for closure, i.e., to suspend the need to find meaning and understanding [142, 143].

Our tolerance for ambiguity is related to our self-efficacy (our belief in our ability to succeed). The higher our self-confidence, the greater our ability to defer resolution of ambiguity. As we have already seen, people with high self-efficacy are more creative [125, 126].

A low tolerance for ambiguity and a high need for closure can induce analytical thinking to create closure. People with these traits can enhance their design effectiveness by practicing the deferral of closure, which can induce intuitive thinking. We can improve our ability to defer closure by practicing withholding judgment as we gently reflect on ambiguous ideas [144]. We learn design by practicing design.

7.3.2 Control of Attention

Another important characteristic of successful designers is the ability to control our attention regarding what needs done at any particular time [145]. Design is a multi-task process and we often need to remain focused on the immediate task and not be distracted by tasks we may have just worked on or that need our attention in the future [146, 147].

Although there are no widely used psychological tests relative to design that directly measure our ability to control our attention, there are several indirect measures. Two such measures will be discussed here: conscientiousness and our ability to handle distractions, i.e. latent inhibition.

7.3.2.1 Conscientiousness
One of the measures of how we control our attention is our conscientiousness. Conscientiousness, one of the traits in the Big 5, is a measure of the diligence or care with which we approach our activities. It is a measure of our ability to remain focused on a project long enough to complete it. It reflects a desire for stability and

a need for closure, i.e., low risk environment. It is also a measure of closed-mindedness and conventional thinking (the opposite of flexibility) [41].

Conscientiousness is positively correlated with our ability to evaluate ideas, as measured by overall academic grades, which reflects analytical thinking, [112–115, 148, 149] but is negatively associated with our ability to generate ideas [108, 150].

Conscientiousness has been correlated with success for professional engineers [151]. It is noted, however, that engineers tend to become less conscientious and more flexible as they get more education through graduate studies [43]. Paradoxically, we have already seen that graduate level education can lead to reduced creativity because it often tends to be focused on analytical thinking [152]. This suggests that graduate studies can both enhance and inhibit design effectiveness.

7.3.2.2 Latent Inhibition

Another measure of our ability to control our attention is how we unconsciously inhibit information from our attention, i.e., how we handle distractions. We are constantly bombarded with information that demands our attention, from thoughts to external sensory stimuli (visual, auditory, touch, etc.). It is not humanly possible to pay attention to everything around and within us. To survive, we automatically inhibit our awareness of most sensory information and actually discard information that we unconsciously judge irrelevant to our immediate needs. Such suppression of awareness of information is called latent inhibition. High levels of latent inhibition indicate high levels of unconscious suppression of information, while low levels provide more conscious choices for what we suppress and what we bring into our awareness.

Latent inhibition, although necessary for survival, comes at a cost. We do not consciously choose what information comes into our attention. Our unconscious judgments, with all of their biases (discussed in a later chapter), determine what comes into our awareness without us even knowing about it.

Our level of latent inhibition reflects our effectiveness with design. Creative people, i.e., those who are better at generating ideas, tend to be less inhibited (have lower levels of latent inhibition). Creative people have a broader, more diffuse focus of attention than those with higher latent inhibition and its corresponding narrower focus of attention [145, 153–160]. Designers with higher levels of latent inhibition and a narrower focus of attention tend to be less effective in generating ideas but can be more effective in evaluating ideas [156, 161, 162]. Our level of latent inhibition appears to be imbedded in our neural activity [163].

7.3.3 Secondary Characteristics

In addition to the above-mentioned characteristics of effective designers, i.e., flexibility in thinking and control of our attention, other psychological characteristics may also impact our design effectiveness, but perhaps to a lesser level. Some of these secondary characteristics include our emotional stability, social orientation, intelligence, and gender.

7.3.3.1 Emotional Stability

Emotional stability involves our ability to remain in balance and stay productive, particularly in difficult or adversarial conditions. Studies of emotional stability have identified several key points related to design.

Low levels of emotional instability are somewhat correlated with our ability to generate original ideas. Low levels of emotional instability may enhance our ability to switch between thinking modes. High levels of emotional instability, such as pathological illnesses like psychosis or manic-depressive illness, are not correlated with creativity. The stereotypical emotionally unstable artists tend to not be professionally successful, at least not in their lifetimes. Similarly, the stereotypical emotionally detached engineers also tend to not be professionally successful. Successful designers in all disciplines tend toward emotional stability [164–169]. It is noted that emotional instability is less common in engineering than in art. Engineering requires more analytical thinking, which tends to stabilize emotions [41, 170, 171].

7.3.3.2 Social Orientation

Our social orientation reflects our need to be with others and, in particular, our need to be accepted by others. Socially oriented people tend to focus on compliance with cultural and social norms and rituals so they can maintain their interrelationships with others. Less socially oriented people, i.e., those who are more socially independent, tend to focus on personal achievements and individual success.

People with a lower social orientation tend to be more creative than people with a higher social orientation because they are less focused on compliance and harmony with others and are more willing to work on new ideas that others may disagree with or that may disrupt the status quo [41, 172].

This does not mean, however, that people with a high social orientation are less effective designers. Even though a high social orientation may inhibit original idea generation, it may also result in a more effective ability to identify the needs of the end users of a design project. A person with a high social orientation may be better at clarifying the project and selecting the final idea for implementation. A high social orientation may suggest a preference for usefulness over originality.

The primary impacts of social orientation on design effectiveness tend to be indirect. Designers, including both artists and engineers, often do not have contact with the end users of their designs. Artists rarely meet the people who purchase their works and engineers often design to external, written criteria. Because of this, both artists and engineers are more likely to have more meaningful contacts with their peers, supervisors, and critics than with the actual users of their designs. As a result, their social orientation may be more focused on peer recognition than with satisfying the needs of the ultimate users of their designs. This can influence how a project is framed and which design selection criteria are used [173].

Even though the correlation between social orientation and design success appears to be weak, we can use our understanding of our own social orientation to enhance our design effectiveness. If we engage in social situations that are different from our preferred social orientation, we add some discomfort into our thinking.

Such discomfort disrupts sequential, analytical thinking and can induce intuitive thinking. This, of course, enhances creativity (idea generation) [174, 175]. By disengaging in such mismatched social activities, we can reengage our analytical thinking to balance our design processes.

7.3.3.3 Intelligence
Intelligence involves our ability to learn and adapt in new conditions. Although many different types of intelligence have been defined, studies of them have shown a mixed and complex relationship with design. Overall, there may be a weak, but positive, link between some types of intelligence and the ability to be an effective designer [102, 103, 176–189]. One reason for the mixed relationship between intelligence and design is because intelligence tends to be linked with analytical thinking, but not necessarily with intuitive thinking. Design requires that we effectively use both.

7.3.3.4 Gender
The impact of gender on effectiveness as a designer has shown mixed results. There are gender differences for various cognitive processes and their associated neural responses. Women and men do process information differently. This difference, however, has not been shown to impact overall design effectiveness [190–201].

7.4 Impact of Cultural Background

A final characteristic of some successful designers is their cultural background and related experiences. The most widely studied cultural differences have been those between Eastern and Western cultures. Eastern cultures are based heavily on conforming behavior and collective thought, while Western cultures are based heavily on individualism and independent thought. Eastern cultures are more socially oriented, while Western cultures are more individually oriented.

With regard to design, Western cultures tend to be more creative (original) than Eastern cultures [202–208]. Designers from Eastern cultures tend to rely more on intuition than analysis, while designers in Western cultures tend to have a more balanced use of intuition and analysis [209, 210]. This indicates that a greater use of intuition does not necessarily result in a higher level of creativity. We have already seen that artists, with their greater use of intuition relative to engineers, are not necessarily more creative than engineers. Intuition must be balanced with analysis (and vice versa), even though that balance may be different for different people or for different disciplines.

We can enhance our design effectiveness by expanding our experiences with other cultures. Such experiences can broaden the information stored in our memories for our later use. One important way to gain exposure with other countries is

to live in them, [68, 211, 212] even if it is only for a relatively short time period [213]. Simply learning a second language and becoming bilingual can also enhance our creativity [214–216].

7.5 Closing

The key conclusions from this chapter are

1. Effective (expert) designers behave differently from less effective (novice) designers. Expert designers follow a plan for the design process, while novice designers tend to use trial and error guesswork in their design process.
2. Expert designers take more time than novices with each of the three universal design activities of clarifying the project, generating ideas, and selecting one final idea for implementation.
3. The Five-Factor Model of Personality (Big 5) has identified that the psychological trait of openness to experience is strongly correlated with idea generation (creativity). The trait of conscientiousness (ability to stay focused on the design project) appears to be somewhat correlated with both clarifying the project and selecting the final idea.
4. The Myers-Briggs Type Indicator (MBTI) has identified the trait of intuition (perhaps defined differently from this book) as being correlated with idea generation and the traits of sensing, thinking and judging as being correlated with clarifying the project and selecting one idea for implementation.
5. The Kirton Adaption-Innovation Inventory identifies two types of designers: adaptors and innovators. Adaptors appear to be more effective with the universal design activities of clarifying the project and selecting one idea while innovators appear to be more effective with the universal design activity of generating ideas.
6. Although standardized psychological tests have identified common traits of effective designers, people with any traits can be effective designers. People can be more effective in one of the three universal design activities and be less effective in the others, yet still be effective designers.
7. One of the most important characteristic of effective designers is flexibility in thinking. Effective designers tend to be more open to new experiences, curious, and have a high tolerance for ambiguity (low need for cognitive closure). Effective designers are able to appropriately balance intuitive and analytical thought.
8. A second important characteristic of effective designers is the ability to control their attention. Effective designers can stay focused on the project through a high level of conscientiousness. They also tend to have low levels of latent inhibition, i.e., they unconsciously suppress less sensory information to which they have been exposed, giving them more choices of what to bring into their awareness.

9. Other characteristics that appear to have only a secondary importance on design effectiveness include emotional stability, social orientation (need for approval of others), intelligence, and gender.
10. Cultural background can impact design effectiveness. Designers from Eastern cultures tend to be biased toward social conformity, while designers from Western cultures tend to be biased toward individualism. Designers from Western cultures tend to be more creative than those from Eastern cultures because they are better able to balance intuition and analysis.
11. Exposure to other cultures, through immigration, travel, or becoming bilingual can enhance creativity.

7.6 Questions

1. When you design, do you have a plan? Do you systematically work through your plan or do you just improvise? Do you consciously focus on each of the three universal design activities? How you handle the messiness of design?
2. Do you treat your design activities with professionalism or more casually?
3. Have you taken any of the three psychology tests discussed here? How do you describe yourself within each? Which traits do you relate to? Which ones do you not relate to? Can you identify your strengths and weaknesses of your psychological traits regarding design?
4. What is flexible thinking to you? Are you open to try new experiences? Are you curious about things? What was the last topic you explored simply because you were curious? Can you tolerate ambiguity and unfinished things or do you need closure? How has this impacted your designs?
5. Are there specific areas in which you feel that you are or are not a flexible thinker? How can you use this understanding to enhance your design effectiveness?
6. Are you aware of how you control your attention or do you let it be controlled outside of your awareness?
7. How conscientious are you? Do you stay focused because it is who you are or because you know that you must? Do you tend to want to finish what you start or do you tend to want to move on to new things before completing a task? Knowing this tendency, what can you do to enhance your ability to design?
8. What can you do to suppress your latent inhibition, i.e., what can you do to be more aware of things in your life that are currently below the level of your conscious awareness? What we think we see is often not what is really there. Instead, we "see" what we think is there. Artists are trained to closely observe visual appearances to see what is actually there, while engineers are not. How might this impact latent inhibition? How might this impact your design effectiveness?

9. How might your social orientation, emotional stability, intelligence, or gender impact your design effectiveness? How can you use this awareness to enhance your design effectiveness?

10. Is it more important for you to get agreement from others before continuing a project or is working independently more important? Why? How might this impact your ability to design? Knowing this tendency, what can you do to enhance your ability to design?

11. Do you have experience with other cultures? How has that experience impacted your design effectiveness? What are ways you can obtain multi-cultural experience within the context of your current life?

References

1. Ahmed, S., Christensen, B.T.: An in situ study of analogical reasoning in novice and experienced design engineers. J. Mech. Des. **131**, 111004-1–111004-9 (2009). https://doi.org/10.1115/1.3184693

2. Ahmed, S., Wallace, K.M., Blessing, L.T.M.: Understanding the differences between how novice and experienced designers approach design tasks. Res. Eng. Des. **14**, 1–21 (2003). https://doi.org/10.1007/s00163-002-0023-z

3. Ball, L.J., Ormerod, T.C., Morley, N.J.: Spontaneous analogising in engineering design: a comparative analysis of experts and novices. Des. Stud. **25**, 495–508 (2004). https://doi.org/10.1016/j.destud.2004.05.004

4. Ball, L.J., Evans, St. BT Evans, J., Dennis, I., Ormerod, T.C.: Problem-solving strategies and expertise in engineering design. Thinking and Reasoning **3**(4), 247–270 (1997). https://doi.org/10.1080/135467897394284

5. Cross, N., Cross, A.C.: Expertise in engineering design. Res. Eng. Des. **10**, 141–149 (1998). https://doi.org/10.1007/BF01607156

6. Ho, C.-H.: Some phenomena of problem decomposition strategy for design thinking: differences between novices and experts. Des. Stud. **22**, 27–45 (2001). https://doi.org/10.1016/S0142-694X(99)00030-7

7. Kavakli, M., Gero, J.S.: The structure of concurrent cognitive actions: a case study on novice and expert designers. Des. Stud. **23**, 25–40 (2002). https://doi.org/10.1016/S0142-694X(01)00021-7

8. Kay, S.: The figural problem solving and problem finding of professional and semiprofessional artists and nonartists. Creativity Res. J. **4**(3), 233–252 (1991). https://doi.org/10.1080/10400419109534396

9. Lloyd, P., Scott, P.: Discovering the design problem. Des. Stud. **15**(2), 125–140 (1994). https://doi.org/10.1016/0142-694X(94)90020-5

10. Miall, R.C., Tchalenko, J.: A painter's eye movements: a study of eye and hand movement during portrait drawing. Leonardo **34**(1), 35–40 (2001). https://doi.org/10.1162/002409401300052488

11. Smith, R.P., Leong, A.: An observational study of design team process: a comparison of student and professional engineers. J. Mech. Des. **120**, 636–642 (1998). https://doi.org/10.1115/1.2829326

12. Vogt, S., Magnussen, S.: Expertise in pictorial perception: eye-movement patterns and visual memory in artists and laymen. Perception **36**, 91–100 (2007). https://doi.org/10.1068/p5262

13. Atman, C.J., Adams, R.S., Cardella, M.E., Turns, J., Mosborg, S., Saleem, J.: Engineering design processes: a comparison of students and expert practitioners. J. Eng. Educ. **96**(4), 359–379 (2007). https://doi.org/10.1002/j.2168-9830.2007.tb00945.x

14. Cross, N., Christiaans, H., Dorst, K.: Design expertise amongst student designers. J. Art Des. Educ. **13**(1) (1994). https://doi.org/10.1111/j.1476-8070.1994.tb00356.x

15. Kim, J., Ryu, H.: A design thinking rationality framework: framing and solving design problems in early concept generation. Human-Comput. Interact. **29**, 516–553 (2014). https://doi.org/10.1080/07370024.2014.896706

16. Kumsaikaew, P., Jackman, J., Dark, V.J.: Task relevant information in engineering problem solving. J. Eng. Educ. 227–239 (2006). https://doi.org/10.1002/j.2168-9830.2006.tb00895.x

17. Mentzer, N., Becker, K., Sutton, M.: Engineering design thinking: high school students' performance and knowledge. J. Eng. Educ. **104**(4), 417–432 (2015). https://doi.org/10.1002/jee.20105

18. Rosen, D.S., Kim, Y.E., Mirman, D., Kounios, J.: All you need to do is ask? the exhortation to be creative improves performance more for nonexpert than expert jazz musicians. Psychol. Aesthetics, Creativity, Arts **11**(4), 420–427 (2017). https://doi.org/10.1037/aca0000087

19. Atman, C.J., Cardella, M.E., Turns, J., Adams, R.: Comparing freshman and senior engineering design processes: an in-depth follow-up study. Des. Stud. **26**, 325–357 (2005). https://doi.org/10.1016/j.destud.2004.09.005

20. Bonnardel, N., Marmeche, E.: Towards supporting evocation processes in creative design: a cognitive approach. Int. J. Hum Comput Stud. **63**, 422–435 (2005). https://doi.org/10.1016/j.ijhcs.2005.04.006

21. Popovic, V.: Expertise development in product design – strategic and domain-specific knowledge connections. Des. Stud. **25**, 527–545 (2004). https://doi.org/10.1016/j.destud.2004.05.006

22. Runco, M.A., Acar, S.: Do tests of divergent thinking have and experiential bias. Psychol. Aesthetics, Creativity, Arts **4**(3), 144–148 (2010). https://doi.org/10.1037/a0018969

23. Sharmin, M., Bailey, B.P., Coats, C., Hamilton, K.: Understanding knowledge management practices for early design activity and its implications for reuse. In: Proceedings of the 27th International Conference on Human Factors in Computing Systems, CHI 2009, Boston, MA (2009). https://doi.org/10.1145/1518701.1519064

24. Axelsson, O.: Individual differences in preferences to photographs. Psychol. Aesthetics, Creativity, Arts **1**(2), 61–72 (2007). https://doi.org/10.1037/1931-3896.1.2.61

25. Cupchik, G.C., Gebotys, R.J.: The search for meaning in art: interpretive styles and judgments of quality. Vis. Arts Res. **14**(2), 38–50 (1988). https://www.jstor.org/stable/20715675

26. Liu, Y.-T.: Some phenomena of seeing shapes in design. Des. Stud. **16**, 367–385 (1995). https://doi.org/10.1016/0142-694X(94)00001-T

27. Novick, L.R.: Analogical transfer, problem similarity, and expertise. J. Exp. Psychol. Learn. Mem. Cogn. **14**(3), 510–520 (1988). https://doi.org/10.1037//0278-7393.14.3.510

28. Dane, E., Rockmann, K.W., Pratt, M.G.: When should I trust my gut? Linking domain expertise to intuitive decision-making effectiveness. Organ. Behav. Hum. Decis. Process. **119**, 187–194 (2012). https://doi.org/10.1016/j.obhdp.2012.07.009

29. Durning, S.J., Constanzo, M.E., Artino, A.R., Graner, J., van der Vleuten, C., Beckman, T. J., Wittich, C.M., Roy, M.J., Holmboe, E.S., Schuwirth, L.: Neural basis of nonanalytical reasoning expertise during clinical evaluation. Brain Behav. 1–10 (2015). https://doi.org/10.1002/brb3.309

30. Kirk, U., Skov, M., Christensen, M.S., Nygaard, N.: Brain correlates of aesthetic experience. Brain Cogn. **69**(2), 306–315 (2009). https://doi.org/10.1016/j.bandc.2008.08.004

31. Liu, S., Erkkinen, M.G., Healey, M.L., Xu, Y., Swett, K.E., Chow, H.M., Braun, A.R.: Brain activity and connectivity during poetry composition: toward a multidimensional model of the creative process. Hum. Brain Mapp. **36**, 3351–3372 (2015). https://doi.org/10.1002/hbm.22849

32. Solso, R.L.: Brain activities in a skilled versus a novice artist: an fMRI study. Leonardo **34** (1), 31–34 (2001). https://doi.org/10.1162/002409401300052479

33. Andersson, P.: Does experience matter in lending? A process-tracing study on experienced loan officers' and novices' decision behavior. J. Econ. Psychol. **25**, 471–492 (2004). https://doi.org/10.1016/S0167-4870(03)00030-8

34. Devine, D.J., Kozlowski, S.W.J.: Domain-specific knowledge and task characteristics in decision making. Organ. Behav. Human Decis. Process **64**(3), 294–306 (1995). https://doi.org/10.1006/obhd.1995.1107

35. Hirt, E.R., Sherman, S.J.: The role of prior knowledge in explaining hypothetical events. J. Exp. Soc. Psychol. **21**, 519–543 (1985). https://doi.org/10.1016/0022-1031(85)90023-X

36. Ofir, C.: Ease of recall vs recalled evidence in judgment: experts vs laymen. Organ. Behav. Hum. Decis. Process. **81**(1), 28–42 (2000). https://doi.org/10.1006/obhd.1999.2864

37. Raab, M., Johnson, J.G.: Expertise-based differences in search and option-generation strategies. J. Experiential Psychol. Appl. **13**(3), 158–170 (2007). https://doi.org/10.1037/1076-898X.13.3.158

38. Shanteau, J.: How much information does an expert use? Is it relevant. Acta Psychol. **81**, 75–86 (1992). https://doi.org/10.1016/0001-6918(92)90012-3

39. Shanteau, J.: Psychological characteristics and strategies of expert decision makers. Acta Physiol. (Oxf) **68**, 203–215 (1988). https://doi.org/10.1016/0001-6918(88)90056-X

40. Abuhamdeh, S., Csikszentmihalyi, H.: The artistic personality: a systems perspective. In: Sternberg, R.J., Grigorenko, E.L., Singer, J.L. (eds.) Creativity from Potential to Realization. American Psychological Association, Washington, DC (2004). https://doi.org/10.1037/10692-003

41. Feist, G.J.: A meta-analysis of personality in scientific and artistic creativity. Pers. Soc. Psychol. Rev. **2**(4), 290–309 (1998). https://doi.org/10.1207/s15327957pspr0204_5

42. Mumford, M.D., Costanza, D.P., Threlfall, K.V., Baughman, W.A., Reiter-Palmon, R.: Personality variables and problem-construction activities: an exploratory investigation. Creativity Res. J. **6**(4), 365–389 (1993). https://doi.org/10.1080/10400419309534493

43. Van Der Molen, H.T., Schmidt, H.G., Kruisman, G.: Personality characteristics of engineers. Eur. J. Eng. Educ. **32**(5), 495–501 (2007). https://doi.org/10.1080/03043790701433111

44. Costa, P. T., Jr. McCrae, R.R.: The five-factor model of personality and its relevance to personality disorders. J. Pers. Disord. **6**(4), 343–359 (1992). https://doi.org/10.1521/pedi.1992.6.4.343

45. McCrae, R.R., Costa, P.T., Jr.: Validation of the five-factor model of personality across instruments and observers. J. Pers. Soc. Psychol. **52**(1), 81–90 (1987). https://doi.org/10.1037//0022-3514.52.1.81

46. Myers, I.B.: MBTI manual: a guide to the development and use of the Myers-briggs type indicator, CPP Inc., Sunnyvale, CA (2003). https://doi.org/10.1037//0022-3514.52.1.81

47. Dollinger, S.J., Palaskonis, D.G., Pearson, J.L.: Creativity and intuition revisited. J. Creative Behav. **38**(4), 244–259 (2004). https://doi.org/10.1002/j.2162-6057.2004.tb01243.x

48. Wilde, D.J.: Changes among ASEE creativity workshop participants. J. Eng. Educ. **82**(3), 167–170 (1993). https://doi.org/10.1002/j.2168-9830.1993.tb00096.x

49. Felder, R.M., Felder, G.N., Dietz, E.J.: The effects of personality type on engineering student performance and attitudes. J. Eng. Educ. **91**(1), 3–17 (2002). https://doi.org/10.1002/j.2168-9830.2002.tb00667.x

50. Kirton, M.: Adaptors and innovators: a description and measure. J. Appl. Psychol. **61**(5), 622–629 (1976). https://doi.org/10.1037/0021-9010.61.5.622

51. Ee, J., Seng, T.O., Kwang, N.A.: Styles of creativity: adaptors and innovators in a singapore context. Asia Pac. Educ. Rev. **8**(3), 364–373 (2007). https://doi.org/10.1007/BF03026466

52. Gelade, G.: Creative style, personality, and artistic endeavor. Genet. Soc. Gen. Psychol. Monogr. **128**(3), 213–234 (2002)

53. Kwang, N.A., Rodrigues, D.: A big-five personality profile of the adaptor and innovator. J. Creative Behav. **36**(4), 254–268 (2002). https://doi.org/10.1002/j.2162-6057.2002.tb01068.x

54. Puccio, G.J., Treffinger, D.J., Talbot, R.J.: Exploratory examination of relationships between creativity styles and creative products. Creativity Res. J. **8**(2), 157–172 (1995). https://doi.org/10.1207/s15326934crj0802_4

55. Aguilar-Alonso, A.: Personality and creativity. Pers. Individ. Differ. **21**(6), 959–969 (1996). https://doi.org/10.1016/S0191-8869(96)00162-6

56. Basadur, M.: Optimal ideation-evaluation ratios. Creativity Res. J. **8**(1), 63–75 (1995). https://doi.org/10.1207/s15326934crj0801_5

57. Brophy, D.R.: Comparing the attributes, activities, and performance of divergent, convergent, and combination thinkers. Creativity Res. J. **13**(3–4), 439–455 (2001). https://doi.org/10.1207/s15326934crj1334_20

58. Choi, J.N.: Individual and contextual predictors of creative performance: the mediating role of psychological process. Creativity Res. J. **16**(2–3), 187–199 (2004). https://doi.org/10.1080/10400419.2004.9651452

59. Kim, Y.S., Jin, S.T., Lee, S.W.: Relations between design activities and personal creativity modes. J. Eng. Des. **22**(4), 235–257 (2011). https://doi.org/10.1080/09544820903272867

60. Madjar, N., Oldham, G.R.: Task rotation and polychronicity: effects on individuals' creativity. Human Perform. **19**(2), 117–131 (2006). https://doi.org/10.1207/s15327043hup1902_2

61. Puccio, G., Grivas, C.: Examining the relationship between personality traits and creativity styles. Creativity Innov. Manage. **18**(4), 247–255 (2009). https://doi.org/10.1111/j.1467-8691.2009.00535.x

62. Thunholm, P.: Decision-making style: habit, style, or both. Pers. Individ. Differ. **36**, 931–944 (2004). https://doi.org/10.1016/S0191-8869(03)00162-4

63. Benedek, M., Nordtveldt, N., Jauk, E., Koschmieder, C., Pretsch, J., Krammer, G., Neubauer, A.C.: Assessment of creativity evaluation skills: a psychometric investigation in prospective teachers. Thinking Skills and Creativity **21**, 75–84 (2016). https://doi.org/10.1016/j.tsc.2016.05.007

64. Grohman, M., Wodniecka, Z., Ktusak, M.: Divergent Thinking and Evaluation Skills: Do They Always Go Together? J. Creative Behav. **40**(2), 125–145 (2006). https://doi.org/10.1002/j.2162-6057.2006.tb01269.x

65. Runco, M.A., Smith, W.R.: Interpersonal and intrapersonal evaluations of creative ideas. Pers. Individ. Differ. **13**(3), 295–302 (1992). https://doi.org/10.1016/0191-8869(92)90105-X

66. Runco, M.A., Vega, L.: Evaluating the creativity of children's ideas. J. Soc. Behav. Pers. **5**(5), 439–452 (1990)

67. Silvia, P.J.: Discernment and creativity: how well can people identify their most creative ideas? Psychol. Aesthetics, Creativity, Arts **2**(3), 139–146 (2008). https://doi.org/10.1037/1931-3896.2.3.139

68. Feist, G.J.: How development and personality influence scientific thought, interest, and achievement. Rev. Gen. Psychol. **10**(2), 163–182 (2006). https://doi.org/10.1037/1089-2680.10.2.163

69. Kenett, Y.N., Anaki, D., Faust, M.: Investigating the structure of semantic networks in low and high creative persons. Front. Human Neurosci. **8**, Article 407, 1–16 (2014). https://doi.org/10.3389/fnhum.2014.00407

70. Arden, R., Chavez, R.S., Grazioplene, R., Jung, R.E.: Neuroimaging creativity: a psychometric view. Behav. Brain Res. **214**, 143–156 (2010). https://doi.org/10.1016/j.bbr.2010.05.015

71. Basten, U., Biele, G., Heekeren, H.R., Fiebach, C.J.: How the brain integrates costs and benefits during decision making. In: Proceedings of the National Academy of Science, vol. 107, no. 50, pp. 21767–21772 (2010). https://doi.org/10.1073/pnas.0908104107

72. Bekhtereva, N.P., Danko, S.G., Starchenko, M.G., Pakhomov, S.V., Medvedev, S.V.: Study of brain organization of creativity: III. Brain activation assessed by the local cerebral blood flow and EEG. Human Physiol. **27**(4), 390–397 (2001). https://doi.org/10.1023/A:1010946332369

73. Bekhtereva, N.P., Starchenko, M.G., Klyucharev, V.A., Vorob'ev, V.A., Pakhomov, S.V., Medvedev, S.V.: Study of the brain organization of creativity: II. Positron-emission tomography data. Human Physiol. **26** (5), 12–18 (2000). https://doi.org/10.1007/BF02760367

74. Benedek, M., Jauk, E., Fink, A., Koschutnig, K., Reishofer, G., Ebner, F., Neubauer, A.C.: To create or to recall? Neural mechanisms underlying the generation of creative new ideas. NeuroImage **88**, 125–133 (2014). https://doi.org/10.1016/j.neuroimage.2013.11.021

75. Boccia, M., Piccardi, L., Palermo, L., Nori, R., Palmiero, M.: Where do bright ideas occur in our brain? Meta-analytic evidence from neuroimaging studies of domain-specific creativity. Front. Psychol. **6**, Article 1195, 1–12 (2015). https://doi.org/10.3389/fpsyg.2015.01195

76. Chavez-Eakle, R.A., Graff-Guerrero, A., Garcia-Reyna, J.-C., Vaugher, V., Cruz-Fuentes, C.: Cerebral blood flow associated with creative performance: a comparative study. NeuroImage **38**, 519–528 (2007). https://doi.org/10.1016/j.neuroimage.2007.07.059

77. Dietrich, A., Kanso, R.: A review of EEG, ERP, and neuroimaging studies of creativity and insight. Psychol. Bull. **136**(5), 822–848 (2010). https://doi.org/10.1037/a0019749

78. Dietrich, A.: Who's afraid of a cognitive neuroscience of creativity? Methods **42**, 22–27 (2007). https://doi.org/10.1016/j.ymeth.2006.12.009

79. Ellamil, M., Dobson, C., Beeman, M., Christoff, K.: Evaluative and generative modes of thought during the creative process. NeuroImage **59**, 1783–1794 (2012). https://doi.org/10.1016/j.neuroimage.2011.08.008

80. Gonen-Yaacovi, G., de Souza, L.C., Levy, R., Urbanski, M., Josse, G., Volle, E.: Rostral and caudal prefrontal contribution to creativity: a meta-analysis of functional imaging data. Front. Human Neurosci. **7**, Article 465, 1–22 (2013). https://doi.org/10.3389/fnhum.2013.00465

81. Hugdahl, K.: Hemispheric asymmetry: contributions from brain imaging. Wiley Interdisc. Rev Cogn. Sci. **2**(5), 461–478 (2011). https://doi.org/10.1002/wcs.122

82. Jung, R.E., Grazioplene, R., Caprihan, A., Chavez, R.S., Haier, R.J.: White matter integrity, creativity, and psychopathology: disentangling constructs with diffusion tensor imaging. PlosOne **5**(3), e9818 (2010).https://doi.org/10.1371/journal.pone.0009818

83. Jung, R.E., Segall, J.M., Bockholt, H.J., Flores, R.A., Smith, S.M., Chavez, R.S., Hailer, R. J.: Neuroanatomy of creativity. Hum. Brain Mapp. **31**, 398–409 (2010). https://doi.org/10.1002/hbm.20874

84. Katz, A.N.: Creativity and the cerebral hemispheres. In: Runco M.A. (ed.) The Creativity Research Handbook, vol. 1. Hampton Press, Cresskill, New Jersey (1997)

85. Kuhnen, C.M., Knutson, B.: The neural basis of financial risk taking. Neuron **47**, 763–770 (2005). https://doi.org/10.1016/j.neuron.2005.08.008

86. Mayseless, N., Aharon-Peretz, J., Shamay-Tsoory, S.: Unleashing creativity: the role of left-temporoparietal regions in evaluating and inhibiting the generation of creative ideas. Neuropsychologia **64**, 157–168 (2014). https://doi.org/10.1016/j.neuropsychologia.2014.09.022

87. Minati, L., Grisoli, M., Franceschetti, S., Epifani, F., Granvillano, A., Medford, N., Harrison, N.A., Piacentini, S., Critchley, H.D.: Neural signatures of economic parameters during decision-making: a functional MRI (fMRI), electroencephalography (EEG) and autonomic monitoring study. Brain Topogr. **25**, 73–96 (2012). https://doi.org/10.1007/s10548-011-0210-1

88. Paulus, M.P., Hozack, N., Zauscher, B., McDowell, J.E., Frank, L., Brown, G.G., Braff, D. L.: Prefrontal, parietal, and temporal cortex networks underlie decision-making in the presence of uncertainty. NeuroImage **13**(1), 91–100 (2001). https://doi.org/10.1006/nimg.2000.0667

89. Sawyer, K.: The cognitive neuroscience of creativity: a critical review. Creativity Res. J. **23** (2), 137–154 (2011). https://doi.org/10.1080/104004192011.571191

90. Wager, T.D., Phan, K.L., Liberzon, I., Taylor, S.F.: Valence, gender, and lateralization of functional brain anatomy in emotion: a meta-analysis of findings from neuroimaging. Neuroimage **19**, 513–531 (2003). https://doi.org/10.1016/s1053-8119(03)00078-8

91. Bowden, E.M., Beeman, M.J.: Getting the right idea: semantic activation in the right hemisphere may help solve insight problems. Psychol. Sci. **9**(6), 435–440 (1998). https://doi.org/10.1111/1467-9280.00082

92. Beeman, M.J., Bowden, E.: The right hemisphere maintains solution-related activation for yet-to-be-solved problems. Memory and Cogn. **28**(7), 1231–1241 (2000). https://doi.org/10.3758/bf03211823

93. Bowden, E.M., Beeman, M.J.: Aha! insight experience correlates with solution activation in the right hemisphere. Psychon. Bull. Rev. **10**(3), 730–737 (2003).https://doi.org/10.3758/BF03196539

94. Rosen, D.S., Oh, Y., Erickson, B., Zhang, F., Kim, Y.E., Kounios, J.: Dual-process contributions to creativity in jazz improvisations: an SPN-EEG study. NeuroImage **213**, 116632 (2020).https://doi.org/10.1016/j.neuroimage.2020.116632

95. De Young, C.G., Hirsh, J.B., Shane, M.S., Papademetris, X., Rajeevan, N., Gray, J.R.: Testing predictions from personality neuroscience: brain structure and the big five. Psychol. Sci. **21**(6), 820–828 (2010). https://doi.org/10.1177/0956797610370159

96. Chui, I., Shu, L.H.: Investigating effects of oppositely related semantic stimuli on design concept creativity. J. Eng. Educ. **23**(4), 271–296 (2012). https://doi.org/10.1080/09544828.2011.603298

97. Coskun, H.: Cognitive stimulation with convergent and divergent thinking exercises in brainwriting: incubation, sequence priming, and group context. Small Group Res. **36**, 466–498 (2005).https://doi.org/10.1177/1046496405276475

98. Dijksterhuis, A., Meurs, T.: Where creativity resides: the generative power of unconscious thought. Conscious. Cogn. **15**, 135–146 (2006). https://doi.org/10.1016/j.concog.2005.04.007

99. Howard-Jones, P.A., Murray, S.: Ideational productivity, focus of attention, and context. Creativity Res. J. **15**(2–3), 153–166 (2003). https://doi.org/10.1080/10400419.2003.9651409

100. Ritter, S.M., Damian, R.I., Simonton, D.K., van Baaren, R.B., Stick, M., Derks, J., Dijksterhuis, Ap. D.: Diversifying experiences enhance cognitive flexibility. J. Exp. Soc. Psychol. **48**, 961–964 (2012). https://doi.org/10.1016/j.jesp.2012.02.009

101. Madjar, N., Oldham, G.R.: Preliminary tasks and creative performance on a subsequent task: effects of time on preliminary tasks and amount of information about the subsequent task. Creativity Res. J. **14**(2), 239–251 (2002). https://doi.org/10.1207/S15326934CRJ1402_10

102. Batey, M., Chamorro-Premuzic, T., Furnham, A.: Individual differences in ideational behavior: can the big five and psychometric intelligence predict creativity scores. Creativity Res. J. **22**(1), 90–97 (2010). https://doi.org/10.1080/10400410903579627

103. Batey, M., Furnham, A., Safiullina, X.: Intelligence, general knowledge and personality as predictors of creativity. Learn. Individ. Differ. **20**, 532–535 (2010). https://doi.org/10.1016/j.lindif.2010.04.008

104. Jauk, E., Benedek, M., Neubauer, A.C.: The road to creative achievement: a latent variable model of ability and personality predictors. Eur. J. Pers. **28**, 95–105 (2014). https://doi.org/10.1002/per.1941

105. King, L.A., Walker, L.M., Broyles, S.J.: Creativity and the Five-factor model. J. Res. Pers. **30**, 189–203 (1996). https://doi.org/10.1006/jrpe.1996.0013

106. McCrae, R.R.: Creative, divergent thinking, and openness to experience. J. Pers. Soc. Psychol. **52**(6), 1258–1265 (1987). https://doi.org/10.1037/0022-3514.52.6.1258

107. Sanchez-Ruiz, M.J., Hernandez-Torrano, D., Perez-Gonzalez, J.C., Batey, M., Petrides, K. V.: The relationship between trait emotional intelligence and creativity across subject domains. Motiv. Emot. **35**, 461–473 (2011). https://doi.org/10.1007/s11031-001-9227-8

108. Silva, P.J., Nusbaum, E.C., Berg, C., Martin, C., O'Connor, A.: Openness to experience, plasticity, and creativity" exploring lower-order, high-order, and interactive effects. J. Res. Pers. **43**, 1087–1090 (2009). https://doi.org/10.1016/j.jrp.2009.04.015

109. Sung, S.Y., Choi, J.N.: Do big five personality factors affect individual creativity: the moderating role of extrinsic motivation. Soc. Behav. Pers. **37**(7), 941–956 (2009). https://doi.org/10.2224/sbp.2009.37.7.941

110. Wolfradt, U., Pretz, J.E.: Individual differences in creativity: personality, story writing, and hobbies. Eur. J. Pers. **15**, 297–310 (2001). https://doi.org/10.1002/per.409

111. Beaty, R.E., Kaufman, S.B., Benedek, M., Jung, R.E., Kenett, Y.N., Jauk, E., Neubauer, A. C., Silvia, P.J.: Personality and complex brain networks: the role of openness to experience in default network efficiency. Hum. Brain Mapp. **37**, 773–779 (2016). https://doi.org/10. 1002/hbm.23065

112. Chamorro-Premuzic, T.: Creativity versus conscientiousness: which is a better predictor of student performance? Appl. Cogn. Psychol. **20**, 521–531 (2006). https://doi.org/10.1002/ acp.1196

113. Chamorro-Premuzic, T., Furnham, A.: Art judgment: a measure related to both personality and intelligence. Imagination, Cogn., Pers. **24**(1), 3–24 (2004–2005). https://doi.org/10. 2190/U4LW-TH9X-80M3-NJ54

114. Chamorro-Premuzic, T., Furnham, A.: Personality traits and academic examination performance. Eur. J. Pers. **17**, 237–250 (2003). https://doi.org/10.1002/per.473

115. Chamorro-Premuzic, T., Furnham, A.: Personality predicts academic performance: evidence from two longitudinal university samples. J. Res. Pers. **37**, 319–338 (2003). https://doi.org/ 10.1016/S0092-6566(02)00578-0

116. Feist, G.J.: Predicting interest in and attitudes toward science from personality and need for cognition. Pers. Individ. Differ. **52**, 771–775 (2012). https://doi.org/10.1016/j.paid.2012.01. 005

117. Kaufman, S.B.: Opening up openness to experience: a four-factor model and relations to creative achievement in the arts and sciences. J. Creative Behav. **47**(4), 233–255 (2013). https://doi.org/10.1002/jocb.33

118. Perrine, N.E., Brodersen, R.M.: Artistic creative behavior: openness and the mediating role of interests. J. Creative Behav. **39**(4), 217–236 (2005). https://doi.org/10.1002/j.2162-6057. 2005.tb01259.x

119. Csikszentmihalyi, M.: Creativity: Flow and the Psychology of Discovery and Invention. HarperCollins Publishers, New York (1996)

120. Harrison, S., Dossinger, K.: Pliable guidance: a multilevel model of curiosity, feedback seeking, and feedback giving in creative work. Acad. Manag. J. **60**(6), 2051–2072 (2017). https://doi.org/10.5465/amj.2015.0247

121. Vidler, D.: Convergent and divergent thinking, text-anxiety, and curiosity. J. Exp. Educ. **43** (2), 79–85 (1974). https://doi.org/10.1080/00220973.1974.10806324

122. Dyer, J.H., Gregersen, H.B., Christensen, C.: Entrepreneur behaviors, opportunity recognition, and the origins of innovative ventures. Strateg. Entrepreneurship J. **2**, 317–338 (2008). https://doi.org/10.1002/sej.59

123. Kasperson, C.J.: An analysis of the relationship between information sources and creativity in scientists and engineers. Human Commun. Res. **4**(2), 113–119 (1978). https://doi.org/10. 1111/j.1468-2958.1978.tb00601.x

124. Kasperson, C.J.: Psychology of the scientist: XXXVII. Scientific creativity: a relationship with information channels. Psychol. Rep. **42**, 691–694 (1978). https://doi.org/10.2466/pr0. 1978.42.3.691

125. Puente-Diaz, R., Cavazos-Arroyo, J.: Creative Self-efficacy: the influence of affective states and social persuasion as antecedents and imagination and divergent thinking as consequences. Creativity Res. J. **29**(3), 304–312 (2017). https://doi.org/10.1080/10400419. 2017.1360067

126. Puente-Diaz, R., Cavazos-Arroyo, J.: An exploration of some antecedents and consequences of creative self-efficacy among college students. J. Creative Behav. **52**(3), 256–266 (2016). https://doi.org/10.1002/jocb.149
127. Root-Bernstein, R.S., Bernstein, M., Garnier, H.: Correlations between avocations, scientific style, work habits, and professional impact of scientists. Creativity Res. J. **8**(2), 115–137 (1995). https://doi.org/10.1207/s15326934crj0802_2
128. Root-Bernstein, R., Allen, L., Beach, L., Bhadula, R., Fast, J., Hosey, C., Kremkow, B., Lapp, J., Lonc, K., Pawelec, K., Podufaly, A., Russ, C., Tennant, L., Vrtis, E., Weinlander, S.: Arts foster scientific success: avocations of nobel, national academy, royal society, and sigma Xi members. J. Psychol. Sci. Technol. **1**(2), 51–63 (2008). https://doi.org/10.1891/1939-7054.1.2.51
129. Root-Bernstein, R.S., Bernstein, M., Garnier, H.: Identification of scientists making high-impact contributions, with notes on their methods of working. Creativity Res. J. **6**(4), 329–343 (1993). https://doi.org/10.1080/10400419309534491
130. Root-Bernstein, R., Root-Bernstein, M.: Artistic scientists and scientific artists: the link between polymathy and creativity. In: Sternberg, R.J., Grigorenko, E.L., Singer, J.L. (eds.) Creativity from Potential to Realization. American Psychological Association, Washington, DC (2004). https://doi.org/10.1037/10692-008
131. Kashdan, T.B., Stiksma, M.C., Disabato, D.J., McKnight, P.E., Bekier, J., Kaji, J., Lazarus, R.: The five-dimensional curiosity scale: capturing the bandwidth of curiosity and identifying four unique subgroups of curious people. J. Res. Pers. **73**, 130–149 (2018). https://doi.org/10.1016/j.jrp.2017.11.011
132. Kashdan, T.B., Afram, A., Brown, K.W., Birnbeck, M., Drvoshanov, M.: Curiosity enhances the role of mindfulness in reducing defensive responses to existential threat. Pers. Individ. Differ. **50**, 1127–1132 (2011). https://doi.org/10.1016/j.paid.2011.02.015
133. Kashdan, T.B., Gallagher, M.W., Silvia, P.J., Winterstein, B.P., Breen, W.E., Terhar, D., Steger, M.F.: The curiosity and exploration inventory-II: development, factor structure, and initial psychometrics. J. Pers. Res. **43**, 987–998 (2009). https://doi.org/10.1016/j.jrp.2009.04.011
134. Hagtvedt, L.P., Dossinger, K., Harrison, S.H., Huang, L.: Curiosity made the cat more creative: specific curiosity as a driver of creativity. Organ. Behav. Hum. Decis. Process. **150**, 1–13 (2019). https://doi.org/10.1016/j.obhdp.2018.10.007
135. Hardy, J.H., III., Ness, A.M., Mecca, J.: Outside the Box: epistemic curiosity as a predictor of creative problem solving and creative performance. Pers. Individ. Differ. **104**, 230–237 (2017). https://doi.org/10.1016/j.paid.2016.08.004
136. Atchley, R.A., Keeney, M., Burgess, C.: Cerebral hemispheric mechanisms linking ambiguous word meaning retrieval and creativity. Brain Cogn. **40**, 479–499 (1999). https://doi.org/10.1006/brcg.1999.1080
137. Zenasni, F., Besancon, M., Lubart, T.: Creativity and tolerance of ambiguity: an empirical study. J. Creative Behav. **42**(1), 61–73 (2008). https://doi.org/10.1002/j.2162-6057.2008.tb01080.x
138. Toh, C.A., Miller, S.R.: Choosing creativity: the role of individual risk and ambiguity aversion on creative concept selection in engineering design. Res. Eng. Des. **27**, 195–219 (2016). https://doi.org/10.1007/s00163-015-0212-1
139. Toh, C.A., Miller, S.R.: Creativity in design teams: the influence of personality traits and risk attitudes on creative concept selection. Res. Eng. Design **27**, 73–89 (2016). https://doi.org/10.1007/s00163-015-0207-y
140. Freund, T., Kruglanski, A.W., Shpitzajzen, A.: The freezing and unfreezing of impressional primacy: effects of the need for structure and the fear of invalidity. Pers. Soc. Psychol. Bull. **11**(4), 479–487 (1985). https://doi.org/10.1177/0146167285114013
141. Kruglanski, A.W., Webster, D.M.: Motivated closing of the mind: 'Seizing' and 'Freezing.' Psychol. Rev. **103**(2), 263–283 (1996). https://doi.org/10.1037/0033-295X.103.2.263

142. Ostrofsky, J., Shobe, E.: The relationship between need for cognitive closure and the appreciation, understanding, and viewing time of realistic and nonrealistic figurative paintings. Empirical Stud. Arts **33**(1), 106–113 (2015). https://doi.org/10.1177/0276237415570016

143. Wiersema, D.V., van der Schalk, J., van Kleef, G.A.: Who's afraid of red, yellow, and blue? Need for cognitive closure predicts aesthetic preferences. Psychol. Aesthetics, Creativity, Arts **6**(2), 168–174 (2012). https://doi.org/10.1037/a0025878

144. Ong, L.S., Leung, A.K.-Y.: Opening the creative mind of high need for cognitive closure individuals through activation of uncreative ideas. Creativity Res. J. **25**(3), 286–292 (2013). https://doi.org/10.1080/10400419.2013.813791

145. Vartanian, O.: Variable attention facilitates creative problem solving. Psychol. Aesthetics, Creativity, Arts **3**(1), 57–59 (2009). https://doi.org/10.1037/a0014781

146. Anderson, B.A.: A value-driven mechanism of attentional selection. J. Vis. **13**(3), 1–16 (2013). https://doi.org/10.1167/13.3.7

147. Niebur, E., Hsiao, S.S., Johnson, K.O.: Synchrony: a neuronal mechanism for attentional selection? Curr. Opin. Neurobiol. **12**, 190–194 (2002). https://doi.org/10.1016/s0959-4388(02)00310-0

148. Kashdan, T., Yuen, M.: Whether highly curious students thrive academically depends on perceptions about school learning environment: a study of hong kong adolescents. Motiv. Emot. **31**, 260–270 (2007). https://doi.org/10.1007/s11031-007-9074-9

149. O'Connor, M.C., Paunonen, S.V.: Big five personality predictors of post-secondary academic performance. Pers. Individ. Differ. **43**, 971–990 (2007). https://doi.org/10.1016/j.paid.2007.03.017

150. George, J.M., Zhou, J.: When openness to experience and conscientiousness are related to creative behavior: an interactional approach. J. Appl. Psychol. **86**(3), 513–524 (2001). https://doi.org/10.1037/0021-9010.86.3.513

151. Kline, P., Lapham, S.L.: Personality and faculty in british universities. Pers. Individ. Differ. **13**(7), 855–857 (1992). https://doi.org/10.1016/0191-8869(92)90061-S

152. Simonton, D.K.: Formal education, eminence and dogmatism: the curvilinear relationship. J. Creative Behav. **17**(3), 149–162 (1983). https://doi.org/10.1002/j.2162-6057.1983.tb00348.x

153. Benedek, M., Franz, F., Heene, M., Neubauer, A.C.: Differential effects of cognitive inhibition and intelligence on creativity. Pers. Individ. Differ. **53**, 480–485 (2012). https://doi.org/10.1016/j.paid.2012.04.014

154. Carson, S.H., Peterson, J.B., Higgins, D.M.: Decreased latent inhibition is associated with increased creative achievement in high-functioning individuals. J. Pers. Soc. Psychol. **85**(3), 499–506 (2003). https://doi.org/10.1037/0022-3514.85.3.499

155. Grobroz, M., Necka, E.: Creativity and cognitive control: explorations of generation and evaluation skills. Creativity Res. J. **15**(2 and 3), 183–197 (2003). https://doi.org/10.1080/10400419.2003.9651411

156. Martindale, C.: Biological bases of creativity. In: Sternberg, R.J. (ed.) Handbook of Creativity. Cambridge University Press, Cambridge (1999)

157. Martindale, C., Anderson, K., Moore, K., West, A.N.: Creativity, oversensitivity, and rate of habituation. Pers. Individ. Differ. **20**(4), 423–427 (1996). https://doi.org/10.1016/0191-8869(95)00193-X

158. Peterson, J.B., Carson, S.: Latent inhibition and openness to experience in a high-achieving student population. Pers. Individ. Differ. **28**, 323–332 (2000). https://doi.org/10.1016/S0191-8869(99)00101-4

159. Peterson, J.B., Smith, K.W., Carson, S.: Openness and extraversion are associated with reduced latent inhibition: replication and commentary. Pers. Individ. Differ. **33**, 1137–1147 (2002). https://doi.org/10.1016/S0191-8869(02)00004-1

160. Radel, R., Davranche, K., Fournier, M., Dietrich, A.: The role of (dis)inhibition in creativity: decreased inhibition improves idea generation. Cognition **134**, 110–120 (2015). https://doi. org/10.1016/j.cognition.2014.09.001
161. Gabora, L.: Revenge of the 'Neurds': characterizing creative thought in terms of the structure and dynamics of memory. Creativity Res. J. **22**(1), 1–13 (2010). https://doi.org/10. 1080/10400410903579494
162. Vartanian, O., Martindale, C., Kwiatkowski, J.: Creative potential, attention, and speed of information processing. Pers. Individ. Differ. **43**, 1470–1480 (2007). https://doi.org/10.1016/ j.paid.2007.04.027
163. Fink, A., Neubauer, A.C.: EEG alpha oscillations during the performance of verbal creativity tasks: differential effects of sex and verbal intelligence. Int. J. Psychophysiol. **62**, 46–53 (2006). https://doi.org/10.1016/j.ijpsycho.2006.01.001
164. Chavez-Eakle, R.A., Lara, M.D.C., Cruz-Fuentes, C.: Personality: a possible bridge between creativity and psychopathology. Creativity Res. J. **18**(1), 27–38 (2006). https://doi.org/10. 1207/s15326934crj1801_4
165. Ghadirian, A.-M., Gregoire, P., Kosmidis, H.: Creativity and the evolution of psychopathologies. Creativity Res. J. **13**(2), 145–148 (2001). https://doi.org/10.1207/ s15326934crj1302_2
166. Ko, Y.-G., Kim, J.-Y.: Scientific geniuses' psychopathology as a moderator in the relation between creative contribution types and eminence. Creativity Res. J. **20**(3), 251–261 (2008). https://doi.org/10.1080/10400410802278677
167. Post, F.: Creativity and psychopathology: a study of 291 world-famous men. Br. J. Psychiatry **165**, 22–34 (1994). https://doi.org/10.1192/bjp.165.1.22
168. Richards, R.L.: Relationships between creativity and psychopathology: an evaluation and interpretation of the evidence. Genet. Psychol. Monogr. **103**, 261–324 (1981)
169. Schuldberg, D.: Six subclinical spectrum traits in normal creativity. Creativity Res. J. **13**(1), 5–16 (2001). https://doi.org/10.1207/S15326934CRJ1301_2
170. Kaufman, J.C., Baer, J.: I Bask in dreams of suicide: mental illness, poetry, and women. Rev. Gen. Psychol. **6**(3), 271–286 (2002). https://doi.org/10.1037/1089-2680.6.3.271
171. Ludwig, A.M.: Method of madness in the arts and sciences. Creativity Res. J. **11**(2), 93–101 (1998). https://doi.org/10.1207/s15326934crj1102_1
172. Dollinger, S.J., Dollinger, S.M.C., Centeno, L.: Identity and creativity. Identify: An Int. J. Theory Res. **5**(4), 315–339 (2005). https://doi.org/10.1207/s1532706xid0504_2
173. Eckert, C.M., Blackwell, A.F., Bucciarelli, L.L., Earl, C.F.: Shared conversations across design. Des. Issues **26**(3), 27–39 (2010). https://doi.org/10.1162/DESI_a_00027
174. James, K.: Goal conflict and originality of thinking. Creativity Res. J. **8**(3), 285–290 (1995). https://doi.org/10.1207/s15326934crj0803_7
175. James, K., Chen, J., Goldberg, C.: Organizational conflict and individual creativity. J. Appl. Soc. Psychol. **22**(7), 545–566 (1992). https://doi.org/10.1111/j.1559-1816.1992.tb00989.x
176. Batey, M., Furnman, A.: Creativity, intelligence, and personality: a critical review of the scattered literature. Genet., Soc., Psychol. Monogr. **132**(4), 355–429 (2006). https://doi.org/ 10.3200/MONO.132.4.355-430
177. Feist, G.J., Barron, F.X.: Predicting creativity from early to late adulthood: intellect, potential, and personality. J. Res. Pers. **37**, 62–88 (2003). https://doi.org/10.1016/S0092-6566(02)00536-6
178. Furnham, A., Bachtair, B.: Personality and intelligence as predictors of creativity. Pers. Individ. Differ. **45**, 613–617 (2008). https://doi.org/10.1016/j.paid.2008.06.023
179. Jauk, E., Benedek, M., Dunst, B., Neubauer, A.C.: The relationship between intelligence and creativity: new support for the threshold hypothesis by means of empirical breakpoint detection. Intelligence **41**, 212–221 (2013). https://doi.org/10.1016/j.intell.2013.03.003
180. Karwowski, M., Dul, J., Gralewski, J., Jauk, E., Jankowska, D.M., Gajda, A., Chruszczewski, M.H., Benedek, M.: Is creativity without intelligence possible? A necessary

condition analysis. Intelligence **57**, 105–117 (2016). https://doi.org/10.1016/j.intell.2016.04. 006

181. Kim, K.H.: Can only intelligent people be creative? J. Secondary Gifted Educ. **41**(2. 2/3), 57–66 (2005). https://doi.org/10.4219/jsge-2005-473

182. Kim, K.H.: Meta-analysis of the relationship of creative achievement to both IQ and divergent thinking test scores. J. Creative Behav. **42**(2), 106–130 (2008). https://doi.org/10. 1002/j.2162-6057.2008.tb01290.x

183. McCabe: Influence of creativity and intelligence on academic performance. J. Creative Behav. **25**(2), 116–122 (1991). https://doi.org/10.1002/j.2162-6057.1991.tb01361.x

184. Nusbaum, E.C., Silva, P.J.: Are intelligence and creativity really so different? fluid intelligence, executive processes, and strategy use in divergent thinking. Intelligence **39**, 36–45 (2011). https://doi.org/10.1016/j.intell.2010.11.002

185. Plucker, J.A., Esping A.: Intelligence and creativity: a complex but important relationship. Asia Pac. Educ. Rev. **16**, 153–159 (2015). https://doi.org/10.1007/s12564-015-9374-9

186. Powers, D.E., Kaufman, J.C.: Do standardized tests penalize deep-thinking, 186, or conscientious students? Some personality correlates of graduate record examinations test scores. Intelligence **32**, 145–153 (2004). https://doi.org/10.1016/j.intell.2003.08.003

187. Sligh, A.C., Conners, F.A., Roskos-Ewoldsen, B.: Relation of creativity to fluid and crystallized intelligence. J. Creative Behav. **39**(2), 123–136 (2005). https://doi.org/10.1002/j. 2162-6057.2005.tb01254.x

188. Sternberg, R.J.: What is the common thread of creativity? Its dialectical relation to intelligence and wisdom. Am. Psychol. **56**(4), 360–362 (2001). https://doi.org/10.1037// 0003-066X.56.4.360

189. Zuckerman, M., Li, C., Lin, S., Hall, J.A.: The negative intelligence-religiosity relation: new and confirming evidence. Pers. Soc. Psychol. Bull. (2019). https://doi.org/10.1177/ 0146167219879122

190. Abraham, A., Thybusch, K., Pieritz, K., Hermann, C.: Gender differences in creative thinking. behavioral and fMRI findings. Brain Imaging Behav. **8**, 39–51 (2014). https://doi. org/10.1007/s11682-013-9241-4

191. Baer, J., Kaufman, J.C.: Gender differences in creativity. J. Creative Behav. **42**(2), 75–105 (2008). https://doi.org/10.1002/j.2162-6057.2008.tb01289.x

192. Brown, N.W., Joslin, M.: Comparison of female and male engineering students. Psychol. Rep. **77**, 35–41 (1995). https://doi.org/10.2466/pr0.1995.77.1.35

193. Fallik, B., Eliot, J.: Intuition, cognitive style, and hemispheric processing. Percept. Mot. Skills **60**, 683–697 (1985). https://doi.org/10.2466/pms.1985.60.3.683

194. Forisha, B.L.: Creativity and imagery in men and women. Percept. Mot. Skills **47**, 1255–1264 (1978). https://doi.org/10.2466/pms.1978.47.3f.1255

195. Goldsmith, R.E., Matherly, T.A.: Creativity and self-esteem: a multiple operationalization validity study. The J. Psychol. **122**(1m), 47–56 (1988). https://doi.org/10.1080/00223980. 1988.10542942

196. Kleibeuker, S.W., Koolschijn, P.C.M.P., Jolles, D.D., De Dreu, C.K.W., Crone, E.A.: The neural coding of creative idea generation across adolescence and early adulthood. Front. Human Neurosci. **7**, Article 905, 1–12 (2013). https://doi.org/10.3389/fnhum.2013.00905

197. Razumnikova, O.M.: Gender differences in hemispheric organization during divergent thinking: an EEG investigation in human subjects. Neurosci. Lett. **362**, 193–195 (2004). https://doi.org/10.1016/j.neulet.2004.02.066

198. Razumnikova, O.M.: Gender-dependent frequency-spatial organization of the brain cortex activity during convergent and divergent thinking: II. Analysis of the EEG coherence. Human Physiol. **31**(3), 275–284 (2005). https://doi.org/10.1023/B:HUMP.0000049580. 11362.08

199. Razumnikova, O.M., Volf, N.V.: Sex differences in the relationship between creativity and hemispheric information selection at the global and local levels. Human Physiol. **38**(5), 478–486 (2012). https://doi.org/10.1134/S0362119712040111

200. Razumnikova, O.M., Volf, N.V., Tarasova, I.V.: Strategy and results: sex differences in electrographic correlates of verbal and figural creativity. Human Physiol. **35**(3), 285–294 (2009). https://doi.org/10.1134/S0362119709030049

201. Volf, N.V., Tarasova, I.V.: The relationship between EEG q and b oscillations and the level of creativity. Human Physiol. **36**(2), 132–138 (2010). https://doi.org/10.1134/S0362119710020027

202. Jaskyte, K.: Employee creativity in U.S. and lithuanian nonprofit organizations. Nonprofit Manage. Leadersh. **18**(4), 465–484 (2008). https://doi.org/10.1002/nml.198

203. Kharkhurin, A.B., Motalleebi, S.N.S.: The impact of culture on the creative potential of American, Russian, and Iranian college students. Creativity Res. J. **20**(4), 404–411. https://doi.org/10.1080/10400410802391835

204. Ng., A. K.: A cultural model for creative and conforming behavior. Creativity Res. J. **15**(2–3), 223–233 (2003). https://doi.org/10.1080/10400419.2003.9651414

205. Niu, W., Sternberg, R.J.: Cultural influences on artistic creativity and its evaluation. Int. J. Psychol. **36**(4), 225–241 (2001). https://doi.org/10.1080/00207590143000036

206. Palmiero, M., Nakatani, C., van Leeuwen, C.: Visual creativity across cultures: a comparison between Italians and Japanese. Creativity Res. J. **29**(1), 86–90 (2017). https://doi.org/10.1080/10400419.2017.1263514

207. Yi, X., Hu, W., Scheithauer, H., Niu, W.: Cultural and bilingual influences on artistic creativity performances: comparison of German and Chinese students. Creativity Res. J. **15**(1), 97–108 (2013). https://doi.org/10.1080/10400419.2013.752260

208. Zha, P., Walczyk, J.J., Griffith-Foss, D.A., Tobacyk, J.J., Walczyk, D.F.: The Impact of culture and individualism-collectivism on the creative potential and achievement of American and Chinese adults. Creativity Res. J. **18**(3), 355–366 (2006). https://doi.org/10.1207/s15326934crj1803_10

209. Buchtel, E., Norenzayan, A.: Which should you use, intuition or logic? Cultural differences in injunctive norms about reasoning. Asian J. Soc. Psychol. **11**, 264–273 (2008). https://doi.org/10.1111/j.1467-839X.2008.00266.x

210. Nisbett, R.E., Peng, K., Choi, I., Norenzayan, A.: Culture and systems of thought: holistic versus analytic cognition. Psychol. Rev. **108**(2), 291–310 (2001). https://doi.org/10.1037/0033-295x.108.2.291

211. Huntsinger, C.S., Jose, P.E., Krieg, D.B., Luo, Z.: Cultural differences in Chinese American and European American children's drawing skills over time. Early Child. Res. Q. **26**, 134–145 (2011). https://doi.org/10.1016/j.ecresq.2010.04.002

212. Maddux, W.W., Galinsky, A.D.: Cultural borders and mental barriers: the relationship between living abroad and creativity. J. Pers. Soc. Psychol. **96**(5), 1047–1061 (2009). https://doi.org/10.1037/a0014861

213. Leung, A.K., Chiu, C.: Multicultural experience, idea receptiveness, and creativity. J. Cross Cult. Psychol. **41**(5–6), 723–741 (2010). https://doi.org/10.1177/0022022110361707

214. Kharkhurin, A.V.: Bilingual verbal and nonverbal creative behavior. Int. J. Bilingualism **14**(2), 211–275 (2010). https://doi.org/10.1177/1367006910363060

215. Kharkhurin, A.V.: The role of bilingualism in creative performance on divergent thinking and invented creatures tests. J. Creative Behav. **43**(1), 59–71 (2009). https://doi.org/10.1002/j.2162-6057.2009.tb01306.x

216. Leikin, M.: The effect of bilingualism on creativity: developmental and educational perspectives. Int. J. Bilingualism **17**(4), 431–447 (2012). https://doi.org/10.1177/1367006912438300

Enhancing Our Ability to Design

<div style="text-align: right">**8**</div>

8.1 Introduction

Yes, we can improve our ability to design through long term activities like design education, training, and practice, but they take time. What can we do right now? What can we do today to enhance our ability to design today? This chapter reviews many of the methods of cognitive enhancement that have been proposed for improving our design effectiveness. Some of them even work.

8.2 Cognitive Enhancement

Cognitive enhancement is doing something that is intended to enhance our cognition, i.e., boost our mental performance in some way. Many different methods for cognitive enhancement have been proposed [1–6]. One common factor found in many of these methods is that they increase the dopamine level in the brain. Dopamine is a naturally occurring neurotransmitter that works by assisting neurons in sending signals. Dopamine allows us to use all of our brains more effectively. Dopamine levels are strongly and positively correlated with an increase in some measures of creativity [7–13], reduced latent inhibition and openness to experience, [8, 14, 15] as well as a positive mood (discussed in the following chapter) [16, 17]. If our dopamine levels are too high, however, our ability to both generate and evaluate ideas may be negatively impacted [7, 16, 18].

We will now review some of the methods of cognitive enhancement that may enhance our ability to design.

J. Reis, *Advanced Design*, https://doi.org/10.1007/978-3-030-95782-7_8

8.3 Incubation

Incubation can significantly enhance our ability to design. Incubation occurs when we work on a design project, take a break and do something unrelated for a while, and then return again to the project. The period when we are not working on our project is called the incubation period [19–33].

The benefits of incubation on design can occur through two different, but related, mechanisms. First, we can unconsciously process material as we do something else. During this unconscious processing, new and unexpected insights can arise about our design project. Because we are not following a sequential train of thought during the incubation period, this unconscious processing involves intuitive thought. Second, the incubation process can help us get out of a state of design fixation. By doing something completely different, we are able to return to our design with a fresh perspective.

8.4 Sleep and Dreams

Sleeping and dreaming are things we all spend many hours doing every day. Both sleep and dreams can impact our ability to design.

8.4.1 Sleep

The mere act of sleeping can enhance our ability to design. During sleep, memories are stored, restructured, and integrated with other memories. Sleeping alters our neural patterns and can induce additional learning. As a result, we can achieve enhanced cognitive performance by "sleeping on it". All we need to do is to defer design decisions until after we have slept for a while. The cognitive enhancement from sleep is greater than that of incubating for the same period of time without sleep [34, 35].

There are two different types of sleep: REM (Rapid Eye Movement) and NREM (Non-Rapid Eye Movement) sleep. REM sleep tends to have higher levels of neural activity than NREM sleep and usually involves more dreaming. Both types of sleep appear to increase some measures of creativity while decreasing others [36–38].

It is noted that the lack of sleep has a strong and negative effect on our creativity and ability to design [39–45]. Sleep deprivation can be particularly important for designers because the open-ended nature of design projects does not provide clear stopping points for rest. The lack of clear stopping points can create a culture of working long hours, particularly for students (art students in studio classes and engineering students in project classes) who can feel pressured to pull all-nighters [46].

8.4.2 Dreams

Dreams can enhance our ability to design. They are particularly useful as a source of new ideas [47–56]. Examples of ideas received in dreams include Otto Loewi, a Nobel Prize winner for his discovery of chemical transmissions in nerve impulses [57], Dmitri Mendeleyev for the Periodic Table of chemistry [58], August Kekule for the structure of the benzene ring, Elias How for the sewing machine needle, David Parkinson for improvements in anti-aircraft guns, Samuel Coleridge for his poem "Kubla Khan", and Robert Lewis Stevenson for key scenes in Dr. Jekyll and Mr. Hyde [48].

Dreams appear to aid idea generation by suppressing the executive control functions of the brain. Thus, when we dream, we are less inhibited [47]. On the other hand, dreams do not appear to impact our ability to evaluate or select our ideas [59].

To use dreams to enhance our ability to design may require some effort; we may need to alter how we approach dreaming. Perhaps the simplest way to do this is to gently think about our design project as we prepare to sleep. We often dream about what was in our final waking thoughts. Simply putting out attention on something can increase the number of dreams we have related to that topic [55].

A second method for using dreams to enhance our ability to design is to develop our ability to recall dreams. Our dream recall is positively related to our creativity [53, 60]. Our ability to recall dreams can be enhanced by keeping a dream log. All we need to do is keep a pencil and paper by our bed and write down our dreams upon waking [61]. A flashlight with a red filter can aid this if we wake in the middle of the night and do not want to turn on a bright light to record our dreams. Because information in dreams tends to be symbolic, dream interpretation may require that we understand our personal (and often unconscious) symbolism. Many different approaches to dream interpretation are available, but are outside the scope of this book.

A third method to enhance our ability to design using dreams is to learn lucid dreaming. Lucid dreams are dreams in which we become consciously aware that we are dreaming while we are dreaming and can consciously alter our dreams as we dream [62, 63]. People who have developed the ability to have lucid dreams tend to be more creative than those who have not [64–67].

8.4.3 Hypnagogia

A final sleep-related method to enhance our ability to design is hypnagogia. Hypnagogia is the transition state from waking to sleeping. It is related to hypnopompia, which is the reverse transition from sleep to wakefulness. During these transition periods the executive functions of our brains are suppressed, allowing increased creativity.

The painter Salvador Dali often took naps while sitting in a chair with a key in his hand. When he drifted off to sleep, his hand would relax and he would drop the key. The sound of the key hitting the floor then would wake him. He then painted the images he had just seen in the transition state from waking to sleeping, i.e., the state of hypnagogia [68]. Thomas Edison reputedly did the same thing to find solutions to engineering problems, only with steel balls in his hand. Other creative people, such as Brahms, Puccini, Wagner, and Goethe have also reportedly used hypnagogia as a source for their inspirations [69].

8.5 Focused Imagination

We can also use our imagination to enhance our ability to design.

Highly creative people in virtually all domains use vivid imagery as a key component of their creative process. Painters often see a completed painting in their minds before they begin. Music composers often hear their music in their minds before they first express it or write it down. Engineers can see in their mind's eye what possible solutions might look like. For designers in all disciplines, internal imagery is a key process that allows previous perceptions to be combined and modified in novel ways [70].

Our ability to focus our imagination has been positively linked to our ability to generate ideas [71–75]. However, using our imagination may be most effective if we focus on images that are within the same discipline as our design activities. This effect may be domain-specific [76–79]. Some ways to enhance our domain-specific usage of imagination include imagining that our design processes are occurring much further into the future than the present time [80, 81] or imagining that we are playful children as we design [82]. Shifting our imagination can be a way to practice metacognition and switching of our thinking modes.

It is noted that daydreaming (also known as mind wandering or spontaneous thought) is not the same as focused imagination. Imagination involves a consciously targeted focus, while daydreaming is more spontaneous. Daydreams have been only weakly correlated with creativity [83–85].

8.6 Meditation

Meditation beyond simple relaxation has been shown to enhance our ability to design [86–95]. Meditation appears to enhance creativity [90, 96–102], particularly for closed-ended insight problems [103–105]. A key role of meditation in design may be from its effectiveness in developing our intuitive thinking mode. It may also enhance our metacognition and give us practice switching thinking modes, which enhances our ability to design.

8.7 Hypnosis

Hypnosis has been shown to enhance our ability to design though an increase of some, but not all, measures of creativity. This enhancement comes primarily from a strengthening our intuitive thinking mode while suppressing our analytical thinking mode [73, 106–111]. It may also enhance our metacognition and give us practice switching thinking modes. One reason for some of the inconsistent results from hypnosis may be from the use of inconsistent methods for guiding our attention after a hypnotic state had been achieved. Of course, inconsistent measures of creativity may also have played a role.

Our creativity appears to be positively linked to our hypnotizability (our ability to be hypnotized) [106–108, 110, 112–114]. Our ability to be hypnotized may be linked with our openness to experience.

8.8 Posture and Exercise

Both our posture and our level of exercise can enhance our ability to design.

An open posture tends to enhance our ability to design. Sitting with an open posture (no crossed arms or legs) can enhance idea generation [115], as can adopting facial expressions like smiling or raising an eyebrow (opposite of frowning) [116–118]. Further, when we lift upward with our hands or pull things toward us, we tend to be more effective at generating ideas. Conversely, when we push downward with our hands or push things away from us, we tend to be more effective at evaluating and selecting ideas [119–123].

Exercise has been shown to enhance a number of measures of creativity, including idea generation [124–138].

8.9 Food and Drink

Although a good diet can have an indirect impact on our ability to design through better health, the direct effects of foods and drinks appear to be limited.

Caffeine, primarily ingested through coffee or tea, appears to have a mixed effect on our ability to design: some studies show an increase in some measures of creativity and others show a decrease [139–143]. Caffeine, however, may offset some of the effects of sleep deprivation [144].

Chocolate can provide a moderate cognitive enhancement [145], particularly for overcoming age-related cognitive decline [143, 146]. Its effect on our ability to design, however, is unclear. It is noted, however, that countries with higher per capita chocolate consumption have more per capita Nobel laureates [147]. Of course, Nobel laureates are from Disciplines of Discovery, not Disciplines of Creation. As we have seen those in Disciplines of Discovery solve insight problems while those in Disciplines of Creation solve design problems.

Glucose supplements (sugar) appear to be able to offset cognitive decline in elderly people but appear to have little effect on healthy people with a good diet [148–151].

Resveratrol, an ingredient found in red wine, has been shown to provide a number of health benefits, but has not been linked with enhancing our ability to design [152].

8.10 Mind-Altering Substances

A number of mind-altering substances are available, both legally and illegally, that significantly alter cognition and, in some cases, can alter our ability to design. These substances include alcohol, cannabis (marijuana), prescription drugs, and hallucinatory (psychedelic) drugs.

8.10.1 Alcohol and Cannabis

Because of the ease with which alcohol and cannabis (marijuana) can be acquired, they are both widely used as recreational drugs to alter cognition. Depending on their usage, they may either positively or negatively impact our ability to design.

Low to moderate intoxication from alcohol has been shown to enhance idea generation but inhibit idea evaluation and selection. High levels of intoxication, however, inhibit all dimensions of design effectiveness. Interestingly, the belief that imbibing alcohol enhances creativity may increase creativity as much as the imbibition effect itself. This suggests that the cognitive enhancement of imbibing alcohol may be, at least partially, the result of the placebo effect [143, 153–158]. Or course, as designers, our goal is to enhance our ability to design. If the placebo effect works for us, then it works for us! Alcohol (and perhaps its placebo effect) may enhance our ability to design by enhancing our openness to experience, which has been linked to creativity [159–162].

Cannabis, unlike alcohol, has been shown to decrease all dimensions of design effectiveness, including creativity, under all levels of intoxication [163, 164]. Low levels of cannabis intoxication do not appear to have the same impact as alcohol on our inhibitions. Like alcohol, the belief that cannabis can enhance creativity does result in an increased creativity. This suggests that any cognitive enhancement from using cannabis may also be, at least partially, from the placebo effect [160]. Cannabis users who are not under its influence tend to have a higher creativity than non-cannabis users. This does not necessarily indicate that using cannabis leads to creativity but may simply reflect that creative people are more likely to use cannabis [165–167].

8.10.2 Prescription Drugs

Prescription drugs are available to counter some of the negative effects on cognition of certain medical conditions. The most commonly used drugs for this purpose are methylphenidate (Ritalin) and amphetamine to treat symptoms of attention-deficit/hyperactivity disorder (ADHD) and modafinil to treat sleep disorders. The effectiveness of these drugs to enhance our ability to design, however, is unclear [3, 9, 168–171]. The belief that these drugs enhances creativity has resulted in an increase in creativity, suggesting the presence of the placebo effect [172].

One positive link with these drugs to design effectiveness, particularly modafinil, is that they can partially negate the cognitive impairment of sleep deprivation. They do not enhance cognition above the levels of being well-rested, however [144, 173, 174].

8.10.3 Hallucinatory Drugs

The most commonly used hallucinatory drugs for altering cognition include magic mushrooms (psilocybin), ayahuasca (DMT), peyote (mescaline), and LSD. These drugs have been shown to enhance some people's ability to design. It is noted that the use of these drugs is largely illegal outside of cultures that use them as part of their spiritual practices.

The most widely reported impact of these drugs relative to design is enhanced idea generation. This impact tends to not occur during the intoxicating period itself but after the intoxication period has ended. The resulting cognitive enhancement has been shown to last for weeks to decades after a single intoxication period, particularly if the user had a mystical-type experience [175–185]. The impact of hallucinatory drugs is particularly strong for visual artists. Using LSD has been shown to result in aesthetically superior artwork [186–188]. It is noted that people who have had near-death experiences have also reported positive life-long impacts [189], but the relationship between near-death experiences and our ability to design is unclear.

Microdosing of hallucinogenic drugs has also been reported to enhance cognition. Microdosing involves taking a dose of a drug at levels significantly lower than that required for an intoxicating effect (typically a dose about one tenth that required to notice any intoxication). Self-reporting of people who engage in microdosing suggest improved mood, cognition (including problem solving ability), and creativity. People who microdose tend to have a higher openness to experience and be more extroverted, but this may be from creative people being more likely to microdose [190–194]. Similar to other mind-altering substances, the placebo effect may play a role in any enhanced creativity from microdosing.

8.11 Technology

The final methods that we will discuss for enhancing our ability to design involve using technology to alter our neural activities. Three types of technology are discussed here:

(1) neurofeedback that allows us to monitor and alter our neural activity in real time,
(2) transcranial stimulation that externally applies electrical currents to our brain, and
(3) entraining our brainwaves through rhythmic sensory inputs.

8.11.1 Neurofeedback

Neurofeedback is a type of biofeedback in which we learn to alter our neural activity, which in turn, can enhance our ability to design. Although neurofeedback has been reported using functional magnetic resonance imaging (fMRI) [195], the most common forms of neurofeedback relative to design involve using an electroencephalogram (EEG) [196].

The neural activity in our brain generally occurs in cyclic patterns (waves) that have different frequencies depending on how we are thinking. These waves are created by the coherent firing of neurons across wide regions of the brain. For simplicity, these frequencies have been grouped into bands. These bands are

- Beta: The beta band (frequencies between about 13 and 30 Hz) is the frequency band that most commonly occurs during waking activity. When we use analytical thought, our brainwaves are primarily in the beta band.
- Alpha: The alpha band (frequencies between about 8 and 13 Hz) is more common when we are relaxed, particularly with our eyes closed. When we use intuitive thought, our brainwaves are primarily in the alpha band.
- Theta: The theta band (frequencies between about 4 and 8 Hz) occurs primarily when we are in very deep state of relaxation, such as hypnagogia, meditation, or hypnosis. Theta band frequencies are also associated with intuitive thought.
- Delta: The delta band (frequencies below 4 Hz) occur during sleep.
- Gamma: The gamma band (frequencies above about 30 Hz) appear to be the mechanism by which the different parts of the brain share information with each other. Gamma band frequencies tend to be present when we are solving problems.

The most common forms of neurofeedback involve either altering the level of alpha waves relative to beta waves (alpha training) or altering the level of alpha waves relative to theta waves (alpha/theta training). Such training can help us enter into an intuitive thought mode and enhance idea generation. Both forms of

neurofeedback have been shown to produce a modest enhancement of creativity. Training can also enhance activity in the gamma band, but its impact on our ability to design is unclear [197–216]. Neurofeedback has the benefit of aiding metacognition and switching thinking modes.

8.11.2 Transcranial Stimulation

Transcranial stimulation involves sending an electrical current directly into the brain through electrodes placed on the skull or inducing an electrical current in the brain through magnetic induction from coils placed near the skull. These electrical currents alter the neural activity in our brains and can enhance our ability to design.

There are three major approaches to cognitive enhancement by transcranial stimulation.

1. Transcranial Direct Current Simulation (tDCS). This is the most common form of transcranial stimulation. In this method, two electrodes are applied to the skull and a weak voltage is applied between them to induce a current through the brain. Although the voltages and currents involved are generally not strong enough to force the neurons in the brain to fire, they do alter the resting membrane potential of the neurons near the electrodes, which alters their susceptibility to firing. Neurons near the anode of the electrical circuit become more likely to fire, while neurons near the cathode are less likely to fire. tDCS tends to be a surface effect, with little penetration deep into the brain. tDCS devices are relatively inexpensive and are widely available.
2. Transcranial Alternating Current Stimulation (tACS): This method is related to tDCS, but an alternating current is applied between the two electrodes instead of a direct (constant) current. tACS devices are not as widely available.
3. Transcranial Magnetic Stimulation (TMS): This method involves stimulating a current within the brain by magnetic induction. Electrical coils are placed over the skull and a current is passed through them. This electrical current induces a magnetic field deep within the brain, which can be strong enough to force neurons to fire. The induced magnetic field can be applied with a single pulse, or a series of repetitive pulses. TMS devices are very expensive and may require regulatory approval for use.

Transcranial direct current stimulation (tDCS) has been shown to either enhance or impair cognition, depending on how it is applied and what measures of cognition were used [217, 218]. tDCS can enhance some measures of creativity [219–227], while impairing others [227]. It has also been shown to enhance analytical thinking and alter decision making [228–233]. Although tDCS appears to have potential for enhancing our ability to design, more research is needed to clarify how to use it for design activities.

Transcranial alternating current stimulation (tACS) may also provide cognitive enhancement. It has been shown to enhance some measures of creativity, including idea generation [234–236], and it also may enhance analytical thinking and alter

decision making [237, 238]. tACS also appears to have potential for enhancing our ability to design, but it too needs more research.

Transcranial magnetic stimulation (TMS) has also been shown to provide some levels of cognitive enhancement [239–249], but its impact on design remains unclear [3, 250, 251].

8.11.3 Brainwave Entrainment

Brainwave entrainment involves providing a cyclic, external stimulus to the brain at a desired frequency, typically either alpha or theta frequencies. This stimulus then induces the brain to amplify its own electrical waves at the same frequency through entrainment. Inducing these frequencies can enhance our ability to design [252, 253].

Acoustic stimulation through binaural beats is a common method of brainwave entrainment for cognitive enhancement. Binaural beats occur when two musical notes at slightly different frequencies are played simultaneously. From constructive and destructive interference of the two frequencies, a third tone (the binaural beat) can be heard with a frequency equal to the different between the frequencies of the two original tones. Binaural beats are widely used by musicians when tuning instruments.

When used for cognitive enhancement, binaural beats are normally induced by wearing earphones with one note played through one side of the headphone and the other note played through the other side. The binaural beats, themselves, are never acoustically generated but are induced neurologically within the brain.

Preliminary results suggest that brainwave entrainment through the use of binaural beats can provide cognitive enhancement, and, in particular, may aid creativity [18, 254–258]. More research is needed, however, to clarify how to use it to enhance design. Brainwave entrainment may be a way to practice metacognition and switching thinking modes.

Other methods of entraining brainwaves include both transcranial alternating current and transcranial magnetic stimulation, as well as optical stimulation using pulses of light at the desired frequencies. The impact of those technologies on design effectiveness is unclear [259].

8.12 Closing

The key conclusions from this chapter are

1. Many cognitive enhancement methods are available that can enhance our ability to design. Many of these methods involve increasing the natural levels of dopamine in our brain, which is linked to an increased creativity.

2. Incubation can enhance our ability to design. We incubate our ideas by engaging in a different activity for a period of time that shifts our attention away our current design project.

3. Sleep can enhance our ability to design above that of incubating for the same period of time without sleep. Dreams can enhance our ability to design simply by putting attention on them. The hypnagogic state as we fall asleep can be a source of ideas. Lack of sleep significantly impairs our ability to design, but excess sleep does not enhance it.

4. Our imagination can enhance our ability to generate ideas if we focus it within the overall domain of our design project.

5. Meditation can enhance our ability to design through an increased creativity.

6. Hypnosis can enhance our ability to design through an increased creativity.

7. An open posture may enhance idea generation while a closed posture may enhance idea evaluation and selection.

8. Exercise seems to enhance our ability to design, including our ability to generate ideas.

9. Foods and drinks do not appear to enhance our ability to design.

10. Alcohol in low doses appears to enhance creativity, but cannabis does not appear to have a similar effect. Both substances will impair creativity in high doses and both substances impair our ability to evaluate and select ideas at all doses.

11. Prescription drugs taken to enhance cognition in the presence of some medical conditions have not shown to enhance our ability to design. Some prescription drugs may partially offset the cognitive impairment of sleep deprivation, do but not provide an enhancement above that of a well-rested state.

12. Hallucinatory drugs may enhance our ability to design through an increased creativity following the experience.

13. Neurofeedback can enhance our creativity by training us to control the primary frequencies of our brain waves.

14. Direct current transcranial stimulation (tDCS) has potential for enhancing our ability to design, including both generating ideas and making design selections.

15. Brainwave entrainment through binaural beats may enhance idea generation.

8.13 Questions

1. What methods of cognitive enhancement have you tried? What results did you get?

2. Do you use incubation as you design? Do you take breaks during which you do something else that takes your attention away from your design project?

3. Do you always get enough sleep? Can you identify how sleep deprivation impacts your ability to design?

4. Do you pay attention to your dreams? Do you keep a dream journal? Have you ever received any ideas or guidance from your dreams?

5. Have you ever used hypnagogia to generate ideas? What did you do?
6. Do you have a vivid imagination? Do you focus your imagination on your design project or do you let it wander without any control? Has it helped?
7. Do you meditate? If so, what benefits have you noticed? Does it help your designing?
8. Have you even undergone hypnosis? Self-hypnosis? Guided meditation? Can you identify any design-related benefits from your experiences?
9. Have you noticed an impact on your design effectiveness from your posture? What was it? Have you ever deliberately altered you posture to alter your thinking mode? If you are a painter, have you noticed a difference in your designs from how you hold your paintbrush?
10. Have you noticed any design-related benefits from physical exercise? Do you believe that more (or less) exercise would enhance your design effectiveness? Have you ever experienced 'runners high'? Does that state enhance your design effectiveness?
11. Have you ever used low levels of alcohol to help generate ideas? Do you know how much alcohol would result in an impairment of cognition?
12. Have you used cannabis? How has it impacted your designs?
13. Have you ever taken prescription drugs that altered your ability to design? Did it enhance or impair your ability to design?
14. Have you used any hallucinatory drugs? Did it impact your designs?
15. Have you experimented with technological approaches to cognitive enhancement? If so, what were your results?

References

1. Bostrom, N., Sandberg, A.: Cognitive enhancement: methods, ethics, regulatory challenges. Sci. Eng. Ethics **15**, 311–341 (2009). https://doi.org/10.1007/s11948-009-9142-5
2. Dresler, M., Sandberg, A., Ohla, K., Bublitz, C., Trenado, C., Mroczko-Wasowicz, A., Kuhn, S., Repantis, D.: Non-pharmacological cognitive enhancement. Neuropharmacology **64**, 529–543 (2013). https://doi.org/10.1016/j.neuropharm.2012.07.002
3. Farah, M.J., Smith, M.E., Ilieva, I., Hamilton, R.H.: Cognitive enhancement. Wiley Interdiscip. Rev. Cogn. Sci. **5**, 95–103 (2014). https://doi.org/10.1002/wcs.1250
4. Hamilton, R., Messing, S., Chatterjee, A.: Rethinking the thinking cap. Neurology **76**, 187–193 (2011). https://doi.org/10.1212/WNL.0b013e318205d50d .
5. Lynch, G., Palmer, L.C., Gall, C.M.: The likelihood of cognitive enhancement. Pharmacol. Biochem. Behav. **99**, 116–129 (2011). https://doi.org/10.1016/j.pbb.2010.12.024
6. Reiner, M., Gruzelier, J., Bamidis, P.D.: Cognitive enhancement: a system view. Int. J. Psychophysiol. **122**, 1–5 (2017). https://doi.org/10.1016/j.ijpsycho.2017.07.011
7. Akbari Chermahini, S., Hommel, B.: The (b)link between creativity and dopamine: spontaneous eye blink rates predict and dissociate divergent and convergent thinking. Cognition **115**, 458–465 (2010). https://doi.org/10.1016/j.cognition.2010.03.007
8. Faust-Socher, A., Kenett, Y.N., Cohen, O.S., Hassin-Baer, S., Inzelberg, R.: enhanced creative thinking under dopaminergic therapy in Parkinson disease. Ann. Neurol. **75**(6), 935–942 (2014). https://doi.org/10.1002/ana.24181
9. Gvirts, H.Z., Mayseless, N., Segev, A., Lewis, D.Y., Feffer, K., Barnea, Y., Bloch, Y., Shamay-Tsoory, S.G.: Novelty-seeking trait predicts the effect of methylphenidate on

creativity. J. Psychopharmacol. **31**(5), 599–605 (2017). https://doi.org/10.1177/0269881116667703

10. Mayseless, N., Uzefovsky, F., Shalev, I., Ebstein, R.P., Shamay-Tsoory, S.G.: The association between creativity and 7r polymorphism in the dopamine receptor D4 gene (DRD4). Front. Human Neurosci. **7**, Article 502, 1–7 (2013). https://doi.org/10.3389/fnhum.2013.00502

11. Reuter, M., Roth, S., Holve, K., Hennig, J.: Identification of first candidate genes for creativity: a pilot study. Brain Res. **1069**, 190–197 (2006). https://doi.org/10.1016/j.brainres.2005.11.046

12. Takeuchi, H., Taki, Y., Sassa, Y., Hashizume, H., Sekiguchi, A., Fukushima, A., Kawashima, R.: Regional gray matter volume of dopaminergic system associate with creativity: evidence from voxel-based morphology. Neuroimage **51**, 578–585 (2010). https://doi.org/10.1016/j.neuroimage.2010.02.078

13. Zabelina, D.L., Colzato, L., Beeman, M., Hommel, B.: Dopamine and the creative mind: individual differences in creativity are predicted by interactions between dopamine genes DAT and COMT. PlosOne **11**(1), 1–16 (2016). https://doi.org/10.1371/journal.pone.0146768

14. Peterson, J.B., Carson, S.: Latent inhibition and openness to experience in a high-achieving student population. Personal. Individ. Differ. **28**, 323–332 (2000). https://doi.org/10.1016/S0191-8869(99)00101-4

15. Swerdlow, N.R., Stephany, N., Wasserman, L.C., Talledo, J., Sharp, R., Auerbach, P.P.: Dopamine agonists disrupt visual latent inhibition in normal males using a within-subject paradigm. Psychopharmocology **169**, 314–320 (2003). https://doi.org/10.1007/s00213-002-1325-6

16. Akbari, Chermahini, S., Hommel, B.: More creative through positive mood? Not everyone. Front. Human Neurosci. **6**, Article 319, 1–7 (2012). https://doi.org/10.3389/fnhum.2012.00319

17. Ashby, F.G., Isen, A.M., Turken, U.: A neuropsychological theory of positive affect and its influence on cognition. Psychol. Rev. **106**(3), 529–550 (1999). https://doi.org/10.1037/0033-295x.106.3.529

18. Reedijk, S.A., Bolders, A., Hommel, B.: The impact of binaural beats on creativity. Front. Human Neurosci. **7**, Article 786, 1–7 (2013) https://doi.org/10.3389/fnhum.2013.00786

19. Baird, B., Smallwood, J., Mrazek, M.D., Kam, J.W.Y., Franklin, M.S., Schooler, J.W.: Inspired by distraction: mind wandering facilitates creative incubation. Psychol. Sci. **23**(10), 1117–1122 (2012). https://doi.org/10.1177/0956797612446024

20. Browne, B.A., Cruse, D.F.: The incubation effect: illusion or illumination. Hum. Perform. **1**(3), 177–185 (1988). https://doi.org/10.1207/s15327043hup0103_3

21. De Vries, M., Witteman, C.L.M., Holland, R.W., Dijksterjuis, A.: The unconscious thought effect in clinical decision making: an example in diagnosis. Med. Decis. Mak. **30**, 578–581 (2010). https://doi.org/10.1177/0272989X09360820

22. Dijksterhuis, A., Meurs, T.: Where creativity resides: the generative power of unconscious thought. Conscious. Cognit. **15**, 135–146 (2006). https://doi.org/10.1016/j.concog.2005.04.007

23. Dodds, R.A., Ward, T.B., Smith, S.M.: A review of experimental research on incubation in problem solving and creativity. In: Runco (ed.) Creativity Research Handbook. Hampton Press (1997)

24. Ellwood, S., Pallier, G., Snyder, A., Gallate, J.: The incubation effect: hatching a solution? Creat. Res. J. **21**(1), 6–14 (2009). https://doi.org/10.1080/10400410802633369

25. Gilhooly, K.J., Georgiou, G.J., Sirota, M., Paphiti-Galeano, A.: Incubation and suppression processes in creative problem solving. Think. Reason. **21**(1), 130–146 (2015). https://doi.org/10.1080/13546783.2014.953581

26. Houtz, J.C., Frankel, A.D.: Effects of incubation and imagery training on creativity. Creat. Res. J. **5**(2), 183–189 (1992). https://doi.org/10.1080/10400419209534432

27. Kohn, N., Smith, S.M.: Partly versus completely out of your mind: effects of incubation and distraction on resolving fixation. J. Creat. Behav. **43**(2), 102–118 (2009). https://doi.org/10.1002/j.2162-6057.2009.tb01309.x
28. Penny, C.G., Godsell, A., Scott, A., Balsom, R.: Problem variables that promote incubation effects. J. Creat. Behav. **38**(1), 35–55 (2004). https://doi.org/10.1002/j.2162-6057.2004.tb01230.x
29. Shah, J.J., Smith, S.M., Vargas-Hernandez, N., Gerkins, D.R., Wulan, M.: Empirical studies of design ideation: alignment of design experiments with lab experiments. In: Proceedings of the DETC 2003: ASME 2003 International Conference on Design Theory and Methodology, Chicago, IL, Sept. 2–6 (2003). https://doi.org/10.1115/DETC2003/DTM-48679
30. Sio, U.N., Ormerod, T.C.: Does incubation enhance problem solving? A meta-analysis review. Psychol. Bull. **135**(1), 94–120 (2009). https://doi.org/10.1037/a0014212
31. Smith, S.M., Blankenship, S.E.: Incubation and the persistence of fixation in problem solving. Am. J. Psychol. **105**(1), 61–87 (1991). https://doi.org/10.2307/1422851
32. Tsenn, J., Atilola, O., McAdams, D.A., Linsey, J.S.: The effects of time and incubation on design concept generation. Des. Stud. **35**, 500–526 (2014). https://doi.org/10.1016/j.destud.2014.02.003
33. Vargas-Hernandez, N., Shah, J.J., Smith, S.M.: Understanding design ideation mechanisms through multilevel aligned empirical studies. Des. Stud. **31**, 382–410 (2010). https://doi.org/10.1016/j.destud.2010.04.001
34. Gaab, N., Paetzold, M., Becker, B., Walker, M.P., Schlaug, G.F.: The influence of sleep on auditory learning: a behavioral study. NeuroReport **15**(4), 731–734 (2004). https://doi.org/10.1097/00001756-200403220-00032
35. Wagner, U., Gais, S., Haider, H., Verleger, R., Born, J.: Sleep inspires insight. Nature **427**, 352–355 (2004). https://doi.org/10.1038/nature02223
36. Cai, D.J., Mednick, S.A., Harrison, E.M., Kanady, J.C., Mednick, S.C.: REM, not incubation, improves creativity by priming associative networks. Proc. Natl. Acad. Sci. **106**(25), 10130–10134 (2009). https://doi.org/10.1073/pnas.0900271106
37. Drago, V., Foster, P.S., Heilman, K.M., Arico, D., Williamson, J., Montanga, P., Ferri, R.: Cyclic alternating pattern in sleep and its relationship to creativity. Sleep Med. **12**, 361–366 (2011). https://doi.org/10.1016/j.sleep.2010.11.009
38. Walker, M.P., Liston, C., Hobson, J.A., Stickgold, R.: Cognitive flexibility across the sleep-wake cycle: REM-sleep enhancement of anagram problem solving. Cogn. Brain Res. **14**, 317–324 (2002). https://doi.org/10.1016/s0926-6410(02)00134-9
39. Harrison, Y., Horne, J.A.: One night of sleep loss impairs innovative thinking and flexible decision making. Org. Behav. Human Dec. Proces. **78**(2), 128–145 (1999). https://doi.org/10.1006/obhd.1999.2827
40. Horne, J.A.: Sleep loss and 'Divergent' thinking ability. Sleep **11**(6), 528–536 (1988). https://doi.org/10.1093/sleep/11.6.528
41. Pace-Schott, E.F., Nave, G., Morgan, A., Spencer, R.M.C.: Sleep-dependent modulation of affectively guided decision-making. J. Sleep Res. **21**, 30–39 (2012). https://doi.org/10.1111/j.1365-2869.2011.00921.x
42. Philibert, I.: sleep loss and performance in residents and nonphysicians: a meta-analytic examination. Sleep **278**(11), 1392–1402 (2005). https://doi.org/10.1093/sleep/28.11.1392
43. Pilcher, J.J., Huffcutt, A.I.: Effects of sleep deprivation on performance: a meta-analysis. Sleep **19**(4), 318–326 (1996). https://doi.org/10.1093/sleep/19.4.318
44. Vartanian, O., Bouak, F., Caldwell, J.L., Cheung, B., Cupchik, G., Jobidon, M.-E., Lam, Q., Nakashima, A., Paul, M., Peng, H., Silva, P.J., Smith, I.: The effects of a single night of sleep deprivation on fluency and prefrontal cortex function divergent thinking. Front. Human Neurosci. **8**, Article 214, 1–12 (2014). https://doi.org/10.3389/fnhum.2014.00214
45. Wimmer, F., Hoffmann, R.F., Bonato, R.A., Moffitt, A.R.: The effects of sleep deprivation on divergent thinking and attention processes. J. Sleep Res. **1**, 223–230 (1992). https://doi.org/10.1111/j.1365-2869.1992.tb00043.x

46. King, E., Daunis, M., Tami, C., Scullin, M.K.: Sleep in studio based courses: outcomes for creativity task performance. J. Inter. Des. **42**(4), 5–27 (2017). https://doi.org/10.1111/joid.12104

47. Barrett, D.: Dreams and creative problem-solving. Ann. N. Y. Acad. Sci. **1406**, 646–667 (2017). https://doi.org/10.1111/nyas.13412

48. Barrett, D.: The 'Committee of Sleep': a study of dream incubation for problem solving. Dreaming **3**(2), 115–122 (1993). https://doi.org/10.1037/h0094375

49. Bogzaran, F.: Lucid art and hyperspace lucidity. Dreaming **13**(1), 29–42 (2003). https://doi.org/10.1023/A:1022186217703

50. Bogzaran, F.: The creative process: paintings inspired from the lucid dream. Lucidity Letter **6**(2), 1–4 (1987)

51. Bulkeley, K.: Dreaming and the cinema of David Lynch. Dreaming **13**(1), 49–60 (2003). https://doi.org/10.1023/A:1022190318612

52. Kuiken, D., Smith, L.: Impactful dreams and metaphor generation. Dreaming **1**(2), 135–145 (1991). https://doi.org/10.1037/h0094326

53. Pagel, J.F., Kwaitkowski, C., Broyles, K.E.: Dream use in film making. Dreaming **9**, 247–256 (1999). https://doi.org/10.1023/A:1021384019464

54. Schredl, M., Erlacher, D.: Self-reported effects of dreams on waking-life creativity: an empirical study. J. Psychol. **141**(1), 35–46 (2007). https://doi.org/10.3200/JRLP.141.1.35-46

55. Uga, V., Lemut, M.C., Zampi, C., Zilli, I., Salzarulo, P.: Music in dreams. Conscious. Cogn. **15**, 351–357 (2006). https://doi.org/10.1016/j.concog.2005.09.003

56. Van de Castle, R.: Our dreaming mind. Ballantine Books, New York (1994)

57. Loewi, O.: An autobiographical sketch. Perspect. Biol. Med. 4(1), 3–25 (1960). https://doi.org/10.1353/pbm.1960.0006

58. Strathern, P.: Mendeleyev's Dream. Thomas Dunne Boks, New York (2000)

59. Cartwright, R.D.: Problem solving: waking and dreaming. J. Abnorm. Psychol. **83**(4), 451–455 (1974). https://doi.org/10.1037/h0036811

60. Schredl, M.: Creativity and dream recall. J. Creat. Beh. 29(1), 16–24 (1995). https://doi.org/10.1002/j.2162-6057.1995.tb01420.x

61. Sierra-Siegert, M., Jay, E.-L., Florez, C., Garcia, A.E.: Minding the dreamer within: an experimental study on the effects of enhanced dream recall on creative thinking. Journal of Creative Behavoir **535**(1), 83–96 (2016). https://doi.org/10.1002/jocb.168

62. La Berge, S.: Lucid dreaming as a learnable skill: a case study. Percept. Mot. Skills **51**, 1039–1042 (1980). https://doi.org/10.2466/pms.1980.51.3f.1039

63. Paulsson, T., Parker, A.: The effects of a two-week reflection-intention training program on lucid dream recall. Dreaming **16**(1), 22–35 (2006). https://doi.org/10.1037/1053-0797.16.1.22

64. Blagrove, M., Hartnell, S.J.: Lucid dreaming: associations with internal locus of control, need for cognition, and creativity. Personal. Individ. Differ. **28**, 41–47 (2000). https://doi.org/10.1016/S0191-8869(99)00078-1

65. Bourke, P., Shaw, H.: Spontaneous lucid dreaming frequency and waking insight. Dreaming **24**(2), 152–159 (2014). https://doi.org/10.1037/a0036908

66. Stumbrys, T., Daunyte, V.: Visiting the land of dream muses: the relationship between lucid dreaming and creativity. Int. J. Dream Res. **11**(2), 207–212 (2018). https://doi.org/10.11588/ijodr.2018.2.48667

67. Zink, N., Pietrowsky, R.: relationship between lucid dreaming, creativity and dream characteristics. Int. J. Dream Res. **6**(2), 98–103 (2013). https://doi.org/10.11588/ijodr.2013.2.10640

68. Dali, S.: 50 Secrets of Magic Craftsmanship. Dover Publications (1992)

69. Mavromatis, A.: Hypnagogia. Routledge and Kegan Paul, New York (1987)

70. Chavez, R.A.: Imagery as a core process in the creativity of successful and awarded artists and scientists and its neurobiological correlates. Front. Psychol. **7**, Article 351, 1–6 (2016). https://doi.org/10.3389/fpsyg.2016.00351

71. Anderson, R.E., Helstrup, T.: Visual discovery in mind and on paper. Mem. Cognit. **21**(3), 283–293 (1993). https://doi.org/10.3758/BF03208261

72. Anderson, R.E., Helstrup, T.: Multiple perspectives on discovery and creativity in mind and on paper. In: Roskos-Ewoldson, B., Intons-Peterson, M.J., Anderson, R.E. (eds.) Imagery, Creativity, and Discovery: A Cognitive Perspective. Elsevier (1993)

73. Barrios, M.B., Singer, J.L.: The treatment of creative blocks: a comparison of waking imagery, hypnotic dream, and rational discussion techniques. Imagin. Cognit. Personal. **1**(1), 89–109 (1981–1982). https://doi.org/10.2190/69G4-6YCM-N11H-EEEW

74. Shaw, G.A., Belmore, S.M.: The relationship between imagery and creativity. Imagin. Cognit. Personal. **2**(2), 115–123 (1982–1983). https://doi.org/10.2190/4RGA-Y1A6-HEK5-LMF8

75. Vellera, C., Gavard-Perret, M.-L.: A better understanding of the role and underlying mechanism of stimulating mental imagery in improving the creativity of "Ordinary" users. Recherche et Applications en Merketing **31**(3), 111–130 (2016). https://doi.org/10.1177/2051570716658462

76. LeBoutillier, N., Marks, D.F.: Mental imagery and creativity: a meta-analytic review study. Br. J. Psychol. **94**, 29–44 (2003). https://doi.org/10.1348/000712603762842084

77. Palmiero, M., Nori, R., Aloisi, V., Ferrara, M., Piccardi, L.: Domain-specificity of creativity: a study on the relationship between visual creativity and visual mental imagery. Front. Psychol. **6**, Article 1870, 1–8 (2015). https://doi.org/10.3389/fpsyg.2015.01870

78. Palmiero, M., Cardi, B., Belardinelli, M.O.: The role of vividness of visual mental imagery on different dimensions of creativity. Creat. Res. J. **23**(4), 372–375 (2011). https://doi.org/10.1080/10400419.2011.621857

79. Palmiero, M., Nakatani, C., Raver, C., Belardinelli, M.O., van Leeuwen, C.: Abilities within and across visual and verbal domains: how specific is their influence on creativity. Creat. Res. J. **22**(4), 369–377 (2010). https://doi.org/10.1080/10400419.2010.523396

80. Chiu, F.-C.: Fit between future thinking and future orientation on creative imagination. Think. Skills Creat. **7**, 234–244 (2012). https://doi.org/10.1016/j.tsc.2012.05.002

81. Förster, J., Friedman, R.S., Liberman, N.: Temporal construal effects on abstract and concrete thinking: consequences for insight and creative cognition. J. Pers. Soc. Psychol. **87**(2), 177–189 (2004). https://doi.org/10.1037/0022-3514.87.2.177

82. Zabelina, D.L., Robinson, M.D.: Child's play: facilitating the originality of creative output by a priming manipulation. Psychol. Aesthet. Creat. Arts **4**(1), 57–65 (2010). https://doi.org/10.1037/a0015644

83. Singer, J.L., Antrobus, J.S.: A factor-analytic study of daydreaming and conceptually-related cognitive and personality variables. Percept. Motor Skills **17**, 187–209 (1963). https://doi.org/10.2466/pms.1963.17.1.187

84. Singer, J.L., McCraven, V.G.: Some characteristics of adult daydreaming. J. Psychol. **51**, 151–164 (1961). https://doi.org/10.1080/00223980.1961.9916467

85. Singer, J.L., Schonbar, R.A.: Correlates of daydreaming: a dimension of self-awareness. J. Consult. Psychol. **25**(1), 1–6 (1961). https://doi.org/10.1037/h0048906

86. Chiesa, A., Calati, R., Serretti, A.: Does mindfulness training improve cognitive abilities? A systematic review of neuropsychological findings. Clin. Psychol. Rev. **31**, 449–464 (2011). https://doi.org/10.1016/j.cpr.2010.11.003

87. Greenberg, J., Reiner, K., Meiran, N.: 'Mind the Trap': mindfulness practice reduced cognitive rigidity. PLoS ONE **7**(5), Article e36206, 1–8 (2012). https://doi.org/10.1371/journal.pone.0036206

88. Hodgins, H.S., Adair, K.C.: Attentional processes and meditation. Conscious. Cogn. **19**, 872–878 (2010). https://doi.org/10.1016/j.concog.2010.04.002

89. Holzel, B.K., Lazar, S.W., Gard, T., Schuman-Oliver, Z., Vago, D.R., Ott, U.: How does mindfulness meditation work? Proposing mechanisms of action from a conceptual and neural perspective. Perspect. Psychol. Sci. **6**(6), 537–559 (2011). https://doi.org/10.1177/1745691611419671

90. Horan, R.: The neuropsychological connection between creativity and meditation. Creat. Res. J. **21**(2–3), 199–222 (2009). https://doi.org/10.1080/10400410902858691

91. Jain, S., Shapiro, S.L., Swanick, S., Roesch, S.C., Mills, P.J., Bell, I., Schwartz, G.E.R.: A randomized controlled trial of mindfulness meditation versus relaxation training: effects of distress, positive state of mind, rumination, and distraction. Ann. Behav. Med. **33**(1), 11–21 (2007). https://doi.org/10.1207/s15324796abm3301_2

92. Krampen, G.: Promotion of creativity (divergent productions) and convergent productions by systematic-relaxation exercises: empirical evidence from five experimental studies with children, young adults, and elderly. Eur. J. Pers. **11**, 83–99 (1997). https://doi.org/10.1002/(SICI)1099-0984(199706)11:2%3c83::AID-PER280%3e3.0.CO;2-5

93. Levy, D.M., Wobbrock, J.O., Kaszniak, A.W., Ostergen, M.: The effects of mindfulness meditation training on multitasking in a high-stress information environment. In: Proceedings of the Graphics Interface (GI '12), Canadian Information Processing Society, Toronto, CA, May 28–30, pp. 45–52 (2012)

94. Sedlmeier, P., Eberth, J., Schwarz, M., Zimmermann, D., Haarig, F., Jaeger, S., Kunze, S.: The psychological effects of meditation: a meta-analysis. Psychol. Bull. **138**(6), 1139–1171 (2012). https://doi.org/10.1037/a0028168

95. Tang, Y.-Y., Ma, Y., Wang, J., Fan, Y., Feng, S., Lu, Q., Yu, Q., Sui, D., Rothbart, M.K., Fan, M., Posner, M.: Short-term meditation training improves attention and self-regulation. Proc. Natl. Acad. Sci. **104**(43), 17152–17156 (2007). https://doi.org/10.1073/pnas.0707678104

96. Baas, M., Nevicka, B., Ten Velden, F.S.: Specific mindfulness skills differentially predict creative performance. Pers. Soc. Psychol. Bull. **40**(9m), 1092–1106 (2014). https://doi.org/10.1177/0146167214535813

97. Colzato, L. S., Ozturk, A., Hommel, B.: Meditate to create: the impact of focused-attention and open-monitoring training of convergent and divergent thinking. Front. Psychol. **3**, Article 116, 1–5 (2012). https://doi.org/10.3389/fpsyg.2012.00116

98. Ding, X., Tang, Y.-Y., Deng, Y., Tang, R., Posner, M.I.: Mood and personality predict improvement in creativity due to meditation training. Learn. Individ. Differ. **37**, 217–221 (2015). https://doi.org/10.1016/j.lindif.2014.11.019

99. Ding, X., Tang, Y.-Y., Tang, R., Posner, M.I.: Improving creativity performance by short-term meditation. Behav. Brain Funct. **10**(9), 1–8 (2014). https://doi.org/10.1186/1744-9081-10-9

100. Jedrczak, A., Beresford, M., Clements, G.: The TM-Sidhi program, pure consciousness, creativity, and intelligence. J. Creat. Behav. **19**(4), 270–275 (1985). https://doi.org/10.1002/j.2162-6057.1985.tb00409.x

101. Lebuda, I., Zabelina, D.L., Karwowski, M.: Mind full of ideas: a meta-analysis of the mindfulness-creativity link. Personal. Individ. Differ. **93**, 22–26 (2016). https://doi.org/10.1016/j.paid.2015.09.040

102. Muller, B.C.N., Gerasimova, A., Ritter, S.M.: Concentration meditation influences creativity by increasing cognitive flexibility. Psychol. Aesthet. Creat. Arts **10**(3), 278–286 (2016). https://doi.org/10.1037/a0040335

103. Ostafin, B.D., Kassman, K.T.: Stepping out of history: mindfulness improves insight problem solving. Conscious. Cogn. **21**, 1031–1036 (2012). https://doi.org/10.1016/j.concog.2012.02.014

104. Ren, J., Huang, Z., Luo, J., Wei, G., Ying, X., Ding, Z., Wu, Y., Luo, F.: Meditation promotes insightful problem-solving by keeping people in a mindful and alert conscious state. Sci. China Live Sci. **54**(10), 961–965 (2011). https://doi.org/10.1007/s11427-011-4233-3

105. Strick, M., van Noorden, T.H.J., Ritskes, R.R., de Ruiter, J.R., Dijksterhuis, A.: Zen meditation and access to information in the unconscious. Conscious. Cogn. **21**, 1476–1481 (2012). https://doi.org/10.1016/j.concog.2012.02.010

106. Ashton, M.A., McDonald, R.D.: Effects of hypnosis on verbal and non-verbal creativity. Int. J. Clin. Exp. Hypn. **33**(1), 15–26 (1985). https://doi.org/10.1080/00207148508406632
107. Bowers, K.S., van der Meulen, S.J.: Effect of hypnotic susceptibility on creativity test performance. J. Pers. Soc. Psychol. **14**(3), 247–256 (1970). https://doi.org/10.1037/h0028889
108. Council, J.R., Bromley, K.A., Zabelina, D.L., Waters, C.G.: Hypnotic enhancement of creative drawing. Int. J. Clin. Exp. Hypn. **55**(4), 467–485 (2007). https://doi.org/10.1080/00207140701506623
109. Gur, R.C., Reyher, J.: Enhancement of creativity via free-imagery and hypnosis. Am. J. Clin. Hypn. **18**(4), 237–249 (1976). https://doi.org/10.1080/00029157.1976.10403806
110. Lynn, S.J., Sivec, H.: The hypnotizable subject as creative problem-solving agent. In: Fromm, E., Nash, M.R. (eds.) Contemporary Hypnosis Research, pp. 292–333. Guilford Press, New York (1992)
111. Straus, R.A.: A naturalistic experiment investigating the effects of hypnotic induction upon creative imagination scale performance in a clinical setting. Int. J. Clin. Exp. Hypn. **28**(3), 218–224 (1980). https://doi.org/10.1080/00207148008409847
112. Bowers, P.: Hypnosis and creativity: the search for the missing link. J. Abnorm. Psychol. **88** (5), 564–572 (1979). https://doi.org/10.1037/0021-843X.88.5.564
113. Manmiller, J.L., Kumar, V.K., Pekala, R.J.: Hypnotizability, creative capacity, creative styles, absorption, and phenomenological experiences during hypnosis. Creat. Res. J. **17**(1), 9–24 (2005). https://doi.org/10.1207/s15326934crj1701_2
114. Perry, C., Wilder, S., Appignanesi, A.: Hypnotic susceptibility and performance on a battery of creativity measures. Am. J. Clin. Hypn. **15**(3), 170–180 (1973). https://doi.org/10.1080/00029157.1973.10402241
115. Andolfi, B.R., Di Nuzzo, C., Antonietti, A.: Opening the mind through the body: the effects of posture on creative processes. Think. Skills Creat. **24**, 20–28 (2017). https://doi.org/10.1016/j.tsc.2017.02.012
116. Friedman, R.S., Fishbach, A., Förster, J., Werth, L.: Attentional priming effects on creativity. Creat. Res. J. **15**(203), 277–286 (2003). https://doi.org/10.1207/S15326934CRJ152&3_18
117. Johnson, K.J., Waugh, C.E., Fredrickson, B.L.: Smile to see the forest: facially expressed positive emotions broaden cognition. Cogn. Emot. **24**(2), 299–321 (2010). https://doi.org/10.1080/02699930903384667
118. Strack, F., Martin, L., Stepper, S.: Inhibiting and facilitating conditions of the human smile: a nonobtrusive test of the facile feedback hypothesis. J. Pers. Soc. Psychol. **54**(5), 768–777 (1988). https://doi.org/10.1037//0022-3514.54.5.768
119. Aue, T., Scherer, K.R.: Facilitation of arm movements by their outcome desirability. Soc. Sci. Inf. **53**(3), 471–485 (2013). https://doi.org/10.1177/0539018413483938
120. Förster, J., Friedman, R.S., Ozelsel, A., Denzler, M.: Enactment of approach and avoidance behavior influences the scope of perceptual and conceptual attention. J. Exp. Soc. Psychol. **42**, 133–146 (2006). https://doi.org/10.1016/j.jesp.2005.02.004
121. Friedman, R.S., Förster, J.: The influence of Approach and Avoidance Motor Actions on Creative Cognition. J. Exp. Soc. Psychol. **38**, 41–55 (2002)
122. Friedman, R.S., Förster, J.: The effects of approach and avoidance motor actions on the elements of creative insight. J. Personal. Soc. Psychol. **79**(4), 477–492 (2000). https://doi.org/10.1006/jesp.2001.1488
123. Schwarz, N.: Situated cognition and the wisdom of feelings, cognitive tuning. In: Barrett, L. G., Salovey, P. (eds.) The Wisdom in Feeling: Psychological Processes. Guilford Press, New York (2002)
124. Ben-Soussan, T.D., Berkovich-Ohana, A., Pierevincenzi, C., Glicksohn, J., Carducci, F.: Embodied cognitive flexibility and neuroplasticity following quadrato motor training. Front. Phys. **6**, Article 1021, 1–11 (2015). https://doi.org/10.3389/fpsyg.2015.01021

125. Ben-Soussan, T.D., Glicksohn, J., Goldstein, A., Berkovich-Ohana, A., Donchin, O.: Into the square and out of the box: the effects of quadrato motor training on creativity and alpha coherence. Plos One **8**(1), e55023 (2013). https://doi.org/10.1371/journal.pone.0055023

126. Blanchette, D.M., Ramocki, S.P., O'del, J.N., Casey, M.S.: Aerobic exercise and creative potential: immediate and residual effects. Creativ. Res. J. **17**(2 and 3), 257–264 (2005). https://doi.org/10.1080/10400419.2005.9651483

127. Colzato, L.S., Szapora, A., Pannekoek, J.N., Hommel, B.: The impact of physical exercise on convergent and divergent thinking. Front. Human Neurosci. **7**, Article 824, 1–6 (2013). https://doi.org/10.3389/fnhum.2013.00824

128. Curnow, K.E., Turner, E.T.: The effect of exercise and music on the creativity of college students. J. Creat. Behav. **26**(1), 50–52 (1992). https://doi.org/10.1002/j.2162-6057.1992.tb01156.x

129. Frith, E., Loprinzi, P.D.: Experimental effects of acute exercise and music listening on cognitive creativity. Physiol. Behav. **191**, 21–28 (2018). https://doi.org/10.1016/j.physbeh.2018.03.034

130. Gondola, J.C.: The effects of a single bout of aerobic dancing on selected tests of creativity. J. Soc. Behav. Personal. **2**(2), 275–278 (1987)

131. Gondola, J.C.: The enhancement of creativity through long and short term exercise programs. J. Soc. Behav. Personal. **1**(1), 77–82 (1986)

132. Hotting, K., Roder, B.: Beneficial effects of physical exercise on neuroplasticity and cognition. Neurosci. Biobehav. Rev. **37**, 2243–2257 (2013). https://doi.org/10.1016/j.neubiorev.2013.04.005

133. Netz, Y., Tomer, R., Axelrad, S., Argov, E., Inbar, O.: The effect of a single aerobic training session on cognitive flexibility in late middle-aged adults. Int. J. Sports Med. **28**, 82–87 (2007). https://doi.org/10.1055/s-2006-924027

134. Oppezzo, M., Schwartz, D.L.: Give your ideas some legs: the positive effect of walking on creative thinking. J. Exp. Psychol. **40**(4), 1142–1152 (2014). https://doi.org/10.1037/a0036577

135. Smith, P.J., Blumenthal, J.A., Hoffman, B.M., Cooper, H., Strauman, T.A., Welsh-Bohmer, K., Browndyke, J.N., Sherwood, A.: Aerobic exercise and neurocognitive performance: a meta-analysis review of randomized controlled trials. Psychosom. Med. **72**, 239–252 (2010). https://doi.org/10.1097/PSY.0b013e3181d14633

136. Sternberg, H., Sykes, E.A., Moss, T., Lowery, S., LeBoutillier, N., Dewey, A.: Exercise enhances creativity independent of mood. Br. J. Sports Med. **31**, 240–245 (1997). https://doi.org/10.1136/bjsm.31.3.240

137. Teixeira-Machado, L., Arida, R.M., Mari, J. de J.: Dance for neuroplasticitiy: a descriptive systematic review. Neurosci. Biobehav. Rev. **96**, 232–240 (2019). https://doi.org/10.1016/j.neubiorev.2018.12.010

138. Zhou, Y., Zhang, Y., Hommell, B., Zhang, H.: The impact of bodily states on divergent thinking: evidence for a control-depletion account. Front. Psychol. **8**, Article 1546, 1–9 (2017). https://doi.org/10.3389/fpsyg.2017.01546

139. Camfield, D.A., Stough, C., Farrimond, J., Scholey, A.B.: Acute effects of tea constituents L-theanine, caffeine, and epigallocatechin gallate on cognitive function and mood: a systematic review and meta-analysis. Nutr. Rev. **72**(8), 507–522 (2014). https://doi.org/10.1111/nure.12120

140. Einother, S.J.L., Baas, M., Rowson, M., Giesbrecht, T.: Investigating the effects of tea, water, and a positive affect induction on mood and creativity. Food Qual. Prefer. **39**, 56–61 (2015). https://doi.org/10.1016/j.foodqual.2014.06.016

141. Hausser, J.A., Schlemmer, A., Kaiser, S., Kalis, A., Mojzisch, A.: The effects of caffeine on option generation and subsequent choice. Psychopharmacology **231**, 3719–3727 (2014). https://doi.org/10.1007/s00213-014-3506-5

142. Huang, Y., Choe, Y., Lee, S., Wang, E., Wu, Y., Wang, L.: Drinking tea improves the performance of divergent creativity. Food Qual. Prefer. **66**, 29–35 (2018). https://doi.org/10.1016/j.foodqual.2017.12.014

143. Nurk, E., Refsum, H., Drevon, C.A., Tell, G.S., Nygaard, H.A., Engedal, K., Smith, A.D.: Intake of flavonoid-rich wine, tea, and chocolate by elderly men and women in associated with better cognitive test performance. J. Nutr. **139**(1), 120–127 (2009). https://doi.org/10.3945/jn.108.095182

144. Bonnet, M.H., Balkin, T.J., Dinges, D.F., Roehrs, T., Rogers, N.L., Wesensten, N.J.: The use of stimulants to modify performance during sleep loss: a review by the sleep deprivation and stimulant task force of the American academy of sleep medicine. Sleep **28**(9), 1163–1187 (2005). https://doi.org/10.1093/sleep/28.9.1163

145. Drake, R., Felbaum, D., Huntley, C., Reed, A., Matthews, L., Raudenbush, B.: Effects of chocolate consumption on enhancing cognitive performance. Appetite **49**, 288 (2007). https://doi.org/10.1016/j.appet.2007.03.061

146. Desideri, G., Kwik-Uribe, C., Grassi, D., Necozione, S., Ghiadoni, L., Mastroiacovo, D., Raffaele, A., Ferri, L., Bocale, R., Lechiara, M.C., Marini, C., Ferri, C.: Benefits in cognitive function, blood pressure, and insulin resistance through cocoa flavanol consumption in elderly subjects with mild cognitive impairment. Hypertension **60**, 794–801 (2012). https://doi.org/10.1161/HYPERTENSIONAHA.112.193060

147. Messerli, F.: Chocolate consumption, cognitive function, and nobel laureates. N. Engl. J. Med. **367**(16), 1562–1564 (2012). https://doi.org/10.1056/NEJMon1211064

148. Macpherson, H., Roberstson, B., Sunram-Lea, S., Stough, C., Kennedy, D., Scholey, A.: Glucose administration and cognitive function: differential effects of age and effort during a dual task paradigm in younger and older adults. Psychopharmacology **232**, 1135–1142 (2015). https://doi.org/10.1007/s00213-014-3750-8

149. Mantantzis, K., Maylor, E.A., Schlaghecken, F.: Gain without pain: glucose promotes cognitive engagement and protects positive affect in older adults. Psychol. Aging **33**(5), 789–797 (2018). https://doi.org/10.1037/pag0000270

150. Van de Rest, O., van der Zwaluw, N.L., de Groot, L.C.P.G.M.: Effects of glucose and sucrose on mood: a systematic review of interventional studies. Nutr. Rev. **76**(2), 108–116 (2017). https://doi.org/10.1093/nutrit/nux065

151. Van der Zwaluw, N.L., van de Rest, O., Kessels, R.P.C., de Groot, L.C.P.M.: Short-term effects of glucose and sucrose on cognitive performance and mood in elderly people. J. Clin. Exp. Psychol. **36**(5), 517–527 (2014). https://doi.org/10.1080/13803395.2014.912613

152. Wightman, E.L., Reay, J.L., Haskell, C.F., Williamson, G., Dew, T.P., Kennedy, D.O.: Effects of resveratrol alone or in combination with piperine on cerebral blood flow parameters and cognitive performance in human subjects: a randomised, double-blind, placebo-controlled, cross-over investigation. Br. J. Nutr. **112**, 203–213 (2014). https://doi.org/10.1017/S0007114514000737

153. Benedek, M., Panzierer, L., Jauk, E., Neubauer, A.C.: Creativity on tap? Effects of alcohol intoxication on creative cognition. Conscious. Cogn. **56**, 128–134 (2017). https://doi.org/10.1016/j.concog.2017.06.020

154. Jarosz, A.F., Colflesh, G.J.H., Wiley, J.: Uncorking the muse: alcohol intoxication facilitates creative problem solving. Conscious. Cogn. **21**, 487–493 (2012). https://doi.org/10.1016/j.concog.2012.01.002

155. Norlander, T.: Inebriation and inspiration? A review of the research on alcohol and creativity. J. Creat. Behav. **33**(1), 22–44 (1999). https://doi.org/10.1002/J.2162-6057.1999.TB01036.X

156. Norlander, T., Gustafsen, R.: Effects of alcohol on a divergent figural fluency test during the illumination phase of the creative process. Creat. Res. J. **11**(3), 265–274 (1998). https://doi.org/10.1207/s15326934crj1103_5

157. Norlander, T., Gustafson, R.: Effects of alcohol on picture drawing during the verification phase of the creative process. Creat. Res. J. **10**(4), 355–362 (1997). https://doi.org/10.1207/s15326934crj1004_7

158. Norlander, R., Gustafson, R.: Effects of alcohol on scientific thought during the incubation phase of the creative process. J. Creat. Behav. **30**(4), 231–248 (1996). https://doi.org/10.1002/j.2162-6057.1996.tb00771.x

159. Gustafson, R.: Effect of alcohol on quantity of creative production using the purdue tests. Psychol. Rep. **69**, 83–90 (1991). https://doi.org/10.2466/pr0.1991.69.1.83

160. Hicks, J.A., Pedersen, S.L., Friedman, R.S., McCarthy, D.M.: Expecting innovation: psychoactive drug primes and the generation of creative solutions. Exp. Clin. Psychopharmacol. **19**(4), 314–320 (2011). https://doi.org/10.1037/a0022954

161. Lang, A.R., Verret, L.D., Watt, C.: Drinking and creativity: objective and subjective effects. Addict. Behav. **9**, 395–399 (1984). https://doi.org/10.1016/0306-4603(84)90040-6

162. Lapp, W.M., Collins, R.L., Izzo, C.V.: On the enhancement of creativity by alcohol: pharmacology or expectation. Am. J. Psychol. **107**(2), 173–206 (1994). https://doi.org/10.2307/1423036

163. Bourassa, M., Vaugeois, P.: Effects of marijuana use on divergent thinking. Creat. Res. J. **13**(3–4), 411–416 (2001). https://doi.org/10.1207/s15326934crj1334_18

164. Kowal, M.A., Hazekamp, A., Colzato, L.S., van Steenbergen, H., van der Wee, N.J.A., Durieux, J., Manai, M., Hommel, B.: Cannabis and creativity: highly potent cannabis impairs divergent thinking in regular cannabis users. Psychopharmacology **232**, 1123–1134 (2015). https://doi.org/10.1007/s00213-014-3749-1

165. Jones, K.A., Blagrove, M., Parrott, A.C.: Cannabis and ecstasy/MDMA: empirical measures of creativity in recreational users. J. Psychoact. Drugs **41**(4), 323–329 (2009). https://doi.org/10.1080/02791072.2009.10399769

166. LaFrance, E., Cuttler, C.: Inspired by Mary Jane? Mechanisms underlying enhanced creativity in cannabis users. Conscious. Cogn. **56**, 68–76 (2017). https://doi.org/10.1016/j.concog.2017.10.009

167. Weckowicz, T.E., Collier, G., Spreng, L.: Field Dependence, cognitive functions, personality traits, and social values in heavy cannabis users and nonuser controls. Psychol. Rep. **41**, 291–302 (1977). https://doi.org/10.2466/pr0.1977.41.1.291

168. Bagot, K.S., Kaminer, Y.: Efficacy of stimulants for cognitive enhancement in non-attention deficit hyperactivity disorder youth: a systematic review. Addiction **109**(4), 547–557 (2014). https://doi.org/10.1111/add.12460

169. Farah, M.J.: When we enhance cognition with adderall, do we sacrifice creativity? A preliminary study. Psychopharmacology **202**, 541–547 (2009). https://doi.org/10.1007/s00213-008-1369-3

170. Ilieva, I., Hook, C.J., Farah, M.J.: Prescription stimulants' effects on healthy inhibitory control, working memory, and episodic memory: a meta-analysis. J. Cogn. Neurosci. **27**(6), 1069–1089 (2015). https://doi.org/10.1162/jocn_a_00776

171. Linssen, A.M.W., Sambeth, A., Vuurman, E.F.P.M., Reidel, W.J.: Cognitive effects of methylphenidate in healthy volunteers: a review of single dose studies. Int. J. Neuropsychopharmacol. **17**, 961–977 (2014). https://doi.org/10.1017/S1461145713001594

172. Cropsey, K.L., Schiavon, S., Hendricks, P.S., Froelich, M., Lentowicz, I., Fargason, R.: Mixed-amphetamine salts expectancies among college students: is stimulant induced cognitive enhancement a placebo effect. Drug Alcohol Depend. **178**, 302–309 (2017). https://doi.org/10.1016/j.drugalcdep.2017.05.024

173. Eliyahu, U., Berlin, S., Hadad, E., Heled, Y., Moran, D.S.: Psychostimulants and military operations. Mil. Med. **172**, 383–387 (2007). https://doi.org/10.7205/milmed.172.4.383

174. Repantis, D., Schlattmann, P., Laisney, O., Heuser, I.: Modafinil and methylphenidate for neuroenhancement in healthy individuals: a systematic review. Pharmacol. Res. **62**, 187–206 (2010). https://doi.org/10.1016/j.phrs.2010.04.002

175. Doblin, R.: Pahnke's 'Good Friday Experiment': a long-term follow-up and methodological critique. J. Transpers. Psychol. **23**(1), 1–28 (1991)
176. Frecska, E., More, C.E., Vargha, A., Luna, L.E.: Enhancement of creative expression and entopic phenomena as after-effects of repeated ayahuasca ceremonies. J. Psychoactive Drugs **44**(3), 191–199 (2012). https://doi.org/10.1080/02791072.2012.703099
177. Harman, W.W., McKim, R.H., Mogar, R.E., Fadiman, J., Stolaroff, M.J.: Psychedelic agents in creative problem-solving: a pilot study. Psychol. Rep. **19**, 211–227 (1966). https://doi.org/10.2466/pr0.1966.19.1.211
178. Krippner, S.: Psychedelic drugs and creativity. J. Psychoactive Drugs **17**(4), 235–246 (1985). https://doi.org/10.1080/02791072.1985.10524328
179. Krippner, S.: Research in creativity and psychedelic drugs. Int. J. Clin. Experim. Hypn. **25** (4), 274–308 (1977). https://doi.org/10.1080/00207147708415985
180. Kuypers, K.P.C., Riba, J., de la Fuente Revenga, M., Barker, S., Theunissen, E.L., Rameakers, J.G.: Ayahuasca enhanced creative divergent thinking while decreasing conventional convergent thinking. Psychopharmacology **233**, 3395–3403 (2016). https://doi.org/10.1007/s00213-016-4377-8
181. Lebedev, A.V., Kaelen, M., Lovden, M., Nilsson, J., Feilding. A., Nutt, D.J., Carhart-Haarris, R.L.: LSD-induced entropic brain activity predicts subsequent personality change. Human Brain Mapp. **37**, 3203–3213 (2016). https://doi.org/10.1002/hbm.23234
182. Lerner, M., Lyvers, M.: Values and beliefs of psychedelic drug users: a cross-cultural study. J. Psychoact. Drugs **38**(2), 143–147 (2006). https://doi.org/10.1080/02791072.2006.10399838
183. MacLean, K.A., Johnson, M.W., Griffiths, R.R.: Mystical experiences occasioned by the hallucinogen psilocybin lead to increases in the personality domain of openness. J. Psychopharmacol. **25**(11), 1453–1461 (2011). https://doi.org/10.1177/0269881111142 0188
184. McGlothlin, W., Cohen, S., McGlothlin, M.S.: Long Lasting effects of LSD on normals. Arch. Gen. Psychiatry **17**, 521–532 (1967). https://doi.org/10.1001/archpsyc.1967.01730290009002
185. Uthaug, M.V., van Oorsouw, K., Kuypers, K.P.C., van Boxtel, M., Broers, N.J., Mason, N. L., Toennes, S.W., Riba, J., Ramaekers, J.G.: Sub-acute and long-term effects of ayahuasca on affect and cognitive thinking style and their association with ego dissolution. Psychopharmacology **235**, 2979–2989 (2018). https://doi.org/10.1007/s00213-018-4988-3
186. Berlin, L., Guthrie, T., Weider, A., Goodell, H., Wolff, H.G.: Studies in human cerebral function: the effects of mescaline and lysergic acid on cerebral processes pertinent to creative activity. J. Nerv. Ment. Dis. **122**(5), 487–491 (1955)
187. Janiger, O., de Rios, M.D.: LSD and creativity. J. Psychoact. Drugs **21**(1), 129–134 (1989). https://doi.org/10.1080/02791072.1989.10472150
188. Jones, M.T.: The creativity of crumb: research on the effects of psychedelic drugs on the comic art of robert crumb. J. Psychoact. Drugs **39**(3), 283–291 (2007). https://doi.org/10.1080/02791072.2007.10400615
189. Moody, R. A.: Life After Life, Harper Collins, 1975.
190. Anderson, T., Petranker, R., Christopher, A., Rosenbaum, D., Weissman, C., Dinh-Williams, L.-A., Hui, K., Hapke, E.: Psychedelic microdosing benefits and challenges: an empirical codebook. Harm Reduct. J. **16**(1), 1–10 (2019). https://doi.org/10.1186/s12954-019-0308-4
191. Anderson, T., Petranker, R., Rosenbaum, D., Weissman, C.R., Dinh-Williams, L.-A., Hui, K., Hapke, E., Farb, N.A.S.: Microdosing psychedelics: personality, mental health, and creativity differences in microdosers. Psychopharmacology **236**, 731–740 (2019). https://doi.org/10.1007/s00213-018-5106-2
192. Bershad, A.K., Schepers, S.T., Bremmer, M.P., Lee, R., de Wit, H.: Acute subjective and behavioral effects of microdoses of LSD in healthy human volunteers. Biol. Psychiatry (2019). https://doi.org/10.1016/j.biopsych.2019.05.019 (in press)

193. Johnstad, P.G.: Powerful substances in tiny amounts: an interview study of psychedelic microdosing. Nordic Stud. Alcohol Drugs **35**(1), 39–51 (2018). https://doi.org/10.1177/1455072517753339

194. Prochazkova, L., Lippelt, D.P., Colzato, L.S., Kuchar, M., Sjoerds, Z.: Exploring the effect of microdosing of psychedelics on creativity in an open-label natural setting. Psychopharmacology **235**, 3401–3413 (2018). https://doi.org/10.1007/s00213-018-5049-7

195. Scharnowski, F., Weiskopf, N.: Cognitive enhancement through real-time fMRI neurofeedback. Behav. Sci. **4**, 122–127 (2015). https://doi.org/10.1016/j.cobeha.2015.05.001

196. Fink, A., Neubauer, A.C.: Brain correlates underlying the generation of original ideas. Int. J. Psychophysiol. **69**, 178 (2008). https://doi.org/10.1016/j.ijpsycho.2008.05.468

197. Agnoli, S., Zanon, M., Mastria, S., Avenanti, A., Corazza, G.E.: Enhancing creative cognition with a rapid right-parietal neurofeedback procedure. Neuropsychologia **118**, 99–106 (2018). https://doi.org/10.1016/j.neuropsychologia.2018.02.015

198. Boynton, T.: Applied research using alpha/theta training for enhancing creativity and well-being. J. Neurother. **5**(½), 5–18 (2001). https://doi.org/10.1300/J184v05n01_02

199. Doppelmayr, M., Weber, E.: Effects of SMR and theta/beta neurofeedback on reaction times, spatial abilities, and creativity. J. Neurother. **15**, 115–129 (2011). https://doi.org/10.1080/10874208.2011.570689

200. Egner, T., Gruzelier, J.H.: Ecological validity of neurofeedback: modulation of slow wave EEG enhances musical performance. NeuroReport **14**(9), 1221–1224 (2003). https://doi.org/10.1097/01.wnr.0000081875.45938.d1

201. Egner, T., Gruzelier, J.H.: EEG biofeedback of low beta band components: frequency-specific effects on variables of attention and event-related brain potentials. Clin. Neurophysiol. **115**, 131–139 (2004). https://doi.org/10.1016/s1388-2457(03)00353-5

202. Gruzelier, J.: Enhancing creativity with neurofeedback in the performing arts: acting, musicians, dancers. In: Burgoyne, S. (ed.) Creativity in Theatre: Theory and Action in Theatre/Drama Education, pp. 233–245. Springer (2018). https://doi.org/10.1007/978-3-319-78928-6_14

203. Gruzelier, J.H.: EEG-neurofeedback for optimizing performance. II. Creativity, the performing arts and ecological validity. Neurosci. Biobehav. Rev. **44**, 142–158 (2014). https://doi.org/10.1016/j.neubiorev.2013.11.004

204. Gruzelier, J.H., Holmes, P., Hirst, L., Bulpin, K., Rahman, S., van Run, C., Leach, J.: Replication of elite music performance enhancement following alpha/theta neurofeedback and application to novice performance and improvisation with SMR benefits. Biol. Psychol. **95**, 96–107 (2014). https://doi.org/10.1016/j.biopsycho.2013.11.001

205. Gruzelier, J.H., Thompson, T., Redding, E., Brandt, R., Steffert, T.: Application of alpha/theta neurofeedback and heart rate variability training to young contemporary dancers: state anxiety and creativity. Int. J. Psychophysiol. **93**, 105–111 (2014). https://doi.org/10.1016/j.ijpsycho.2013.05.004

206. Gruzelier, J.: A theory of alpha-theta neurofeedback, creative performance enhancement, long distance functional connectivity and psychological integration. Cognit. Process. **10**(Supplement 1), S101–S109 (2009). https://doi.org/10.1007/s10339-008-0248-5

207. Haarmann, H.J., George, T., Smaliy, A., Dien, J.: Remote associates test and alpha brain waves. J. Probl. Solving **4**(2), 66–93 (2012). https://doi.org/10.7771/1932-6246.1126

208. Hanslmayr, S., Sauseng, P., Doppelmayr, M., Schabus, M., Klimesch, W.: Increasing individual upper alpha power by neurofeedback improvescognitive performance in human subjects. Appl. Psychophysiol. Biofeedback **30**(1), 1–10 (2005). https://doi.org/10.1007/s10484-005-2169-8

209. Keizer, A.W., Verschoor, M., Verment, R.S., Hommel, B.: The effect of gamma enhancing neurofeedback on the control of feature bindings and intelligence measures. Int. J. Psychophysiol. **75**, 25–32 (2010). https://doi.org/10.1016/j.ijpsycho.2009.10.011

210. Lee, J.-H., Kim, J., Yoo, S-S.: Real-time fMRI-based neurofeedback reinforces causality of attention networks. Neurosci. Res. **72**, 347–354 (2012). https://doi.org/10.1016/j.neures.2012.01.002

211. Lin, W.-L., Shih, Y.-L.: Designing EEG neurofeedback procedures to enhance open-ended versus closed-ended creative potentials. Creat. Res. J. **28**(4), 458–466 (2016). https://doi.org/10.1080/10400419.2016.1229979

212. Marzbani, H., Marateb, H.R., Mansourian, M.: Neurofeedback: a comprehensive review on system design, methodology and clinical applications. Basic Clin. Neurosci. **7**(2), 143–158 (2016). https://doi.org/10.15412/J.BCN.03070208

213. Raymond, J., Sajid, I., Parkinson, L.A., Gruzelier, J.H.: Biofeedback and dance performance: a preliminary investigation. Appl. Psychophysiol. Biofeedback **30**(1), 65–73 (2005). https://doi.org/10.1007/s10484-005-2175-x

214. Raymond, J., Varney, C., Parkinson, L.A., Gruzelier, J.H.: The effects of alpha/theta neurofeedback on personality and mood. Cogn. Brain Res. **23**, 287–292 (2005). https://doi.org/10.1016/j.cogbrainres.2004.10.023

215. Ros, T., Mosley, M.J., Bloom, P.A., Benjamin, L., Parkinson, L.A., Gruzelier, J.H.: Optimizing microsurgical skills with EEG neurofeedback. BMC Neurosci. **10** (2009). https://doi.org/10.1186/1471-2202-10-87

216. Vernon, D.J.: Can neurofeedback training enhance performance? An evaluation of the evidence with implications for future research. Appl. Psychophysiol. Biofeedback **30**(4), 347–364 (2005). https://doi.org/10.1007/s10484-005-8421-4

217. Iuculano, T., Kadosh, R.C.: The mental cost of cognitive enhancement. J. Neurosci. **33**(10), 4482–4486 (2013). https://doi.org/10.1523/JNEUROSCI.4927-12.2013

218. Kadosh, R.C.: Using transcranial electrical stimulation to enhance cognitive functions in the typical and atypical brain. Transl. Neurosci. **4**(1), 20–33 (2013). https://doi.org/10.2478/s13380-013-0104-7

219. Cerruti, C., Schlaug, G.: Anodal transcranial direct current stimulation of the prefrontal cortex enhances complex verbal associative thought. J. Cogn. Neurosci. **21**(10), 1980–1987 (2008). https://doi.org/10.1162/jocn.2008.21143

220. Chi, R.P., Snyder, A.W.: Brain stimulation enables the solution of an inherently difficult problem. Neurosci. Lett. **515**, 121–124 (2012). https://doi.org/10.1016/j.neulet.2012.03.012

221. Chi, R.P., Snyder, A.W.: Facilitate insight by non-invasive brain stimulation. Plos One **6**(2), Article e16655 (2011). https://doi.org/10.1371/journal.pone.0016655

222. Chrysikou, E.G., Hamilton, R.H., Coslett, H.B., Datta, A., Bikson, M., Thompson-Schill, S. L.: Noninvasive transcranial direct current stimulation over the left prefrontal cortex facilitates cognitive flexibility in tool use. Cogn. Neurosci. **4**(2), 81–89 (2013). https://doi.org/10.1080/17588928.2013.768221

223. Colombo, B., Bartesaghi, N., Simonelli, L, Antonietti, A.: The combined effects of neurostimulation and priming on creative thinking. A preliminary tDCS study on dorsolateral prefrontal cortex. Front. Human Neurosci. **9**, Article 403, 1–12 (2015). https://doi.org/10.3389/fnhum.2015.00403

224. Iyer, M.B., Mattu, U., Grafman, J., Lomarev, M., Sato, S., Wassermann, E.M.: Safety and cognitive effect of frontal DC brain polarization in healthy individuals. Neurology **64**, 872–875 (2005). https://doi.org/10.1212/01.WNL.0000152986.07469.E9

225. Mayseless, N., Shamay-Tsoory, S.G.: Enhanced verbal creativity : modulating creativity by altering the balance between right and left inferior frontal gyrus with tDCS. Neuroscience **291**, 167–176 (2015). https://doi.org/10.1016/j.neuroscience.2015.01.061

226. Metuki, N., Sela, T., Lavidor, M.: Enhancing cognitive control components of insight problems solving by anodal tDCS of the left dorsolateral prefrontal cortex. Brain Stimul. **5**, 110–113 (2012). https://doi.org/10.1016/j.brs.2012.03.002

227. Rosen, D.S., Erickson, B., Kim, Y.E., Mirman, D., Hamilton, R.H., Kounios, J.: Anodal tDCS to right dorsolateral prefrontal cortex facilitates performance for novice jazz

improvisers but hinders experts. Front. Human Neurosci. **10**, Article 579, 1–12 (2016). 101.3389/fnhum.2016.00579

228. Beeli, G., Koeneke, S., Gasser, K., Jancke, L.: Brain stimulation modulates driving behavior. Behav. Brain Funct. **4**(34), 1–7 (2008). https://doi.org/10.1186/1744-9081-4-34

229. Boggio, P.S., Campanha, C., Valasek, C.A., Fecteau, S., Pascual-Leone, A., Fregni, F.: Modulation of decision-making in a gambling task in older adults with transcranial direct current stimulation. Eur. J. Neurosci. **31**, 593–597 (2010). https://doi.org/10.1111/j.1460-9568.2010.07080.x

230. Dockery, C.A., Hueckel-Weng, T., Birbaumer, N., Plewnia, C.: Enhancement of planning ability by transcranial direct current stimulation. J. Neurosci. **29**(22), 7271–7277 (2009). https://doi.org/10.1523/JNEUROSCI.0065-09.2009

231. Fecteau, S., Pascual-Leone, A., Zald, D.H., Liguori, P., Theoret, H., Boggio, P.S., Fregni, F.: Activation of prefrontal cortex by transcranial direct current stimulation reduces appetite for risk during ambiguous decision making. J. Neurosci. **27**(23), 6212–6218 (2007). https://doi.org/10.1523/JNEUROSCI.0314-07.2007.

232. Fecteau, S., Knoch, D., Fregni, F., Sultani, N., Boggio, P., Pascual-Leone, A.: Diminishing risk-taking behavior by modulating activity in the prefrontal cortex: a direct current stimulation study. J. Neurosci. **27**(46), 12500–12505 (2007). https://doi.org/10.1523/JNEUROSCI.3283-07.2007

233. Snowball, A., Tachtsidis, I., Popescu, T., Thompson, J., Delazer, M., Zamarian, L., Zhu, T., Kadosh, R.C.: Long-term enhancement of brain function and cognition training and brain stimulation. Curr. Biol. **23**, 987–992 (2013). https://doi.org/10.1016/j.cub.2013.04.045

234. Luft, C.C.B., Zioga, I., Thompson, N.M., Banissy, M.J., Bhattacharya, J.: Right temporal alpha oscillations as a neural mechanism for inhibiting obvious associations. Proc. Natl. Acad. Sci., . 109 (2018). https://doi.org/10.1073/pnas.181146511

235. Puanhvuan, D., Nojima, K., Wonsawat, Y., Iramina, K.: Effects of repetitive transcranial magnetic stimulation and transcranial direct current simulation on posterior alpha wave. IEEE Trans. **8**, 263–268 (2013). https://doi.org/10.1007/978-3-642-29305 4_95

236. Zaehle, T., Rach, S., Herrmann, C.S.: Transcranial alternating current stimulation enhances individual alpha activity in human EEG. PLoS One **5**(11), e13766 (2010). https://doi.org/10.1371/journal.pone.0013766

237. Santarnecchi, E., Polizzotto, N. R., Godone, M., Govannelli, F., Feurra, M., Matzen, L., Rossi, A., Rosse, S.: Frequency-dependent enhancement of fluid intelligence induced by transcranial oscillatory potentials. Curr. Biol. **23**, 1449–1453 (2013). https://doi.org/10.1016/j.cub.2013.06.022

238. Sela, T., Kilim, A., Lavidor, M.: Transcranial alternating current stimulation increases risk-taking behavior in the balloon analog risk task. Front. Neurosci. **6**, Article 22, 1–11 (2012). https://doi.org/10.3389/fnins.2012.00022

239. Barrett, J., Della-Maggiore, V., Chouinard, P.A., Paus, T.: Mechanisms of action underlying the effect of repetitive transcranial magnetic stimulation of mood: behavioral and brain imaging studies. Neuropsychopharmacology **29**, 1172–1189 (2004). https://doi.org/10.1038/sj.npp.1300411

240. Bell, V., Reddy, V., Halligan, P., Kirov, G., Ellis, H.: Relative suppression of magical thinking: a transcranial magnetic stimulation study. Cortex **43**, 551–557 (2007). https://doi.org/10.1016/s0010-9452(08)70249-1

241. Boroojerdi, B., Phipps, M., Kopylev, L., Wharton, C.M., Cohen, L.G., Grafman, J.: Enhancing analogic reasoning with rTMS over the left prefrontal cortex. Neurology **56**, 526–528 (2001). https://doi.org/10.1212/wnl.56.4.526

242. Klimesch, W., Sauseng, P., Gerloff, C.: Enhancing cognitive performance with repetitive transcranial magnetic stimulation at human individual alpha frequency. Eur. J. Neurosci. **17**, 1129–1133 (2003). https://doi.org/10.1046/j.1460-9568.2003.02517.x

243. Kobayashi, M., Pascual-Leone, A.: Transcranial magnetic stimulation in neurology. Lancet Neurol. **2**, 145–156 (2003). https://doi.org/10.1016/s1474-4422(03)00321-1

244. Riding, M.C., Rothwell, J.C.: Is there a future for therapeutic use of transcranial magnetic stimulation. Nat. Rev. Neurosci. **8**, 559–567 (2007). https://doi.org/10.1038/nrn2169
245. Romei, B., Driver, J., Schyns, P.G., Thut, G.: Rhythmic TMS over parietal cortex links distinct brain frequencies to global versus local visual processing. Curr. Biol. **21**, 334–337 (2011). https://doi.org/10.1016/j.cub.2011.01.035
246. Sack, A.T., Kadosh, R.C., Schuhmann, T., Moerel, M., Walsh, V., Goebel, R.: Optimizing functional accuracy of TMS in cognitive studies: a comparison of methods. J. Cognit. Neurosci. **21**(2), 207021 (2008). https://doi.org/10.1162/jocn.2009.21126
247. Silvanto, J., Pascual-Leone, A.: State-dependency of transcranial magnetic stimulation. Brain Topogr. **21**, 1–10 (2008). https://doi.org/10.1007/s10548-008-0067-0
248. Snyder, A.W., Mulcahy, E., Taylor, J.L., Mitchell, D.J., Sachdev, P., Gandevia, S.C.: Savant-like skills exposed in normal people by suppressing the left fronto-temporal lobe. J. Integr. Neurosci. **2**(2), 149–158 (2003). https://doi.org/10.1142/s0219635203000287
249. Thut, G., Veniero, D., Romei, V., Miniussi, C., Schyns, P., Gross, J.: Rhythmic TMS causes local entrainment of natural oscillatory signatures. Curr. Biol. **21**, 1176–1185 (2011). https://doi.org/10.1016/j.cub.2011.05.049
250. Cattaneo, Z., Lega, C., Gardelli, C., Merabet, L.B., Cela-Conde, C.J., Nadal, M.: The role of prefrontal and parietal cortices in esthetic appreciation of representational and abstract art: a TMS study. Neuroimage **4**, 443–450 (2014). https://doi.org/10.1016/j.neuroimage.2014.05.037
251. Van't Wout, M., Kahn, R.S., Sanfey, A.G., Aleman, A.: Repetitive transcranial magnetic stimulation over the right dorsolateral prefrontal cortex affects strategic decision-making. Neuroreport **16**(16), 1849–1852 (2005). https://doi.org/10.1097/01.wnr.0000183907.08149.14
252. Huang, T.L., Charyton, C.: A comprehensive review of the psychological effects of brainwave entrainment. Altern. Ther. Health Med. **14**(5), 38–50 (2008)
253. Thut, G., Miniussi, C., Gross, J.: The functional importance of rhythmic activity in the brain. Curr. Biol. **2**, R658-R663 (2012)
254. Brady, B., Stevens, L.: Binaural-beat induced theta EEG activity and hypnotic susceptibility. Am. J. Clin. Hypn. **43**(1), 53–69 (2000). https://doi.org/10.1080/00029157.2000.10404255
255. Gooden, P., Ciorciari, J., Baker, K., Carrey, A.-M., Harper, M., Kaufman, J.: A high-density EEG investigation into steady state binaural beat stimulation. Plos One **7**(4), e34789 (2012). https://doi.org/10.1371/journal.pone.0034789
256. Lane, J.D., Kasian, S.J., Owens, J.E., Marsh, G.R.: Binaural auditory beats affect vigilance performance and mood. Physiol. Behav. **63**(2), 249–252 (1998). https://doi.org/10.1016/s0031-9384(97)00436-8
257. Stevens, L., Haga, Z., Queen, B., Brady, B., Adams, D., Gilbert, J., Vaughan, E., Leach, C., Nockels, P., McManus, P.: Binaural beat induced theta EEG activity and hypnotic susceptibility: contradictory results and technical considerations. Am. J. Hypn. **45**(4), 295–309 (2003). https://doi.org/10.1080/00029157.2003.10403543
258. Wahbeh, H., Calabrese, C., Zwickey, H., Zajdel, D.: Binaural beat technology in humans: a polit study to assess neuropsychologic, physiologic, and electroencephalographic effects. J. Altern. Complement. Med. **13**(2), 192–206 (2007). https://doi.org/10.1089/acm.2006.6201
259. Budzynski, T., Jordy, J., Budzynski, H.K., Tang, H.-Y., Claypoole, K.: Academic performance enhancement with photic stimulation and EDR feedback. J. Neurother. **3**(3–4), 11–21 (1999). https://doi.org/10.1300/J184v03n03_02

Biases in Design 9

9.1 Introduction

Although we might like to believe that we are rational, thinking people, the truth is that we are not. We are all biased, every one of us. We all make decisions that are influenced by factors unrelated to those decisions. It is part of human nature. This chapter provides an overview of some of our biases, how they impact our ability to design, and what we can do about them. The chapter begins by identifying a primary source of our biases (a need to thrive as living beings) and then identifies many of the resulting heuristics that we use (often unconsciously) to guide our life (and design) decisions. The chapter then discusses biases arising from how we think and feel. The chapter closes by discussing the biases of our preferences and beliefs (value judgements).

9.2 Primary Source of Our Biases

One of the most significant source of our biases is our need to thrive as living beings: physically, emotionally, intellectually, and spiritually, whatever these may mean to us. We learn through experience what conditions support our thriving and what conditions do not. Knowing what conditions support our thriving generates a bias toward creating and sustaining such conditions for the future and against those that threaten our thriving. In this sense, biases can be quite good.

The primary difficulty with such biases, however, is that thriving has two conflicting needs: a need to survive and a need to grow. The conditions for survival are often in conflict with those for growth. Many of our biases support either survival or growth, but not the other. In fact, most of our biases are probably focused on survival at the expense of growth. Yet to thrive, we need both. To better understand this conflict between our need to both survive and grow and how it may

J. Reis, *Advanced Design*, https://doi.org/10.1007/978-3-030-95782-7_9

impact our ability to design, we turn to the psychological concept of regulatory focus.

Regulatory focus involves our bias to advance or promote conditions that support our thriving, and our related bias to avoid or prevent conditions that threaten our thriving. When we want to advance or promote something, we are in a positive regulatory focus and tend to be focused on growth. When we want to avoid or prevent something we are in a negative regulatory focus and tend to be focused on survival. The key biases associated with our regulatory focus and how they can impact design are summarized as follows [1–7]:

- A positive regulatory focus primarily supports our need to expand, grow, and challenge ourselves. We tend to have a positive regulatory focus when we believe we are in a safe environment. When we are in a positive regulatory focus, we tend to maximize rewards through decisions that increase risks. A positive regulatory focus tends to be good for developing new ideas and increasing creativity (originality). We tend to use intuitive thinking when in a positive regulatory focus.
- A negative regulatory focus primarily supports our need to survive, maintain stability, and ensure safety. We tend to have a negative regulatory focus when we believe we are in a dangerous environment. When we are in a negative regulatory focus, we tend to minimize risks through decisions that decrease rewards. A negative regulatory focus tends to be good for evaluating and selecting ideas and for maintaining persistence in the project. We tend to use analytical thinking when in a negative regulatory focus.

Like many dimensions of design, our regulatory focus also has neural correlates so it is deeply imbedded in who we are [6, 8, 9].

We now turn to some of common biases that have been codified into heuristics through repetitive experiences.

9.3 Biases from Heuristics

To ensure our ability to thrive, we rely on the patterns of past experiences (heuristics) for guidance on what to do. We use heuristics to simplify the vast amount of information available to us because we are literally unable to process all of that information without them. Heuristics are necessary for us to survive, but they can also hinder our ability to grow. Unless we deliberately think outside of the mental patterns of our heuristics (think outside the box), we can become biased by them. Our thinking can become constrained by the patterns of our past experiences, which limits our ability to consider anything new. Thus, our past experiences can induce design fixation. Yet, we have already seen that our past experiences can also expand our creativity by providing seed ideas.

We will now look at some of the common heuristics that can bias our designs. These heuristics can be considered to be either internally-based or externally-based, depending on our level of awareness of how we use them.

9.3.1 Creative-Conservative Bias

This bias is based on the fact that our need to thrive as living beings requires that we both grow and survive. To grow, we often must make changes, which require being creative. To survive, we often must limit changes, which requires being conservative. When we have a creative bias to address our need to grow, our approach toward design is different from when we have a conservative bias that addresses our need to survive. Some of the resulting impacts on design are summarized in Table 9.1 [10–20].

A review of this table shows that neither being creative nor being conservative is necessarily better than the other. They both have advantages and they both have disadvantages.

How a design project is initially framed can induce a creative or conservative bias. If the project is framed to maximize rewards, we tend to focus on more creative ideas that bring change. If the project is framed to minimize risks, we tend to focus on more conservative ideas that maintain stability [21–24].

Another factor that can impact our creative/conservative bias is the level of time pressure we feel. Heavy time pressure tends to induce a conservative bias, [25–28] while moderate time pressure tends to induce a creative bias [29–35].

Even though we may have a personal tendency toward being either creative or conservative, we must be both to be effective designers [7]. We must support both our need to survive and our need to grow. We can minimize the biases of being either creative or conservative by switching to the opposite bias as needed. We may need to do this hundreds of times over a single design project. Perhaps the easiest way to overcome this bias is to balance our use of intuitive and analytical thinking.

Table 9.1 Differences between creative and conservative design biases

Creative bias	Conservative bias
Positive regulatory focus	Negative regulatory focus
Make decisions that bring change	Make decisions that bring stability
Intuitive thinking	Analytical thinking
Generate more ideas	Generate fewer ideas
Generate more original ideas	Generate less original ideas
Open to new ideas	Closed to new ideas
Judge ideas more positively	Judge ideas more negatively
Base decisions on deeper design features	Base decisions on superficial design features
Make more errors of judgment	Make fewer errors of judgment

9.3.2 Familiarity Bias

This bias is based on the fact that we tend to like familiar things and dislike unfamiliar things. Familiarity suggests safe conditions in which we can thrive and unfamiliar things suggest risky conditions that may threaten us [36–43].

Familiarity can be as simple as having prior exposure to something. When we are exposed to an idea, including a design idea, one of the first things we do is to recall information from memory that is related to that idea. If it is our first exposure, there will be nothing in memory to recall. The idea will then be automatically judged as being unfamiliar and we will be biased against it. This process occurs unconsciously. An example of this bias is that we commonly judge new products on the market as being inferior to products we have encountered before.

When we are exposed to the idea a second time, we now have something in memory to recall. In this case, the idea will be more familiar and we tend to judge it more positively. The more memories we have of an idea, i.e., the more times we have been exposed to it, the more positively we tend to judge it. This shift in our judgement occurs automatically and unconsciously. This bias is known in psychology as the Mere Exposure Effect. Merely being exposed to an idea biases us in favor of it. Repeated exposures increase that bias [44–59]. Marketers are very aware of this bias and develop marketing plans accordingly. Of course, if we have personal experience with an idea, particularly if it includes strong emotional content, that experience can reduce or even overcome the impact of the Mere Exposure Effect.

One way to gain exposure to new ideas is through education. A broad exposure to ideas is the primary reason for the general education requirements for academic degrees. General education provides memories to support the familiarity bias that we can use later in life, even if we cannot consciously recall those memories. For example, a broad exposure to art can significantly alter our preferences for art compared to those who have had not had such an exposure [60–70].

The overall impact of the familiarity bias is that we are biased toward what we are familiar with. Familiarity supports our need to survive, but can limit our ability to grow. Growth requires that we move into the unfamiliar. Thriving (and design!) requires stability (familiar) balanced with originality (unfamiliar). We want familiarity, but not too much. We want originality, but not too much.

Like most heuristic biases, the familiarity bias can be reduced, but not necessarily eliminated, through analytical thought regarding the bias. We can consciously acknowledge that we may have a familiarity bias and deliberately consider ways to address this bias [71–78]. For example, we can ask ourselves questions like whether

- we selected or rejected an idea because it was familiar (low risk) or unfamiliar (high risk),
- we treated all ideas equally before making a selection,
- familiarity was a factor in how much time and energy we expended (or did not expend) to gather more information on an idea, or
- we pursued or avoided ideas based on their familiarity.

There are no right or wrong answers to these questions. It can be enough to just consider them to minimize the familiarity bias.

9.3.3 Confirmation Bias

This bias is based on the fact that we tend to judge new ideas against what we already believe. We rarely think objectively about new ideas. Since it is much easier to maintain our current beliefs than to reprogram our neural networks to change them, we tend to interpret new ideas in a way that minimizes any neural reprogramming. Thus, we interpret new ideas in a way that confirms our pre-existing (and often unconscious) beliefs. This bias is known as the confirmation bias. It can be considered to be an extreme form of the familiarity bias. Instead of using new ideas to expand our beliefs, we tend to interpret them in ways to maintain and even strengthen our current beliefs.

Through the confirmation bias, we tend to accept and remember ideas that are aligned with what we already believe without considering them critically. We also tend to reject and forget ideas that are not in agreement with what we already believe. As we gather information about design ideas, we tend to seek information that confirms our prior beliefs and tend to ignore information contrary to those beliefs. In fact, we are almost twice as likely to select, remember, and use information that is consistent with our beliefs than information that is inconsistent with those beliefs [79–90]. This often occurs unconsciously.

One form of the confirmation bias that is particularly important for designers can occur if we make a tentative or preliminary selection, including a selection from a previous design cycle. Although we can gain valuable information by making and evaluating preliminary selections, we must ensure that we do not then favor that preliminary selection as we go forward with the design process. Once we have made such a selection, we then tend to use all remaining information to confirm that tentative selection rather than use that information to consider all ideas in a balanced way. As a result, we tend to become biased against all other ideas before it is time to make the final selection. Our tentative selection often becomes a self-fulfilling prophecy.

The confirmation bias often occurs when we have a personal stake in the outcome of a decision or when we have not adequately clarified the project [80, 91]. The confirmation bias can also arise when we judge our ideas in comparison to those of others. We tend favor our own ideas over those of others, particularly if we have invested time and effort in developing them and want to minimize the loss of our sunken costs [92, 93]. Consistent with many other biases, we can minimize the confirmation bias through analytical thinking. We can ask ourselves if we really looked objectively (analytically) at our information or if we just used it to justify what we already wanted or believed.

9.3.4 Simplicity Bias

This bias is based on the fact that we tend to like things that we understand and dislike things that we don't. It is easy to understand how simple ideas may impact

our ability to thrive. It is more difficult to understand how complex ideas may impact our ability to thrive so complex ideas are often considered a threat. As a result, simple ideas are judged more favorably and complex ideas are judged less favorably [94]. We have already seen this bias in the form of the *Take the Simplest* heuristic in Chap. 5.

The simplicity bias is impacted by whether we have the tools or experience to evaluate a new idea. Having the tools to process ideas makes them easier to understand [63]. For example, people untrained in art do not have to tools by which they can understand and judge complex or abstract art. As a result, they tend to judge such art negatively. People with art training have the tools, such as the rules of art, by which they can understand and judge such art. As a result, they tend to judge such art more positively. This simplicity bias in art occurs alongside of, but perhaps independently of, the familiarity bias. Similarly, our mathematical skills may bias us toward or away from ideas that may require the use of mathematics. This can be a significant factor distinguishing designers in engineering who tend to have more advanced mathematical skills from designers in technology.

It is not just how easily we can understand an idea that biases us but also how easily we can obtain information about the idea. For example, if our initial exposure to a new idea is in written form and the text is hard to read, either through its font or color, we tend to judge the idea negatively. This negative judgement occurs regardless of the content of the idea [71, 95–98]. Similarly, if we are doing research for a design project, we can be biased toward ideas about which we can easily obtain information and against ideas about which obtaining information is difficult. Ideas with information readily available through a web search are considered more positively than ideas that require more effort to research.

Consistent with many other heuristic biases, we can minimize the simplicity bias through analytical thinking. We can ask ourselves how simplicity was used as a selection criterion and whether we use that criterion appropriately. Sometimes simple really is better, but sometimes it just doesn't get the job done.

9.3.5 Balance Bias

This bias is based on the fact that we tend to like things that are balanced and dislike things that are not. Balance suggests a stable, safe environment for thriving and unbalanced things suggest an unstable, risky environment that threatens our thriving. Basically, we tend to like things that don't fall over on us and dislike things that do.

Both engineers and artists are taught this bias: engineers through courses in static equilibrium and artists through the heuristics of the rules of art. The balance bias in engineering is relatively straight forward and can be mathematically calculated (the sums of the forces and moments are both zero or things will start moving), while in art it is more psychological. Yet it is a real bias for everyone.

Perhaps the most obvious application of the balance bias in art (painting) involves the spatial layout of elements within a painting. We tend to like a painting

that appears balanced left-to-right about its physical center. As engineers know from studies of static equilibrium, when objects are balanced about their fulcrum, they tend to not to fall over and cause bad things to happen. Similarly, when a painting is visually balanced about its physical center (the fulcrum) it tends to induce a more positive emotional response (aesthetic judgment) than when the painting is not centered [99–101]. Not only is a painting more aesthetically pleasing when it has an overall visual balance about the physical center, it is also more pleasing when the individual colors in the painting are also balanced about the center [102].

Balancing a painting about its physical center is different, however, from making a painting symmetric about its physical center. When a painting is balanced about its physical center, it provides a sense of safety and survival. However, when a painting is also symmetric about its physical center, it induces a sense of stagnation, which inhibits our ability to grow. As a result, a symmetric painting is often judged as being aesthetically unpleasant. Having an asymmetrical painting that is balanced about its physical center, however, provides both a sense of safety and growth. This is a very aesthetically pleasing combination!

The most common way for artists to create an asymmetric, balanced painting is to place the primary center of interest (focal point) slightly to one side of the physical center. This has been codified as a rule of art known as the "rule of thirds". In the rule of thirds, the focal point of the painting is put about one-third of the width of the painting from one of the sides (one sixth of the way from the physical center). This places the primary point of interest close to but not on the physical center. To balance the painting about its physical center, other elements of lesser importance are added near the edge of the opposite side of the painting. Because those additional elements are farther from the physical center of the painting, they have a longer moment arm from the fulcrum than does the focal point. This greater distance from the physical center of less important elements then visually balances the painting about its physical center while maintaining asymmetry [101, 103–105].

A sense of balance is also established by how we orient a painting. Paintings in landscape mode or that have strong horizontal elements (wider than tall) are perceived as being stable. Paintings in portrait mode or that have strong vertical elements (taller than wide) are perceived as having more growth (think tall redwoods). Square paintings tend to feel neutral. Paintings with strong diagonal elements induce a feeling of imbalance that are perceived as having dynamic energy for growth. Sometimes it is good for things to fall over to make room for something new. In fact, the very purpose of design itself is to create something new (but not too new). Many other factors are also involved with establishing a sense of balance but a complete discussion of them is beyond the scope of this book [103, 105–110].

To minimize the impact of this heuristic bias on our design effectiveness, we can use analytical thought and ask ourselves how our bias toward balance may have impacted our design. Usually, balance is good because it supports our need for survival, but sometimes we want the dynamics of imbalance for growth.

9.3.6 Color Perception Bias

This bias is based on the fact that the dominant color we are seeing can alter our emotional state (mood), which can then impact our designs. It may be something as simple as the color of the walls around us or the color of the clothing we see or wear. For artists, this bias can also arise through the dominant colors used in a painting.

Psychologically, red colors impact us differently than blue colors. We tend to associate reds with fire and blues with ice. Thus, reds are associated with warmth and blues with coolth. This concept is widely known in art through the concept of color temperature. Reds are warm colors and blues are cool colors. It is noted that color temperature is opposite that of black body (electromagnetic) radiation in science and engineering where red is associated with being cooler and blue with being warmer.

Although the effect of color temperature on design effectiveness is complex, the following trend commonly occurs: [111–141]

- Warm colors (red, orange, yellow) tend to induce a sense of risk, dangers, potential mistakes, hazards, and analytical, conservative thinking. When we are exposed to reds, we tend to be focused and activated. Warm colors also tend to induce negative regulatory focus, which enhances our performance on detail-oriented task (tasks that require focused, careful attention).
- Cool colors (blue, green, purple) tend to induce a sense of safety, openness, calmness, tranquility, and intuitive, creative thinking. When we are exposed to blues, we tend to be defocused and deactivated. Cool colors also tend to induce a positive regulatory focus which enhances our performance on creative tasks (tasks that require originality).

One common explanation for how perceived colors can alter our emotional state is because our skin color follows the same trend. When we are hot, the flow of blood to our skin increases to enhance cooling and our skin turns red. When we are cold, the flow of blood to our skin decreases to retain heat in the core of our body and our skin turns blue. Our emotional state can also increase or decrease the blood flow to our skin. The conditions that create an emotional state that increases blood flow to our skin (warm color temperature) tend to be those associated with excitement. Similarly, conditions that create an emotional state that decreases blood flow to our skin (cool color temperature) tend to be those associated with serenity.

Color can also impact our design effectiveness through its value (how light or dark the color is) and saturation (how pure or muddy a color is, i.e., how monochromatic). People tend to associate light and pure colors with a pleasant aesthetic context, which can induce an intuitive thinking mode, and dark and muddy colors with an unpleasant aesthetic context, which can induce an analytical thinking mode [36, 125, 142–149]. In reality, the role of color on our design effectiveness is much more complex than the simple approach presented here [115, 143, 146, 150–159].

This bias can be minimized by changing our color environment while being aware of potential changes in our emotional state. This requires analytical thought.

9.4 Biases from How We Think

Now that we have discussed some common heuristics that bias our designs, we will look at how our thinking mode itself can bias our designs. We have seen that we have two different thinking modes: intuitive (non-sequential) and analytical (sequential). Both of these thinking modes have biases. Intuitive thinking can be biased by the context in which we use it (recall our use of seed ideas). Analytical thinking can be biased because it follows a sequential thought pattern (often a heuristic) that may not even recognize information or ideas that are outside of the pattern (a form of familiarity bias). The sequential thinking pattern of analytical thought is, itself, a bias.

In general, the biases associated with our thinking mode are as follows:

- Intuitive thought tends support creative thinking (positive regulatory focus) which supports our need to grow.
- Analytical thought tends to support conservative thinking (negative regulatory focus) which supports our need to survive.

The biases of our thinking modes are not necessarily good or bad, but they do exist and can impact our designs. The most effective way to minimize the impact of these biases is to regularly switch our thinking mode. We can minimize intuitive biases simply by engaging in analytical thought [21, 92, 93, 160]. Even being asked to explain or defend our ideas can reduce our intuitive biases [161, 162]. Similarly, we can minimize analytical biases by engaging in intuitive thought to get outside of any analytical pattern. As we have already seen, effective designers practice metacognition to recognize which thinking mode they are in and then frequently shift between the two modes.

9.5 Biases from How We Feel

We will now look at how our feelings can bias our designs. As introduced in Chap. 2, our feelings can be grouped into two broad categories: feelings as information and feelings as experiences.

Feelings as information uses our Intuition of Judgment, in which we make judgments about something based on how we feel about it. Often, we do not know why we feel the way we do, but we still have those feelings and still make those judgments. We just feel that something is right or wrong and then judge it based on that feeling. Using our feelings as information is often an important part of the

universal design activity of selecting the one final idea for implementation. However, because using our feelings as information involves a type of intuition (Intuition of Judgment), it can be biased by the context in which we use it. The best way to minimize such biases is through the balanced use of analytical thought. We need to explore why we feel the way we do.

We now turn to our feelings as experiences. Our feelings as experiences biases our designs primarily through our mood. We can experience moods without that experience being a judgment of something; they are just our moods. Our moods tend to come in two general types: good moods (positive) and bad moods (negative). We may have neutral moods, but they are relatively uninteresting because they are less likely to create biases during design. Overall, we are biased toward things that make us feel good (positive regulatory focus) and against things that make us feel bad (negative regulatory focus). Further,

- When we feel good, we tend to feel that our environment is familiar, safe, and unthreatening and we tend to be more cooperative. This induces a more relaxed, intuitive thinking mode.
- When we feel bad, we tend to feel that our environment is unsafe and threatening, and we tend to be more competitive. This induces a more intense, analytical thinking mode.

Another way of looking at how our mood can bias our designs is to consider the two primary human emotions: love and fear. When we feel good our hearts are open with love. When we feel bad our hearts are closed with fear. It is really that simple. All we need to do is look at the state of our heart during our design processes to identify some of our biases. Love involves an open, positive regulatory focus (creative) and fear involves a closed, negative regulatory focus (conservative).

Some of the ways that our mood can bias our designs is through how we process information (how we think), as summarized in Table 9.2 [137, 163–178]. A thoughtful look at this table reveals that the biases of one mood are not necessarily better or worse than those of the other. They simply exist and we need to be aware of them.

A second way that our mood can bias our designs is through our ability to generate ideas, i.e., our creativity. The nature of that bias depends upon whether or not we expect to be personally impacted by what we are doing. This impact includes an expectation of being judged by others.

- If we DO NOT expect to be personally impacted, a good (positive) mood tends to increase our creativity and a bad (negative) mood has little impact on our creativity [1, 30, 170, 179–185].
- If we DO expect to be personally impacted, a good mood tends to decrease our creativity and a bad mood tends to increase our creativity [179, 183, 184, 186–188].

Table 9.2 Differences between good and bad moods in design

Good mood	Bad mood
Intuitive thinking	Analytical thinking
Superficial, stereotypical thinking	Systematic, detailed thinking
Broader focus of attention	Narrow focus of attention
Biased toward first ideas	Considers all ideas fairly
Creative thinking	Conservative thinking
Combines information in new ways	Looks at information in familiar ways
Faster, more efficient decision making	Slower, less efficient decision making
Uses internal information (memory and feelings)	Uses external information
More optimistic about outcomes	More pessimistic about outcomes
More cooperative with others	More competitive with others
More errors in judgments	More accurate in judgments
More flexible	Less flexible

There is a reversal of the effect of our mood if we expect to be personally impacted. If we expect to be impacted and are already in a good mood, we tend to act in a way to maintain that mood: we act conservatively to limit any mood change. If we are already in a bad mood, we tend to act creatively to change our negative mood to a positive one.

A third way that our mood can bias our designs is through how we make decisions.

- If we DO NOT expect to be personally impacted, a good mood tends to result in decisions (judgements) that are more positive, lenient, and optimistic (more creative) and a bad mood tends to result in decisions that are more negative, strict, and pessimistic (more conservative) [166–168, 189–199].
- If we DO expect to be personally impacted, however, a good mood tends to result in decisions that are more conservative and a bad mood tends to result in decisions that are more creative [194, 195, 198, 200–202].

Again, we see a reversal of the impact of our mood based on our expectation of being personally impacted.

Now that we have seen ways in which our mood can bias our designs, we can look at ways to mitigate those biases. Just as we have the ability to change our thinking mode, we also have the ability to change our mood. It is noted, however, that it may be easier to shift from a good mood to a bad mood than the other way around [176].

We can induce a positive mood by:

- doing something creative or enjoyable without being judged, [180, 203].
- walking in nature or viewing pictures or videos of nature, [204, 205].
- receiving support from others, both at work or at home. This includes being given positive feedback or a small gift [171, 172, 185, 194].

We can induce a negative mood by:

- being held accountable for our actions, [165].
- engaging in analytical thinking, [206].
- having our decisions become personally relevant to us [169].

We can selectively induce either a positive or negative mood by:

- reading stories or watching movies that have the corresponding tone, [171, 192, 207].
- listening to music that induces the desired feeling, [208–210].
- inducing the corresponding approach/promotion or avoidance/prevention regulatory focus [1].

Finally, we can minimize the biases of our mood simply by being aware of them and how they may bias our ability to design [166, 196].

9.6 Biases from Value Judgements

Now that we have seen some of the ways that our heuristics, thinking, and feelings can bias our designs, we will consider one final source of bias: our value judgments. Our value judgements are our preferences and beliefs, which are often experienced through how we feel about the matter we are judging, i.e., feelings as information. Our preferences are often associated with the soft constraints of design and our beliefs are often associated with the hard constraints, even though we may not be consciously aware of this.

Our preferences tend to be a relative judgment of whether or not we like something and our beliefs tend to be an absolute judgement of whether or not we accept something to be true or valid. Our preferences are ways that we mentally organize our likes and dislikes. Our beliefs are ways that we mentally organize what we consider to be true and false. In this regard, both preferences and beliefs are merely heuristics.

Our value judgements tend to evolve in a particular sequence that occurs outside of our conscious awareness.

1. Our value judgments tend to start with a pattern or heuristic supporting our need to thrive, such as one of those described above.
2. The heuristic becomes a value judgment when we develop personal preferences about potential outcomes associated with that heuristic. These preferences involve whether we like something or not. They often involve our Intuition of Judgment (feelings as information). We know what we like (prefer), even if we may not know why. Our preferences are often associated with the familiarity bias.

3. With more relevant experiences, particularly from people we trust or if those experiences involve strong emotions, our preferences evolve to beliefs. Our judgment of liking evolves to a judgment right or wrong. Thus, beliefs are often preferences taken to an extreme. Our beliefs are often associated with the confirmation bias.

4. The final step in the evolution of our value judgments is for our beliefs to become core beliefs. Core beliefs are deeply held, rigid, and are very resistant to change. Unlike preferences or beliefs, core beliefs tend to not be changed through analytical thought or from exposure to information that is incompatible with those beliefs [211–219]. In fact, core beliefs generated from repetitive exposures to ideas as children are a key factor in the survival of cultures and religions from one generation to the next.

The further our value judgments have evolved along this sequence, the stronger are their associated biases and the less likely we are able to overcome them.

Our value judgments of preferences and beliefs are important in design because we judge new ideas and information according to them. We use them as internally-based heuristics. We tend to favor ideas that are aligned with our value judgments and reject those that are not, even if we do not consciously recognize any underlying reasons for why.

Not only do our value judgements directly bias our design selections, they also bias what information comes into our awareness. Ideas and information that are compatible with our value judgments readily rise into our level of awareness to be consciously processed. Ideas and information that are incompatible with our value judgements are often suppressed from rising to the level of our conscious awareness. We never know what we are not aware of. We can judge without even being aware that we are doing it. Unconscious value judgments can act as a type of latent inhibition.

Our value judgments can be linked with our need to thrive through the concept of evolutionary aesthetics. Although aesthetics is often associated with our emotional response to visual appearances, it can be linked with virtually any type of preference, visual or not [220–235]. Evolutionary aesthetics judges conditions that help with our thriving as being aesthetically pleasing and conditions that threaten our thriving as being aesthetically displeasing [236].

The concept of evolutionary aesthetics can also be linked with the need for cognitive closure, i.e., a need to resolve ambiguity and uncertainty. Cognitive closure suggests a safe environment for thriving because it involves eliminating unknown factors in our lives. We judge such environments as being aesthetically pleasing. For visual design, the need for cognitive closure leads to a preference for "safe" art, i.e., art that is easily to understand. This biases us to judge realistic art more aesthetically pleasing than abstract art [39, 43, 237].

9.7 Closing

The key conclusions from this chapter are.

1. We are not really rational people and our designs are biased by many factors unrelated to our designs.
2. One of our primary needs is to thrive as living beings. We are biased toward conditions that support our ability to thrive and are biased against conditions that do not support our ability to thrive. Our thriving includes a need to survive and a need to grow. What we need for survival, however, is often in conflict with what we need for growth.
3. Because we lack the cognitive capacity and ability to process all of the information available to us, we create heuristics based on patterns of experience that have helped us thrive. When we use heuristics, however, we are biased against information that does not fit within those heuristics. Some common heuristic biases include:

 a. Creative-Conservative bias. Our need to survive leads to a conservative bias in which we act to maintain stability. Our need to grow leads to a creative bias in which we act to create change. A heavy sense of time pressure tends to induce a conservative bias, while a moderate sense of time pressure tends to induce a creative bias.
 b. Familiarity bias. We prefer things that are familiar and not prefer things that are unfamiliar. Familiar things induce a sense of safety and thriving, while unfamiliar things induce a sense of uncertainty and threat. This bias is also known as the Mere Exposure Effect.
 c. Confirmation bias. We tend to interpret new information in a way that confirms what we already believe. We tend to focus on ideas and information compatible with what we already believe and tend to ignore ideas and information incompatible with what we already believe. Even making tentative or preliminary design selections can give rise to this bias.
 d. Simplicity bias. We prefer things that are easy to understand and not prefer things that are hard to understand. Simple things tend to induce a sense of safety and thriving, while complex things tend to induce a sense of uncertainty and threat. We tend to prefer simple designs.
 e. Balance bias. We prefer things that appear stable and not prefer things that are unstable. Things that are balanced provide a sense of safety (they appear to not be ready to fall over), while things that are unbalanced provide a sense of threat (they appear to be ready to fall over). Balance supports our need to survive, while imbalance supports our need to grow.
 f. Color perception bias. Our designs can be biased by the dominant color we perceive. A predominantly red environment induces an emotional state of action, excitement, change, and danger. A predominantly blue environment induces an emotional state of peace and safety. Red tends to induce focused, analytical thinking and blue tends to induce defocused, intuitive thinking.

4. The biases of many of our heuristics can be minimized simply by being aware of them or through using analytical thought.
5. Our thinking mode can bias our designs. If we are in an intuitive thinking mode, we tend to be more creative. If we are in an analytical thinking mode, we tend to be more conservative. A creative bias tends to lead to more original ideas but more errors in decision making, while a conservative bias tends to lead to less original ideas but fewer errors in decision making.
6. The biases of our thinking mode can be minimized or reversed simply by switching to the other mode.
7. Our feelings (mood) can play a significant role in our design effectiveness.

 a. If we do not expect to be personally impacted by our design selections, we tend to be more creative and make more riskier selections when we are in a good mood and we tend to be more conservative and make safer selections when we are in a bad mood.
 b. If we expect to be personally impacted by our activities, however, the role of our mood reverses: a good mood results in a conservative bias and a bad mood results in a creative bias.

8. The impact of the biases from our feelings (mood) can be minimized by switching to the opposite mood.
9. Our value judgments of preferences and beliefs can also bias our designs. Preferences involve whether or not we like something, while beliefs involve whether or not we accept something to be true. Our value judgments can bias our designs through our unconscious decisions on what information we will use in the design processes and through our selections themselves.
10. We tend to interpret new information within the context of our value judgments. If something is compatible with our value judgements, we tend to interpret it more favorably than if it is incompatible.
11. The biases of our value judgments can be minimized by being aware of them. However, the more our value judgments have evolved from an underlying heuristics to core beliefs the more difficult it is to overcome their biases.

9.8 Questions

1. Can you identify things that help you thrive? Can you identify things that help you survive but hinder your growth? Can you identify things that help you grow but hinder your survival? Can you relate these to your designs?
2. Can you identify how any of the heuristics presented here may have impacted your designs? What did (could) you do to balance those impacts?
3. How might your thinking mode bias your designs? Do you practice metacognition? Are you able to switch thinking modes? Does switching modes alter your biases?

4. Are you able to recognize and change your mood to address potential design biases? What do you do? Do you ever even think about your mood and its impact as you design?
5. How have your feelings (mood) impacted your recent design processes? Did you believe that you would be personally impacted by the outcome of the design?
6. How do feelings as information or feelings as experiences impact each of the three Universal Design Activities (clarify an ambiguous project, generate ideas, select one idea to implement)?
7. Are you able to recognize your feelings? Are you able to recognize your thoughts? Are you able to recognize your preferences? Are you able to recognize your beliefs? Are you able to tell the difference between them? Is there a difference? How do they impact your designs?
8. Can you recognize when you use feeling or thinking to make selections? Do you consider there to be a difference between feeling and thinking? What is it? What about a difference between feelings and intuition? Can feelings be a type of non-sequential thought? Do feelings involve processing of information?
9. What are some things that you like? What are some things that you dislike? Can you link those preferences with your need to thrive? Can you link them to one of the heuristics discussed here or any other heuristic? Can you identify how they might have impacted your designs?
10. How do your value judgments of preferences and beliefs impact each of the three Universal Design Activities? What can you do about it? Should you do anything about it?
11. No matter what your opinions and views are, everyone will have a different perspective than you about something. Have you ever considered why you believe the way you do and why others believe differently from you? Can you identify the original source of your beliefs? Can you relate your beliefs to any of the heuristics discussed in this chapter? How might they have impacted your designs?

References

1. Baas, M., De Dreu, C.K.W., Nijstad, A.: A meta-analysis of 25 years of mood-creativity research: hedonic tone, activation, or regulation focus? Psychol. Bull. **134**(6), 799–806 (2008). https://doi.org/10.1037/a0012815
2. Bittner, J.V., Bruena, M., Reitzschel, E.F.: Cooperation goals, regulatory focus, and their combined effects on creativity. Think. Ski. Creat. **19**, 260–268 (2016). https://doi.org/10.1016/j.tsc.2015.12.002
3. Chiu, F.-C.: The effects of exercising self-control on creativity. Think. Ski. Creat. **14**, 20–31 (2014). https://doi.org/10.1016/j.tsc.2014.06.003
4. Crowe, E., Higgins, E.T.: Regulatory focus and strategic inclinations: promotion and prevention in decision-making. Organ. Behav. Hum. Decis. Process. **69**(2), 117–132 (1997). https://doi.org/10.1006/obhd.1996.2675

5. Friedman, R.S., Förster, J.: The effects of promotion and prevention cues on creativity. J. Pers. Soc. Psychol. **81**(6), 1001–1013 (2001). https://doi.org/10.1037//0022-3514.81.6.1001

6. Friedman, R.S., Förster, J.: Effects of motivational cues on perceptual asymmetry: implications for creativity and analytical problem solving. J. Pers. Soc. Psychol. **88**(2), 263–275 (2005). https://doi.org/10.1037/0022-3514.88.2.263

7. Lam, T. W.-H., Chiu, C.-Y.: The motivational function of regulatory focus in creativity. J. Creat. Behav. **36**(2), 138–150, Second Quarter, 2002, https://doi.org/10.1002/j.2162-6057.2002.tb01061.x

8. Davidson, R.J.: Emotion and affective style: hemispheric substrates. Psychol. Sci. **3**(1), 39–43 (1992). https://doi.org/10.1111/j.1467-9280.1992.tb00254.x

9. Pizzagalli, D.A., Sherwood, R.J., Henriques, J.B., Davidson, R.J.: Frontal brain asymmetry and reward responsiveness: a source-localization study. Psychol. Sci. **16**(10), 805–813 (2005). https://doi.org/10.1111/j.1467-9280.2005.01618.x

10. Achtziger, A., Alos-Ferrer, C., Hugelschafer, S., Steinhauser, M.: The neural bias of belief updating and rational decision making. Soc. Cogn. Affect. Neurosci. **9**(1), 55–62 (2014). https://doi.org/10.1093/scan/nss099

11. Carlozzi, A.F., Bull, K.S., Eells, G.T., Hurlburt, J.D.: Empathy as related to creativity, dogmatism, and expressiveness. J. Psychol. **129**(4), 365–373 (1995). https://doi.org/10.1080/00223980.1995.9914974

12. Dollinger, S.J.: Creativity and conservativism. Personality Individ. Differ. **43**, 1025–1035 (2007). https://doi.org/10.1016/j.paid.2007.02.023

13. Feist, G.J., Brady, T.R.: Openness to experience, non-conformity, and the preference for abstract art. Empir. Stud. Arts **22**(1), 7–89 (2004). https://doi.org/10.2190/Y7CA-TBY6-V7LR-76GK

14. Frederick, C.M., Price, B.: Thinking creatively about religion: belief-related differences. J. Creat. Behav. **35**(3), 205–224, Third Quarter (2001). https://doi.org/10.1002/j.2162-6057.2001.tb01047.x.

15. Hilary, G., Hui, K.W.: Does religion matter in corporate decision making in America? J. Financ. Econ. **93**, 455–473 (2009). https://doi.org/10.1016/j.jfineco.2008.10.001

16. Kumar, A., Page, J.K., Spalt, O.G.: Religions beliefs, gambling attitudes, and financial market outcomes. J. Financ. Econ. **102**, 671–708 (2011). https://doi.org/10.2139/ssrn.1356733

17. Rouff, L.L.: Openness, creativity, and complexity. Psychol. Rep. **37**, 1009–1010 (1975). https://doi.org/10.2466/pr0.1975.37.3.1009

18. Rubinstein, G.: Authoritarianism and its relationship to creativity: a comparative study among students of design, behavioral sciences, and law. Personality Individ. Differ. **34**, 695–705 (2003). https://doi.org/10.1016/S0191-8869(02)00055-7

19. Shafir, E.: Choosing versus rejecting: why some options are both better and worse than others. Mem. Cognit. **21**(4), 546–556 (1993). https://doi.org/10.3758/BF03197186

20. Yaniv, I., Schul, Y.: Elimination and inclusion procedures in judgment. J. Behav. Decis. Mak. **10**, 211–220 (1997). https://doi.org/10.1002/(SICI)1099-0771(199709)10:3%3c211::AID-BDM250%3e3.0.CO;2-J

21. Hodgkinson, G.P., Bown, N.J., Maule, A.J., Glaister, K.W., Pearman, A.D.: Breaking the frame: an analysis of strategic cognition and decision making under uncertainty. Strateg. Manag. J. **20**, 977–985 (1999). https://doi.org/10.1002/(SICI)1097-0266(199910)20:10%3c977::AID-SMJ58%3e3.0.CO;2-X

22. Kuhberger, A.: The influence of framing on risky decisions: a meta-analysis. Organ. Behav. Hum. Decis. Process. **75**(1), 23–55 (1998). https://doi.org/10.1006/obhd.1998.2781

23. Levin, I.P., Schneider, S.L., Gaeth, G.J.: All frames are not created equal: a typology and critical analysis of framing effects. Organ. Behav. Hum. Decis. Process. **76**(2), 149–188 (1998). https://doi.org/10.1006/obhd.1998.2804

24. Tversky, A., Kahneman, D.: The framing of decisions and the psychology of choice. Science **211**(4481), 453–458 (1981). https://doi.org/10.1126/science.7455683

25. Hulland, J.S., Kleinmuntz, D.N.: Factors influencing the use of internal summary evaluations versus external information in choice. J. Behav. Decis. Mak. **7**, 79–102 (1994). https://doi.org/10.1002/bdm.3960070202

26. Nowlis, S.M.: The effect of time pressure on the choice between brands that differ in quality, price, and product features. Mark. Lett. **6**(4), 287–295 (1995). https://doi.org/10.1007/BF00996192

27. Suri, R., Monroe, K.B.: The effects of time constraints on consumers' judgments of prices and products. J. Consum. Res. **30**(1), 92–104 (2003). https://doi.org/10.1086/374696

28. Wright, P., Weitz, B.: Time horizon effects on product evaluation strategies. J. Mark. Res. **14**, 429–443 (1977). https://doi.org/10.1177/002224377701400401

29. Baer, M., Oldham, G.R.: The curvilinear relation between experience creative time pressure and creativity: moderating effects of openness to experience and support for creativity. J. Appl. Psychol. **91**(4), 963–970 (2006). https://doi.org/10.1037/0021-9010.91.4.963

30. Binnewies, C., Wornlein, S.C.: What makes a creative day? A diary study on the interplay between affect, job stressors, and job control. J. Organ. Behav. **32**, 589–607 (2011). https://doi.org/10.1002/job.731

31. Hansson, R.O., Keating, J.P., Terry, C.: The effects of mandatory time limits in the voting booth on liberal-conservative voting patterns. J. Appl. Soc. Psychol. **4**(4), 336–342 (1974). https://doi.org/10.1111/j.1559-1816.1974.tb02605.x

32. Johns, G.A., Morse, L.W.: Divergent thinking as a function of time and prompting to "be creative" in undergraduates. J. Creat. Behav. **31**(2), 156–165, Second Quarter (1997). https://doi.org/10.1002/j.2162-6057.1997.tb00788.x

33. Ohly, S., Sonnentag, S., Pluntke, F.: Routinization, work characteristics and their relationships with creativity and proactive behaviors. J. Organ. Behav. **27**, 257–279 (2006). https://doi.org/10.1002/job.376

34. Svenson, O., Edland, A.: Change of preferences under time pressure: choices and judgments. Scand. J. Psychol. **28**, 322–330 (1987). https://doi.org/10.1111/j.1467-9450.1987.tb00769.x

35. Wright, P.: The harassed decision maker: time pressures, distractions, and the use of evidence. J. Appl. Psychol. **59**(5), 555–561 (1974). https://doi.org/10.1037/h0037186

36. Axelsson, O.: Towards a psychology of photography: dimensions underlying aesthetic appeal of photographs. Percept. Mot. Skills **105**, 441–424 (2007). https://doi.org/10.2466/pms.105.2.411-434

37. Goldstein, D.G., Gigerenzer, G.: Models of ecological rationality: the recognition heuristic. Psychol. Rev. **109**(1), 75–90 (2002). https://doi.org/10.1037/0033-295x.109.1.75

38. Martindale, C., Moore, K.: Priming, prototypicality, and preference. J. Exp. Psychol. Hum. Percept. Perform. **14**(4), 661–670 (1988). https://doi.org/10.1037/0096-1523.14.4.661

39. Ostrofsky, J., Shobe, E.: The relationship between need for cognitive closure and the appreciation, understanding, and viewing time of realistic and nonrealistic figurative paintings. Empir. Stud. Arts **33**(1), 106–113 (2015). https://doi.org/10.1177/0276237415570016

40. Reimer, T., Katsikopoulos, K.V.: The use of recognition in group decision-making. Cogn. Sci. **28**, 1009–1029 (2004). https://doi.org/10.1016/j.cogsci.2004.06.004

41. Volz, K.G., Schooler, L.J., Schubotz, R.I., Raab, M., Gigerenzer, G., Von Cramon, D.Y.: Why you think Milan is larger than Modena: neural correlates of the recognition heuristic. J. Cogn. Neurosci. **18**(11), 1924–1936 (2006). https://doi.org/10.1162/jocn.2006.18.11.1924

42. Whitfield, T.W.A.: Predicting preference for familiar, everyday objects: an experimental confrontation between two theories of aesthetic behavior. J. Exp. Psychol. **3**, 221–327 (1983). https://doi.org/10.1016/S0272-4944(83)80002-4

43. Wiersema, D.V., van der Schalk, J., van Kleef, G.A.: Who's afraid of red, yellow, and blue? Need for cognitive closure predicts aesthetic preferences. Psychol. Aesthet. Creat. Arts **6**(2), 168–174 (2012). https://doi.org/10.1037/a0025878

44. Arkes, H.R., Hackett, C., Boehm, L.: The generality of the relation between familiarity and judged validity. J. Behav. Decis. Mak. **2**, 81–94 (1989). https://doi.org/10.1002/bdm. 3960020203
45. Bacon, F.T.: Credibility of repeated statements: memory for trivia. J. Exp. Psychol.: Hum. Learn. Mem. **5**(3), 241–252 (1979). https://doi.org/10.1037/0278-7393.5.3.241
46. Betsch, T., Plessner, H., Schwieren, C., Gutig, R.: I like it but I don't know why: a value-account approach to implicit attitude formation. Pers. Soc. Psychol. J. **27**(2), 242–253 (2001). https://doi.org/10.1177/0146167201272009
47. Bornstein, R.F., D'Agostino, P.R.: Stimulus recognition and the mere exposure effect. J. Pers. Soc. Psychol. **63**(4), 545–552 (1992). https://doi.org/10.1037/0022-3514.63.4.545
48. Bornstein, R.F.: Exposure and affect: overview and meta-analysis of research, 1968–1987. Psychol. Bull. **106**(2), 265–289 (1989). https://doi.org/10.1037/0033-2909.106.2.265
49. Cutting, J.E.: Gustave, Caillebotte, French impressionism, and mere exposure. Psychon. Bull. Rev. **10**(2), 319–343 (2003). https://doi.org/10.3758/BF03196493
50. Fang, X., Singh, S., Ahluwalia, R.: An examination of different explanations for the mere exposure effect. J. Consum. Res. **34**(1), 97–103, June 1007, https://doi.org/10.1086/513050.
51. Förster, J.: Cognitive consequences of novelty and familiarity: how mere exposure influences level of construal. J. Exp. Soc. Psychol. **45**, 444–447 (2009). https://doi.org/10. 1016/j.jesp.2008.10.011
52. Hawkins, S.A., Hoch, S.J.: Low-involvement learning: memory without evaluation. J. Consum. Res. **19**(2), 212–225 (1992). https://doi.org/10.1086/209297
53. Janiszewski, C.: Preattentive mere exposure effects. J. Consum. Res. **20**(3), 376–392 (1993). https://doi.org/10.1086/209356
54. Kunst-Wilson, W.R., Zajonc, R.B.: Affective discrimination of stimuli that cannot be recognized. Science **207**(4430m), 557–558 (1980). https://doi.org/10.1126/science.7352271.
55. Leder, H.: Determinants of preference: when do we like what we know? Empir. Stud. Arts **19**(2), 201–211 (2001). https://doi.org/10.2190/5TAE-E5CV-XJAL-3885
56. Moreland, R.L., Zajonc, R.B.: Is stimulus recognition a necessary condition for the occurrence of exposure effects? J. Pers. Soc. Psychol. **35**(4), 191–199 (1977). https://doi.org/ 10.1037//0022-3514.35.4.191
57. Schwartz, M.: Repetition and rated truth value of statements. Am. J. Psychol. **95**(3), 393–407, Fall (1982). https://doi.org/10.2307/1422132.
58. Zajonc, R.B.: Attitudinal effects of mere exposure. J. Pers. Soc. Psychol. Monogr. Suppl. **9**(2), 1–27 (1968). https://doi.org/10.1037/h0025848
59. Zajonc, R.B.: Mere exposure: a gateway to the subliminal. Curr. Dir. Psychol. Sci. **10**(6), 224–228 (2001). https://doi.org/10.1111/1467-8721.00154
60. Axelsson, O.: Individual differences in preferences to photographs. Psychol. Aesthet. Creat. Arts **1**(2), 61–72 (2007). https://doi.org/10.1037/1931-3896.1.2.61
61. Cupchik, G.C., Vartanian, O., Crawley, A., Mikulis, D.J.: Viewing artworks: contributions of cognitive control and perceptual facilitation to aesthetic experience. Brain Cogn. **70**, 84–91 (2009). https://doi.org/10.1016/j.bandc.2009.01.003
62. Hekkert, P., Van Wieringen, P.C.W.: Beauty in the eye of expert and nonexpert beholders: a study in the appraisal of art, **109**(3), 389–407, Autumn 1996, https://doi.org/10.2307/ 1423013
63. Förster, M., Fabi, W., Leder, H.: Do i really feel it? The contributions of subjective fluency and compatibility in low-level effects on aesthetic appreciation. Front. Hum. Neurosci. **9**, Article 373e (2015). https://doi.org/10.3389/fnhum.2015.00373.
64. Hekkert, P., van Wieringen, P.C.W.: The impact of level of expertise on the evaluation of original and altered versions of post-impressionistic paintings. Acta Physiol. (Oxf) **94**(2), 117–131 (1996). https://doi.org/10.1016/0001-6918(95)00055-0
65. Kirk, U., Skov, M., Christensen, M.S., Nygaard, N.: Brain correlates of aesthetic experience. Brain Cogn. **69**(2), 306–315 (2009). https://doi.org/10.1016/j.bandc.2008.08.004

66. Kirk, U., Skov, M., Hulme, O., Christensen, M.S., Zeki, S.: Modulation of aesthetic value by semantic context: an fMRI study. Neuroimage **44**, 1125–1132 (2009). https://doi.org/10.1016/j.neuroimage.2008.10.009

67. Locher, P.J.: An empirical investigation of the visual rightness theory of picture perception. Acta Physiol. (Oxf) **114**, 147–164 (2003). https://doi.org/10.1016/j.actpsy.2003.07.001

68. Silva, P.J., Barona, C.M.: Do people prefer curved objects? Angularity, expertise, and aesthetic preferences. Empir. Stud. Arts **27**(1), 25–42 (2009). https://doi.org/10.2190/EM.27.1.b

69. Specht, S.M.: Successive contrast effects for judgments of abstraction in artwork following minimal pre-exposure. Empir. Stud. Arts **25**(1), 63–70 (2007). https://doi.org/10.2190/W717-88W2-2233-12H3

70. Winston, A.S., Cupchik, G.C.: The evaluation of high art and popular art by naive and experienced viewers. Vis. Arts Res. **18**(1), 1–14, Spring (1992)

71. Hernandez, I., Preston, J.L.: Disfluency disrupts the confirmation bias. J. Exp. Soc. Psychol. **49**, 178–182 (2013). https://doi.org/10.1016/j.jesp.2012.08.010

72. Hirt, E.R., Markman, K.D.: Multiple explanation: a consider-an-alternative strategy for debiasing judgments. J. Pers. Soc. Psychol. **69**(6), 1069–1086 (1995). https://doi.org/10.1037/0022-3514.69.6.1069

73. Hirt, E.R., Sherman, S.J.: The role of prior knowledge in explaining hypothetical events. J. Exp. Soc. Psychol. **21**, 519–543 (1985). https://doi.org/10.1016/0022-1031(85)90023-X

74. Jacoby, L.L., Kelley, C., Brown, J., Jasechko, J.: Becoming famous overnight: limits on the ability to avoid unconscious influences of the past. J. Pers. Soc. Psychol. **56**(3), 326–338 (1989). https://doi.org/10.1037/0022-3514.56.3.326

75. Koehler, D.J.: Explanation, imagination, and confidence in judgment. Psychol. Bull. **110**(3), 499–519 (1991). https://doi.org/10.1037//0033-2909.110.3.499

76. Kruglanski, A.W., Freund, T., Bar-Tal, D.: Motivational effects in the mere-exposure paradigm. Eur. J. Soc. Psychol. **26**, 479–499 (1996). https://doi.org/10.1002/(SICI)1099-0992(199605)26:3%3c479::AID-EJSP770%3e3.0.CO;2-U

77. Sherman, S.J., Zehner, K.S., Johnson, J., Hirt, E.R.: Social explanation: the role of timing, set, and recall on subjective likelihood estimates. J. Pers. Soc. Psychol. **44**(6), 1127–1143 (1983). https://doi.org/10.1037/0022-3514.44.6.1127

78. Sherman, S.J., Skov, R.B., Hervitz, E.F., Stock, C.B.: The effects of explaining hypothetical future events: from possibility to probability to actuality and beyond. J. Exp. Soc. Psychol. **17**, 142–158 (1981). https://doi.org/10.1016/0022-1031(81)90011-1

79. Frost, P., Casey, B., Griffin, K., Raymundo, L., Farrell, C., Carrigan, R.: The influence of confirmation bias on memory and source monitoring. J. Gen. Psychol. **142**(4), 238–252 (2015). https://doi.org/10.1080/00221309.2015.1084987

80. Hart, W., Albarracin, D., Eagly, A.H., Brechan, I., Lindberg, M.J., Merrill, L.: Feeling validated versus being correct: a meta-analysis of selective exposure to information. Psychol. Bull. **135**(4), 555–588 (2009). https://doi.org/10.1037/a0015701

81. Kleider, H.M., Pezdek, K., Goldfinger, S.D., Kirk, A.: Schema-driven source misattribution errors: remembering the expected from a witnessed event. Appl. Cogn. Psychol. **22**, 1–20 (2008). https://doi.org/10.1002/acp.1361

82. Koehler, J.J.: The influence of prior beliefs on scientific judgments of evidence quality. Organ. Behav. Hum. Decis. Process. **56**, 28–55 (1993). https://doi.org/10.1006/obhd.1993.1044

83. Lord, C.G., Ross, L., Lepper, M.R.: Biased assimilation and attitude polarization: the effects of prior theories on subsequently considered evidence. J. Pers. Soc. Psychol. **37**(11), 2098–2109 (1979). https://doi.org/10.1037/0022-3514.37.11.2098

84. O'Sullivan, C.S., Durso, F.T.: Effect of schema-incongruent information on memory for stereotypical attributes. J. Pers. Soc. Psychol. **47**(1), 55–70 (1984). https://doi.org/10.1037/0022-3514.47.1.55

85. Rosenthal, R., Rubin, D.B.: Interpersonal expectancy effects: the first 345 studies. Behav. Brain Sci. **3**, 377–415 (1978). https://doi.org/10.1017/S0140525X00075506
86. Shechory, M., Nachson, I., Glicksohn, J.: Effects of stereotypes and suggestion on memory. Int. J. Offender Ther. Comparative. Criminol. **54**(1), 113–130 (2010). https://doi.org/10.1177/0306624X08322217
87. Snyder, M., Swann, W.B., Jr.: Hypothesis-testing processes in social interaction. J. Pers. Soc. Psychol. **36**(11), 1202–1212 (1978). https://doi.org/10.1037/0022-3514.36.11.1202
88. Swann, W.B., Jr., Giuliano, T.: Confirmatory search strategies in social interaction: how, when, why, and with what consequences. J. Soc. Clin. Psychol. **5**(4), 511–524 (1987). https://doi.org/10.1521/jscp.1987.5.4.511
89. Taber, C.S., Lodge, M.: Motivated skepticism in the evaluation of political beliefs. Am. J. Polit. Sci. **50**(3), 755–769 (2006). https://doi.org/10.1111/j.1540-5907.2006.00214.x
90. Wason, P.C.: On the failure to eliminate hypotheses in a conceptual task. Q. J. Exp. Psychol. **12**(3), 129–140 (1960). https://doi.org/10.1080/17470216008416717
91. Dawson, E., Gilovich, T., Regan, D.T.: Motivated reasoning and performance on the Wason selection task. Pers. Soc. Psychol. Bull. **28**(10), 1379–1387 (2002). https://doi.org/10.1177/014616702236869
92. Nikander, J.B., Liikkanen, L.A., Laakso, M.: The preference effect in design concept evaluation. Des. Stud. **35**, 473–499 (2014). https://doi.org/10.1016/j.destud.2014.02.006
93. Yaniv, I.: Receiving other people's advice: influence and benefit. Organ. Behav. Hum. Decis. Process. **93**, 1–13 (2004). https://doi.org/10.1016/j.obhdp.2003.08.002
94. McGlone, M.S., Tofighbakhsh, J.: Birds of a feather flock conjointly (?): rhythm as reason in aphorisms. Psychol. Sci. **11**(5), 424–428 (2000). https://doi.org/10.1111/1467-9280.00282
95. Alter, A.L., Oppenheimer, D.M.: Easy on the mind, easy on the wallet: the roles of familiarity and processing fluency in valuation judgments. Psychon. Bull. Rev. **15**(5), 985–990 (2008). https://doi.org/10.3758/PBR.15.5.985
96. Reber, R., Schwarz, N.: Effects of perceptual fluency on judgments of truth. Conscious. Cogn. **8**, 338–342 (1999). https://doi.org/10.1006/ccog.1999.0386
97. Reber, R., Winkielman, P., Schwarz, N.: Effects of perceptual fluency on affective judgments. Psychol. Sci. **9**(1), 45–48 (1998). https://doi.org/10.1111/1467-9280.00008
98. Reber, R., Wurtz, P., Zimmermann, T.D.: Exploring "fringe" consciousness: the subjective experience of perceptual fluency and its objective bases. Conscious. Cogn. **13**, 47–60 (2004). https://doi.org/10.1016/S1053-8100(03)00049-7
99. Locher, P., Cornelis, E., Wagemans, J., Stappers, P.J.: Artists' use of compositional balance for creating visual displays. Empir. Stud. Arts **19**(2), 213–227 (2001). https://doi.org/10.2190/EKMD-YMN5-NJUG-34BK
100. Locher, P.J., Stappers, P.J., Overbeeke, K.: The role of balance as an organizing design principle underlying adults' compositional strategies for creating visual displays. Acta Physiol. (Oxf) **99**, 141–161 (1998). https://doi.org/10.1016/S0001-6918(98)00008-0
101. Palmer, S.E., Gardner, J.S., Wickens, T.D.: Aesthetic issues in spatial composition: effects of position and direction of framing single objects. Spat. Vis. **21**(3–5), 421–449 (2008). https://doi.org/10.1163/156856808784532662
102. Firstov, V., Firstov, V., Voloshinov, A., Locher, P.: The colorimetric barycenter of paintings. Empir. Stud. Arts **25**(2), 209–217 (2007). https://doi.org/10.2190/10T0-2378-0583-73Q4
103. Freimuth, M., Wapner, S.: The influence of lateral organization on the evaluation of paintings. Br. J. Psychol. **70**, 211–218 (1979). https://doi.org/10.1111/j.2044-8295.1979.tb01678.x
104. McCormick, P.A.: Orienting attention without awareness. J. Exp. Psychol. Hum. Percept. Perform. **23**(1), 168–180 (1997). https://doi.org/10.1037//0096-1523.23.1.168
105. Swartz, P., Hewitt, D.: Lateral organization in pictures and aesthetic preference. Percept. Mot. Skills **30**, 991–1007 (1970). https://doi.org/10.2466/pms.1970.30.3.991

106. Banich, M.T., Heller, W., Levy, J.: Aesthetic preference and picture asymmetries. Cortex **25**, 187–195 (1989). https://doi.org/10.1016/s0010-9452(89)80036-x
107. Heidenreich, S.M., Turano, K.A.: Where does one look when viewing artwork in a museum? Empir. Stud. Arts **29**(1), 51–72 (2011). https://doi.org/10.2190/EM.29.1.d
108. Latto, R., Russell-Duff, K.: An oblique effect in the selection of line orientation by twentieth century painters. Empir. Stud. Arts **20**(1), 49–60 (2002). https://doi.org/10.2190/3VEY-RC3B-9GM7-KGDY
109. Nachson, I., Argaman, E., Luria, A.: Effects of directional habits and handedness on aesthetic preference for left and right profiles. J. Cross Cult. Psychol. **30**(1), 106–114 (1999). https://doi.org/10.1177/0022022199030001006
110. Sammartino, J., Palmer, S.E.: Aesthetic issues in spatial composition: effects of vertical position and perspective on framing single objects. J. Exp. Psychol. Hum. Percept. Perform. **38**(4), 865–879 (2012). https://doi.org/10.1037/a0027736
111. Ali, M.R.: Pattern of EEG recovery under photic stimulation by light of different colors. Electroencephalogr. Clin. Neurophysiol. **33**, 332–335 (1972). https://doi.org/10.1016/0013-4694(72)90162-9
112. Buechner, V.L., Maier, M.A., Lichtenfeld, S., Elliot, A.J., Curr. Psychol. **34**, 422–433 (2015). https://doi.org/10.1007/s12144-014-9266-x
113. Dael, N., Perseguers, M.-N., Marchand, C., Antonietti, J.-P., Mohr, C.: Put on that color, it fits your emotion: colour appropriateness as a function of expressed emotion. Q. J. Exp. Psychol. **69**(8), 1619–1630 (2016). https://doi.org/10.1080/17470218.2015.1090462
114. Elliot, A. J.: Color and psychological functioning: a review of theoretical and empirical work. Front. Psychol. **6**, Article 368, 1–8 (2015). https://doi.org/10.3389/fpsyg.2015.00368
115. Elliot, A.J., Maier, M.A.: Color psychology: effects of perceiving color on psychological functioning in humans. Annu. Rev. Psychol. **65**, 95–120 (2014). https://doi.org/10.1146/annurev-psych-010213-115035
116. Elliot, A.J., Aarts, H.: Perception of the color red enhances the force and velocity of motor output. Emotion **11**(2), 445–449 (2011). https://doi.org/10.1037/a0022599
117. Elliot, A.J., Kayser, D.N., Greitemeyer, T., Lichtenfeld, S., Gramzow, R.H., Maier, M.A., Liu, H.: Red, rank, and romance in women viewing men. J. Exp. Psychol. Gen. **139**(3), 399–417 (2010). https://doi.org/10.1037/a0019689
118. Elliot, A.J., Maier, M.A., Binser, M.J., Friedman, R., Pekrun, R.: The effect of red on avoidance behavior in achievement contexts. Pers. Soc. Psychol. Bull. **35**(3), 365–375 (2009). https://doi.org/10.1177/0146167208328330
119. Elliot, A.J., Niesta, D.: Romantic red: red enhances men's attraction to women. J. Pers. Soc. Psychol. **95**(5), 1150–1164 (2008). https://doi.org/10.1037/0022-3514.95.5.1150
120. Elliot, A.J., Maier, M.A., Moller, A.C., Friedman, R., Meinhardt, J.: Color and psychological functioning: the effect of red on performance attainment. J. Exp. Psychol. Gen. **136**(1), 154–168 (2007). https://doi.org/10.1037/0096-3445.136.1.154
121. Green, W.K., Hasson, S.M., Mohammed, S.K., Phillips, C.I., Richards, P.E., Smith, M.E., Jr., White, A.: Effect of viewing selected colors on the performance of gross and fine motor tasks. Percept. Mot. Skills **54**, 778 (1982). https://doi.org/10.2466/pms.1982.54.3.778
122. Knez, I.: Effects of colour of light on nonvisual psychological processes. J. Environ. Psychol. **21**, 201–208 (2001). https://doi.org/10.1006/jevp.2000.0198
123. Knez, I.: Effects of indoor lighting on mood and cognition. J. Environ. Psychol. **15**, 39–51 (1995). https://doi.org/10.1016/0272-4944(95)90013-6
124. Kuller, R., Mikellides, B., Janssens, J.: Color, arousal, and performance—a comparison of three experiments. Color. Res. Appl. **34**(2), 141–152 (2009). https://doi.org/10.1002/col.20476
125. Kwallek, N., Lewis, C.M., Lin-Hsiao, J.W.D., Woodson, H.: Effects of nine monochromatic office interior colors and clerical tasks and worker mood. Color. Res. Appl. **21**(6), 448–458 (1996). https://doi.org/10.1002/(SICI)1520-6378(199612)21:6%3c448::AID-COL7%3e3.0.CO;2-W

126. Kwallek, N., Lewis, C.M.: Effects of environmental colour on males and females: a red or white or green office. Appl. Ergon. **21**(4), 275–278 (1990). https://doi.org/10.1016/0003-6870(90)90197-6

127. Lehrl, S., Gerstmeyer, K., Jacob, J.H., Freiling, H., Henkel, A.W., Meyrer, R., Wiltfang, J., Kornhuber, J., Bleich, S.: Blue light improves cognitive performance. J. Neural Transm. **114**, 457–460 (2007). https://doi.org/10.1007/s00702 006-0621-4

128. Maier, M.A., Elliot, A.J., Lee, B., Lichtenfeld, S., Barchfeld, P., Pekrun, R.: The influence of red on impression formation in a job application context. Motiv. Emot. **37**, 389–401 (2013). https://doi.org/10.1007/s11031-012-9326-1

129. Maier, M.A., Elliot, A.J., Lichtenfeld, S.: Mediation of the negative effect of red on intellectual performance. Pers. Soc. Psychol. Bull. **34**(11), 1530–1540 (2008). https://doi.org/10.1177/0146167208323104

130. Mehta, R and Zhu, R.: Blue or red? Exploring the effects of color on cognitive task performances. Science **3232**, 1226–1229 (2009). https://doi.org/10.1126/science.1169144 .

131. Moller, A.C., Elliot, A.J., Maier, M.A.: Basic hue-meaning associations. Emotion **9**(6), 898–902 (2009). https://doi.org/10.1037/a0017811

132. Ou, L.-C., Luo, M. R., Woodcock, A., Wright, A.: A study of colour emotion and colour preference. Part I: colour emotions for single colours. Color. Res. Appl. **29**(3), 232–240 (2004). https://doi.org/10.1002/col.20010.

133. Palmer, S.E., Schloss, K.B.: An ecological valence theory of human color preference. Proc. Natl. Acad. Sci. **107**(19), 8877–8882, (2010). https://doi.org/10.1073/pnas.0906172107.

134. Pravossoudovitch, K., Cury, F., Yount, S.G., Elliot, A.J,: Is red the colour of danger? Testing an implicit red-danger association. Ergonomics **57**(4), 503–510 (2014). https://doi.org/10.1080/00110439.2014.889220

135. Schloss, K.B., Hawthorne-Madell, D., Palmer, S.E.: Ecological influences on individual differences in color preference. Atten. Percept. Psychophys. **77**, 2803–2816 (2015). https://doi.org/10.3758/sw13414-015-0954-x

136. Soldat, A.S., Sinclair, R.C.: Colors, Smiles, and frowns: external affective cues can directly affect responses to persuasive communications in a mood-like manner without affecting mood. Soc. Cogn. **19**(4), 469–490 (2001). https://doi.org/10.1521/soco.19.4.469.20756

137. Soldat, A.S., Sinclair, R.C., Mark, M.M.: Color as an environmental processing cue: external affective cues can directly affect processing strategy wthout affecting mood. Soc. Cogn. **15** (1), 55–71 (1997). https://doi.org/10.1521/soco.1997.15.1.55

138. Stone, N.J.: Environmental view and color for a simulated telemarketing task. J. Environ. Psychol. **23**, 63–78 (2003). https://doi.org/10.1016/S0272-4944(02)00107-X

139. Stone, N.J.: Designing effective study environments. J. Environ. Psychol. **21**, 179–190 (2001). https://doi.org/10.1006/jevp.2000.0193

140. Viola, A.U., James, L.M., Schlangen, L.J.M., Dijk, D.-J.: Blue-enriched white light in the workplace improves self-reported alertness, performance and sleep quality. Scand. J. Work Environ. Health **34**(4), 297–306 (2008). https://doi.org/10.5271/sjweh.1268

141. Wilson, G.D.: Arousal properties of red versus green. Percept. Mot. Ski. **23**, 947–949 (1966). https://doi.org/10.2466/pms.1966.23.3.947

142. Deng, X., Hui, S.K., Hutchinson, J.W.: Consumer preferences for color combinations: an empirical analysis of similarity-based color relationships. J. Consum. Psychol. **20**, 476–484 (2010). https://doi.org/10.1016/j.jcps.2010.07.005

143. Guilford, J.P., Smith, P.C.: A system of color-preferences. Am. J. Psychol. **72**(4), 487–502 (1959). https://doi.org/10.2307/1419491

144. Labrecque, L.I., Milne, G.R.: Exciting red and competent blue: the importance of color in marketing. J. Acad. Mark. Sci. **40**, 711–727 (2012). https://doi.org/10.1007/s11747-010-0245-y

145. Manav, B.: An experimental study on the appraisal of the visual environment at offices in relation to colour temperature and illuminance. Build. Environ. **42**, 979–983 (2007). https://doi.org/10.1016/j.buildenv.2005.10.022

146. Manav, B.: Color-emotion associations and color preferences: a cast study for residences. Color. Res. Appl. **32**(2), 144–151 (2007). https://doi.org/10.1002/col.20294
147. Meier, B.P., Robinson, M.D., Clore, G.L.: Why good guys wear white: automatic inferences about stimulus valence based on brightness. Psychol. Sci. **15**(2), 82–87 (2004). https://doi.org/10.1111/j.0963-7214.2004.01502002.x
148. Schloss, K.B., Palmer, S.E.: Aesthetic response to color combinations: preference, harmony, and similarity. Atten. Percept. Psychophys. **73**, 551–571 (2011). https://doi.org/10.3758/s13414-010-0027-0
149. Valdez, P., Mehrabain, A.: Effects of color on emotions. J. Exp. Psychol. Gen. **123**(4), 394–409 (1994). https://doi.org/10.1037/0096-3445.123.4.394
150. Dailey, A., Martindale, C., Borkum, J.: Creativity, synesthesia, physiognomic perception. Creat. Res. J. **10**(1), 1–8 (1997). https://doi.org/10.1207/s15326934crj1001_1
151. Jiang, F., Lu, S., Yao, X., Yue, X., Au, W.T.: Up or down? How culture and color affect judgments. J. Behav. Decis. Mak. **27**, 226–234 (2014). https://doi.org/10.1002/bdm.1800
152. Kumi, R., Conway, C.M., Limayem, M., Goyal, S.: Learning in color: how color and affect influence learning outcomes. IEEE Trans. Prof. Commun. **56**(1), 2–15 (2013). https://doi.org/10.1109/TPC.2012.2208390
153. Ou, L.-C., Luo, M.R., Sun, P.-L., Hu, N.-C., Chen, H.-S., Guan, S.-S., Woodcock, A., Caivano, J.L., Huertas, R., Tremeau, A., Billger, M., Izadan, H., Richter, K.: A cross-cultural comparison of colour emotion for two-colour combinations. Color. Res. Appl. **37**(1), 23–43 (2012). https://doi.org/10.1002/col.20648
154. Ou, L.-C., Luo, M.R.: A colour harmony model for two-colour combinations. Color. Res. Appl. **31**(3), 191–204 (2006). https://doi.org/10.1002/col.20208
155. Ou, L.-C., Luo, M.R., Woodcock, A., Wright, A.: A study of colour emotion and colour preference. Part ii: colour emotions for two-colour combinations. Color. Res. Appl. **29**(4), 292–298 (2004). https://doi.org/10.1002/col.20024.
156. Ou, L.-C., Luo, M.R., Woodcock, A., Wright, A.: A study of colour emotion and colour preference. Part III: colour preference modeling. Color. Res. Appl. **29**(5), 381–389 (2004). https://doi.org/10.1002/col.20047.
157. Schaie, K.W.: Scaling the association between colors and mood-tones. Am. J. Psychol. **74**(2), 266–273 (1961). https://doi.org/10.2307/1419412
158. Shi, J., Zhang, C., Jiang, F.: Does red undermine individuals' intellectual performance? A test in China. Int. J. Psychol. **50**(1), 81–84 (2015). https://doi.org/10.1002/ijop.12076
159. Wexner, L.B.: The degree to which colors (hues) are associated with mood-tones. J. Appl. Psychol. **38**(6), 432–435 (1954). https://doi.org/10.1037/h0062181
160. Nordgren, L. F. and Dijksterhuis, Ap.: The devil is in the deliberation: thinking too much reduces preference consistency. J. Consum. Res. **36**(1), 39–46 (2009). https://doi.org/10.1086/596306.
161. Novemsky, N., Dhar, R., Schwarz, N., Simonson, I.: Preference fluency in choice. J. Mark. Res. **44**(3), 347–356 (2007). https://doi.org/10.1509/jmkr.44.3.347
162. Wanke, M., Bless, H., Biller, B.: Subjective experience versus content of information in the construction of attitude judgments. Pers. Soc. Psychol. Bull. **22**(11), 1105–1113 (1996). https://doi.org/10.1177/01461672962211002
163. Ashby, F.G., Isen, A.M., Turken, U.: A neuropsychological theory of positive affect and its influence on cognition. Psychol. Rev. **106**(3), 529–550 (1999). https://doi.org/10.1037/0033-295x.106.3.529
164. Bakamitsos, G.A.: A cue alone or a probe to think? The dual role of affect in product evaluation. J. Consum. Res. **33**, 403–412 (2006). https://doi.org/10.1086/508525
165. Bodenhausen, G.V., Kramer, G.P., Susser, K.: Happiness and stereotypic thinking in social judgment. J. Pers. Soc. Psychol. **66**(4), 621–632 (1994). https://doi.org/10.1037/0022-3514.66.4.621

166. Clore, G.L., Schwarz, N., Conway, M.: Affective causes and consequences of social information processing. In: Wayer, R.S., Srull, T.K. (eds.) Handbook of Social Cognition, Lawrence Erlbaum Associates, Hillsdale, New Jersey (1994)

167. Forgas, J.P.: Don't worry, be sad! On the cognitive, motivational, and interpersonal benefit of negative mood. Curr. Dir. Psychol. Sci. **22**(3), 225–232 (2013). https://doi.org/10.1177/0963721412474458

168. Forgas, J.P.: Can negative affect eliminate the power of first impressions? Affective influences on primacy and recency effects in impression formation. J. Exp. Soc. Psychol. **47**, 425–429 (2011). https://doi.org/10.1016/j.jesp.2010.11.005

169. Forgas, J.P., George, J.M.: Affective influences on judgments and behavior in organizations: an information processing perspective. Organ. Behav. Hum. Decis. Process. **86**(1), 3–24 (2001). https://doi.org/10.1006/obhd.2001.2971

170. Isen, A.M.: On the relationship between affect and creative problem solving. In: Russ, S.W. (ed.) Affect, Creative Experience, and Psychological Adjustment. Philadelphia, Brunner/Mazel, 1999.

171. Isen, A.M., Daubman, K.A., Nowicki, G.P.: Positive affect facilitates creative problem solving. J. Pers. Soc. Psychol. **52**(6), 1122–1131 (1987). https://doi.org/10.1037/0022-3514.52.6.1122

172. Isen, A.M., Means, B.: The influence of positive affect on decision-making strategy. Soc. Cogn. **2**(1), 18–31 (1983). https://doi.org/10.1521/soco.1983.2.1.18

173. Koch, A.S., Forgas, J.P.: Feeling good and feeling truth: the interactive effects of mood and processing fluency. J. Exp. Soc. Psychol. **48**, 481–485 (2012). https://doi.org/10.1016/j.jesp.2011.10.006

174. Luce, M.F., Bettman, J.R., Payne, J.W.: Choice processing in emotionally difficult decisions. J. Exp. Psychol. Learn. Mem. Cogn. **23**(2), 384–405 (1997). https://doi.org/10.1037//0278-7393.23.2.384

175. Rowe, G., Hirsh, J.B., Anderson, A.K.: Positive affect increases the breadth of attentional selection. Proc. Natl. Acad. Sci. **104**(1), 282–288 (2007). https://doi.org/10.1073/pnas.0605198104.

176. Ruder, M., Bless, H.: Mood and the reliance on the ease of retrieval heuristic. J. Pers. Soc. Psychol. **85**(1), 20–32 (2003). https://doi.org/10.1037/0022-3514.85.1.20 .

177. Schwarz, N.: Situated cognition and the wisdom of feelings, cognitive tuning. In: Barrett, L. G., Salovey, P. (eds.) The Wisdom in Feeling: Psychological Processes, Guilford Press, New York (2002)

178. Sinclair, R.C., Mark, M.M.: The effect of mood state on judgemental accuracy: processing strategy as a mechanism. Cogn. Emot. **9**(5), 417–438 (1995). https://doi.org/10.1080/02699939508408974

179. Adaman, J. E. and Blaney, P. H.: The effects of musical mood induction on creativity. J. Creat. Behav. **29**(2), 95–108, Second Quarter (1995). https://doi.org/10.1002/j.2162-6057.1995.tb00739.x.

180. Amabile, T.M., Barsade, S.G., Mueller, J.S., Staw, B.M.: Affect and creativity at work. Adm. Sci. Q. **50**(3), 367–403 (2005). https://doi.org/10.2189/asqu.2005.50.3.367

181. Davis, M.A.: Understanding the relationship between mood and creativity: a meta-analysis. Organ. Behav. Hum. Decis. Process. **108**, 25–38 (2009). https://doi.org/10.1016/j.obhdp.2008.04.001

182. Friedman, R.S., Förster, J., Denzler, M.: Interactive effects of mood and task framing on creative generation. Creat. Res. J. **19**(2–3), 141–162 (2007). https://doi.org/10.1080/10400410701397206

183. George, J.M., Zhou, J.:Dual tuning in a supportive context: joint contributions of positive mood, negative mood, and supervisor behaviors to employee creativity. Acad. Manag. J. **50**(3), 605–622 (2007). https://doi.org/10.5465/AMJ.2007.25525934

184. Kaufmann, G.: Expanding the mood-creativity equation. Creat. Res. J. **5**, **2–3**, 131–135 (2003). https://doi.org/10.1207/S15326934CRJ152&3_03

185. Madjar, N., Oldham, G.R., Pratt, M.G.: There's no place like home? The contributions of work and nonwork creativity support to employees' creative performance. Acad. Manag. J. **45**(4), 757–767 (2002). https://doi.org/10.2307/3069309

186. Akinola, M., Mendes, W.B.: The dark side of creativity: biological vulnerability and negative emotions lead to greater artistic creativity. Personality and Social Psychology Bulletin, Nol. **34**(12), 1677–1686 (2008). https://doi.org/10.1177/0146167208323933

187. George, J.M., Zhou, J.: Understanding when bad moods foster creativity and good one's don't: the role of context and clarity of feelings. J. Appl. Psychol. **87**(4), 687–697 (2002). https://doi.org/10.1037/0021-9010.87.4.687

188. Kaufmann, G., Vosburg, S.K.: 'Paradoxical' mood effects on creative problem-solving. Cogn. Emot. **12**(2), 151–170 (1997). https://doi.org/10.1080/026999397379971

189. Au, K., Chan, F., Wang, D., Vertinsky, I.: Mood in foreign exchange trading: cognitive processes and performance. Organ. Behav. Hum. Decis. Process. **91**, 322–338 (2003). https://doi.org/10.1016/S0749-5978(02)00510-1

190. Elsbach, K.D., Barr, P.S.: The effects of mood on individuals' use of structured decision protocols. Organ. Sci. **10**(2), 181–198 (1999). https://doi.org/10.1287/orsc.10.2.181

191. Forgas, J.P., East, R.: On being happy and gullible: mood effects on skepticism and the detection of deception. J. Exp. Soc. Psychol. **44**, 1362–1367 (2008). https://doi.org/10.1016/j.jesp.2008.04.010

192. Forgas, J.P., Moylan, S.: After the movies: transient mood and social judgments. Pers. Soc. Psychol. Bull. **13**(4), 467–477 (1987). https://doi.org/10.1177/0146167287134004

193. Isen, A.M.: An influence of positive affect on decision making in complex situations: theoretical issues with practical implications. J. Consum. Psychol. **11**(2), 75–85 (2001). https://doi.org/10.1207/S15327663JCP1102_01

194. Isen, A.M., Geva, N.: The influence of positive affect on acceptable level of risk: the person with a large canoe has a large worry. Organ. Behav. Hum. Decis. Process. **39**, 145–154 (1987). https://doi.org/10.1016/0749-5978(87)90034-3

195. Isen, A.M., Patrick, T.: The effect of positive feelings on risk taking: when the chips are down. Organ. Behav. Hum. Perform. **31**, 194–202 (1983). https://doi.org/10.1016/0030-5073(83)90120-4

196. McFarland, C., White, K., Newth, S.: Mood acknowledgement and correction for the mood-congruency bias in social judgment. J. Exp. Soc. Psychol. **39**, 483–491 (2003). https://doi.org/10.1016/S0022-1031(03)00025-8

197. Peters, E., Slovic, P.: The springs of action: affective and analytical information processing in choice. Pers. Soc. Psychol. Bull. **26**(12), 1465–1475 (2000). https://doi.org/10.1177/01461672002612002

198. Wright, W.F., Bower, G.H.: Mood effects on subjective probability assessment. Organ. Behav. Hum. Decis. Process. **52**, 276–291 (1992). https://doi.org/10.1016/0749-5978(92)90039-A

199. Yeun, K.S.L., Lee, T.M.C.: Could mood state affect risk-taking decisions?. J. Affect. Disord. **75**, 11–18 (2003). https://doi.org/10.1016/S0165-0327(02)00022-8

200. Blay, A.D., Kadous, K., Sawers, K.: The impact of risk and affect on information search efficiency. Organ. Behav. Hum. Decis. Process. **117**, 80–87 (2012). https://doi.org/10.1016/j.obhdp.2011.09.003

201. Mittal, V., Ross, W.T., Jr.: The impact of positive and negative affect and issue framing on issue interpretation and risk taking. Organ. Behav. Hum. Decis. Process. **76**(3), 298–324 (1998). https://doi.org/10.1006/obhd.1998.2808

202. Nygren, T.E., Isen, A.M., Taylor, P.J., Dulin, J.: The influence of positive affect on the decision rule in risk situations: focus on outcome (and especially avoidance of loss) rather than probability. Organ. Behav. Hum. Decis. Process. **66**(1), 59–72 (1966). https://doi.org/10.1006/obhd.1996.0038

203. Madjar, N., Oldham, G.R.: Preliminary tasks and creative performance on a subsequent task: effects of time on preliminary tasks and amount of information about the subsequent task. Creat. Res. J. **14**(2), 239–251 (2002). https://doi.org/10.1207/S15326934CRJ1402_10

204. Atchley, R.A., Stayer, D.L., Atchley, P.: Creativity in the wild: improving creative reasoning through immersion in natural settings. PlosOne **7**(12), e51474 (2012). https://doi.org/10.1371/journal.pone.0051474

205. Berman, M.G., Jonides, J., Kaplan, S.: The cognitive benefits of interacting with nature. Psychol. Sci. **19**(12), 1207–1212 (2008). https://doi.org/10.1111/j.1467-9280.2008.02225.x

206. Chermahini, S.A., Hommel, B.: Creative mood swings: divergent and convergent thinking affect mood in opposite ways. Psychol. Res. **76**, 634–640 (2012). https://doi.org/10.1007/s00426-011-0358-z

207. Boytos, A., Smith, K., Kim, J.: The underdog advantage in creativity. Think. Ski. Creat. **26**, 96–101 (2017). https://doi.org/10.1016/j.tsc.2017.10.003

208. McCraty, R., Barrios-Choplin, B., Atkinson, M., Tomasino, D.: The effects of different types of music on mood, tension, and mental clarity. Altern. Ther.**4**(1), 75–84 (1998)

209. Ritter, S.M., Ferguson, S.: Happy creativity: listening to happy music facilitates divergent thinking. PLOS One **12**(9), 1–14, e0182210 (2017). https://doi.org/10.1371/journal.pone.0182210

210. Threadgold, E., Marsh, J.E., McLatchie, N., Ball, L.J.: Background music stints creativity: evidence from compound remote associate tasks. Appl. Cogn. Psychol., 1–16 (2019). https://doi.org/10.1002/acp3532

211. Anderson, C.A., Lepper, M.R., Ross, L.: Perseverance of social theories: the role of explanation in the persistence of discredited information. J. Pers. Soc. Psychol. **39**(6), 1037–1049 (1980). https://doi.org/10.1037/h0077720

212. Crocker, J., Fiske, S.T., Taylor, S.E.: Schematic bases of belief change. In: Eiser, J.R. (ed.) Attitudinal Judgment. Springer, New York (1984).

213. Delavechia, T.R., Velasquez, M.L., Duran, E.P., Matsumoto, L.S., de Oleveira, I.: R: Changing negative core beliefs with trial-based thought record. Arch. Clin. Psychiatry **43**(2), 31–33 (2016). https://doi.org/10.1590/0101-60830000000078

214. Howe, L.C., Krosnick, J.A.: Attitude strength. Annu. Rev. Psychol. **68**, 327–351 (2017). https://doi.org/10.1146/annurev-psych-122414-033600

215. Markus, H.: Self-schemata and processing information about the self. J. Pers. Soc. Psychol. **3**(2), 63–78 (1977). https://doi.org/10.1037/0022-3514.35.2.63

216. Padesky, C.A.: Schema change processes in cognitive therapy. Clin. Psychol. Psychother. **1**(5), 276–2787 (1994). https://doi.org/10.1002/cpp.5640010502

217. Ross, L., Lepper, M.R., Hubbard, M.: Perseverance in self-perception and social perception: biased attributional processes in the debriefing paradigm. J. Pers. Soc. Psychol. **32**(5), 880–892 (1975). https://doi.org/10.1037/0022-3514.32.5.880.

218. Walsh, J.P., Charalambides, L.C.: Individual and social origins of belief structure change. J. Soc. Psychol. **130**(4), 517–532 (1990). https://doi.org/10.1080/00224545.1990.9924614

219. Zuwerink, J.R., Devine, P.G.: Attitude Importance and resistance to persuasion: it's not just the thought that counts. J. Pers. Soc. Psychol. **70**(5), 931–944 (1996). https://doi.org/10.1037/0022-3514.70.5.931

220. Bergeron, V. and Lopes, D. M.: Aesthetic theory and aesthetic science. In: Shimamura, A.P., Palmer, S.E. (eds.) Aesthetic Science: Connecting Minds, Brains, and Experience. Oxford University Press, Oxford (2012). https://doi.org/10.1093/acprof:oso/9780199732142.003.0024.

221. Berghman, M., Hekkert, P.: Towards a unified model of aesthetic pleasure in design. New Ideas Psychol. **47**, 136–144 (2017). https://doi.org/10.1016/j.newideapsych.2017.03.004

222. Boselie, F. and Leeuwenberg, E.: Birkhoff revisited: beauty as a function of effect and means. Am J Psychol **98**(1), 1–39, Spring (1985). https://doi.org/10.2307/1422765

223. Brown, S., Gao, X., Tisdelle, L., Eickhoff, S.B., Liotti, M.: Naturalizing aesthetics: brain areas for aesthetic appraisal across sensory modalities. Neuroimage **58**, 250–258 (2011). https://doi.org/10.1016/j.neuroimage.2011.06.012

224. Chatterjee, A., Vartanian, O.: Neuroaesthetics. Trends Cogn. Sci. **18**(7), 370–375 (2014). https://doi.org/10.1016/j.tics.2014.03.003

225. Jacobsen, T.: Bridging the arts and sciences: a framework for the psychology of aesthetics. Leonardo **39**(2), 155–162 (2006). https://doi.org/10.1162/leon.2006.39.2.155

226. Jacobson, T., Schubotz, R.I., Hofel, L., Cramon, C.Y.V.: Brain correlates of aesthetic judgment of beauty. Neuroimage **29**, 276–285 (2006). https://doi.org/10.1016/j.neuroimage. 2005.07.010

227. Langlois, J. H., Kalakanis, L., Rubenstein, A. J., Larson, A., Hallam, M., and Smoot, M.: Maxims or myths of beauty? A meta-analytic and theoretical review. Psychol. Bull. **126**(3), 390–423 (2000). https://doi.org/10.1037/0033-2909.126.3.390 .

228. Leder, H., Nadal, M.: Ten years of a model of aesthetic appreciation and aesthetic judgments: the aesthetic episode—developments and challenges in empirical aesthetics. Br. J. Psychol. **105**, 443–464 (2014). https://doi.org/10.1111/bjop.12084

229. Locher, P., Krupinski, E.A., Mello-Thoms, C., Nodine, C.F.: Visual Interest in pictorial art during an aesthetic experience. Spat. Vis. **21**(1–2), 55–77 (2007). https://doi.org/10.1163/ 156856807782753868

230. Pearce, M.T., Zaidel, D.W., Vartanian, O., Skov, M., Leder, H., Chatterjee, A., Nadal, M.: Neuroaesthetics: the cognitive neuroscience of aesthetic experience. Perspect. Psychol. Sci. **11**(2), 265–279 (2016). https://doi.org/10.1177/1745691615621274

231. Ramachandran, V.S., Hirstein, W.: The science of art: a neurological theory of aesthetic experience. J. Conscious. Stud. **6**(6–7), 15–51 (1999)

232. Reimann, M., Zaichkowsky, J., Neuhaus, C., Bender, T., Weber, B.: Aesthetic package design: a behavioral, neural, and psychological investigation. J. Consum. Psychol. **20**(4), 431–441 (2010). https://doi.org/10.1016/j.jcps.2010.06.009

233. Shimamura, A.P.: Toward a science of aesthetics. In: Shimamura, A.P., Palmer, S.E. (eds.) Aesthetic Science: Connecting Minds, Brains, and Experience, Oxford University Press, Oxford (2012)

234. Tsukiuira, T., Cabeza, R.: Shared brain activity for aesthetic and moral judgments: implications for the beauty-is-good stereotype. Soc. Cogn. Affect. Neurosci. **6**, 138–148 (2011). https://doi.org/10.1093/scan/nsq025

235. Zeki, S., Lamb, M.: The neurology of kinetic art. Brain **117**, 607–636 (1994). https://doi.org/ 10.1093/brain/117.3.607

236. Nadal, M., Gomez-Puerto, G.: Evolutionary approaches to art and aesthetics. In Tinio P.P.L., Smith, J.K. (eds.) The Psychology of Aesthetics and the Arts. Cambridge University Press, Cambridge, UK (2014)

237. Chirumbolo, A., Brizi, A., Mastandrea, S., Mannentti, L.: Beauty is no quality in thing themselves': epistemic motivation affects implicit preferences for art. PlosOne **9**(10), e110323, pp. 1–9 Oct. 2014, https://doi.org/10.1371/journal.pone.0110323.

Designing with Others

10

10.1 Introduction

We now look at what happens when we design with others. Although artists almost always work alone on their design projects, engineers almost always work on teams. The chapter starts by looking at how working with others impacts our ability to complete the three universal design activities: clarify a design project, generate ideas, and select our final idea for implementation. It then discusses the composition of effective design teams. It closes by identifying ways that leadership and management can influence team design effectiveness.

10.2 Individual Versus Team Design

Perhaps the greatest difference between designing with others and working alone is that team design is inherently a social activity. Because of this, team members not only need good design skills, they also need good interpersonal skills. Team design involves interaction and negotiation among team members. Team members must be able to rely on other team members' expertise and reliability because it is rarely possible for just one person to do everything or even to understand everything [1–6]. When we work with others, we can complete designs far more complex that those we can complete when working alone. In fact, the most significant design breakthroughs tend to come from teams, not individuals [7].

Because team design is a social activity, we must make adjustments to how we approach design, including each of the three universal design activities.

© The Author(s), under exclusive license to Springer Nature Switzerland AG 2022
J. Reis, *Advanced Design*, https://doi.org/10.1007/978-3-030-95782-7_10

10.2.1 Clarifying the Project

Perhaps the most significant need for team design during the universal design activity of clarifying the project is to ensure that all team members are working on the same project. For complex projects, teams may need to develop formal, written problem statements that provide a shared vision of the purpose of the project and the constraints within which they must operate. Without such a shared vision, team members often work toward conflicting goals without realizing it. In fact, they may unknowingly work on different projects [8–11].

10.2.2 Generating Ideas

The most significant need for team design during the universal design activity of generating ideas is to recognize that idea generation remains an individual task. Even when developing ideas with others, all ideas are still generated by individuals. We may build on what others say and they may build on what we say, but all ideas ultimately come from our individual intuitive thinking. All team members can do is provide seed ideas for each other. Because idea generation is essentially an individual process, the success of teams to generate original ideas depends on the team having individual team members who can effectively generate ideas [12].

Perhaps the best-known method to generate ideas with others is team brainstorming. During team brainstorming, individuals take turns sharing their individual ideas with the group while everyone else simply listens. All judging or evaluating of ideas is deferred to a later time. Team brainstorming, however, has been shown to be a very inefficient way to generate ideas. More effective idea generation occurs when the same number of individuals brainstorm in isolation for the same period of time (often called nominal teams) [9, 13–18].

There are two primary reasons why team brainstorming tends to be ineffective. First, when we are listening to the ideas of others, we are not generating ideas ourselves. We do not effectively use our time while waiting for our turn to speak. This process is called production blocking [19–24]. Second, some people take the opportunity to disengage from idea generation when others are talking and let others generate all of the ideas, particularly on large teams. This process is called social loafing [25, 26].

Several methods have been proposed to address these limitations of team brainstorming:

1. Hybrid brainstorming in which team members generate ideas separately and then meet to share them [27–29].
2. Writing down our ideas as we listen to others [19, 30].
3. Using technology to simultaneously share written ideas as others speak. This variation is known as electronic brainstorming [9, 31–44]. Electronic brainstorming appears to be particularly effective for teams greater than about eight members [32, 45].

With a few exceptions, these methods do increase the effectiveness of team brainstorming above that of traditional team brainstorming. These methods, however, do not increase the effectiveness above that of the same number of individuals brainstorming in isolation.

Even though team brainstorming is normally less effective for idea generation than individuals brainstorming in isolation, there are significant organizational benefits to team brainstorming. These benefits include [46]

1. Enhancing organizational memory of design solutions from sharing of information.
2. Expanding skill sets of team members from sharing of expertise
3. Sharing and clarifying institutional values
4. Increasing networking within an organization.

10.2.3 Selecting One Idea

One of the most significant needs for team design during the universal design activity of selecting one idea for implementation is to agree on a way for decisions to be made. In many cases, decisions are made with some variation of the Consensual Assessment Technique. [47] In the Consensual Assessment Technique, a design idea is considered to be the preferred idea to the extent that the team members subjectively and independently agree that it is [48]. In this method, individual team members use their own subjective interpretation of the selection criteria to evaluate the design ideas, even though those subjective criteria may differ among the team members [49, 50].

One limitation to the Consensual Assessment Technique is that it does not address how the team resolves differences in subjective evaluations. The resolution of such differences can be done through voting rules such as majority voting, plurality voting, or consensus [51, 52]. When using such voting rules, simple majority methods have been shown to be more effective in identifying better ideas than super majorities or unanimous requirements [53].

Another way to address team conflict on which idea should be selected for implementation is to take that decision away from the team. The final decision is often made by someone outside of the team, such as a manager or executive. Having people higher in the organization make the final selection is common when the risks associated with the decision are high. This has the benefit of shifting responsibility for the outcome of the design selection away from the people who must provide the greatest creativity within an organization, i.e., the designers. As we have seen, holding people responsible for the risks of a design reduces their ability to generate original ideas.

10.2.4 Other Impacts

Two additional problems requiring adjustments when we design with others are a bias toward analytical thought and team design fixation (group think).

When we design with others, the simple act of explaining our ideas to others tends to induce analytical thought. Because analytical thought tends to result in conservative thinking, designs from teams tend to be less creative than individual designs [9, 16–18, 54–57]. This bias, however, can be somewhat overcome if the team has clear guidelines to focus on originality [55, 58]. Ultimately, team design, like individual design, is most effective when we balance intuitive and analytical thought.

When we design with others, we can become fixated on a limited set of ideas. Design fixation on teams (group think) can occur when a dominant team member or members suppress the discussion of alternative ideas [17, 59–62], team members become fixated on their own ideas [59, 63], or the team defers to the "experts" on the team [64]. Teams need to be aware of becoming fixated and take appropriate actions to overcome that fixation. Fortunately, many of the methods for overcoming individual design fixation also work for team fixation.

10.3 Creating Effective Teams

One of the first steps in creating effective design teams is to ensure that everyone on the team has a shared vision for both the project itself and for the role of every member of the team (including themselves). There must be a clear understanding of factors like what information is needed and by whom, who will gather the information, how information will be gathered, how information will be shared, and how the various design activities will be conducted. Basically, everyone on the team needs to know who does what. Team members must be able to blend their different skills and temperaments through compromise, negotiation, and planning. Team members must feel that they are an interdependent part of the team while still having a clear individual role [65–76].

A second factor in creating effective teams is for all team members to have a shared knowledge that is directly related to the design project, i.e., all team members must have some relevant experience. Having shared, relevant knowledge provides a framework for discussion; people tend to discuss topics with which they have some familiarity. Team members who lack this common framework may be unable to place their ideas within that framework, and as a result, they may not get their ideas discussed by the team. [9, 77–82].

In addition to a shared knowledge relevant to the design project, individual team members should also have some relevant knowledge that is different from that of the other team members, i.e., diversity of relevant knowledge. All team members should have something different to bring to the team. Such diversity of knowledge within the shared framework can result in wider ranges of ideas being generation

and more factors being considered when making decisions [60, 83–86]. This can lead to improved team effectiveness [87–92].

Diversity on teams without having any shared knowledge that is directly relevant to the design project, however, generally does not enhance to team effectiveness and can actually reduce it. Such diversity may include differences in ability, gender, race, ethnic or national background, status in the organizational hierarchy, or personality type [8, 88, 89, 93–98]. Having people without any relevant knowledge on a team can nevertheless be beneficial to an organization because it can serve as training for future projects. Difficulties associated with team members not having relevant knowledge can be minimized through effective communication among team members and by selecting team members who believe that having diversity not directly relevant to the project has intrinsic value [99, 100].

A third factor in creating effective teams is to ensure that the team members have the interpersonal skills to work together. When teams effectively work together, the shared feelings can lead to greater team cohesion, improved cooperation, decreased conflict, and increased perceived team effectiveness [101, 102]. This strength of team cohesion is so powerful that it can even lead to a functional synchronization of brainwaves among team members: team members can share a common neural response pattern in a process known as hyperscanning. Our brainwaves become entrained with those of other team members. We literally think alike! [103–106] Of course, hyperscanning can lead to group think, so independence of thought is still required.

As much as we would like team members to work well with each other, people are still people. Conflicts will still occur among team members. Conflict, however, is not necessarily good nor bad. A moderate level of conflict and competition among team members can actually enhance team effectiveness [107, 108], particularly when the team dynamics ensures that all ideas are considered, i.e., they work against group think [109–111]. However, too much conflict and competition can impair team effectiveness. [77, 112]. If conflict impairs team effectiveness, then conflict management and resolution methods may be required.

10.4 Supervising Design Teams

We close the topic of design on teams by discussing ways that teams can be best supervised to support effective design.

One of the first steps in effectively supervising team design is to understand the type of operating environment in which the design process will occur. In particular, will the process occur in a stable, slow-paced environment that has low-to-moderate time pressure or in an unstable, fast-paced environment that has heavy-time pressure? Slow paced environments provide time for decisions to be made using analytical thought with detailed planning. Fast-paced environments, however, must rely more on organizational improvisation and intuition because there isn't time to collect or analyze all of the desired data [113–123]. Not only does a fast-paced

environment require rapid decision making, success is often dependent upon it. Slow-paced environments provide time for planning and analytical thinking, so they do not necessarily require rapid decision making for success [122, 124–126].

Artists almost always work in a slow-paced environment. It is rare that they need to complete a large number of works within a short period of time on a regular basis. Applied artists, however, often work in a fast-paced environment. They must complete their designs before the competition completes theirs. Engineers work in either a slow-paced or fast-paced environment, depending upon the type of organization with which they are employed. Engineers in a slow-paced environment, such as governmental agencies and academic institutions, are focused on long-term goals, while engineers in a fast-paced environment, such those working in new product design, are focused on getting the design completed as quickly as possible [127, 128].

A difficulty created by the environment in which a team operates is that the environment tends to induce the opposite mode of thinking from what is actually needed. Fast-paced environments tend to have heavy time pressure which tends to induce conservative, analytical thinking. Yet, fast-paced environments need the quickness of creative, intuitive thinking, and improvisation because there is simply insufficient time for analytical thinking. One the other hand, an environment with low-to-moderate time pressure tend to bias us individually toward creative, intuitive thought, but the act of working on teams, even in such an environment, tends to bias us toward conservative, analytical thought. This can create conflict about which thinking mode we should use. The only solution to these conflicts is to ensure that team appropriately balances intuitive and analytical thinking.

Another step to effectively supervise team design is to ensure that the organizational structure is appropriate to the operating environment. Organizations in fast-paced environments should have a structure that provides cross-functional integration so designers can quickly and easily communicate with others across the organization. When ideas must pass through intermediate people, the ideas that reach others tend to be less creative and more conservative because intermediate people tend to use analytical thought to filter which ideas more forward [123, 129–136]. Organizational structures in low-paced environments are less critical to success.

A third step in effectively supervising team design is to have effective leadership for the team. Leadership, as opposed to management, requires leading change and not just managing the status quo. Leadership is required in fast-paced environments, while management is often sufficient in slow-paced environments.

Leaders must not only set the direction and strategic focus for the team, but they must also facilitate the effectiveness of individual team members [137, 138]. Perhaps the most effective leadership style for supporting effective team design is a focus on developing employees rather than controlling their performance. This type of leadership is known as transformational leadership. Transformational leadership involves the leader setting a vision of change that challenges the status quo and then inspires team members to implement that change through shared goals [139–144].

Other leadership characteristics linked to effective team design include emotional intelligence, in which leaders are aware of and understand their and their team members' emotions [145, 146], a willingness to reflect on the effectiveness of their own leadership style and how it affects others [147, 148], and benevolent leadership in which leaders allow for mistakes, provide coaching and mentoring, and show concern for team members' career development [149].

A final step in effectively supervising team design is for team members to be effectively motivated. There are two primary types of motivation: intrinsic and extrinsic. Intrinsic motivation is when a team member is motivated through the personal enjoyment, satisfaction, and challenge of the work itself. Extrinsic motivation is when the team member is motivated through rewards for performance, evaluation, surveillance, or competition. Of the two types of motivation, intrinsic motivation is significantly more effective in supporting effective design [72, 73, 128, 150–162]. Intrinsic motivation typically occurs when:

- We are doing things that are enjoyable to us. When we do things that give us personal pleasure, we are motivated to continue doing those things. Since the process of design is inherently creative and most people find creativity to be enjoyable, simply being encouraged to design can induce intrinsic motivation.
- We do things that are challenging to us. The tasks must require us to think in new ways to address the project needs and constraints. In many cases, a complex project with a heavy workload under moderate time pressure can instill in us a personal drive to succeed. We get pleasure out of successfully solving difficult problems without being told how to do it.

In summary, there are several key steps that a team leader can take to help ensure that team members are intrinsically motivated [72, 73, 128, 150–162]. Leaders must ensure that:

- Team members believe that creativity is truly valued. Because creativity requires risk, team members must feel safe to fail without being punished.
- Team members feel trusted by the leaders to do their jobs. Team members must have sufficient autonomy to be flexible. Micromanagement discourages intrinsic motivation.
- Team members are asked to describe projects and activities in general terms, particularly in the early phases of a project when creativity is most important. Asking for justifications and details early in the project can make team members feel that they are being judged, which leads to analytical, conservative thinking and reduces creativity.
- Team members are rewarded for their overall creative performance rather than for achieving specific, measurable milestones. Deadlines should be considered as design constraints instead of a specific personnel evaluation metric.
- Team members receive formative feedback instead of evaluative feedback. Team member creativity goes up when they receive feedback that is constructive and

helps to induce more intuitive thinking. Team members become more conservative and engage in more analytical thinking when they receive feedback that is based on whether they met quantifiable or analytical standards.

- Team members are appropriately encouraged to balance intuitive and analytical thought.

10.5 Closing

The key conclusions of this chapter are

1. Formal, written problem statements may be necessary to ensure all team members are working on the same problem.
2. Idea generation is more effective when done individually instead of as a team. Group brainstorming is less effective in generating ideas than the same number of individuals brainstorming in isolation.
3. Activities that inhibit team idea generation include listening to others instead of generating our own ideas (production blocking) and allowing others to do all of the idea generation (social loafing).
4. Although methods for enhancing team brainstorming exist, such as electronic brainstorming, these methods do not increase idea generation above the level of the same number of individuals brainstorming in isolation.
5. When team decisions are based on some type of voting, a simple majority has been shown to be the most effective process.
6. Teams can become fixated on the favored ideas of dominant team members, their own ideas, or on the ideas of perceived experts.
7. Team design can be dominated by analytical thinking from having to explain ideas to others, which biases teams toward conservative thinking.
8. Effective team design requires that all team members understand everyone's respective roles on the team.
9. Relevant diversity can enhance team effectiveness as long as team members have a shared knowledge related to the design project that they can use to create a common framework for discussion.
10. A moderate level of conflict on a team may enhance effectiveness over that of a team with no conflict, particularly when the conflict results in more ideas getting discussed. A high level of conflict, however, impairs team effectiveness.
11. Organizations in fast-paced environments must rely on intuition and improvisation. Organizations in slow-paced environments have more time to use analysis and planning.
12. Design effectiveness for teams can be enhanced

 a. through transformational leadership that provides a vision for where the team is going and supports its team members to develop ways to get there.
 b. when team members feel their job is challenging.

 c. when team members are intrinsically motivated (they do what they do because they enjoy it) rather than being extrinsically motivated (they are rewarded for achieving specific goals).

 d. when team members feel that creativity is truly valued and that they will not be punished for failure because they took risks.

 e. when team members receive formative feedback on their performance instead of evaluative feedback.

 f. when team members are given both flexibility and autonomy to make their own decisions without being micro-managed.

 g. when intuitive and analytical thinking on the team is appropriately balanced.

10.6 Questions

1. What types of social skills are needed by members of a team? How do you develop them?
2. What interpersonal skills are needed by artists? By engineers? Are they different?
3. If individuals are better at generating ideas than teams, why are a majority of engineering breakthroughs made by teams and not by individuals?
4. What are ways a team can develop a problem statement? Is developing a problem statement a design project in itself?
5. Have you ever engaged in team brainstorming? What was your experience like? Was it successful? Did you used methods to minimize production blocking and social loafing? Did those methods work? If you engaged in team brainstorming again, what would you do the same? What would you do differently?
6. Since teams tend to be dominated by analytical thought, how might intuitive thought be encouraged?
7. Have you engaged in team decision making and idea selection? What method did you use? Was it effective? Did you agree with the team decision? Were opposing ideas fairly considered? How do you know?
8. Should teams decide how decisions are to be made before or after a design project has begun? What are the pros and cons of each approach?
9. When defining team member roles, how might you handle potential overlap of roles among team members?
10. How can diversity of team membership help team effectiveness? How can diversity of team membership hurt team effectiveness?
11. What types of conflict occur between team members? How can team conflict be resolved?
12. How can teams minimize design fixation (group think)?
13. For the team design projects in which you have been involved, did you operate in a fast-paced or slow-paced environment? Was the distinction important? What did you do to address the needs of your operating environment?

14. Do you feel that your leadership truly values creativity? In what ways does your leadership support creativity? In what ways does it inhibit creativity?
15. Have you enjoyed designing on teams? Did you feel your creative contributions were valued? Rewarded?
16. What could your team leadership have done to enhance your contributions? What could you have done differently?
17. How can team leaders better balance intuitive and analytical thinking of team members?
18. Are you intrinsically or extrinsically motivated in your design activities? What can you do to enhance your intrinsic motivation?
19. Have you ever served as a leader of a design team? What was the experience like? Were you effective?

References

1. Barczak, G., Lassk, F., Mulki, J.: Antecedents of team creativity: an examination of team emotional intelligence, team trust, and collaborative culture. Creativ. Innov. Manag. **19**(4), 332–345 (2010). https://doi.org/10.1111/j.1467-8691.2010.00574.x
2. Bechtoldt, M.N., De Dreu, C.K.W., Nijstad, B.A., Choi, H.-S.: Motivated information processing, social tuning, and group creativity. J. Pers. Soc. Psychol. **99**(4), 622–637 (2010). https://doi.org/10.1037/a0019386
3. Cross, N., Cross, A.: Observations of teamwork and social process in design. Des. Stud. **16**(2), 143–170 (1995). https://doi.org/10.1016/0142-694X(94)00007-Z
4. Oak, A.: What can talk tell us about design?: Analyzing conversation to understand practice. Des. Stud. **32**(3), 211–234 (2011). https://doi.org/10.1016/j.destud.2010.11.003
5. Tiwana, A., McLean, E.R.: Expertise integration and creativity in information system development. J. Manag. Inf. Syst. **22**(1), 13–43 (2005). https://doi.org/10.1080/07421222.2003.11045836
6. Zhou, C., Luo, L.: Group creativity in learning context: understanding in a social-cultural framework and methodology. Creat. Educ. **3**(4), 392–399 (2012). https://doi.org/10.4236/ce.2012.34062
7. Singh, J., Fleming, L.: Lone inventors as sources of breakthroughs: myth or reality. Manag. Sci. **56**(1), 41–56 (2010). https://doi.org/10.1287/mnsc.1090.1072
8. Cronin, M.A., Weingart, L.R.: Representational gaps, information processing, and conflict in functionally diverse teams. Acad. Manag. Rev. **32**(3), 761–773 (2007). https://doi.org/10.5465/AMR.2007.25275511
9. Kerr, N.L., Tindale, R.S.: Group performance and decision making. Annu. Rev. Psychol. **55**, 623–655 (2004). https://doi.org/10.1146/annurev.psych.55.090902.142009
10. Kurtzberg, T.R., Mueller, J.S.: The influence of daily conflict on perceptions of creativity: a longitudinal study. Int. J. Confl. Manag. **16**(4), 335–353 (2005)
11. Milch, K.F., Weber, E.U., Appelt, K.C., Handgraaf, M.J.J., Krantz, D.H.: From individual preference construction to group decisions: framing effects and group processes. Organ. Behav. Hum. Decis. Process. **108**, 242–255 (2009). https://doi.org/10.1016/j.obhdp.2008.11.003
12. Pirola-Merlo, A., Mann, L.: The relationship between individual creativity and team creativity: aggregating across people and time. J. Organ. Behav. **25**, 235–257 (2004). https://doi.org/10.1002/job.240
13. Faure, C.: Beyond brainstorming: effects of different group procedures on selection of ideas and satisfaction with the process. J. Creat. Behav. **38**(1), 13–34 (2004). https://doi.org/10.1002/j.2162-6057.2004.tb01229.x

14. Hoegl, M., Parboteeah, K.P.: Creativity in innovative projects: how teamwork matters. J. Eng. Tech. Manag. **24**, 148–166 (2007). https://doi.org/10.1016/j.jengtecman.2007.01.008
15. Larey, T.S., Paulus, P.B.: Group preference and convergent tendencies in small groups: a content analysis of group brainstorming performance. Creat. Res. J. **12**(3), 175–184 (1999). https://doi.org/10.1207/s15326934crj1203_2
16. Paulus, P.B., Putman, V.L., Dugosh, K.L., Dzindolet, M.T., Coskun, H.: Social and cognitive influences in group brainstorming: predicting production gains and losses. Eur. Rev. Soc. Psychol. **12**(1), 299–325 (2002). https://doi.org/10.1080/14792772143000094
17. Putman, V.L., Paulus, P.B.: Brainstorming, brainstorming rules and decision making. J. Creat. Behav. **43**(1), 23–39 (2009). https://doi.org/10.1002/j.2162-6057.2009.tb01304.x
18. Rietzschel, E.F., Nijstad, B.A., Stroebe, W.: Productivity is not enough: a comparison of interactive and nominal brainstorming groups on idea generation and selection. J. Exp. Soc. Psychol. **42**, 244–251 (2006). https://doi.org/10.1016/j.jesp.2005.04.005
19. Diehl, M., Stroebe, W.: Productivity loss in idea-generating groups: tracking down the blocking effect. J. Pers. Soc. Psychol. **61**(3), 392–403 (1991). https://doi.org/10.1037/0022-3514.61.3.392
20. Diehl, M., Stroebe, W.: Productivity loss in brainstorming groups: toward the solution of a riddle. J. Pers. Soc. Psychol. **53**(3), 497–509 (1987). https://doi.org/10.1037/0022-3514.53.3.497
21. Kohn, N.W., Paulus, P.B., Choi, Y.: Building on the ideas of others: an examination of the idea combination process. J. Exp. Soc. Psychol. **47**, 554–561 (2011)
22. Mullen, B., Johnson, C., Salas, E.: Productivity loss I brainstorming groups: a meta-analytic integration. Basic Appl. Soc. Psychol. **12**(1), 3–23 (1991). https://doi.org/10.1016/j.jesp.2011.01.004
23. Nijstad, B.A., Stroebe, W., Lodewijkx, H.F.M.: Production blocking and idea generation: does blocking interfere with cognitive processes? J. Exp. Psychol. **39**, 531–548 (2003). https://doi.org/10.1016/S0022-1031(03)00040-4
24. Stroebe, W., Diehl, M.: Why groups are less effective than their members: on productivity losses in idea-generating groups. Eur. Rev. Soc. Psychol. **5**(1), 271–303 (1994). https://doi.org/10.1080/14792779543000084
25. Karau, S.J., Williams, K.D.: The effects of group cohesiveness on social loafing and social compensation. Group Dyn. Theory Res. Pract. **1**(2), 156–168 (1997). https://doi.org/10.1037/1089-2699.1.2.156
26. Karau, S.J., Williams, K.D.: Social loafing: a meta-analytic review and theoretical integration. J. Pers. Soc. Psychol. **65**(4), 681–706 (1993). https://doi.org/10.1037/0022-3514.65.4.681
27. Brophy, D.R.: A comparison of individual and group efforts to creatively solve contrasting types of problems. Creat. Res. J. **18**(3), 293–315 (2006). https://doi.org/10.1207/s15326934crj1803_6
28. Girotra, K., Terwiesch, C., Ulrich, K.T.: Idea generation and the quality of the best idea. Manag. Sci. **56**(4), 591–605 (2010). https://doi.org/10.1287/mnsc.1090.1144
29. Linsey, J.S., Clauss, E.F., Kurtoglu, T., Murphy, J.T., Wood, K.L., Markman, A.B.: An experimental study of group idea generation techniques: understanding the roles of idea representation and viewing methods. J. Mech. Des. **133**, 031008–1 through 031008–15 (2011). https://doi.org/10.1115/1.4003498
30. Paulus, P.B., Yang, H.-C.: Idea generation in groups: a basis for creativity in organizations. Organ. Behav. Hum. Decis. Process. **82**(1), 76–87 (2000). https://doi.org/10.1006/obhd.2000.2888
31. Barki, H., Pinsonneault, A.: Small group brainstorming and idea quality: is electronic brainstorming the most effective approach? Small Group Res. **32**(2), 158–205 (2001). https://doi.org/10.1177/104649640103200203
32. DeRosa, D.M., Smith, C.L., Hantula, D.A.: The medium matters: mining the long-promised merit of group interaction in creative idea generation tasks in a meta-analysis of the

electronic group brainstorming literature. Comput. Hum. Behav. **23**, 1549–1581 (2007). https://doi.org/10.1016/j.chb.2005.07.003

33. Gallupe, R.B., Cooper, W.H., Grize, M.-L., Bastianutti, L.M.: Blocking electronic brainstroms. J. Appl. Psychol. **79**(1), 77–86 (1994)

34. Gallupe, R.B., Bastianutti, L.M., Cooper, W.H.: Unblocking brainstorms. J. Appl. Psychol. **76**(1), 137–142 (1991). https://doi.org/10.1037/0021-9010.79.1.77

35. Jung, J.H., Lee, Y., Karsten, R.: The moderating effect of extraversion-introversion differences on group idea generation performance. Small Group Res. **43**(1), 30–49 (2012). https://doi.org/10.1177/1046496411422130

36. Kerr, D.S., Murthy, U.S.: Divergent and convergent idea generation in teams: a comparison of computer-mediated and face-to-face communication. Group Dir. Negot. **13**(4), 381–399 (2004). https://doi.org/10.1023/B:GRUP.0000042960.38411.52

37. Paulus, P.B., Larey, T.S., Putman, V.L., Leggett, K.L., Roland, E.J.: Social influence processes in computer brainstorming. Basic Appl. Soc. Psychol. **18**(1), 3–14 (1996). https://doi.org/10.1207/s15324834basp1801_2

38. Pinsonneault, A., Barki, H., Gallupe, R.B., Hoppen, N.: Electronic brainstorming: the illusion of productivity. Inf. Syst. Res. **10**(2), 110–133 (1999). https://doi.org/10.1287/isre.10.2.110

39. Potter, R.E., Balthazard, P.: The role of individual memory and attention processing during electronic brainstorming. MIS Q. **28**(4), 621–643 (2004). https://doi.org/10.2307/25148657

40. Ray, D.K., Romano, N.C., Jr.: Creative problem solving in GSS groups: do creative styles matter? Group Decis. Negot. **22**, 1129–1157 (2013). https://doi.org/10.1007/s10726-012-9309-3

41. Roy, M.C., Gauvin, S., Limayem, M.: Electronic group brainstorming: the role of feedback on productivity. Small Group Res. **27**(2), 215–247 (1996). https://doi.org/10.1177/1046496496272002

42. Sosik, J.J., Avolio, B.J., Kahai, S.S.: Inspiring group creativity: comparing anonymous and identified electronic brainstorming. Small Group Res. **29**(1), 3–31 (1998). https://doi.org/10.1177/1046496498291001

43. Thompson, L., Brajkovich, L.F.: Improving the creativity of organizational work groups. Acad. Manag. Exec. **17**(1), 96–111 (2003). https://doi.org/10.5465/AME.2003.9474814

44. Ziegler, R., Diehl, M., Zijlstra, G.: Idea production in nominal and virtual groups: does computer-mediated communication improve group brainstorming. Group Process. Intergroup Relat. **3**(2), 141–158 (2000). https://doi.org/10.1177/1368430200032003

45. Dennis, A.R., Valacich, J.S.: Computer brainstorms: more heads are better than one. J. Appl. Psychol. **78**(4), 531–537 (1993). https://doi.org/10.1037/0021-9010.78.4.531

46. Sutton, R.I., Hargadon, A.: Brainstorming groups in context: effectiveness in a product design firm. Adm. Sci. Q. **41**(4), 685–718 (1996). https://doi.org/10.2307/2393872

47. Amabile, T.M.: Social psychology of creativity: a consensual assessment technique. J. Pers. Soc. Psychol. **43**(5), 997–1013 (1982). https://doi.org/10.1037/0022-3514.43.5.997

48. Kaufman, J.C., Baer, J.: Beyond new and appropriate: who decides what is creative. Creat. Res. J. **24**(1), 83–91 (2012). https://doi.org/10.1080/10400419.2012.649237

49. Runco, M.A., McCarthy, K.A., Svenson, E.: Judgments of the creativity of artwork from students and professional judges. J. Psychol. **128**(1), 23–31 (1994). https://doi.org/10.1080/00223980.1994.9712708

50. Runco, M.A., Mraz, W.: Scoring divergent thinking tests using total ideational output and a creativity index. Educ. Psychol. Measur. **52**, 213–221 (1992). https://doi.org/10.1177/001316449205200126

51. Hastie, R., Kameda, T.: The robust beauty of majority rules in group decisions. Psychol. Rev. **112**(2), 494–508 (2005). https://doi.org/10.1037/0033-295X.112.2.494

52. Song, F.: Intergroup trust and reciprocity in strategic interactions: effects of group decision-making mechanisms. Organ. Behav. Hum. Decis. Process. **108**, 164–173 (2009). https://doi.org/10.1016/j.obhdp.2008.06.005

53. Sorkin, R.D., West, R., Robinson, D.E.: Group performance depends on the majority rule. Psychol. Sci. **9**(6), 456–463 (1998). https://doi.org/10.1111/1467-9280.00085
54. Barlow, C.M.: Deliberate insight in team creativity. J. Creat. Behav. **34**(2), 101–117 (2000). https://doi.org/10.1002/j.2162-6057.2000.tb01204.x
55. Gigone, D., Hastie, R.: Proper analysis of the accuracy of group judgments. Psychol. Bull. **121**(1), 149–167 (1997). https://doi.org/10.1037/0033-2909.121.1.149
56. Hill, G.W.: Group versus individual performance: are N+1 heads better than one? Psychol. Bull. **91**(3), 517–539 (1982). https://doi.org/10.1037/0033-2909.91.3.517
57. Laughlin, P.R., Bonner, B.L., Altermatt, T.W.: Collective versus individual induction with single versus multiple hypotheses. J. Pers. Soc. Psychol. **75**(6), 1481–1489 (1998). https://doi.org/10.1037/0022-3514.75.6.1481
58. Jungermann, J.: The two camps on rationality. Adv. Psychol. **16**, 63–86 (1983). https://doi.org/10.1016/S0166-4115(08)62194-9
59. Ehrlenspiel, K., Giapoulis, A., Gunther, J.: Teamwork and design methodology— observations about teamwork in design education. Res. Eng. Design **9**, 61–69 (1997). https://doi.org/10.1007/BF01596482
60. Gruenfeld, D.H., Mannix, E.A., Williams, K.Y., Neale, M.A.: Group composition and decision making: how member familiarity and information distribution affect process and performance. Organ. Behav. Hum. Decis. Process. **67**(1), 1–15 (1996). https://doi.org/10.1006/obhd.1996.0061
61. Kerr, N.L.: Group decision making at a multialternative task: extremity, interfaction distance, pluralities, and issue importance. Organ. Behav. Hum. Decis. Process. **52**, 64–95 (1992). https://doi.org/10.1016/0749-5978(92)90046-A
62. Weaver, K., Garcia, S.M., Schwarz, N., Miller, D.T.: Inferring the popularity of an opinion from its familiarity: a repetitive voice can sound like a chorus. J. Pers. Soc. Psychol. **92**(5), 821–833 (2007). https://doi.org/10.1037/0022-3514.92.5.821
63. Onarheim, B., Christensen, B.T.: Distributed idea screening in stage gate development process. J. Eng. Des. **23**, 660–673 (2012). https://doi.org/10.1080/09544828.2011.649426
64. Bonner, B.L., Baumann, M.R., Dalal, R.S.: The effects of member expertise on group decision-making and performance. Organ. Behav. Hum. Decis. Process. **88**, 719–736 (2002). https://doi.org/10.1016/S0749-5978(02)00010-9
65. Baer, M., Oldham, G.R., Jacobsohn, G.C., Hollingshead, A.B.: The personality composition of teams and creativity: the moderating role of team creative confidence. J. Creat. Behav. **42**(4), 255–282 (2008). https://doi.org/10.1002/j.2162-6057.2008.tb01299.x
66. De Vreede, T., Boughzala, I., De Vreede, G.-J., Reiter-Palmon, R.: A model and exploratory field study on team creativity. In: 45th Hawaii international conference on systems sciences, IEEE Computer Society (2012). https://doi.org/10.1109/HICSS.2012.66
67. Hirst, G., Van Knippenberg, D., Chen, C.-H., Sacramento, C.A.: How does bureaucracy impact individual creativity? A cross-level investigation of team contextual influences on goal orientation-creativity relationships. Acad. Manag. J. **54**(3), 624–641 (2011). https://doi.org/10.5465/AMJ.2011.61968124
68. Mumford, M.D., Feldman, M.M., Hein, M.B., Nagao, D.J.: Tradeoffs between ideas and structure: individual versus group performance in creative problem solving. J. Creat. Behav. **35**(1), 1–23 (2001). https://doi.org/10.1002/j.2162-6057.2001.tb01218.x
69. Nakui, T., Paulus, P.B., Van Der Zee, K.I.: The role of attitudes in reactions toward diversity in workgroups. J. Appl. Soc. Psychol. **41**(10), 2327–2351 (2011). https://doi.org/10.1111/j.1559-1816.2011.00818.x
70. Stout, R.J., Cannon-Bowers, J.A., Salas, E., Milanovich, D.M.: Planning, shared mental models, and coordinated performance: an empirical link is established. Hum. Factors **41**(1), 61–71 (1999). https://doi.org/10.1518/001872099779577273
71. Tagger, S.: individual creativity and group ability to utilize individual creative resources: a multilevel model. Acad. Manag. J. **45**(2), 315–330 (2002). https://doi.org/10.2307/3069349
72. Amabile, T.M.: How to kill creativity. Harvard Business Review, pp. 77–87 (1998)

73. Amabile, T.M., Schatzel, E.A., Moneta, G.B., Kramer, S.J.: Leader behaviors and the work environment for creativity: perceived leader support. Leadersh. Q. **15**, 5–32 (2004). https://doi.org/10.1016/j.leaqua.2003.12.003

74. Gilson, L.L., Shalley, C.E.: A little creativity goes a long way: an examination of teams' engagement in creative processes. J. Manag. **30**(4), 453–470 (2004). https://doi.org/10.1016/j.jm.2003.07.001

75. Isaksen, S.G., Ekvall, G.: Managing for innovation: the two faces of tension in creative climates. Creativ. Innov. Manag. **19**(2), 73–88 (2010). https://doi.org/10.1111/j.1467-8691.2010.00558.x

76. Van Der Vegt, G.S., Janssen, O.: Joint impact of interdependence and group diversity on innovation. J. Manag. **29**, 729–751 (2003). https://doi.org/10.1016/S0149-2063_03_00033-3

77. Devine, D.J.: Effects of cognitive ability, task knowledge, information sharing, and conflict on group decision-making effectiveness. Small Group Res. **30**(5), 608–634 (1999). https://doi.org/10.1177/104649649903000506

78. Gigone, D., Hastie, R.: The common knowledge effect: information sharing and group judgment. J. Pers. Soc. Psychol. **65**(5), 959–974 (1993). https://doi.org/10.1037/0022-3514.65.5.959

79. Larson, J.R., Jr., Foster-Fishman, P.G., Keys, C.B.: Discussion of shared and unshared information in decision-making groups. J. Pers. Soc. Psychol. **67**(3), 446–461 (1994). https://doi.org/10.1037/0022-3514.67.3.446

80. Stasser, G., Titus, W.: Pooling of unshared information in group decision making: biased information sampling during discussion. J. Pers. Soc. Psychol. **48**(6), 1467–1478 (1985). https://doi.org/10.1037/0022-3514.48.6.1467

81. Stasser, G., Taylor, L.A., Hanna, C.: Information Sampling in structured and unstructured discussions of three- and six-person groups. J. Pers. Soc. Psychol. **56**(1), 67–78 (1989). https://doi.org/10.1037/0022-3514.57.1.67

82. Van Ginkel, W.P., van Knippenberg, D.: Knowledge about the distribution of information and group decision making: when and why does it work. Organ. Behav. Hum. Decis. Process. **108**, 218–229 (2009). https://doi.org/10.1016/j.obhdp.2008.10.003

83. Fink, A., Grabner, R.H., Gebauer, D., Reishofer, G., Koschutnig, K., Ebner, F.: Enhancing creativity by means of cognitive stimulation: evidence from an fMRI study. Neuroimage **52**, 1687–1695 (2010). https://doi.org/10.1016/j.neuroimage.2010.05.072

84. Lehoux, P., Hivon, M., Williams-Jones, B., Urbach, D.: The worlds and modalities of engagement of design participants: a qualitative case study of three medical innovations. Des. Stud. **32**(4), 313–332 (2011). https://doi.org/10.1016/j.destud.2011.01.001

85. Linsey, J.S., Green, M.G., Murphy, J.T., Wood, K.L., Markman, A.B.: 'Collaborating to Success': an experimental study of group idea generation techniques. In: Proceedings of the IDETC/CIE 2005, ASME 2005 International Design Engineering Technical Conferences and Computers and Information in Engineering Conference, Long Beach, CA, Sept. 24–28 (2005). https://doi.org/10.1115/DETC2005-85351

86. Littlepage, G.E., Silbiger, H.: Recognition of expertise in decision-making groups: effects of group size and participation patterns. Small Group Res. **23**(3), 344–355 (1992). https://doi.org/10.1177/1046496492233005

87. Basadur, M., Head, M.: Team performance and satisfaction: a link to cognitive style within process framework. J. Creat. Behav. **35**(4), 227–245 (2001).https://doi.org/10.1002/j.2162-6057.2001.tb01048.x

88. Bowers, C.A., Pharmer, J.A., Salas, E.: When member homogeneity is needed in work teams: a meta-analysis. Small Group Res **31**(3), 305–327 (2000). https://doi.org/10.1177/104649640003100303

89. Choi, J.N.: Group composition and employee creative behavior in a Korean electronics company: distinct effects of relational demography and group diversity. J. Occup. Organ. Psychol. **80**, 213–234 (2007). https://doi.org/10.1348/096317906X110250

90. Kurtzberg, T.R.: Feeling creative, being creative: an empirical study of diversity and creativity in teams. Creat. Res. J. **17**(1), 51–65 (2005). https://doi.org/10.1207/s15326934crt1701_5

91. Porac, J.F., Wade, J.B., Fischer, H.M., Brown, J., Kanfer, A., Bowker, G.: Human capital heterogeneity, collaborative relationships, and publication patterns in a multidisciplinary scientific alliance: a comparative case study of two scientific teams. Res. Policy **33**, 661–678 (2004). https://doi.org/10.1016/j.respol.2004.01.007

92. Taylor, A., Greve, H.R.: Superman or the fantastic four? Knowledge combination and experience in innovative teams. Acad. Manag. J. **49**(4), 723–740 (2006). https://doi.org/10.5465/AMJ.2006.22083029

93. Kichuk, S.L., Wiesner, W.H.: The big five personality factors and team performance: implications for selecting successful product design teams. J. Eng. Tech. Manag. **14**, 195–221 (1997). https://doi.org/10.1016/S0923-4748(97)00010-6

94. Littlepage, G., Robinson, W., Reddington, K.: Effects of task experience and group experience on group performance, member ability, and recognition of expertise. Organ. Behav. Hum. Decis. Process. **69**(2), 133–147 (1997). https://doi.org/10.1006/obhd.1997.2677

95. Mannix, E., Neale, M.A.: What differences make a difference? The promise and reality of diverse teams in organizations. Psychol. Sci. Public Interest **6**(2), 31–55 (2005). https://doi.org/10.1111/j.1529-1006.2005.00022.x

96. Martins, L. L., Shalley, C. E., and Gilson, L. L., "Virtual Teams and Creative Performance," Proceedings of the 42nd Hawaii International Conference on System Sciences," 2009, DOI: https://doi.org/10.1109/HICSS.2009.1018 .

97. Polzer, J.T., Milton, L.P., Swaan, W.B.: Capitalizing on diversity: interpersonal congruence in small work groups. Adm. Sci. Q. **47**(2), 296–324 (2002). https://doi.org/10.2307/3094807

98. Taggar, S.: Group composition, creative synergy, and group performance. J. Creat. Behav. **35**(4), 261–286 (2001). https://doi.org/10.1002/j.2162-6057.2001.tb01050.x

99. Homan, A.C., van Knippenberg, D., Van Kleef, G.A., De Dreu, C.K.W.: Bridging faultlines by valuing diversity: diversity beliefs, information elaboration, and performance in diverse work groups. J. Appl. Psychol. **92**(5), 1189–1199 (2007). https://doi.org/10.1037/0021-9010.92.5.1189

100. Lovelace, K., Shapiro, D.L., Weingart, L.R.: Maximizing cross-functional new product teams' innovativeness and constraint adherence: a conflict communications perspective. Acad Manag. **44**(4), 779–793 (2001). https://doi.org/10.5465/3069415

101. Barsade, S.G.: The ripple effect: emotional contagion and its influence on group behavior. Adm. Sci. Q. **47**, 644–675 (2002). https://doi.org/10.2307/3094912

102. Paez, D., Rime, B., Basabe, N., Wlodarczyk, A., Zumeta, L.: Psychosocial effects of perceived emotional synchrony in collective gatherings. J. Pers. Soc. Psychol. **108**(5), 711–729 (2015). https://doi.org/10.1037/pspi0000014

103. Astolfi, L., Toppi, J., De Vico Fallani, F., Vecchiato, G., Salinari, S., Mattia, D., Cincotti, F., Babiloni, F.: Neuroelectrical hyperscanning measures simultaneous brain activity in humans. Brain Topogr. **23**, 243–256 (2010). https://doi.org/10.1007/s10548-010-0147-9

104. Dumas, G., Nadel, J., Soussignan, R., Martinerie, J., Garnero, L.: Inter-brain synchronization during social interaction. PLoS One **5**(8), e12166, 1–10 (2010). doi: https://doi.org/10.1371/journal.pone.0012166

105. Muller, V., Sanger, J., Lindenberger, U.: Intra- and inter-brain synchronization during musical improvisation on the guitar. PLoS One **8**(9), E73852, 1–23 (2013). https://doi.org/10.1371/journal.pone.0073852

106. Perez, A., Carreiras, M., Dunabeitia, J.A.: Brain-to-brain entrainment: EEG interbrain synchronization while speaking and listening. Sci. Rep. **7**(4190) (2017). https://doi.org/10.1038/s41598-017-0446-4

107. Badke-Schaub, P., Goldschmidt, G., Meijer, M.: How does cognitive conflict in design teams support the development of creative ideas? Creat. Innov. Manag. **19**(2), 119–133 (2010). https://doi.org/10.1111/j.1467-8691.2010.00553.x

108. De Dreu, C.K.W.: When too little or too much hurts: evidence for a curvilinear relationship between task conflict and innovation in teams. J. Manag. **32**(1), 83–107 (2006). https://doi.org/10.1177/0149206305277795

109. De Dreu, C.K.W.: Team innovation and team effectiveness: the importance of minority dissent and reflexivity. Eur. J. Work Organ. Psy. **11**(2), 285–298 (2002). https://doi.org/10.1080/13594320244000175

110. De Dreu, C.K.W., West, M.A.: Minority dissent and team innovation: the importance of participation in decision making. J. Appl. Psychol. **86**(6), 1191–1201 (2001). https://doi.org/10.1037/0021-9010.86.6.1191

111. Nijstad, B.A., Berger-Selman, F., De Dreu, C.K.W.: Innovation in top management teams: minority dissent, transformational leadership, and radical innovations. Eur. J. Work Organ. Psy. **23**(2), 310–322 (2014). https://doi.org/10.1080/1359432X.2012.734038

112. De Dreu, C.K.W., Weingart, L.R.: Task versus relationship conflict, team performance, and team member satisfaction: a meta-analysis. J. Appl. Psychol. **88**(4), 741–749 (2003). https://doi.org/10.1037/0021-9010.88.4.741

113. Agor, W.H.: How intuition can be used to enhance creativity in organizations. J. Creat. Behav. **25**(1), 11–19 (1991). https://doi.org/10.1002/j.2162-6057.1991.tb01348.x

114. Akgun, A.E., Lynn, G.S.: New product development team improvisation and speed-to-market: an extended model. Eur. J. Innov. Manag. **5**(3), 117–129 (2002). https://doi.org/10.1108/14601060210436709

115. Chelariu, C., Johnston, W.J., Young, L.: Learning to improvise, improvising to learn. a process of responding to complex environments. J. Bus. Res. **55**, 141–147 (2002)

116. Covin, J.G., Slevin, D.P., Heeley, M.B.: Strategic decision making in an intuitive vs. technocratic mode: structural and environmental considerations. J. Bus. Res. **52**, 51–667 (2001). https://doi.org/10.1016/S0148-2963(00)00149-1

117. Dayan, M., Elbanna, S.: Antecedents of team intuition and its impact on the success of new product development projects. J. Prod. Innov. Manag. **28**(1), 159–174 (2011). https://doi.org/10.1111/j.1540-5885.2011.00868.x

118. Fredrickson, J.W.: The comprehensiveness of strategic decision processes: extension, observations, future decisions. Acad. Manag. J. **27**(3), 445–466 (1984). https://doi.org/10.2307/256039

119. Fredrickson, J.W., Mitchell, T.R.: Strategic decision process: comprehensiveness and performance in an industry with an unstable environment. Acad. Manag. J. **27**(2), 399–423 (1984). https://doi.org/10.5465/255932

120. Miner, A.S., Bassoff, P., Moorman, C.: Organizational improvisation and learning: a field study. Adm. Sci. Q. **46**(2), 304–337 (2001). https://doi.org/10.2307/2667089

121. Moorman, C., Miner, A.S.: The convergence of planning and execution: improvisation in new product development. J. Mark. **62**(3), 1–20 (1998). https://doi.org/10.1177/002224299806200301

122. Nakata, C., Hwang, J.: Design thinking for innovation: composition, consequence, and contingency. J. Bus. Res. **118**, 117–128 (2020). https://doi.org/10.1016/j.jbusres.2020.06.038

123. Wally, S., Baum, J.R.: Personal and structural determinants of the pace of strategic decision making. Acad. Manag. J. **37**(4), 932–956 (1994). https://doi.org/10.2307/256605

124. Baum, J.R., Wally, S.: Strategic Decision Speed and Firm Performance. Strateg. Manag. J. **24**, 1107–1129 (2003). https://doi.org/10.1002/smj.343

125. Judge, W.Q., Miller, A.: Antecedents and outcomes of decision speed in different environmental contexts. Acad. Manag. J. **34**(2), 449–463 (1991). https://doi.org/10.2307/256451

126. Leybourne, S., Sadler-Smith, E.: The role of intuition and improvisation in project management. Int. J. Project Manag. **24**, 483–492 (2006). https://doi.org/10.1016/j.ijproman. 2006.03.007

127. Akgun, A.E., Byrne, J.C., Lynn, G.S., Keskin, H.: New product development in turbulent environments: impact of improvisation and unlearning on new product performance. J. Eng. Tech. Manag. **24**, 203–230 (2007). https://doi.org/10.1016/j.jengtecman.2007.05.008

128. Hunter, S.T., Bedell, K.E., Mumford, M.D.: Climate for creativity: a quantitative review. Creat. Res. J. **19**(1), 69–90 (2007). https://doi.org/10.1080/10400410709336883

129. Akgun, A.E., Lynn, G.S., Byrne, J.C.: Antecedents and consequences of unlearning in new product development teams. J. Prod. Innov. Manag. **23**, 73–88 (2006). https://doi.org/10. 1111/j.1540-5885.2005.00182.x

130. Arad, S., Hanson, M.A., Schneider, R.J.: A framework for the study of relationships between organizational characteristics and organizational innovation. J. Creat. Behav. **31**(1), 42–58 (1997). https://doi.org/10.1002/j.2162-6057.1997.tb00780.x

131. Barczak, G., Griffin, A., Kahn, K.B.: Perspective: trends and drivers of success in NPD practices: results of the 2003 PDMA best practices study. J. Prod. Innov. Manag. **26**, 3–23 (2009). https://doi.org/10.1111/j.1540-5885.2009.00331.x

132. Davis, J.P., Eisenhardt, K.M., Bingham, C.B.: Optimal structure, market dynamism, and the strategy of simple rules. Adm. Sci. Q. **54**, 413–452 (2009). https://doi.org/10.2189/asqu. 2009.54.3.413

133. Dougherty, D., Hardy, C.: Sustained product innovation in large, mature organizations: overcoming innovation-to-organization problems. Acad. Manag. J. **39**(5), 1120–1153 (1996). https://doi.org/10.2307/256994

134. Hemlin, S.: creative knowledge environments: an interview study with group members and group leaders of university and industry R&D groups in biotechnology. Creativ. Innov. Manag. **18**(4), 278–285 (2009). https://doi.org/10.1111/j.1467-8691.2009.00533.x

135. Hoegl, M., Weinkauf, K., Gemuenden, H.G.: Interteam coordination, project commitment, and teamwork in multiteam R&D projects: a longitudinal study. Org. Sci. **15**(1), 38–55 (2004). https://doi.org/10.1287/orsc.1030.0053

136. Troy, L.C., Hirunyawipada, T., Paswan, A.K.: Cross-functional integration and new product success: an empirical investigation of the findings. J. Mark. **72**(6), 132–146 (2008). https:// doi.org/10.1509/jmkg.72.6.132

137. Chen, M.-H.: Entrepreneurial leadership and new ventures: creativity in entrepreneurial teams. Creat. Innov. Manag. **16**(3), 239–249 (2007). https://doi.org/10.1111/j.1467-8691. 2007.00439.x

138. Eisenhardt, K.M., Tabrizi, B.H.: Accelerating adaptive processes: product innovation in the global computer industry. Adm. Sci. Q. **40**(1), 84–110 (1995). https://doi.org/10.2307/ 2393701

139. Carmeli, A., Sheaffer, Z., Binyamin, G., Reiter-Palmon, R., Shimoni, T.: Transformational leadership and creative problem-solving: the mediating role of psychological safety and reflexivity. J. Creat. Behav. **48**(2), 115–135 (2014). https://doi.org/10.1002/jocb.43

140. Eisenbeiss, S.A., van Knippenberg, D., Boerner, S.: Transformational leadership and team innovation: integrating team climate principles. J. Appl. Psychol. **93**(6), 1438–1446 (2008). https://doi.org/10.1037/a0012716

141. Jung, D.I.: Transformational and transactional leadership and their effects on creativity in groups. Creat. Res. J. **13**(2), 185–195 (2001). https://doi.org/10.1207/s15326934crj1302_6

142. Keller, R.T.: Transformational leadership, initiating structure, and substitutes for leadership: a longitudinal study of research and development project team performance. J. Appl. Psychol. **91**(1), 202–210 (2006). https://doi.org/10.1037/0021-9010.91.1.202

143. Shin, S.J., Zhou, J.: When is educational specialization heterogeneity related to creativity in research and development teams? Transformational leadership as a moderator. J. Appl. Psychol. **92**(6), 1709–1721 (2007). https://doi.org/10.1037/0021-9010.92.6.1709

144. Shin, S.J., Zhou, J.: Transformational leadership, conservation, and creativity: evidence form Korea. Acad. Manag. J. **46**(6), 703–714 (2003). https://doi.org/10.2307/30040662

145. Castro, F., Gomes, J., de Sousa, F.C.: Do intelligent leaders make a difference? The effect of a leader's emotional intelligence on followers' creativity. Creat. Innov. Manag. **21**(2), 171–182 (2012). https://doi.org/10.1111/j.1467-8691.2012.00636.x

146. Rego, A., Sousa, F., Pina e Cunha, M., Correia, A., Saur-Amaral, I.: Leader self-reported emotional intelligence and perceived employee creativity: an exploratory study. Creativ. Inno. Manag. **16**(3), 250–264 (2007). https://doi.org/10.1111/j.1467-8691.2007.00435.x

147. Mitchell, J.R., Shepherd, D.A., Sharfman, M.P.: Erratic strategic decisions: when and why managers are inconsistent in strategic decision making. Strateg. Manag. J. **32**(7), 683–704 (2011). https://doi.org/10.1002/smj.905

148. Ollila, S.: Creativity and innovativeness through reflective project leadership. Reflect. Proj. Leadersh. **9**(3), 195–200 (2000). https://doi.org/10.1111/1467-8691.00172

149. Wang, A.-W., Cheng, B.-S.: When does benevolent leadership lead to creativity? The moderating role of creative role identity and job autonomy. J. Organ. Behav. **31**, 106–121 (2010). https://doi.org/10.1002/job.634

150. Amabile, T.M.: Creativity in Context. Westview Press, Boulder, CO (1996)

151. Amabile, T.M., Barsade, S.G., Mueller, J.S., Staw, B.M.: Affect and creativity at work. Adm. Sci. Q. **50**(3), 367–403 (2005). https://doi.org/10.2189/asqu.2005.50.3.367

152. Bharadwaj, S., Menon, A.: making innovation happen in organizations: individual creativity mechanisms, organizational creativity mechanisms or both? J. Prod. Innov. Manag. **17**, 424–434 (2000). https://doi.org/10.1016/S0737-6782(00)00057-6

153. Dewett, T.: Linking intrinsic motivation, risk taking, and employee creativity in an R&D environment. R&D Manag. **37**(3), 197–208 (2007). https://doi.org/10.1111/j.1467-9310.2007.00469.x

154. Ekvall, G., Ryhammar, L.: The creative climate: its determinants and effects at a swedish university. Creat. Res. J. **12**(4), 303–310 (1999). https://doi.org/10.1207/s15326934crj1204_8

155. Hennessey, B.A., Amabile, T.M.: Creativity. Annu. Rev. Psychol. **61**, 569–598 (2010). https://doi.org/10.1146/annurev.psych.093008.100416

156. Khurana, A., Rosenthal, S.R.: Towards holistic 'Front Ends' in new product development. J. Prod. Innov. Manag. **15**, 57–74 (1998). https://doi.org/10.1016/S0737-6782(97)00066-0

157. Kleinsmann, M., Buijs, J., Valkenburg, R.: Understanding the complexity of knowledge integration in collaborative new product development teams: a case study. J. Eng. Technol. Manag. **27**, 20–32 (2010). https://doi.org/10.1016/j.jengtecman.2010.03.003

158. Ma, H.-H.: The effect size of variables associated with creativity: a meta-analysis. Creat. Res. J. **21**(1), 30–42 (2009). https://doi.org/10.1080/10400410802633400

159. McCoy, J.M.: Linking the physical work environment to creative context. J. Creat. Behav. **39**(3), 169–191 (2005). https://doi.org/10.1002/j.2162-6057.2005.tb01257.x .

160. Oldham, G.R., Cummings, A.: Employee creativity: personal and contextual factors at work. Acad. Manag. J. **39**(3), 607–634 (1996). https://doi.org/10.2307/256657

161. Shalley, C.E., Gilson, L.L.: What leaders need to know: a review of social and contextual factors that can foster or hinder creativity. Leadersh. Q. **15**, 33–53 (2004). https://doi.org/10.1016/j.leaqua.2003.12.004

162. Zhou, J., Shalley, C.E.: Research on employee creativity: a critical review and directions for future research. Res. Pers. Hum. Resour. Manag. **22**, 165–217 (2003). https://doi.org/10.1016/S0742-7301(03)22004-1

Epilogue

<div align="right">

11

</div>

I started this project with a simple curiosity of how my design activities in engineering were related to my design activities in art. I had no idea that it would evolve into what it has become. I had no idea that it would cover such a diversity of topics or even that it would develop into a book. As I bring this project to a close, I reflect back on what I really learned. What are the most important things that I got out of doing this? Three things stand out.

First, design can be learned and it can be taught. Anyone and everyone in any discipline can enhance their ability to design. The simplest way to do this is to focus on enhancing our abilities in each of the three universal design activities (clarify an ambiguous project, generate ideas, and select one idea to implement). This book provides a number of ways to do this.

Next, there is one overarching psychological principle that we can use to enhance our effectiveness in completing each of the three universal design activities. Simply stated, we need to balance the use of our intuitive (non-sequential) and analytical (sequential) thinking. One is not more or less important than the other. We do this by first developing our metacognition so we can recognize which thinking mode we are in and then we learn to consciously switch back and forth between modes as we design. This does require practice. This book provides a number of ways to do this as well.

Finally, as I look back through this book and read between the lines, I see many holes in our understanding of design. I see many opportunities for future research. One unanswered question, however, stands out above all others for advancing design effectiveness. The question is this:

How can we nurture and develop curiosity?

One final question: Now that you have gotten to here, what are your going to do next? Just curious.

Index

A

Aesthetic(s), 3, 11, 26, 47, 51, 52, 121, 171, 172, 177
Affect, 26, 199
Alcohol, 144
Ambiguity/Ambiguous
tolerance of ambiguity, 120
Analogies, 68
Analysis/Analytical, 7, 11, 21–25, 27, 29, 50, 52, 62–64, 66, 67, 87–92, 94, 96, 108, 110, 117–119, 121–126, 143, 146, 147, 166–177, 196–202, 211

B

Belief(s), 26, 61, 88, 120, 121, 165, 169, 176, 177
Bias(s), 25, 165
balance bias, 170
color perception bias, 172
confirmation bias, 169, 177
creative-conservative bias, 167
familiarity bias, 168–170, 173, 176
feeling biases, 173
simplicity bias, 169
thinking mode biases, 173
Biomimicry, 68
Brainstorming, 62, 63, 194, 195, 200, 201

C

Cannabis, 144
Clarify/Clarifying, 3, 5, 23, 27, 45, 49, 50, 64–66, 73, 86, 107, 115, 117, 118, 123, 125, 193–195, 211
Closed-ended, 6, 7, 23, 87, 142
Co-evolve, 50
Cognitive closure, 121, 125, 177

Cognitive enhancement, 139, 143–145, 147, 148
Conscientiousness, 117, 121, 122, 125
Conscious/Unconscious, 22, 23, 26, 46, 89, 108–110, 119, 122, 126, 140, 141, 169, 176, 177
Consensual Assessment Technique, 10, 195
Conservative, 22, 50, 115, 167, 172–175, 196, 198–200
Constraint(s), 3, 8, 46, 47, 49, 64, 65, 83–85
hard constraints, 4, 47, 49, 84, 86, 90, 93, 176
soft constraints, 4, 7, 48, 86, 90, 92, 93, 176
Creative, 22, 28, 49, 50, 91, 115, 121–124, 126, 142, 167, 172–175, 196, 198, 199, 202
Creativity, 6–9, 11, 23, 29, 48, 63, 116, 118–120, 122–126, 139–145, 147, 148, 166, 174, 195, 199, 201, 202
Culture/Cultural, 115, 123, 124, 126, 127, 140, 145, 177
Curiosity, 62, 119, 120, 211

D

Decision theory, 87
Decompose/Decomposition, 5, 7, 62
Default Network, 23, 108, 110, 119
Defer, 4, 62, 63, 83, 84, 121, 140, 196
Design education, 21, 27, 28, 139
Design fixation, 61, 70, 140, 166, 196, 201
Design problem, 6–8, 11, 12, 22, 28, 53, 62, 87, 93, 95, 116, 143
Design space, 64
Design training, 21, 27, 28
Discipline(s) of Creation, 11, 12, 24, 28, 116, 121, 143

Discipline(s) of Discovery, 10, 12, 24, 28, 116, 121, 143
Discipline(s) of Management, 11
Diversity, 196, 197, 200, 201, 211
Domain-general, 2, 9, 10, 12, 65, 68, 90, 91, 95, 108–111
Domain-specific, 2, 9, 10, 28, 66, 68, 95, 108–111, 142
Dream(s), 140, 141

E
Effective/Effectiveness, 13, 21, 22, 24, 25, 27–29, 62, 64, 65, 69, 71, 85, 90, 93–95, 109, 115, 116, 118–127, 139, 142–145, 148, 167, 171, 172, 193–202, 211
Eliminate, 2, 4, 84–86, 88
Emotion. *See* Feelings
Emotional stability, 118, 122, 123, 126, 127
Entrainment, 146, 148
Environment, 13, 25, 27, 95, 110, 117, 122, 166, 170, 174, 177, 197, 198, 200, 201
Executive Control Network, 23, 108, 110
Exercise, 143
Expert(s), 71, 115, 116, 125, 196, 200
Extroversion/Extrovert, 116, 117

F
Faculty, 12
Feasible/Feasibility, 85, 86
Feeling(s), 21, 26, 27
 feelings as experiences, 26, 173, 174
 feelings as information, 26, 89, 173, 176
Five Factor Model of Personality (Big 5), 116, 117, 119, 121, 125
Flexibility, 4, 7, 48, 49, 115, 118–120, 122, 125, 201
Food/Drink
 caffeine, 143
 chocolate, 143
 glucose, 144
 resveratrol, 144

G
Gender, 118, 122, 124, 126, 127, 197
Generate/Generating Ideas, 3–5, 7, 24, 27, 29, 61, 62, 64, 70, 71, 94, 107, 115, 117, 118, 121, 122, 125, 142, 143, 174, 193, 194, 200, 201, 211
Grow, 49, 165–168, 171, 173

H
Hallucinatory drugs, 144, 145
Heuristic/Heuristics, 21, 23, 25, 50, 51, 66, 88, 90, 93–95, 166, 173, 176
 externally-based heuristics, 26, 89, 90
 internally-based heuristics, 26, 89, 117, 177
Hierarchy, 5, 62, 197
Hypnagogia, 141, 146
Hypnosis, 143, 146

I
Idea generation, 49, 53, 144, 166
Ideation. *See* Generate Ideas
Ill-Defined, 3, 6–8, 47, 120
Imagination, 45, 69, 142
Implementation, 2, 9, 10, 13, 14, 63, 107, 123, 125, 193, 195
Improvisation
 artistic improvisation, 108–111
 organizational improvisation, 107–111, 197
Incubation, 140
Insight problem, 7, 8, 10, 12, 23, 28, 87, 93, 95, 116, 121, 142, 143
Intelligence, 22, 27, 118, 122, 124, 126, 127, 199
Interpersonal. *See* Social
Intuition/Intuitive, 11, 21–25, 27, 29, 50, 52, 61, 62, 86, 88, 90, 93, 94, 96, 107, 108, 117, 140, 142, 143, 146, 166–174, 211, 175
 intuition of idea generation, 24, 62, 109
 intuition of judgment, 24, 26, 63, 88, 89, 94, 173, 176
 intuition of understanding, 23, 50, 51
Iteration/Iterative, 6, 46, 50, 53, 65, 85, 87, 91, 107, 108, 110

J
Judgement, 10, 48, 63, 89, 95, 165, 168, 170, 175

K
Kirton Adaption-Innovation Inventory, 116, 117, 125
Knowing, 24, 89, 122, 126, 127

L
Latent inhibition, 121, 122, 125, 126, 139, 177
Leader/Leadership, 193, 198–200, 202

M

Marijuana. *See* Cannabis
Meditation, 142, 146
Metacognition, 24, 63, 119, 142, 143, 147,
 148, 173, 211
Metaphor(s), 69, 91
Mindfulness, 89
Mode, 22–24, 26, 27, 118, 119, 123, 142, 143,
 147, 148, 173, 175, 198, 211
Models
 imaginative, 53
 maquettes, 53, 84
 mathematical, 84
 prototypes, 53, 65, 84
 visualization, 53
Mood, 26, 107, 116, 139, 172, 174–176
Morphological, 62, 64, 67
Motivation, 9, 24, 199, 202
Multiple criteria method(s), 88, 92, 93, 95
Myers Briggs Type Inventory, 116, 117, 120,
 125

N

Neural, 3, 6, 23, 26, 27, 29, 51, 70, 73, 87, 89,
 108, 116, 119, 120, 122, 124, 140, 146,
 147, 166, 169, 197
Neurofeedback, 146
Neuroplasticity, 27
Non-sequential, 117, 173, 211
Novice(s), 71, 115, 116, 125

O

Open-ended, 6, 7, 22, 140
Openness to experience, 116, 117, 119, 120,
 125, 139, 143–145
Original/Originality, 7–9, 11, 22, 28, 29, 48,
 49, 63, 65, 68, 70, 85, 91, 92, 115, 118,
 123, 124, 166, 167, 172, 194–196

P

Pattern, 6, 22, 23, 25, 26, 28, 66, 67, 166, 173,
 176, 197
Posture, 143
Preference(s)/Preferred, 4, 7, 13, 24, 26, 48, 49,
 83, 86–93, 96, 117, 118, 121, 123, 165,
 168, 176, 177, 195
Preliminary, 5, 53, 65, 169
Premature, 63, 84, 120
Prescription drugs, 144, 145
Problem finding, 45
Problem solving, 6, 29
Professional judgment, 89, 90, 93

Psychology/Psychological, 11, 26, 27,
 115–119, 121, 122, 125, 126, 166, 168,
 170, 211
Purpose, 1, 3, 4, 8, 10, 11, 46–51, 53, 62, 66,
 83–86, 90, 93, 107, 109, 194

Q

Quality, 6, 49, 63, 72
Quantity, 62, 72

R

Rational. *See* Analysis
Regulatory focus, 166, 167, 172–174, 176
Reward(s), 48, 50, 71, 92, 166, 167, 199
Risk(s), 12, 25, 28, 46, 48, 50, 71, 86, 92, 122,
 166–168, 172, 195, 199, 201

S

Seed Idea(s), 49, 61, 64–66, 68, 69, 71, 108,
 166, 173, 194
Select/Selection, 3–5, 8, 13, 14, 22, 24, 27, 48,
 50, 53, 63, 72, 83–85, 87–95, 107, 110,
 116, 118, 120, 123, 143, 144, 166,
 168–170, 174, 177, 193, 195, 201, 211
Sequential, 22, 23, 50, 124, 140, 173, 211
Single criterion method(s), 88, 90, 93
Six hats, 52, 65
Six men, 51, 65
Sketches/Sketching, 46, 53, 65, 84
Sleep, 140, 143, 145, 146
Social/Solitary, 13, 123
Success, 46, 93, 94, 119, 120, 122, 123, 194,
 198
Survive, 122, 165–168, 173

T

Team, 13, 46, 193–202
Thinking, 11, 21, 22, 25, 27, 51, 52, 64, 66, 70,
 115, 117–126, 146, 147, 166, 172, 173,
 178, 194, 196, 198–202
Thrive, 49, 165–168, 170, 176, 177
Time/Timelessness, 25, 28, 46, 48, 50, 62, 65,
 71, 107–111, 115, 118, 121, 125, 167,
 194, 197–200
Transcranial stimulation, 146, 147

U

Universal design activity(s), 1–6, 8, 23, 29, 45,
 50, 53, 61, 63, 65, 72, 83, 85, 107, 108,
 110, 117, 118, 125, 126, 174, 193–195,
 211

Useful/Usefulness, 4, 6, 8, 10, 12, 14, 28,
 46–49, 63, 65, 68, 71, 83, 85, 87, 88,
 90, 93, 96, 108, 115, 123

W
Well-defined, 6, 8

V
Value Judgment(s), 26, 176, 177

Printed in the United States
by Baker & Taylor Publisher Services